URBAN SPACE AS HERITAGE
IN LATE COLONIAL CUBA

URBAN
SPACE
AS
HERITAGE
IN LATE
COLONIAL
CUBA

Classicism and Dissonance

on the Plaza de Armas

of Havana,

1754–1828

PAUL NIELL

University of Texas Press
Austin

This book is a part of the
LATIN AMERICAN AND CARIBBEAN
ARTS AND CULTURE
publication initiative,
funded by a grant from the
Andrew W. Mellon Foundation.

Requests for permission to reproduce
material from this work should be sent to:

Permissions
University of Texas Press
P.O. Box 7819
Austin, TX 78713-7819

http://utpress.utexas.edu/index.php/rp-form
The paper used in this book meets the minimum requirements of
ANSI/NISO Z39.48-1992 (R1997)
(Permanence of Paper). ∞

Library of Congress Cataloging-in-Publication Data
Niell, Paul B., 1976– author.
Urban space as heritage in late colonial Cuba : classicism
and dissonance on the Plaza de Armas of Havana, 1754–1828 /
Paul Niell. — First edition.
 pages cm
Includes bibliographical references and index.
ISBN 978-0-292-76659-4 (cloth : alk. paper)
1. Plaza de Armas (Havana, Cuba)—History. 2. Architecture,
Colonial—Cuba—Havana. 3. Cultural property—Cuba—Havana.
4. Architecture and society—Cuba—Havana—History—18th century.
5. Architecture and society—Cuba—Havana—History—19th century.
I. Title.
NA804.H3N54 2015
711'.5509729123—dc23 2014036201

doi:10.7560/766594

For Johnette

CONTENTS

ILLUSTRATIONS

PLATES

ACKNOWLEDGMENTS

ON THE JOURNEY to this book's completion, I am most grateful to the following people and institutions for their assistance. What began as a dissertation was advanced by the support of the Latin American and Iberian Institute at the University of New Mexico in the form of a Dissertation Fellowship and Field Research Grant. Further investigations were carried out with the assistance of the Office of Research and Economic Development at the University of North Texas, including two Research Initiation Grants and a Junior Faculty Summer Research Fellowship. I thank my dissertation committee chair and adviser, Ray Hernández-Durán, for challenging me to address the role of art and material culture in the formation and reformation of Spanish colonial societies. Ray's passion for the spatial dimensions of colonial art and architecture inspired me as a graduate student, and his steadfast support as a mentor helped me to see this project through to a dissertation. The other members of my committee, Justine Andrews, Christopher Mead, and Charles Burroughs, also deserve special thanks. It has been a pleasure to work with Theresa May, my editor at the University of Texas Press. I thank Nancy Warrington for her meticulous copyediting of the manuscript and the two anonymous reviewers for their insightful suggestions.

The years spent researching and writing this book have been a circuitous path paved by the generosity of many wonderful people. For assistance with research in Havana, I thank Daniel Taboada, Ihosvany de Oca, Patricia Rodríguez Alomá, Arturo Pedroso, and, most of all, Eusebio Leal Spengler. For advice on Cuban research in the United States, I thank Louis A. Pérez Jr., Matt Childs, and Theresa Singleton. In Havana, my sincere gratitude goes to the employees of the Archivo Nacional de Cuba, Archivo de la Sociedad Económica de La Habana, Biblioteca del Museo de la Ciudad de La Habana, and the Biblioteca Nacional José Martí. In Seville, Spain, the staff of the Archivo General de Indias provided gracious sup-

port. In the United States, I thank the staff of the Benson Latin American Collection at the University of Texas at Austin, the Vanderbilt University Library, the Smathers Library at the University of Florida, and the Cuban Heritage Collection at the University of Miami.

Other scholars who have offered invaluable advice throughout the course of this research include Kelly Donahue-Wallace, Magali Carrera, Stacie Widdifield, Susan Deans-Smith, Carla Bocchetti, and the late David L. Craven. I thank the journals *Cultural Landscapes: A Journal of Cultural Studies, The Art Bulletin*, and *The Latin Americanist* for allowing me to reprint brief portions of already published articles. The following deserve thanks for their support through this process: Jeannette Peterson, Denise Baxter, Mike Vatalaro, Constance Cortez, Patricia Sarro, Chris Wilson, Kirsten Buick, the late Pam Simpson, Linda Rodríguez, and Luis Gordo-Peláez. For their assistance in research and preparing various aspects of this project, I thank Joe Hartman, Valorie Fair, and Emily Thames. Most recently, I thank my colleagues in the Department of Art History at Florida State University for their support.

Such an undertaking would not have been possible without the love and support of my parents, Nan and Barry Niell. Their compassion has instilled in me a deep fascination with and respect for the human experience. I am also fortunate to have had a mother- and father-in-law in Delores and John Meekins, whose generosity has benefited this project in numerous ways. I thank my brother, Jonathan Niell, for many stimulating conversations back and forth across the Atlantic via e-mail and Skype as he pursued his archaeology degree in Ireland. My deepest appreciation, love, and gratitude, however, go to my wife, Johnette Meekins, who has been on this meandering road with me for over a decade. All of the critical junctures in this project have met with her gaze, and she has been an inspiration at every one of them.

URBAN SPACE AS HERITAGE
IN LATE COLONIAL CUBA

INTRODUCTION

In November 2010, Joe Hartman, a graduate student studying with me at the University of North Texas, visited Havana, Cuba, to conduct fieldwork for his thesis and to observe the city's November 16 birthday celebration on the main plaza. This annual event occurs at El Templete (The Little Temple, completed 1828), a civic monument on the Plaza de Armas, where, as legend has it, Spanish conquistadors founded the city under a ceiba tree in the early sixteenth century, an event the structure commemorates. According to the story, the conquerors conducted the first Catholic Mass and meeting of the *cabildo* (town council) under the shade of the ceiba in 1519.[1] The contemporary ritual in Havana allows the city to reactivate its foundational narrative in an apparent effort to reuse the past for agendas in the present—specifically, to underpin civic, regional, and national identities. The following recounts Joe's description of the proceedings and summarizes the content of two films of the event that he brought back.[2]

The ceremony transpired November 15–16, and its inaugural event occurred at eight o'clock in the evening of the first day, when a crowd of journalists, invited guests, church officials, and acolytes assembled on the Plaza de Armas and moved from the old Spanish colonial governor's residence, the Casa de Gobierno (Government House), to the ceiba tree and the area around El Templete, on the east side of the plaza.

In this location, Eusebio Leal Spengler, the city historian of Havana, addressed the crowd through a loudspeaker while standing in front of the monument's neoclassical portico. Leal explained that the development of the civic ritual involving the ceiba tree cannot be accounted for empirically. Rather, he said, the celebration constitutes an aspect of Cuban culture that relates to an unquantifiable notion of identity in Havana. Perhaps Leal echoed the writings of the Cuban anthropologist Fernando Ortiz (1881–1969), particularly the latter's statement that "the real history of Cuba is the history of its intermeshed transculturations."[3] The city historian then ceremoniously circled the ceiba tree three times counterclockwise and tossed coins into the air, trailed by a procession of acolytes carrying censers. After these initial turns around the tree, the remainder of the entourage followed Leal's example. This select group of guests seemed to contain conspicuously few people of African descent; across the plaza, however, and outside the gates of El Templete, a recently erected metal fence restrained another, more ethnically diverse crowd of waiting spectators.

After this exclusive ceremony, police allowed the remaining crowd into El Templete to likewise participate in the ritual. Each followed the processional program of making three turns counterclockwise around the tree, touching the tree's trunk as they passed, with some people dropping money at its base. Scores of spectators visited the tree throughout the night and the following day as guards constantly monitored the site.[4] This communal, yet hierarchical and policed, ritual at the foundational ceiba tree of Havana is the performance of heritage, a memory craft that fashions contemporary significance out of the things of the past, and sometimes, as in this case, by the appropriation and articulation of a natural and phenomenal link to that past. The tree is reinscribed through this civic ritual in which a site of heritage production in Havana's past is reactivated in the present to serve a variety of interests and agendas.

As Leal Spengler implied in 2010, this heritage site and its commemorative monuments are the result of a transcultural process. People in Havana continue to use the space five hundred years after the initial Europeans arrived in the Caribbean and after absorbing the influences of Spanish viceregal rule that persisted for almost four centuries in Cuba (1511–1898), the Cuban republic (1902–1959), and the ongoing Castro revolutionary government. During this time, the indigenous people of Cuba resisted

Spanish rule and were assimilated into the dominant society and violent-ly oppressed; immigrants arrived from Spain, other parts of Europe, and the Americas; contraband trade flourished; an island-born Creole society emerged interspersed with arriving Spaniards and foreigners; and ships brought hundreds of thousands of Africans to labor on the island as slaves, which contributed in turn to large free populations of African descent. These historical processes informed the development of a complex Cuban material culture of which the foundational ceiba and the monuments erected to represent it form a part.

The circumambulation of the ceiba tree that takes place at the Novem-ber 16 ceremony functions to remake heritage on the site, but it is one of entangled histories, memories, and identities. The light touching of the tree on each pass, for example, and the offerings placed at its base are found throughout literature on the African Diaspora pertaining to the use of ceibas in devotional rituals.[5] People of African descent in Cuba, Hai-ti, Jamaica, Brazil, and elsewhere widely regard this particular type of tree as a divine or semidivine entity. African Diaspora religious practice, par-ticularly in Catholic contexts, is frequently found to have merged the reli-gious culture of the dominant society with remembered African beliefs and practices, a process that has often been described by scholars as syn-cretism, acculturation, or transculturation.[6] An especially striking example of such new cultural production and multivalent seeing in Cuba is the fact that November 16 marks not only the date of Havana's founding but also the day that celebrates the Afro-Cuban deity Aggayú.[7] Such an example, among many others, suggests African-Atlantic culture as an indispensable part of Cuban spatial production and points to the multiple cultural land-scapes that coexist in Cuba.

This book focuses on the history of the symbolic ceiba tree site of Havana and associated cultural production from 1754 to 1828, consider-ing the monuments built to commemorate and reconfigure the tree and its narrative as part of a heritage process in early-nineteenth-century Cuba. By the late 1820s, the mainland viceroyalties of New Spain and Peru had already formed independent nations, leaving only Cuba and Puerto Rico as loyal territories of Spain in the Americas. The heritage work that was El Templete in 1828 was a means of fixing history in an effort to render certain identities as likewise stable and anchored to place. This effort to locate a predictable past, I argue, was simultaneously a design to deny the

social instability that plagued Havana's slave society as well as the political upheaval that had rocked the Spanish Americas by the 1820s. In this sense, the monument was the construction of a *lieu de mémoire* (site of memory), as defined by Pierre Nora, who argued that such sites arise from a response to the pressures and anxieties of rapid social transformation.[8] I maintain that this conscious memory craft in early-nineteenth-century Havana came from dominant groups within the fabric of Cuban material culture and reveals competing interests.

HERITAGE AS METHODOLOGY

In recent years, Heritage Studies have increasingly defined heritage as more than an object or site, but also a process by which people use the past for present purposes. In *The Ashgate Research Companion to Heritage and Identity* (2008), David C. Harvey argues that "heritage is itself not a thing and does not exist by itself—nor does it imply a movement or a project. Rather, heritage is about the process by which people use the past—a 'discursive construction'—with material consequences."[9] This new constructivist approach to heritage emphasizes the idea of "present-centeredness" and probes "the ways in which very selective past material artifacts, natural landscapes, mythologies, memories and traditions become cultural, political and economic resources for the present."[10] This new theoretical approach to heritage has primarily been focused on and practiced within the United Kingdom, Australia, and the United States, with much less attention being given to the areas that comprise the former Spanish viceregal Americas. In the present book, I selectively subscribe to this new conception of heritage, arguing that heritage has much to offer Spanish colonial and early national Latin American art history, as well as art history in general. This is so, I contend, not only because heritage thus defined has been a global practice seen perhaps at all stages of human civilization, but also because it facilitates the analysis of the operation of material culture in heterogeneous and hierarchical societies. In focusing on how and why societies "presence" the past, heritage allows for the identification of dominant voices and strategies as well as subaltern responses and tactics within a colonial milieu. It also appears in multiple domains, which helps identify interrelations between overlapping areas of discourse, such as poetry, prose, history, philosophy, and popular publications.

The hierarchical, negotiated, and contested nature of Spanish colonial societies and their complex uses of images, objects, and spaces suggest that an academic analysis of heritage as process, object, and site could contribute to the broader study of how colonial discourses maintain colonial ideologies.[11] In their book *Dissonant Heritage: The Management of the Past as a Resource in Conflict* (1996), Gregory Ashworth and J. E. Tunbridge have argued that an intrinsic dissonance exists in the construction of heritage found in disagreements about its significance and use.[12] Created through collective interpretation, heritage is inherently contested, and variant explanations of its meaning produce the ambivalent relationships that exist between heritage, place, and identity.[13] In societal discourses of inclusion and exclusion, the ownership of heritage by one group implies another group's disinheritance. Yet this dissonance can perhaps by theorized as a succession of degrees of social affirmation or disavowal, with some groups sharing different aspects or levels in a particular heritage expression, while others become more completely disinherited.

The emphasis on dissonance in Heritage Studies offers a means to move beyond colonizer-colonized binaries as we seek to understand the creation of meaning in late colonial contexts. If heritage is a process with implicit layers of cultural agreement and discord, then it calls into question the complex, overlapping, and contested interests of multiple groups.[14] Dissonance might be found, for example, in the competing discourses surrounding the ceiba tree monument of 1828. Visual narratives valorized Cuba's loyalty to Spain based on a constructed view of the past to meet the realities of imperial disintegration. Simultaneously, other combinations of visual signs suggest Cuba and Havana as authentic places that validate a sense of belonging. Rather than working out such contrasts as manifestations of "hybridity," which implies stasis, heritage sets these expressions into motion and evolution as they work against each other in the dynamics of colonial consciousness and social life.[15] Furthermore, the heritage of Havana's foundational ceiba tree seems to have authorized certain views of social difference, such as that between *españoles* (individuals of Spanish descent) and *castas* (individuals of mixed ancestry, including mixtures of Indian-Spaniard, African-Spaniard, and Indian-African). Yet the construction of a collective heritage in late colonial Cuba would need to be considered in relation to the phenomenon of *mestizaje* (pride in miscegenation) known to multiple Spanish American contexts. The pride in or, as

Serge Gruzinski argues, the condition of being of a socially and culturally "mixed" society of European, American, African, and other threads must be thoroughly considered when evaluating such constructions of collective memory.[16]

The erection of heritage monuments in 1754 and 1828 on the Plaza de Armas of Havana is also significant in the relationship established between heritage and the normative modes of social and political representation on the Spanish colonial plaza. A space used by officials to reinforce royal and ecclesiastical authority through architecture, imagery, and ritualized performances, the main plaza of a Spanish town or city became a prestigious space for the expression of power and for social appropriation. As colonial societies took form over time, the plaza became an important site in the definition of a sense of place in the colonial city. The notion of place itself has been defined and explained in many ways by intellectuals, including contemporary scholars of heritage.[17] In the present book, I consider place as a discourse of belonging that is underpinned or supported by heritage, a belonging to the city, the island, or indeed, the Spanish Empire. Heritage authenticates place by such an effort to fix history and recraft collective memory, in this case, via monuments. The ceiba tree memorials of 1754 and 1828 reinscribed the past and fabricated collective memory to support prevailing identities and sociopolitical agendas. Yet the process of fashioning heritage reveals dissonance spawned by multiple coexisting and competing interests, voices, agendas, and desires.

Place-oriented imaginings in Cuba must be considered in relation to the consciousness of criollos/as, or Creoles (individuals of Spanish blood or Hispanic descent born in Cuba). The growing affection of this group for their American *patria* (homeland) that developed during the colonial period has been explained as a manifestation of "Creole patriotism."[18] Spanish officials repeatedly deployed complex visual, textual, spatial, and performative genres to differentiate colonial subjects and shape loyal subjectivity.[19] Scholars have suggested that Creoles imagined themselves through this colonial framework, one that cultivated loyalty.[20] Viceregal representation performed work in shaping and reshaping colonial subjectivities and was itself formed by local societies and spaces. Creole perceptions of sameness with or difference from *peninsulares*, or Peninsulars (individuals of Spanish blood born in Spain), thus occurred within a complex arena of representation that worked to reproduce the unequal social

and political relationships of colonialism and to foster loyalty to this system.[21] The heritage processes that occurred at Havana's foundational ceiba tree were part of this complex fabric of colonial representation, and thus heritage discourse in this context becomes a particular type of colonial discursive practice.

FASHIONING COLONIAL HERITAGE

The temporal settings for the two ceiba tree heritage monuments in late colonial Havana bracket the transformation of the Plaza de Armas from 1771 to 1791. This reworking of the plaza came during the escalating reforms of the Spanish Bourbon monarchy, which took the throne of Spain from the Austrian Habsburgs during the War of the Spanish Succession, 1700–1714. The Habsburgs had conceived of their American viceroyalties as a composite monarchy of kingdoms, while the Spanish Bourbons increasingly aimed to introduce more rigorous and centralized imperial practices. The so-called Bourbon Reforms intensified after the conclusion of the Seven Years' War in 1763 and were aimed at renovating Spain's stagnating economy along with its science and arts.[22] The Spanish Crown adopted a more stringent translation of Greco-Roman classicism in the visual arts as the official imperial style, denominated by art history as neoclassicism and sponsored by the Royal Academy of San Fernando in Madrid, which opened in 1752. Royal expressions in art and architecture exhibiting a more severe classicism were adapted to American civic contexts in an effort to propagate the image of an ascendant, strong, and prosperous empire and to produce more loyal and industrious subjects.[23]

On March 12, 1828, the *Diario de La Habana*, one of the city's most prominent colonial newspapers, carried a superior order warning that carriages would be prohibited from entering the Plaza de Armas on the 18th, 19th, and 20th of the month due to the celebrations honoring the saint's day[24] of Queen María Josefa Amalia (1803–1829) of Spain, third wife of his majesty King Ferdinand VII (r. 1813–1829, 1833).[25] The festivities culminated in the March 19 inauguration of the new monument to commemorate the city's alleged founding site. El Templete memorialized the site on the east side of the Plaza de Armas where the Spanish conquistadors supposedly held the first Christian Mass and meeting of the *cabildo* (town council) under the tree's generous shade in 1519 (fig. I.1).[26] The *Diario* of March

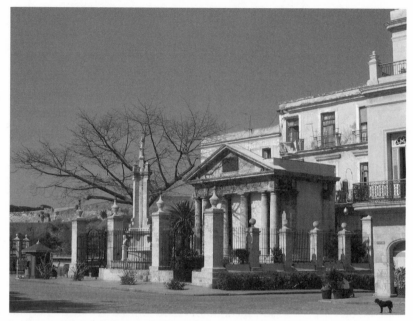

I.1 Antonio María de la Torre et al., El Templete, 1827–1828. Plaza de Armas, Havana, Cuba.
Temple-like structure, approximately 30.25 ft. tall from base to the key of the pediment,
33 ft. wide, and 23.38 ft. deep. Photograph by the author.

16 proclaimed: "The Island of Cuba, faithful to its principles and its duties,
has given on this day to the entire world the ultimate proof of its unblem-
ished loyalty and undeniable patriotism. The magnificent monument that
is presented today to public anticipation, paid for by the inhabitants of
this heroic capital, will preserve for future generations a glorious memory
of the virtues of their ancestors."[27]

This passage demonstrates how the heritage of the ceiba tree operat-
ed to valorize Havana's loyalty to Spain. The sense of place, the discourse
of belonging, in this instance refers to Spain as *patria*, as homeland. Yet
the aspect of heritage that imposed loyalty coexisted with a wide range of
representational forms that seem to validate Cuba's unique history within
the Spanish Empire. This tension creates an important area of dissonance
within this colonial heritage in that it suggests the potential for a lack of
agreement on the significance and use of heritage.

The 1820s heritage process at the ceiba tree is made more complex by a
previous attempt here to construct a site of collective significance. In 1754,

Captain General Francisco Cagigal de la Vega (served in Havana, 1741–1762) had ordered the erection of a vertical limestone pillar at the site to compensate for the governor's mandate to have the ceiba tree removed the previous year—its roots having compromised the nearby fortification wall. The eighteenth-century Cuban historian José Martín Félix de Arrate wrote of the Plaza de Armas: "Until the year 1753, a robust and leafy ceiba survived there that, according to tradition, at the time of the colonization of Havana, was where the first Mass and *cabildo* were celebrated beneath its shade, a fact that Field Marshal D. Francisco Cagigal de la Vega, governor of the plaza, intended to pass on to posterity by raising on the same site a commemorative column that preserves this memory."[28] This 1754 monument mimicked the tree's natural features by employing baroque decorative elements, including curvilinear volutes that adorned a triangular shaft supporting a statue of the Virgin and Child (fig. I.2). The captain general's construction of such a memorial suggests his attempt to assuage public resentment over his removal of the tree, to win popular favor, to immortalize his administration, and perhaps to insinuate himself into local narratives of place. The work reveals an earlier heritage process that surely housed dissonance, yet it is much more difficult to map out than in the 1828 monument. In this later work, the site was not only reused but also the 1754 monument, which was retained and incorporated, a move that juxtaposed elements from the baroque and the emerging neoclassical aesthetics of the city. This conflation of old and new was indeed a part of the heritage process in 1828, as the retention of the past emphasized continuity, civic tradition, and political succession and thus validated the imperial present.[29]

In 1827, royal officials, senior clergy, and the city's elite had expressed renewed interest in the emblematic ceiba tree site by commissioning a monument from engineer Antonio María de la Torre. Begun in November of that year and inaugurated the following March, El Templete preserved and enclosed the 1754 tree memorial built under Cagigal within a stone and iron fence, forming a space to house a new, temple-like structure. The work incorporated a more sober and severe classicism associated with the European art academies and the spread of the so-called neoclassical style.[30] Its Tuscan Doric revival portico fronted a small quasi-cubical building designed to house three academically conceived history paintings narrating the story of the site (fig. I.3; plate 1). For the paintings, the bishop of

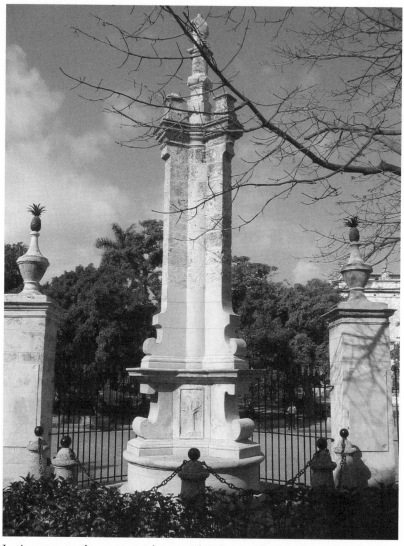

I.2 Anonymous, ceiba tree memorial, c. 1754. Plaza de Armas, Havana, Cuba. Photograph by the author.

Havana, Juan José Díaz de Espada y Landa, hired the French expatriate artist Jean-Baptiste Vermay, who had arrived in 1815 and was a former student of the academic master Jacques-Louis David in Paris. Vermay's pictorial interpretations of the foundational events provided an academic rendering of the site's history for nineteenth-century audiences.

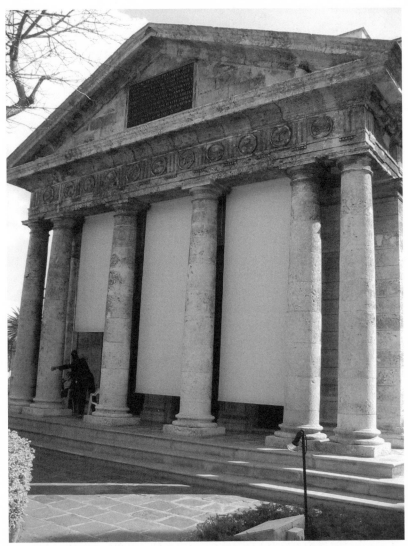

I.3 Antonio María de la Torre et al., portico, detail of El Templete, 1827–1828. Plaza de Armas, Havana, Cuba. Photograph by the author.

The first of these works, for the northern interior wall, was *The First Cabildo* (c. 1827–1828), a painting that depicted the Spanish conquistadors seemingly in the act of founding the town and establishing secular order under the ceiba tree in the sixteenth century (fig. I.4; plate 2). For the opposite (south) wall, the artist painted *The First Mass* (c. 1827–

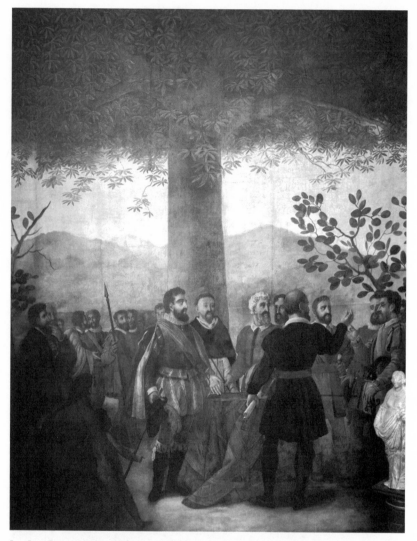

I.4 Jean-Baptiste Vermay, *The First Cabildo*, c. 1827–1828. Oil on canvas, approximately 13.75 × 11 ft. El Templete, Plaza de Armas, Havana, Cuba. Reproduced courtesy of the Oficina del Historiador de la Ciudad de La Habana (hereafter O H C).

1828), a scene depicting a priest holding the first Christian Mass of the city, likewise set beneath the tree's great canopy and attended by a group of conquistadors and Amerindians (fig. I.5; plate 3). Workers installed a third, much larger painting sometime thereafter (c. 1828–1829) against the eastern wall and situated between the other two monumental canvases.

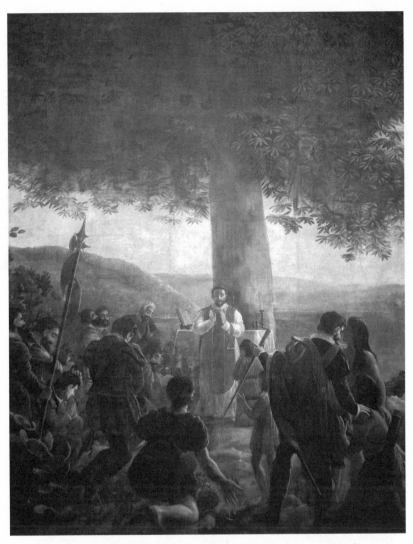

I.5 Jean-Baptiste Vermay, *The First Mass*, c. 1827–1828. Oil on canvas, approximately 13.75 × 11 ft. El Templete, Plaza de Armas, Havana, Cuba. Reproduced courtesy of the OHC.

Known as *The Inauguration of El Templete*, this third scene allowed Vermay to depict the inaugural ceremony of the monument itself on March 19, 1828, in a painting that features a detailed group portrait of Spanish royal officials, the city's bishop, members of the Havana elite and other social ranks, and a self-portrait of the artist (fig. I.6; plate 4). To enrich the

I.6 Jean-Baptiste Vermay, *The Inauguration of El Templete*, c. 1828–1829. Oil on canvas, approximately 13.75×30 ft. El Templete, Plaza de Armas, Havana, Cuba. Reproduced courtesy of the OHC.

focus on conquest history, Bishop Espada donated a marble bust of Christopher Columbus to occupy a ledge on the 1754 pillar (see fig. 3.28).

Approaching this work as a question of heritage exposes problems in Spanish- and English-language scholarship on El Templete that speak to larger problems in the field of late Spanish colonial art history. The first is an overreliance on period styles as authentic signs of specific historical developments, positing El Templete as a neoclassical work that must belong to the Bourbon Empire's implementation of an imperial classicism toward the end of the colonial period. Such a view homogenizes neoclassical forms in the Spanish world and tends to eliminate considerations about how they were reshaped by local conditions, developed local significances, and validated the emergence of a local modernity.

Audiences and patrons in the Americas, in contrast, seemed to use stylistic transitions in the late colonial period to their respective advantage. The colonial press of 1828 framed El Templete as an exemplary work of *buen gusto* (good taste) in spite of the retention of the 1754 pillar, which exhibited baroque aesthetic tendencies.[31] This discourse encouraged the reader to reconcile stylistic difference seemingly to serve heritage (the reuse of the past for present purposes), which underscores perceptions of a

place-specific importance. This passage suggests a slippage in the significa-
tion of *gusto* that lends itself to an effort to validate the city's modernity in
the present. Yet this effort was steered by the socioeconomic and cultural
elite who sought to achieve a certain standard of classicism for internation-
al validation, whereas the baroque seems to have remained popular partic-
ularly among members of the lower social echelons.

The discussion of El Templete's political meaning presents a further
problem that Heritage Studies can address. The significance of the work
has been framed as responding to two agendas in opposition, those of
its most powerful patrons. Historians point to the ideological struggle
between the city's reformist Bishop Espada and the oppressive, reaction-
ary Spanish governor and captain general of the island, Francisco Dioni-
sio Vives.[32] This conflict took center stage in discussions at a conference
organized in 1943 commemorating the Cuban Enlightenment. Fernando
Ortiz reports that in a speech by José Antonio Aguirre, first president of
the Basque Autonomous Community, the politician noted the following:
"Regarding this, I remembered the *jugarreta* (dirty trick) that the Basque
bishop played on the captains general, arranging the construction of El
Templete in this city behind the legendary ceiba, which was a sign of the
jurisdictional liberties of the town of Havana, and consequently, in front
of the palace of the island government, was erected an approximate repro-
duction of the tree of Guernica and of the Sala de Juntas, where the nation-
al liberty of the town was symbolized."[33]

The president contended that Bishop Espada invoked his Basque roots,
enlightened principles, and constitutional advocacy on the Havana plaza
by appropriating a symbolic oak tree in the center of the town of Guer-
nica, Spain. This tree served the Basque people in medieval and early mod-
ern times, as Castilian monarchs were obliged to swear an oath to preserve
Basque *fueros* (regional laws) underneath the Guernica tree. This contextu-
alization of El Templete as a subversive monument, echoed by subsequent
historians, transforms Bishop Espada into a national hero as the man who
brought the Enlightenment to Cuba. The problem in positing this tension
between absolutism and constitutionalism as the explanation for El Tem-
plete's meaning is elucidated by the fact that the work resulted from the
patronage of more individuals than the two rivals in question. According
to archival documents, a group of civic elites, including Creoles and Pen-
insulars, contributed a considerable portion of the necessary funds for El

Templete upon being invited to do so by the captain general. The implications of this "public patronage" have been largely ignored by the historiography, as English-language scholarship has largely disregarded the impact of late colonial public cultures on art and architecture in the Spanish world. Furthermore, the bishop-versus-captain-general contextualization reduces the potential reception of the work by a complex colonial society. Images of Spanish conquistadors, Amerindians, nineteenth-century elites, and Cuban botanical flora must be considered within a fuller colonial setting and on the broader Atlantic world stage.

COLONIAL MODERNITY AND
THE REFORMIST SELF

In order to better situate the heritage process at work on the ceiba tree site in Havana, I turn to scholarship of the early twenty-first century on the multifaceted concept of modernity that emphasizes its local unfolding in global contexts.[34] Such work has emphasized Spain's unique contributions to global modernity, for example, in the areas of cartography, bureaucracy, and natural history.[35] This scholarship counters long-established views propagated by northern European writers that eighteenth-century Spain essentially saw no Enlightenment, as it remained Catholic and loyal to an absolutist monarch. Such views obfuscate imperial contributions to modernity and deny colonialism as providing a framework for the emergence of nationalism.[36]

The Bourbons in Spain increasingly sought to renovate the Spanish state, largely modeled on France. These reforms included the expansion and restructuring of state bureaucracy, intensified record keeping, the promotion of state institutions, the demand for more rigorous urban and architectural planning, and the promotion of education. For the purposes of this study, several such efforts deserve special attention, particularly those aimed at reforming individual subjects. These include the establishment of civil societies in Spain and its colonies abroad for the promotion of a more individualized subjectivity, especially in elite circles.[37] They also encompass the Bourbon effort to implement a disciplining of individual subjects in the interest of making more efficient producers of national wealth.[38] The state increased its technologies of surveillance and began to render its subjects more legible and visible through intensified record

keeping. Reformers also sought more rational approaches to the construction or reconstruction of urban spaces based on extensive planning, an effort that could be seen as an attempt to heighten spatial surveillance and the legibility of social bodies.

The significance of patronage by members of an elite public derives from the Spanish Crown's efforts to promote civil societies to support the spreading of state power and to ameliorate the empire's stagnating economy by incorporating the nobility of various regions into projects for local improvements. Reformers encouraged the assimilation of Sociedades Económicas de Amigos del País (Economic Societies of Friends of the Country) in Spain and the Spanish Americas as tools for economic renovation.[39] In an analysis on the anthropology of the nation-state, Michel-Rolph Trouillot notes the incorporation of civil societies as a state-building apparatus that seeks to construct atomized individual subjects who collectively identify with the state and its mechanisms.[40] Such associations reified a kind of "public sphere" in various parts of urban Spanish America, a phenomenon that Jürgen Habermas addressed in the contexts of France and Germany.[41] Yet, the idea of the Habermasian public sphere cannot simply be applied to Spanish or Spanish American publics, as the latter differed in their general adherence to the Catholic faith and allegiance to the Crown. The Hispanic Enlightenment sought "useful" applications from eighteenth-century science and rationalism for the renovation of empire. Civil societies in the Spanish world empowered and obligated the local nobility in certain urban areas to take more of an active role in public affairs. In Havana, Creole and Peninsular elites served together in such societies, complicating our view of their self-conceptions as distinct groups in all ways. Acting mutually for the sake of public improvements seems to have offered new avenues to prestige and was understood as serving immediate localities as much as the Spanish nation. The existence of such societies in early-nineteenth-century Havana opened up a site for Creole-Peninsular collaboration and perhaps even collective identifying with the city and its various civic improvement projects. Furthermore, such formal associations became an elite space for the emergence of neoclassicism's alterity, in the elite colonial public's identification with, distancing from, or local translation of classical revival.[42]

In an effort to renovate or even construct national culture and reshape nationalist seeing, Spain founded academies of history, language, and

visual arts in the eighteenth century. These institutions not only offered instruction but also carried out research, exploring the Iberian Peninsula for signs of authentic national culture while identifying and validating the nation's participation in the perceived universal language of a Mediterranean classicism, particularly those ruins left by the Roman Empire in Spain. Historians set out to rewrite Spain's history and that of the New World in an effort to render such histories as more empirical, universal, and nationalist narratives of the past. The Alhambra in Grenada, the literature of Cervantes, and other medieval and early modern Spanish productions—entangled with the legacy of Islam—became heritage resources and sites for national redefinition as much as the Roman legacy in Spain. Neoclassicism might be viewed as the authorized heritage discourse in this process, providing an authoritative language in multiple expressive genres that mediated between the local, international, and imperial. While neoclassicism could represent a high cultural authority irrespective of place, efforts were simultaneously under way to expose the uniqueness and authenticity of particular regions, places, or cities. As Spain searched for its own uniqueness, Creoles in the Americas, and even Peninsulars, became increasingly interested in the distinctive nature of their own localities, cities, and regions. Peninsulars even appear to have made efforts to visually insinuate themselves into the narration of American place, a phenomenon that the art historian Emily Engel has observed in viceregal portraiture in South America.[43] Local histories, including conquest narratives; local flora; and the customs of local societies developed as signs of place within imperial geopolitical domains for a complex audience in the Americas. Patriotism was, therefore, not a fixed ontological connection to the land, but a discursive process that reinscribed land, region, nation, and city for various contemporary purposes.

Efforts to classify and homogenize botanical knowledge represent another Spanish contribution to modernity. The work of the art historian Daniela Bleichmar has ably demonstrated the importance of the scientific classification of nature to imperial efforts in the eighteenth-century Spanish world.[44] The ordering of the empire's botanical specimens based on the system of binomial nomenclature invented by the Swedish botanist Carl Linnaeus took on political importance for the control of territory and the exploitation of resources. These efforts, as Bleichmar argues, correspond to broader patterns of rational seeing—of making the empire, its botany, and

its subjects more visible and legible in the interest of political control and economic renovation. The acute attention paid to the ceiba tree in El Templete can be viewed within a nascent scientific discourse in Havana guided by the local botanical garden that opened in 1818, an institution that in many ways sought to imitate Madrid's Royal Cabinet of Natural History.

A final characteristic of global modernity registered in Spain and Spanish America is a rationalization of society whereby social and racial classification were intensified and recast.[45] Even as white and black spheres overlapped in Havana, royal officials and civic elites increasingly sought to separate these realms. Aesthetic valuations became entangled with this reordering of society based on political economy, social tensions, and divisions within the trades. In 1818, the Economic Society founded a drawing school in Havana named the Academy of San Alejandro, after the intendant and Economic Society director Alejandro Ramírez. The new school seems to have been conceived within the racial politics of art production in late colonial Havana.[46] These efforts speak to attempts to rationally identify, control, and manage the ethnic other and to render such order visible, as in the eighteenth-century *casta* painting genre of New Spain. Thus the revised aesthetics that drawing instruction would produce seem to have become a strategy of reform not only imposed by the Bourbon monarchy from without, but also cultivated by an oligarchy from within Cuba.[47]

The appropriation of a rigorous, more archaeologically correct Greco-Roman classical revival, or neoclassicism, can be regarded as a global phenomenon in the eighteenth and nineteenth centuries that was thoroughly entangled with modernity and coloniality. This mode of civic, religious, and private expression spoke a language of cultural authority via the imagined standard of authenticity found in the antique. It can also be said to have represented, validated, and even romanticized a broader rationalist and economic project. Dilip Parameshwar Gaonkar, a scholar of public culture, identifies the construction of the paragon of antiquity as part of a phase in the rise of global modernity in which elite societies became "custodian(s) of the classical . . . [by setting] . . . the measures and models of human excellence that each new age must seek to emulate under altered conditions without ever hoping to surpass it."[48] One could offer that classical revival art and architecture became a means of applying such knowledge-power to perceptual and lived spaces, of reinforcing power relations by

upholding ideologies in day-to-day life.[49] Such theorizing of these global processes involving classicism lends itself to postcolonial ideas involving the cultivation of dependency on a paradigmatic standard, such as Homi Bhabha's notion of mimicry.[50] Hence classicism in history, literature, and visual art served an important role in capitalist processes in various societies worldwide, often as a tool for promoting certain sectors of society and controlling others. Such classicizing values could become entangled with the operation of colonial hierarchies in Spanish colonial contexts that elevated *limpieza de sangre* (purity of blood), as defined by the status of *español* (Spaniard), above the racially mixed *castas* (castes).

In terms of managing a subject population, classicism could gain greater authority through its association with the past via a heritage process imbued with an eighteenth-century tendency to construct essentialized historical foundations. Thus the construction of certain elite identities in Havana's El Templete as belonging to the *patria* or to the city was interconnected with a simultaneous disinheritance of the *castas*, in particular, people of African lineage. As the products of late colonial heritage, such modes of seeing and representing responded to a socioracial crisis that compelled urban elites to attempt to restore tranquillity, quiet phobias, and manage certain sectors of the population even as such expressions were drawn out of a cultural milieu informed by these very subalterns.[51] The successful slave rebellion on the Caribbean island of Saint-Domingue, which began in 1791 and was later known as the Haitian Revolution, generated anxieties among white elites in slave societies throughout the Atlantic world that this event and the subsequent establishment of the independent black republic of Haiti would become a model that might encourage their own slaves and free blacks to revolt. On the neighboring island of Cuba, with its similar demographic conditions, the white elite effectively used civil association to advance racist agendas.

IN THE FIRST TWO CHAPTERS of this book, I establish the conditions for the heritage production at the foundational ceiba tree of Havana by examining Bourbon implementations of classicism and spatial order in the late eighteenth century and the rise of a colonial modernity and reformist selfhood in the opening decades of the nineteenth century, with their implications for vision, representation, and space making. I address

the development of the city's *intramuros* (area within the urban walls) and how the urban fabric became a setting for the construction of social identity, including the practice of a private heritage. This arena of urban discourse via architecture and visual representation, along with military concerns, sets the stage for appreciating why royal officials chose to recon-struct the Plaza de Armas in the manner proposed in the 1770s. Finally, I examine the plaza in relation to a colonial discourse of performance and ritual—how social and political hierarchy was acted out in the reading of the 1812 constitution and in the processions of the city's African mutual aid associations, the *cabildos de naciones*.

In chapter 2, I explore the rise of an elite public in Havana and the mul-tivalence of classical revival. The emergence of a more rigorous interpre-tation of Greco-Roman classicism in the city coincided with the promo-tion and cultivation of a new form of subjectivity, identified by historians as a relatively bounded, atomized individuality. The founding of various forms of civil association in Havana, promoted by the "enlightened" court of Madrid, promoted such reformed subjectivity. Meanwhile, members of civil society contributed actively to various civic projects involving the new classicism. Rather than merely an imperial implementation, several cases bear out the active role of local elites in the construction of a late colonial reformist culture. I examine local understandings of *buen gusto* in the writ-ings of the Cuban priest and intellectual Félix Varela, along with how taste was lived in the social spaces of early-nineteenth-century Havana. Atten-tion is given to Spain's promotion of knowledge in the eighteenth century, especially its academies of language, history, and visual arts, which impact-ed the colonial Americas. The effects of religious reform on the concep-tualization and reception of local classicisms are considered in Havana's religious art and architecture following the arrival of the reformist bish-op Juan José Díaz de Espada y Landa in 1802. Furthermore, I examine the role of portraiture in the colonial social context and address the impact of Jean-Baptiste Vermay on certain representational conventions. Finally, I examine the racial politics surrounding the founding of a drawing school for Havana, led by Vermay, as it relates to growing elite anxieties about the apparent predominance of people of African descent in the visual arts of the city and the growing presence of these individuals in general.

Following a consideration of the urban, social, and artistic condi-tions, I turn in chapter 3 to the construction of heritage in 1754 and 1828

on Havana's ceiba tree site. The emergence of the ceiba tree as a heritage resource in early modern Cuba is considered for its potential Amerindian, European, and African origins. The enigma of the plaza ceiba in Havana and its foundational story are considered against an array of primary documents. The 1754 pillar is addressed in its known context, while the commission and patronage of El Templete are exposed as a collaboration between royal, clerical, and elite sponsors. I examine the typological and symbolic constructs relevant to the 1828 monument, considering their origins in devotional shrines, Enlightenment concepts, Masonic symbolism, and local memorials. From this analysis, El Templete emerges as a new type of interface between architecture and urban space by contrast to the Bourbon palace architecture across the Plaza de Armas. Finally, I consider the Vermay paintings within El Templete as the construction of a heritage gaze shaped by colonial discourse, as I explore potential perceptual and experiential sequences engaged by audiences.

In chapter 4, I examine heritage dissonance in El Templete. The disagreement over the meaning and uses of heritage emerged in multiple contrasting heritage gazes, such as the past as validation of Spanish imperial and paternal governance versus the past as a testament to the dignity and primacy of Cuban place. Various arboreal tropes of European and American origin became additional heritage resources to strengthen claims of varying sorts in the foundational ceiba tree on the Plaza de Armas. A wide array of European and Atlantic world representations, including local devotions, civic signs, revolutionary emblems, and Amerindian figures, among others, are considered for how they provided shape to the legibility of heritage for particular audiences in Havana.

Having established a sense of the dissonance of colonial heritage in El Templete, I focus in chapter 5 on other areas of the monument's multivalence. These include the subaltern meanings of heritage in the monument as well as projects of rationalized social management on the island. The effort to establish new towns for white settlers, initiated by Havana's Economic Society, is considered in tandem with the spatial ordering of these towns and the known racialization of artistic aesthetics in nineteenth-century Cuba. The narrative of historical encounter in the history paintings by Vermay is examined as a practice of disinheritance because of the ways in which Spanish, Creole, and Indian figures appear in the painted series. Finally, the African dimensions of the ceiba tree mentioned in chap-

ter 3 are reconsidered for what they may reveal about subaltern voices and the ways in which elites may have manipulated transcultural signs in urban representation in an effort to sway African audiences. Heritage performed extensive cultural work on this site throughout its known history, as it does today. Its operation before and after the Seven Years' War, in the wake of the Haitian Revolution, and in conjunction with Bourbon Reforms in Cuba suggests heritage as an important framework to view late Spanish colonial art, architecture, and visual culture.

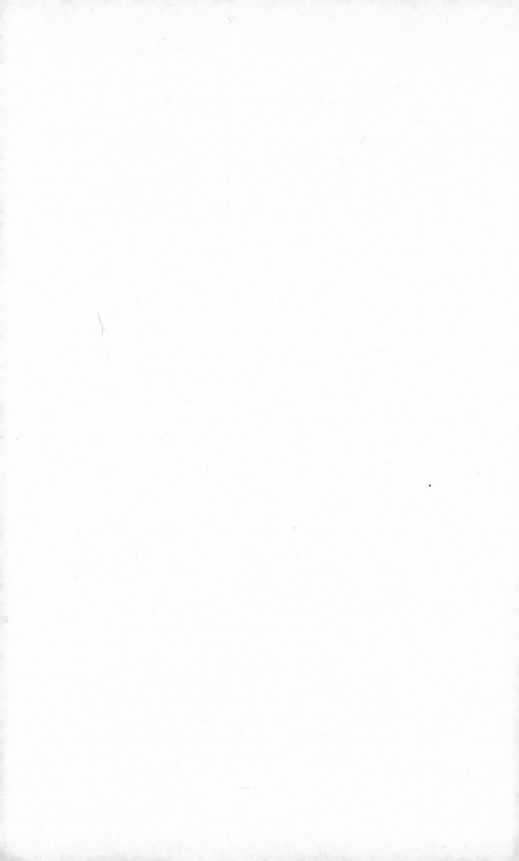

The Plaza de Armas and Spatial Reform

On August 14, 1762, Havana came under British control and occupation near the end of the Seven Years' War (1756–1763).[1] After eleven months, the administration of Spain's King Charles III (r. 1759–1788) had brokered a deal with the English to accept the Spanish territory of Florida in exchange for the return of Cuba. The near loss of the island to a rival European power exposed the geopolitical vulnerabilities of the Spanish Empire. Havana had served as a military outpost since the sixteenth century for control of the Florida Straits and played a central role in the machinations of empire as a vital rendezvous point for Spain's annual fleet system.[2] The island's colonial governors were referred to as "captains general," underscoring their dual administrative and military roles. When Spanish royal officials returned to the city in 1763, they quickly began assessing the weaknesses of Havana's defenses, the inadequacies of its urban fabric, and the potential disloyalty of its Creole inhabitants and then formulating plans for their improvement.

For the urban area within the city walls, in 1763 the military engineer Silvestre Abarca submitted an extensive report and proposal on strategies for "the defense of the Plaza of Havana and its neighboring castillos [fortifications]."[3] Royal officials responded to the British occupation by initiating a project to redefine the Plaza de Armas as the city's central social and political stage by reconstructing the space in a geometric

configuration flanked entirely by civic buildings. The project to rework this plaza from 1771 to 1791 sought to correct the physical irregularities of the space, generating a visual field in which colonial subjects would be more visible to scrutinizing officials and to one another. However neat, orderly, and totalizing Abarca's plan may have been on paper, it was never fully realized due to financial constraints. Furthermore, his designs for a new urban fabric became enmeshed in local building and sociospatial patterns.

The rule of the Bourbons in Spain and the Americas in the second half of the eighteenth century produced a large quantity of urban plans that evince a regular, geometrically conceived quality. These plans reflect efforts to reform urban space, but they also relate to the broader spatial order of reform as conceived abstractly. In terms employed by theorists of the nation-state, one could hypothesize that this rational planning of space was part of a broader strategy of secular reformers to exercise control over the Crown's subjects by rendering them more visible. James C. Scott has argued that the modern nation-state in the eighteenth century and onward begins to exert a fundamentally scopic power: the rendering of its subjects or citizens more legible via advanced record keeping and surveillance.[4] The abstract technologies of power (mathematical measurement, rational planning, and advanced record keeping) were translated into signs and spaces that were read and experienced in the phenomenal realm of the built environment in order to recraft national and colonial subjectivities. Michel-Rolph Trouillot has called this process "the production of both a language and a knowledge for governance and of theoretical and empirical tools that classify and regulate collectivities."[5]

In this chapter, I explore how Bourbon officials reconfigured the Plaza de Armas of Havana and various other urban spaces as projects of reform and royal representation, exploring relationships between a conceived reform and the spatial strategies that composed the governmentality of the state. Regardless of conceived totalities, the implementation of reform in the colonial urban sphere was translated locally, where it became entangled with forms and practices specific to Havana. We should look, therefore, not only for moments when rational spatial order was achieved but also for where it failed or struggled against the contingencies of place. That is to say, it is more instructive to focus on this transfiguration, the place where each Spanish American society produced its own space of reform under the impact of imperial agendas.[6]

SOCIAL LIFE AND COLONIAL
URBAN FORM IN HAVANA

To better understand the significance of the late colonial spatial reform in Havana by royal officials, military engineers, and craftspeople, it is necessary to briefly address how the city developed from the time of its foundation onward. The Spanish conquest of Cuba by Diego Velázquez de Cuéllar (1465–1524) and Pánfilo de Narváez (1478–1528), which began in 1511, resulted in the founding of seven towns at multiple points on the island by 1514. The conquerors established San Cristóbal de La Habana on the island's southern shore, but it was moved in 1519 when a large waterway was discovered on the northwestern coast. The Spanish made this feature the harbor of Havana, a waterway connected to the Florida Straits via a narrow and highly defensible inlet.[7] City builders positioned the colonial city on the western side of this inlet to guard the harbor entrance with stone fortifications. Rather than situating the main plaza in the center of the city, however, the Plaza de Armas developed at its far eastern side, nearest the inlet to the bay. Many of these early conquistador towns in Cuba and the Caribbean exhibit such irregularities of plan. This particular configuration at Havana suggests an attempt to utilize the plaza in defense of the inlet and harbor, thus corresponding to the specific geography of the site. In a sixteenth-century rendering of the city and bay, the plaza appears as the administrative and near physical center of a colonial urban enterprise that included the waterway (fig. 1.1).

For the first two centuries of its history, the Plaza de Armas of Havana accommodated the main parish church, numerous private houses, and a geometrically conceived fortification known as the Castillo de la Fuerza, completed in 1557. Havana's early plaza exhibited an irregular layout, as it predated the urban planning ordinances of the Spanish Laws of the Indies issued in 1573 under Philip II, which stipulated that the central plaza be made into a rectangular configuration, though this was not always followed.[8] Nevertheless, prominent military and religious buildings defined the space in an effort to establish and reinforce policía, a term that the historian Richard L. Kagan argues was multifaceted.[9] Following Aristotle, policía could refer to good government, a polis of citizens who put the community ahead of their own self-interest, maintained political order, and were governed by a rule of law. However, it could also mean urban-

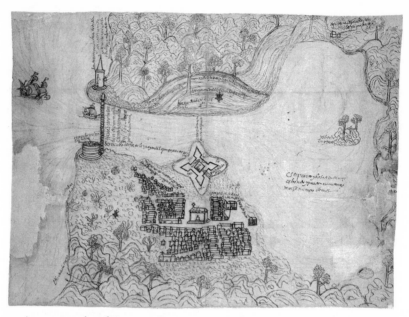

1.1 Anonymous, plan of Havana in perspective, c. 1567. Courtesy of the Archivo General de
Indias, Seville, Spain.

ity (*urbanitas*), the upholding of the urban values of comportment, refine-
ment, and private life that distinguished urban dwellers from rustics and
nomads. Policía could, furthermore, refer to the good Christian commu-
nity, underscoring the religious role that the city was expected to play in its
territories overseas as defender of the faith. In the Americas, the notion of
policía lent itself to the city as a bastion of ordered, lawful, Christian, and
moral life in contrast to the barbarism of heathen Indians.[10]

The central plaza defined certain aspects of policía and became asso-
ciated with government, law, and Christian authority. The *ayuntamiento*
(town hall) and main parish church or cathedral frequently occupied the
plaza mayor (main plaza) to reinforce order and the unity between church
and state. Referred to more frequently in the Caribbean and elsewhere as a
plaza de armas (arms square) to emphasize its military role, the space estab-
lished a sense of urban civility for the colonial city and was often the site
where laws were ratified and punishments carried out at the *picota* (pub-
lic pillory or whipping post). A 1691 plan by Juan Síscara depicts a walled
Havana and represents its Plaza de Armas near the water at bottom right

on the east side of the city. The rendering demonstrates the concentration of wealth in Havana's *parroquia mayor* (main parish) by the greater number of civic buildings and religious complexes (fig. 1.2) in that section. South of the Castillo de la Fuerza and main parish church, Síscara depicts the bishop's palace, a palace for the colonial governor, and the royal jail found on the Plaza de San Francisco, the city's third oldest. To the west, Síscara depicts the Plaza Nueva, the second plaza to be built, completed by the late sixteenth century and the only one in the city to possess the rectangular layout specified in the Laws of the Indies.[11]

The diamond or oval-shaped city depicted in the plan is approximately one mile long and half a mile wide and is divided into *cuarteles* (quarters), with Campeche at the southern end and the Cuartel de la Punta on the north side. It contained three parishes, Espíritu Santo, El Cristo, and El Ángel, in addition to the *parroquia mayor*, with the divisions between these areas delineated in the plan by a squiggly line. By the late seventeenth century, the southernmost parish of Espíritu Santo, the city's poorest, contained many Africans, Amerindians, and members of the racially mixed *castas*, served by the enormous convent of Santa Clara. The westernmost parish of El Cristo, defined by the church of the same name, contained the city's only plaza outside of the main parish. Visitors prayed to St. Christopher, patron saint of travelers, at the sanctuary before journeying beyond the security of the city walls to the west.[12] The small parish of El Ángel possessed only one religious building, the parish church sited on what Síscara's drawing suggests as an open field. Thus, of the city's four parishes in 1691, three of four plazas were located in the *parroquia mayor*, along with five religious complexes, the main parish church, the palace of the governor, and the royal jail.

Síscara's plan attempts to incorporate what Kagan has highlighted as a Spanish perception of a duality in the city inherited from Roman urbanism: the *urbs* (physical aspects) and *civitas* (human element).[13] Kagan argues that *civitas* always seemed to have taken precedence; however, the two were certainly viewed as interconnected on many levels. A chart at the top left of the plan indicates that the *parroquia mayor* contained not only the most plazas and important buildings but also the most people. Of Havana's 2,152 households, 709 lived in the main parish, with the second-highest number, 607 households, in Espíritu Santo. The main parish contained the highest number of *negros* (blacks), with almost three times that

of Espíritu Santo. The Síscara plan thus suggests various sociospatial patterns that continued well into the nineteenth century within the city's *intramuros* (area within the walls).[14] The plan indicates that the main parish possessed a higher concentration of wealthy, slave-owning families who maintained houses to establish and reinforce their wealth and elite identity in proximity to the highest officials of church and state.

As in other Spanish colonial cities in the Americas, social status often came to be defined by one's relative possession of *limpieza de sangre* (purity of blood) within a *sistema de castas* (caste system). In Iberia, blood purity was determined by one's proportion of Spanish blood in relation to Islamic or Jewish impurities. This ideology continued in the Americas, where Indian and African blood constituted the most significant stains on lineage. Determined by birthplace and physical appearance, Peninsulars or *españoles* were typically considered *blancos* (whites) and understood to possess higher status than Creoles, the elite of which would likewise be considered whites or *españoles*.[15] The Catholic Church documented souls according to *raza* (race), with the indigenous people of Cuba typically assuming the designation of *indio* (Indian). However, the island's Amerindian populations of Ciboney and Taíno were severely diminished by genocide, suicide, overwork, and disease. Many of the remaining indigenous people fled to the mountains and lived in small communities throughout the colonial period. The most salient racial categories in colonial Havana included *blanco/a* (white), *mestizo/a* (mixed Spaniard and Indian), *pardo/a* (mixed Spaniard and African), *negro/a* or *moreno/a* (black), and *indio/a* (Indian). The notion of race operated alongside and interacted with the idea of *calidad* (quality or status), which could encompass wealth, social reputation, race, and comportment. Visualizing and performing *calidad* became extremely important to the maintenance of elite status, and the wealthy of Havana used architecture, imagery, and material culture to construct their identities and buttress claims to status before the lower social echelons.[16] Many of these lower and middling people were considered black or mixed populations, including *libertos* (free people of color) and *esclavos* (slaves). Although this racial system held *español* (Spaniard) at its apex and functioned coherently on paper, recent historical studies have emphasized the slippages and ambiguities at work in the *sistema de castas*. The contingencies of race and *calidad* underscore the instability of colonial identities, which were composed within an ide-

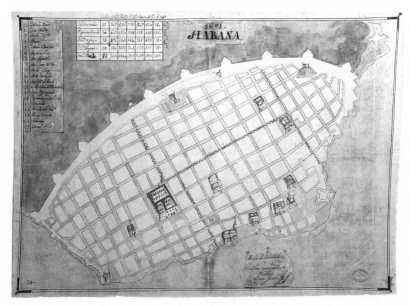

1.2 Juan Síscara, plan of Havana, 1691. Courtesy of the Archivo General de Indias, Seville, Spain.

ological social structure that required outward performance to achieve tangibility.

Architecture became an important tool in performances of colonial identity and for the social mediation and construction of familial claims to status in the urban spaces of Havana. We can perhaps find in this practice a form of private heritage work, one associated with bloodline, landownership, property, and the private possession of material refinements.[17] Imposing private houses reused the past to reinforce the lineage of a family and its elevated civic value. The central doorway of a Spanish colonial house became an important device in reconfiguring the city's semiotic structure, a visual strategy employing heraldry and other decorations. The art historian C. Cody Barteet has exposed the complex form and semiology of the Casa de Montejo (1542–1549) in Mérida in Mexico's Yucatán Peninsula, which functioned, as he convincingly argues, as a complex means of negotiating imperial and local power structures.[18] The house carried forms that communicated the elite's sanction from larger political entities, such as the Church and the king, while co-opting ideological signs from the immediate urban or regional environment to construct the elite's local power in society. An urban fabric of architectural signage was manipulated by

1.3 Central doorway, Casa de la Obra Pía, seventeenth century. Havana, Cuba. Photograph by the author.

the elite via the construction of elaborate doorframes on private houses, such as that of the Casa de la Obra Pía from the seventeenth century (fig. 1.3). Situated on a prominent street in the main parish, the doorframe displayed a family crest set within curvilinear ornament and baroque half-columns. The hierarchical surface of the entry and its imagery draws the eye upward toward a second-story balcony completely surrounded by this rich ornamentation.

Internal divisions within the Havana colonial house mediated activities in day-to-day life and thus assisted in composing socioeconomic and racial hierarchy. First floors possessed offices, utility rooms, stables, and sometimes shops and were coded as the domain of house slaves, such as *caleseros* (coachmen). The elite family resided on the second level, or *piano nobile* (noble floor), usually accessible by a grand staircase that ran from the downstairs *patio* (courtyard) to the upstairs galleries. On the noble floor one found the *sala* (living room), the dining room, and the bedchambers, all elevated above the odorous and clamorous city streets below.[19]

Statements of elite power and prestige gained more currency by the family's fiscal and political ability or fortuitousness to secure a house site on one of the city's public plazas. The Casa del Conde de San Juan Jaruco, situated on the south side of the Plaza Nueva, boasts a prominent *portal* (covered walkway or loggia) defined by an arcade (fig. 1.4). The Plaza Nueva, known as the Plaza Vieja by the nineteenth century, became the site of one of the city's most important markets. Here, colonial residents and foreigners mingled in a multifunctional space of buying and selling, seeing and being seen. Colonial-era texts indicate that a great deal of social life in the Plaza Vieja revolved around the *portals* running the length of the western side. The nineteenth-century Cuban novelist Cirilo Villaverde wrote:

> They entered the arcades of the Plaza Vieja, called the Rosario Arcades. These were made up of some four or five houses, belonging to rich or noble families of Havana, with wide balconies, supported by tall stone arches, the lights of which were concealed during the day by heavy canvas curtains, like the mainsails of boats. The upstairs floor of these houses was occupied by the owners or the tenants, who lived off their income; but the ground floor, with large rooms that were generally dark and poorly ventilated, was occupied by the shops of certain retail merchants.[20]

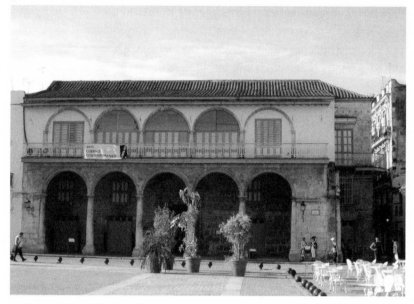

1.4 Façade, Casa del Conde de San Juan Jaruco, seventeenth century. Havana, Cuba. Photograph by the author.

As Villaverde describes, Havana colonial houses maintained a division between second-story residential and first-story commercial and utilitarian space. Urban life involved the intermingling of multiple social classes in the plaza as elite homeowners performed their elevated status and abstention from mixing both spatially and in terms of race and *calidad*. This privileged gaze was constructed by second-story living spaces positioned directly above the social heterogeneity and commercial activity in the streets and public spaces below.

REORDERING URBAN SPACE
UNDER THE BOURBONS

After the Seven Years' War and its dramatic outcome, with the capture and return of Havana by the British, Spanish royal officials focused their attention on improving the city's urban spaces. Captain General Felipe de Fondesviela y Ondeano, marqués de la Torre (r. 1771–1777), initiated such urban projects as the creation of *paseos* (public promenades) that resembled comparable spaces in the imperial capital of Madrid, such as

the Paseo del Prado, and in Mexico City's late-eighteenth-century Alameda. In Havana, construction began in the 1770s on the Paseo de Extramuros and the Alameda de Paula, conceived as axial spaces running along the outside of the western wall and extending along the eastern harbor front, respectively. These open and ordered outdoor retreats appeared in multiple Spanish American cities at this time and were considered a public health improvement. Eighteenth-century reformers believed "bad air" to be a significant cause of disease, and they created open public spaces near waterways or outside of the old city to provide ventilation.[21]

The Alameda de Paula in Havana consists of an axial promenade situated adjacent to the harbor to allow maximum fresh air within the protection of the city's *intramuros*. An urban view based on the work of French lithographer Pierre Toussaint Frédéric Mialhe alludes to the refined social life that transpired on the Alameda (fig. 1.5).[22] Alexander von Humboldt, following his visits to Havana in 1800 and 1804, described the Paseo de Extramuros as "a delightfully cool resort, and generally after sunset [it] is filled with carriages."[23] Elite Creoles and Spaniards appropriated the space in the late afternoons and early evenings, considering it proper to visit the Paseo mainly on horseback or by carriage.[24] The appearance of these public spaces in Spain, New Spain, and Cuba fulfilled growing desires for elite sociability in the empire's largest cities. The construction of promenades, public fountains, monuments, gateways, and civic buildings in this period seems to have been as much the Spanish Crown's way of associating itself with the public's new interest in sociability as it was the monarchy's imposition of new social practices on the people.[25] This dialectic between the elite public and the Crown over the issue of creating reformed public spaces underscores the importance of Creole negotiation of and impact on late colonial reforms.

In the 1770s, Captain General Antonio María de la Torre initiated a reconstruction project for Havana's Plaza de Armas that would extend and regularize portions of the space and install new buildings to serve multiple functions. The "extension of the Plaza de Armas" was considered "useful and convenient to public service," with the objective of erecting buildings for the city council, a city jail, a customhouse, a post office, military barracks, and a "decent habitation for his Governorship."[26] Beginning in 1771, the project arose not only from military concerns but also from broader Spanish attempts to translate eighteenth-century theories of modern

political economy into spaces for the construction of reformed subjects. Concerns for low productivity in the empire can be seen in *Teatro crítico universal* by Benito Jerónimo Feijóo (1676–1764), who blamed the problem on depopulation, protracted wars, and contempt for labor.[27] Reformist authors in Spain proposed *proyectos* (projects) to combat these conditions, including a program of *Nuevas Poblaciones* (New Towns) as a means of populating the countryside, creating towns focused on industry and generating smaller urban environments that would foster simplicity and moderation of thought and life.[28] Public works and new institutions were also part of the broader strategies of creating more productive subjects, growing the empire's population, and ultimately strengthening Spain's economy. In the late eighteenth and early nineteenth centuries, military engineers produced a variety of plans for new building types in Havana, including fortifications, a tobacco factory, a customhouse, an arsenal, city walls, docks, roads, barracks, a hospital, gardens, and an aqueduct that responded to these broader objectives of reform.[29]

The Bourbon project to spatialize the reformist and rational state, with its emphasis on a more rigorous use of geometry, must be viewed in relationship to preceding attempts to make imperial space in the Spanish world. The royal palace and monastery at San Lorenzo de El Escorial, 1563–1584, built under the patronage of Philip II of Spain and designed by Juan Bautista de Toledo and his apprentice Juan de Herrera, emphasized axiality, symmetry, and rigorous geometry. Its architectural surfaces featured an austere classicism, and in its grandeur, El Escorial is considered an important architectonic and spatial sign of imperial ideology and a possible prototype for the Palace of Versailles in Louis XIV's France. The political management of a vast Spanish empire produced new ways of imagining architectural and urban space that have only begun to be mapped in their political context across the Spanish world.[30] The treatise of the ancient Roman architect Vitruvius provided an important model for the Laws of the Indies, ratified by Philip II in 1573. Spanish impulses to impose order on urban space following the consolidation of Spain for Christendom in 1492, the development of colonial enterprise in the Americas, and Philip II's moving of the Spanish court to Madrid can be seen in the reworking of the Plaza Mayor of that city into a more rational configuration in the seventeenth century.[31] Jesús Escobar has even suggested that the Spanish experience of pre-Hispanic architecture and urbanism in the Americas,

1.5 Pierre Toussaint Frédéric Mialhe, *The Alameda de Paula of Havana*, c. 1830. Lithograph. Courtesy of HistoryMiami, Miami, Florida.

admired for its order and clarity, could have had some impact on subsequent construction back in Spain.[32] Thus, by the time of the eighteenth-century Bourbons, various early modern spatial strategies to represent the uniformity of imperial power were well established in the Spanish world. A further development in eighteenth-century space was the Enlightenment's emphasis on large-scale social and economic transformations and desires to carry rationalism further into the recesses of bureaucratic administration as well as the built environment. These accumulated appropriations of established precedent seem to suggest an imperial heritage process, the reuse of Greco-Roman antique and early modern classicism to validate a renovated national present.

In projects for urban renewal in Spain, King Charles III (r. 1759–1788), a major proponent of the Enlightenment and rational reform, promoted additional architectural renovations of the imperial capital of Madrid and its surroundings. The Royal Academy of San Fernando (hereafter RASF), which opened in Madrid in 1752, began to introduce Greco-Roman revival typologies in the second half of the eighteenth century as the academy simultaneously studied medieval remains associated with Christian, Jewish, and Islamic histories in Iberia. The king attracted leading academic paint-

VISTA DE LA PLAZA DE MEXICO NUEVAMENTE ADORNADA PARA LA
CARLOS IV, que se coloco en ella el 9 de Diciembre de 1796 cumple años de
por Miguel la Grua, Marques de Branciforte Virrey de Nueva España, quien
general y comando general de todo este Reyno, e hizo grabar esta Estampa, que

ESTATUA EQUESTRE DE NUESTRO AUGUSTO MONARCA REYNANTE
la Reyna Nuestra Señora MARIA LUISA DE BORBON, su amada Esposa
solicito y logro de la Real Clemencia erigir este Monumento para desahogo de su
dichos á Sus Magestades, en nuevo testimonio de su fidelidad, amor y respeto

1.6 José Joaquín Fabregat, *The Plaza Mayor of Mexico City*, 1797. Engraving. Courtesy of the Nettie Lee Benson Latin American Collection, University of Texas Libraries, The University of Texas at Austin.

1.7 Manuel Tolsá, *Equestrian Portrait of Charles IV* (*"El Caballito"*), 1803. Bronze. Mexico City. Photograph © Emily Umberger.

ers, sculptors, and architects in Spain and Europe to the RASF, including the Italian sculptor Giovanni Domenico Olivieri (1708–1762) and the Spanish architect Juan de Villanueva (1739–1811). This milieu produced a variety of rigorous classicisms in architecture, such as Villanueva's contributions to some of Charles's more ambitious architectural and urban planning projects in Madrid, including the relocation and renovation of the Royal Botanical Garden with the architect Francesco Sabatini (founded in 1755, moved and renovated in 1774), the Royal Cabinet of Natural History building (1785, which later became the Prado Museum), and the renovation of the Plaza Mayor (1791).[33]

Bourbon officials claimed that the projects to reorder urban spaces throughout the empire were designed to instill *buen gusto* (good taste) in the Crown's subjects, in an effort to make them more industrious and efficient producers of national wealth. In the Americas, these projects can be seen as reassertions of imperial authority in the capital cities, especially following the escalation of the Bourbon Reforms after 1763. Yet these efforts often came at the expense of well-established local customs and institutions. In 1796, the reconstruction of Mexico City's Plaza Mayor began with the elimination of the *parián*, a wooden market structure that had served the local population for over a century. The Novo-Hispanic viceroy employed artists at the Royal Academy of San Carlos, which opened in 1785, to rework the plaza. The project involved multiple academicians, including the engraver José Joaquín Fabregat (1748–1807), who produced a print based on a painting of the plaza by Rafael Ximeno y Planes (1759–1825) of the architecture designed by Antonio González Velázquez (c. 1765–1810). The print depicts the existence of an enormous oval reinforced by a gated and continuous balustrade (fig. 1.6). This redesign drew heavily from Michelangelo's work for the Campidoglio hill in Rome that produced the piazza by the same name.[34] The space in Mexico City thus employed not only geometry, but also prestigious models of ancient and early modern European classicism to assert the universal dominion and cultural authority of the Bourbons.

For the center of the new oval on the Plaza Mayor of Mexico City, the sculptor Manuel Tolsá (1757–1816), director of sculpture at San Carlos, designed a bronze equestrian portrait of the Bourbon king Charles IV, who succeeded his father in 1788 (fig. 1.7). For this work, Tolsá appropriated a European type for representing rulership established by the second-

century equestrian portrait of Marcus Aurelius, long identified as a likeness of the Christian emperor Constantine, which stood in the Piazza del Campidoglio in Rome.[35] This sculpture gave rise to later examples in bronze, whether of *condottiere* (mercenary soldiers), including Donatello's Equestrian Statue of Gattamelata (1443–1453) and the portrait of Bartolomeo Colleoni by Andrea del Verrocchio (c. 1483–1488), or, more appropriately in this case, of imperial rulers, as in Pierre Cartellier's Equestrian Statue of Louis XIV (1816). In Tolsá's statue of Charles, as in Louis's portrait, the emperor extends his right arm while holding a short baton symbolizing his imperial rule. Tolsá depicts Charles IV wearing a laurel wreath and dressed as a Roman emperor with armor and cape, an image of a victorious ruler riding into Mexico City in triumph over irregularity and inefficiency.

The equestrian portrait of Charles IV served as a royal monument for a newly redesigned plaza. However, unlike El Templete a few decades later in Havana, this work of the emperor leaves little room for multiple interpretations. It is resolutely imperial, and, to eliminate ambiguity over the emperor's relationship to the Crown's American territories, Tolsá included a quiver of arrows beneath the back hoof of Charles's mighty horse. The work effectively subsumes the particularities of place beneath a forceful statement of universal imperial power.

Beginning in the 1770s in Havana, the Plaza de Armas underwent a similar transformation based on the designs of various military engineers. As with the Plaza Mayor of Mexico City, this project in Cuba reveals the implementation of geometric principles. As in the previous case, older structures and institutions were expendable, as revealed by the demolition of Havana's main parish church, which had stood on the Plaza de Armas since the sixteenth century. The church was dilapidated by the 1770s, yet its destruction suggests symbolically that the main plaza's role in reinforcing the Christian dimensions of *policía* were now less essential. The Bourbon monarchy's emphasis on secular reforms included active attempts to marginalize the Church's power in the Americas. The military engineer Ramón Yoldi drafted a comprehensive 1773 plan titled "Project for the formation of a plaza in the city of Havana, proportioned to its immense neighborhood, and to the magnificent buildings that individuals are constructing, with demonstration of the beauty of it and utilities from which will follow Royal Service and Public well-being" (fig. 1.8).[36] On the north side of the plaza, Yoldi indicates the start of construction of the Casa de

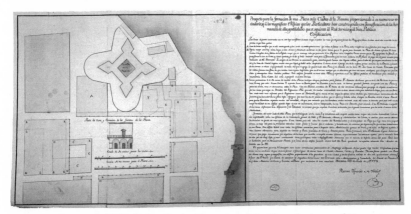

1.8 Ramón Ignacio de Yoldi, *Project for the Formation of the Plaza de Armas of Havana*, 1773. Color drawing. Courtesy of the Archivo General de Indias, Seville, Spain.

Correos (Post Office), stating that this building would serve as a model for the remaining structures, which would be "all uniform in their façades, for greater beauty."[37]

On the west side of the plaza, the plan called for the land of the main parish church to be divided into two parts: one for the extension of the Plaza de Armas and the other for the construction of a Casa de Ciudad, Gobernador y Cárcel (House of the City, Governor, and Jail), also referred to as the Casa de Gobierno (House of Government).[38] The author cites the need for a secure prison, a decent residence for the Spanish governor, and offices for *escribanos* (notary publics) "for the utility and convenience of the city."[39] Along the north side of the plaza, beyond the Casa de Correos and the Castillo and around the corner to the plaza's eastern side, a military barracks would be constructed in place of low-value private houses. A number of medical doctors had advised about the health of troops and the need to build a well-ventilated barracks. The author of the plan, Yoldi, provides no orders or explanation for what was to be done with the politically symbolic ceiba tree monument built in 1754 that occupied the east side of the plaza at this time. However, based on the ultimate adaptation of this plan, it must have been determined that the monument bore enough significance to merit its preservation.

On the remainder of the plaza's east side, houses of "much incommodity to imponderable indecency" apparently served inadequately as offices for the general accountant, the Royal Hacienda, the Customhouse, and

the Administration of the Postal Service.[40] The plan called for a multifunctional Casa de Aduana (Customhouse) to also contain the offices necessary for the dispatch of the General Administration of Incomes and the Office of Registries. The author emphasizes the great utility of the building in this location, near the site of embarkations and disembarkations of products and people. A number of ruined houses belonging to the Mayorazgo de Oquendo occupied the fourth and final side of the plaza. These would be restored and would bear façades equal to those of the other buildings "proportioned to the greatness of this city."[41] The plan emphasized consolidation of building functions, orderliness, uniformity of design, and efficiency of use.

By the end of the eighteenth century, the Casa de Gobierno and the Casa de Correos were the only two buildings completed from this ambitious plan. The military engineers Antonio Fernández Trevejos and Pedro de Medina designed the Casa de Correos (built c. 1771–1776), and Trevejos alone designed the Casa de Gobierno (built c. 1776–1791).[42] An elevation of the Casa de Correos reveals an emphasis on exacting symmetry in the first two stories, with second-floor windows positioned precisely above lower bays created by the arches of the portal (fig. 1.9). On axis with each column are the finial-like ornaments above, along the roofline, that complemented ornamental window lintels. Engaged columns frame the composition on each side with two conspicuously asymmetrical elements, including the right-side tower used as a lookout and to send and receive signals to and from ships on the horizon. Furthermore, a wall and door to the right of the building's façade mediated access to a small botanical garden adjacent to the Casa de Correos.

A plan of the Casa de Correos denotes the continuation of spatial symmetry within, with various ground-floor spaces organized around a central square patio surrounded by portals on four sides (fig. 1.10). The patio sits on axis with the elements of the front, while the building fits neatly to its site on the northwest corner on the Plaza de Armas. The plan carries the surface order of the façade inward, underscoring functionality with well-proportioned spaces tailored to specific uses. The Casa de Correos and the Casa de Gobierno meet at right angles and dominate this northwest corner of the plaza with grandiose façades, including giant portals, the largest of which fronts the Casa de Gobierno along the west side (fig. 1.11). Each building provided space for an expanded bureaucracy

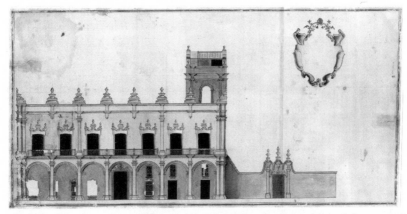

1.9 Attributed to Antonio Fernández Trevejos and Pedro de Medina, plan of the principal façade of the Royal House of the Administration of the Postal Service of Havana, Casa de Correos, c. 1773. Courtesy of the Instituto de Historia y Cultura Militar, Archivo General Militar de Madrid, Spain.

1.10 Attributed to Antonio Fernández Trevejos and Pedro de Medina, plan of the lower floor of the Royal House of the Administration of the Postal Service of Havana, Casa de Correos, c. 1773. Courtesy of the Instituto de Historia y Cultura Militar, Archivo General Militar de Madrid, Spain.

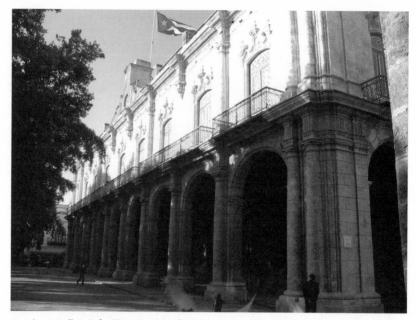

1.11 Antonio Fernández Trevejos, Casa de Gobierno, c. 1776–1791. Plaza de Armas, Havana, Cuba. Photograph by the author.

and conveyed the values of imperial reform through exacting order and monumental grandeur.[43] These great building façades projected an image of imperial order for audiences in the plaza and on the deck of ships entering and exiting the harbor.

In design and spatial layout, the Casa de Correos and Casa de Gobierno partook of American and local architectural patterns, including the influence of royal palace architecture in general as well as the late-eighteenth-century Cuban colonial town house in its *portal* and *piano nobile* (the noble or elite living floor). Both official buildings possessed patterns of interior organization similar to the local town house, such as a *zaguán* (reception hall), courtyard plan, and galleries. Curvilinear window lintels and massive doorways with complex ornamental framing inflected the palaces' overall rational program with elements of Spanish and Cuban architectural vocabularies (fig. 1.12). The retention of local stylistic tendencies, labeled hispano-mudéjar and baroque style by various historians, suggests an effort to incorporate local practices and materials as a means of situating the new buildings within the city's architectural imagery, thereby

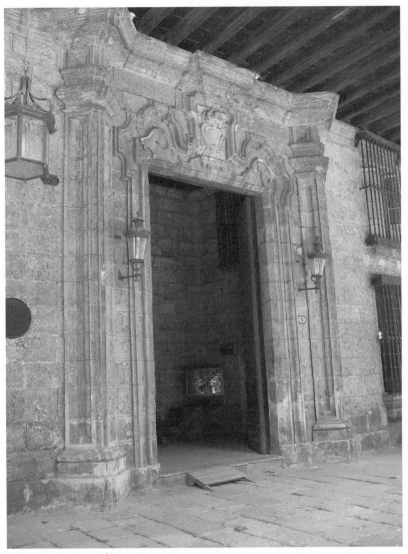

1.12 Central doorway, detail of the Casa de Correos, c. 1771–1776. Plaza de Armas, Havana, Cuba. Photograph by the author.

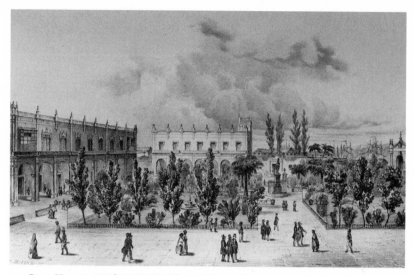

1.13 Pierre Toussaint Frédéric Mialhe, *Plaza de Armas, Havana,* c. 1830. Lithograph. Courtesy of HistoryMiami, Miami, Florida.

creating visual consistency, local relevance, and visual authority. Inside the Casa de Gobierno, the governor would set standards of imperial luxury in the splendor of his colonial court to impress urban inhabitants and generate a dynamic of colonial mimicry.[44] Tapestries, elaborate moldings, exquisite chandeliers, and royal portraits decorated the halls and *salas* in an effort to construct and perform something of the magnificence of the sovereign court in Madrid.

A nineteenth-century painting by Pierre Toussaint Frédéric Mialhe depicts a well-ordered Plaza de Armas of rectangular shape, where subjects move through nineteenth-century garden plots beneath the imposing palaces (fig. 1.13). This image communicates the Bourbon use of the plaza in the exercise of power by constructing a sense of social tranquillity, loyalty, and commercial ease. The eighteenth-century Spanish political imagination projected panoptic ideas onto space in its exhaustive record keeping of political, economic, and social conditions in Cuba.[45] In the reformed Plaza de Armas at the opening of the nineteenth century, the colonial subject could read and experience monumental grandeur and exacting order while also gaining a sense of his or herself within the vast network of the Bourbon Empire. As the art historian Michael Schreffler has convincingly argued, the sixteenth- and seventeenth-century roy-

al palace in Mexico City under Habsburg rule can be seen as an instrument "in the discursive shaping and structuring of the abstract notions of imperial power and allegiance to the crown."[46] In late-eighteenth-century Havana, the palace played a similar role, albeit by constructing a more rigorous shape of power and allegiance with more emphasis on uniformity via the grid in an effort to produce a more easily referenced loyal, industrious, and orderly colonial subject.[47]

The spatial practice of Bourbon order in late-eighteenth-century Havana can be registered in the rigorous planning of royal palaces and in drawings of certain colonial subjects that would perform important roles in the city. The Spanish project to improve the city's defenses following the British occupation of the island involved designs for both *urbs* and *civitas*. Believing another conflict with Great Britain to be imminent, the administration of Charles III inaugurated a system of Creole militias of white, *pardo*, and *moreno* battalions, co-opting locals into military service and granting them special privileges.[48] Creole elites gained prestige from serving as officers, as did free people of color. Visions of imperial uniformity were projected onto diverse colonial bodies of variant ethnicity, racial classification, gender, and social rank through written discourses, visual representations, urban plans, architecture, and urban space. The Casas de Gobierno and Correos on the Plaza de Armas deployed highly visible and uniform elements in an attempt to reinforce hierarchy and a new sense of regimentation commensurate with the ideologies of the state. The visual repetition of these trabeated forms in the palaces confronted colonial subjects in the streets on a daily basis. The aesthetic and descriptive properties of visual studies made of militiamen suggest a relationship between classicism, military reform, and the imagined body (fig. 1.14). These images, made for royal inspection, communicated the effectiveness of military reform and the ability to discipline Creoles of color in the defense of His Majesty's island. Havana's reconstructed main plaza thus became an important setting for social narration and the inscription of new identities.[49]

THE PERFORMANCE OF ORDER

In efforts to shape the loyal subject in the early modern Americas, the Spanish relied heavily on public rituals of church, state, nobility, military, and masses.[50] Under Bourbon rule, such performances continued, perhaps

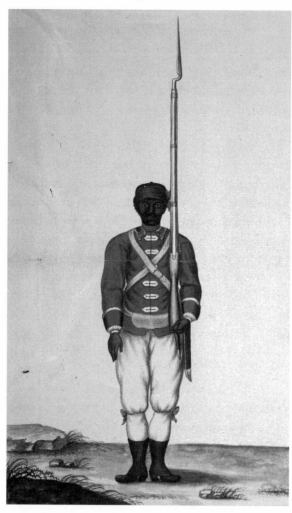

1.14 Anonymous, design
of the uniform of
the Battalion of
Morenos of Havana,
1763. Courtesy of
the Archivo General
de Indias, Seville,
Spain.

reconfigured to promote new reformist values. Thus, the reconstructed
Plaza de Armas became a reformed imperial stage for spectacles of power,
as performance validated the revised social hierarchy.

The obsession with order in late-eighteenth- and early-nineteenth-
century Havana must have owed something to the political tumultuous-
ness in the Spanish world during this period, beginning with the out-
break of the French Revolution in 1789, immediately following the death
of Charles III the previous year. His son and successor, Charles IV, con-
tinued his father's reformist policies but showed significant weaknesses as

head of state. His chief ministers assumed immense power, first José Moñi-
no, the Count of Floridablanca, who reacted to developments in France by
censoring the press and resuscitating the Inquisition to suppress political
subversion. Manuel Godoy, who served as Spain's minister from 1793 to
1808, eroded public confidence in the state as he gained a widespread repu-
tation for corruption and ineptitude. The beheading of France's deposed
monarch, Louis XVI, in 1793 shocked the Spanish world, as it subverted
age-old conceptions of political authority. In March of 1808, supporters
of Prince Ferdinand forced his father, Charles IV, to abdicate in favor of
his son, who became Ferdinand VII. The same year, as Napoleon crossed
Spain to occupy Portugal, he turned on the Spanish Bourbons, deposing
them and placing his brother Joseph on the throne of Spain.[51] In his visual
critique of these events, Francisco de Goya depicted the French massacre of
innocent civilians in Madrid on May 3, 1808.

The French invasion stimulated Spanish nationalism, loyal subjec-
tivity, and Catholic piety, perceived as a struggle against French athe-
ism and regicide. Major capitals and provincial cities held ceremonies
expressing support for Ferdinand VII and the established order. How-
ever, the interruption of Spanish rule caused many Americans to call for
greater autonomy, which set into motion negotiations by the Crown
to ensure American loyalty. Six representatives from the Americas (one
from each of the four viceroyalties and one each from Guatemala and
Cuba) were sent by Spain's Junta Central to a constitutional conven-
tion in Bayonne, France, in 1808 to appease American calls for greater
representation. On September 24, 1810, the Spanish congress, or Cor-
tes, met in Cádiz as a national assembly, representing the entire Span-
ish world. The issue of American loyalty became paramount; however,
the question of allowing Americans representation at the Cortes began
a long negotiation. Spaniards maintained the need for Spanish suprem-
acy and insisted that Indians and Africans could never be represented.
On March 19, 1812, the assembly swore allegiance to a new constitution
that limited monarchical power and created a permanent system of elec-
toral representation, which included the Americas. The ultimate com-
promise in formulating the document made *americanos* (Americans),
Indians, and their descendants citizens of the Spanish nation and equal
judicially to those born in Europe. These new Spanish citizens included
all except people of African descent, which historians see as an effort

to ensure that European delegates would always outnumber Americans, among other racist motives.[52]

In an effort to promulgate the new constitution and to demonstrate American participation in the new contract, the Spanish Cortes issued a royal order: "That the main plaza of all the towns of the Spains, in which this solemn act [of constitution reading and oath swearing] is celebrated or has already been concluded, is denominated from now on as Constitution Plaza, and that this be expressed in a headstone [memorial] erected on the same site."[53] Copies of the document were dispatched to major colonial cities in the Americas with orders that the constitution be read to the public. On July 13, 1812, after thirty-two days of navigation, Lieutenant José Valera conducted his craft bearing the constitution past El Morro castle and into the harbor of Havana.[54] Captain General Juan Ruiz de Apodaca (r. 1812–1815) formally received the new decree and scheduled a public reading of the constitution to the city's population. The captain general invited leading political, civil, and ecclesiastical authorities, owners of the noble titles of Castile, and many other persons of Havana to join in this ceremony of loyalty.

On July 21, 1812, a "brilliant and splendid concourse" assembled at the Casa de Gobierno on the Plaza de Armas at four thirty in the afternoon, and a formal march ensued at five in the evening. A picket of cavalry, two orders of standard bearers, and musicians from the regiment of Cuba led the procession, followed by members of the Ayuntamiento. The city's illustrious bishop Espada proceeded next; then came the former Captain General Salvador de Muro y Salazar, marqués de Someruelos; followed by the leading authorities, officials, and clerks of the army, navy, royal hacienda, and consulate, other magistrates, and all the distinguished nobility. Two richly dressed horses followed a retinue of lackeys. Musicians of the battalion of white militias gave way to the companies of grenadiers of the regiments of infantry of Havana, Mexico, Cuba, and Puebla. The musicians of the battalion of *pardos* came next before the companies of grenadiers of white, *pardo*, and black militias, while a company of dragoons flanked the march.

This well-ordered public performance served to visualize social order commensurate with the recent efforts of the reformist state. It communicated the city's hierarchy in its official, ecclesiastical, social, and military ranks and began in the Plaza de Armas, the city's highest expression

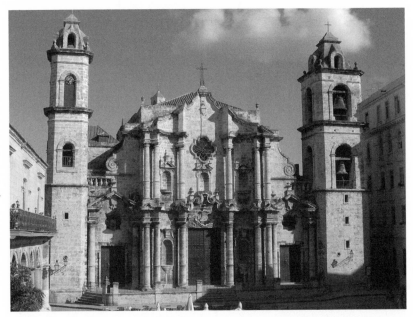

1.15 Pedro de Medina et al., Cathedral of Havana, c. 1748–1771. Plaza de la Catedral, Havana, Cuba. Photograph by the author.

of imperial authority.[55] The spectacle also reveals attempts by the state to incorporate people of color into official events on the plaza as an affirmation of their loyalty, but perhaps more importantly, as a means of narrating their place in the colonial social order. Leaving the Plaza de Armas, the retinue passed by the front of the Casa Capitular and took the old street of Tesorería to the Plaza of the Cathedral. This fifth plaza of Havana was created in the late seventeenth and early eighteenth century on reclaimed land.[56] The group entered a space framed and defined by elite houses and the cathedral. The cathedral was designed by the military engineer Pedro de Medina for the Jesuits and built between 1748 and 1771; its façade displays baroque aesthetics across its surface in linear effects that undulate and swirl like the waves of the nearby Caribbean coast (fig. 1.15).[57]

On this day of celebration in 1812 in the cathedral plaza, a platform had been erected that was "showily decorated and covered internally with carpet." Placed on this platform was a "magnificent canopy with a portrait of our adored monarch Ferdinand VII."[58] The captain general ascended the platform, accompanied by members of the *cabildo*, and read to the gath-

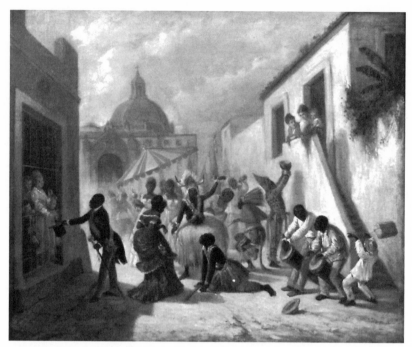

1.16 Víctor Patricio de Landaluze, *The Day of Kings*, c. 1878. Oil on canvas. Courtesy of the Museo Nacional de Bellas Artes, Havana, Cuba.

ered crowd in a "high and intelligible voice the constitution in the presence of an extraordinary concourse."[59] As bells rang, anchored ships punctuated the moment with cannon fire from the harbor. As in other Spanish colonial cities, the portrait of the king symbolized the presence of an otherwise absent monarch and joined visually with the voice of the governor to create a locus of enunciation for the king's authority in the colonial plaza.[60] The reading concluded, the procession reassembled and continued the march down the Calle de San Ignacio to the Plaza Nueva, Havana's second-oldest public square. Another platform had been erected in this plaza as "sumptuously adorned as the first." The captain general "read the constitution for a second time with the same formalities and ostentation" and to the salute of cannon fire in the harbor.[61] When this act was done, the entourage moved on to the Plaza de San Francisco, where officials had "prepared a third platform of equal perspective and brilliance as the other two." The captain general "concluded the third reading of the constitution on it, made another salute, and heard the same satisfaction and joy by the

local Havana town." The procession then returned to the Plaza de Armas and the Casa de Gobierno, which had been illuminated inside and out and prepared by the governor "in order to flatter all those who had accompanied him."[62]

The Casa de Gobierno bore the greatest ephemeral icon in the spectacle of the 1812 constitution reading. A canopy with a portrait of King Ferdinand VII fronted the palace, flanked by two standing grenadiers of the regiment of the infantry of Mexico. Allegories represented the Cortes and Spain by a lion devouring an eagle, a possible reference to Spain's recent triumph over the forces of Napoleon. On the right of the arms of Spain was an allegorical figure of Constancy holding a bust of Ferdinand VII in her left hand and the constitution in her right. Other emblems of regality included lion sculptures, urns on pedestals, crimson drapes, flowers, and a long textual plaque extolling the king's virtues and the heroism of the Spanish nation. In "noble emulation," neighbors on the Plaza de Armas and nearby streets adorned their houses with rich tapestries and brightly burning candles.[63] This account of the imperial performance suggests an urban choreography orchestrated by Spanish authorities with contributions from local elites pivoting around the symbolic and phenomenological centrality of the Plaza de Armas. The spectacle also demonstrates an effort to imbue the Constitution of 1812 with local meaning and collective significance by drawing on the plaza's ability to shape collective memory. The local and imperial past intersected in an effort to make heritage out of the constitution, underscored by the order to erect a memorial stone and rename the main plaza of each city. Celebrating and honoring the new social contract would not last long. By 1814, King Ferdinand VII had abolished the Constitution of 1812 and ordered that all monuments made to it throughout the empire be destroyed.[64]

Civic ritual could also order lower members of colonial society and reify their claims to identity. After 1791, with the completion of the Bourbon palaces, such rituals regularly employed the Plaza de Armas and the Casa de Gobierno as central elements and included the processions of Havana's African *cabildos de naciones* (councils of nations).[65] *The Day of Kings*, a late-nineteenth-century oil painting by Víctor Patricio de Landaluze, depicts such an event, held on January 6, the day of Epiphany (fig. 1.16). Incoming African slaves, considered *negros de naciones* (blacks of [African] nations) or *bozales*, were socialized into Catholicism and colo-

nial life by placement in various *cabildos de nación*.[66] Each *cabildo* maintained a patron saint, and in the nineteenth century, increasingly occupied the *barrios de extramuros* (neighborhoods outside the city walls). During feast days such as the Epiphany and occasionally on Sundays, *cabildos* would leave their neighborhoods in the *extramuros* and process through the streets of Havana soliciting *aguinaldo* (gratuity) from local, usually white residents.[67] A number of nineteenth-century travelers described these Epiphany celebrations and noted their culmination at the Casa de Gobierno, where the *cabildo* king faced the captain general in order to receive a generous *aguinaldo* from the Spanish state.

The use of various types of clothing, headgear, and accessories by *cabildo* members operated within a colonial symbolic economy and effectively identified the organizations' hierarchies.[68] *Cabildos* maintained kings and queens, a symbolic royal court, and lesser members who served as dancers, drummers, and flag bearers in performances. As a transculturation of West African and European ideas of kingship, *cabildo* members appropriated a wide range of Atlantic world imagery and material culture to compose their identities in urban space within the symbolic economy of colonial society. As seen in the Landaluze print, the king is depicted as a figure extending his top hat to Creole residents who stand safely behind the iron bars of their townhome as they seem to contemplate providing the man with *aguinaldo*. The *cabildo* queen appears underneath an umbrella in the background dressed in white. Drummers play batá drums vigorously in the lower right of the scene, and other characters perform to the left of these drummers.

In the ritual entrance into the courtyard of the Casa de Gobierno, the *cabildo* king met the Spanish governor in a symbolic exchange of power and an official Spanish acknowledgment of *cabildo* presence and identity. This procession and its rituals embodied colonial mimicry, further demonstrating the importance of the late-eighteenth- and early-nineteenth-century Plaza de Armas in its spatiality of power and uniformity within the colonial imagination. It was a space in which a sense of belonging to the city was negotiated and appropriated by a wide spectrum of the city's population. By the 1790s, the plaza itself existed as a heritage vehicle, a space of constructed and reconstructed memory that had begun to carry new ideals of "enlightened" reform.

Classicism and Reformed
Subjectivity

If the state has no institutional or geographical fixity, its pres-
ence becomes more deceptive than otherwise thought, and we
need to theorize the state beyond the empirically obvious.

MICHEL-ROLPH TROUILLOT,
"The Anthropology of the State"

The Bourbon promotion of a more severe and func-
tional classicism in the late-eighteenth- and early-
nineteenth-century Spanish world belonged to a
large-scale heritage process, that is, the use of an imagined
past to support agendas in the present. It also coincided
with and related to important epistemological and subjec-
tive transformations throughout various parts of the empire.
As the historian Jorge Cañizares-Esguerra has demonstrat-
ed, while intellectuals and "enlightened" ideologues in eigh-
teenth-century Northern Europe attempted to paint Ibe-
ria as the antithesis of the Enlightenment, Spain underwent
its own process of rational reform in this era.[1] Bureaucratic
reorganization, intensified record keeping, scientific classifi-
cation, the institutionalization of charity and public services,
and the promotion of civil associations are just some of the
aspects of global modernity in the eighteenth- and early-
nineteenth-century Spanish world. Historians have examined
these changes for some time, but there is far less work on the

visualization and spatialization of such reforms, for example, in the synthesis of an architecture, image, and space of reform in the societies of Spanish colonial America.[2]

Cuba underwent its own process of reform and modernization imposed from without but also cultivated one from within by a Creole and Peninsular elite and indeed by colonial society in general. The most salient aspect of Cuban modernity, broadly speaking, that began to appear in the second half of the eighteenth century was the emergence of civil associations that promoted a new subjectivity. The constitution of this new sense of self can be considered in anthropological terms as that of the bounded and atomized individual reshaped for economic reform as part of an elite public. The rise of civil society and the rational worldview it began to engender entered into a complex milieu of imperial and colonial identities. As Spanish intellectuals promoted rational political economy, the state sought to establish institutions that implemented discipline in the body politic to generate more efficient producers of national wealth. The standard of reason became central to many forms of intellectual investigation, as reformers promoted the rationalization of society and its members.[3] Havana began to adopt various European sciences, such as botany and chemistry, thought by many elites to be useful in the promotion of agriculture and industry. These developments contributed to the emergence of a dynamic and negotiated public culture in late colonial Havana led by Creole and Peninsular elites, but one that must have had an impact on multiple echelons of society.

HISTORY, ANTIQUITY, AND CLASSIFICATION

The production of history in the eighteenth-century Spanish world can be considered in multiple ways. For the purposes of this study, I emphasize history's importance in relationship to new forms of colonial subjectivity, that is, the ability to render a packaged and accessible version of the past in the service of creating identities in the present. The revision of Spanish history served the project of imperial expansion and state building by constructing presumably "objective," and hence authoritative, histories based largely on archival sources.

In an effort to stimulate cultural renewal in the Spanish Empire, the Bourbons established a number of royal academies of language, histo-

ry, and visual arts in the eighteenth century. Each academy systematical-
ly studied Spanish contributions to their field while adopting more ratio-
nal methodologies for appreciating and reproducing Spanish culture.
The Royal Academy of History, established in the 1740s, began address-
ing the production of Spanish and Spanish American histories. As illus-
trated by Jorge Cañizares-Esguerra, the academy occupied itself above all
else with a reformist objective of rewriting the history of the New World,
one that revised its sources by eliminating outdated chronicles and eyewit-
ness accounts.[4] During the mid-eighteenth century, the academy debated
the means by which to write revised and critical histories of America that
would be patriotic histories as well, insofar as they would generally serve
to elevate the Spanish nation. In the late eighteenth century, the academy
advocated the establishment of the Archivo General de Indias (General
Archive of the Indies), founded in Seville, Spain, by Juan Bautista Muñoz
in 1785 to catalog documents pertaining to the Spanish Americas after
almost three centuries of colonial rule. New histories would be based on
a critical examination of archival documents that were open to the pub-
lic, which would therefore have a higher likelihood of producing histo-
ries based on established "facts," not impassioned chronicles. The effort,
furthermore, speaks to the Bourbon obsession with the centralization of
knowledge and power.

In spite of Spain's state-level reformist agendas in the eighteenth cen-
tury, Northern European intellectuals frequently used Iberia and its early
modern history as a foil for their own rational advances. The pre-Hispanic
civilizations of the Americas, particularly the Aztec and the Inca, became
examples of what might have been learned from peoples living close to
nature had not the religious fanatics and greedy conquistadors disrupted
them in the sixteenth century. According to such thinkers as Adam Smith
(1723–1790), abbé Guillaume-Thomas-François Raynal (1713–1796), Cor-
nelius de Pauw (1739–1799), and William Robertson (1721–1793), recov-
ering this valuable past could not be achieved by relying on sixteenth- and
seventeenth-century accounts because these were not made by individuals
sufficiently trained as "philosophical" observers and thus lacked credibil-
ity.[5] Furthermore, these authors generally regarded Creoles as degenerate
and inept, incapable of producing sufficient histories of their own territo-
ries. Cañizares-Esguerra argues that such biases produced a reaction from
lettered residents of the American viceroyalties, who began to write their

own histories of the New World, relying on the very kinds of documents denounced by Spanish historians. We can also locate a nascent American antiquarianism in the attention paid to the pre-Hispanic civilizations of the Aztec and the Inca, including their visual culture.

The French naturalist Georges-Louis Leclerc, comte de Buffon (1707–1788), likewise called for new, more systematic ways of constructing knowledge of natural history than had been produced by earlier chroniclers. Spanish authors distinguished between civil histories of people, places, and events, and natural histories of flora and fauna. Natural historiography underwent a similar transformation in the eighteenth-century Spanish world, the visual component of which has been illuminated by Daniela Bleichmar.[6] In the eighteenth century, Spain co-opted the system of binomial nomenclature invented by the Swedish botanist, zoologist, and physician Carl Linnaeus (1707–1778) to classify the empire's botanical variety. Science informed the visual culture of the Hispanic Enlightenment, which served as a tool of empire, especially to control agricultural commodities and territory. The Spanish monarchs dispatched no less than fifty-seven botanical expeditions overseas between 1760 and 1808, which produced images of imperial nature that could be returned to Madrid for study and archiving.[7] The language of the Linnaean system provided imperial discourses with a consistent and "efficient" code for use by the European center, allowing botanical species, climate, and soil conditions to be recorded without much, if any, regard for local contingencies, including Amerindian or Creole terminology and explanations of nature. The use of Linnaean taxonomy was an attempt to standardize European botanical study of world flora, reducing American varietals to the binomial system. The production of scientific knowledge began to construct a type of vision, whether it was received or contested. Just as the magisterial gaze of Cartesian linear perspective attempted to conquer nature and establish empirical space, the Linnaean system did likewise with the objects of nature from the perspective of the scientific observer.[8]

Botanical representation worked hand in hand with text to allow students and natural scientists, often far from the source, to study and classify the natural history of the colonial world. Spanish officials, naturalists, and political theorists produced botanical knowledge as a tool to consolidate power over territory, manipulate agriculture, and boost the national economy. In Madrid, the Royal Botanical Garden, established by Charles III in

the late eighteenth century, served alongside the Royal Cabinet of Natural History as laboratories of botanical experimentation, training centers, and clearinghouses for correspondence in the widespread network of botanical discourse in the late eighteenth and early nineteenth centuries. The Botanical Garden of Havana was formally founded in 1816, though it had its origins in the early 1790s. It housed a school of botany and a herbarium that aimed to cultivate discernment and knowledge in the Havana public on the order of nature.[9]

The Royal Academy of Language, created in 1711, attempted to revive Spanish literature and make it accessible for the public in some form. The writings of Cervantes and the Spanish mystics, for example, suddenly received new attention and critical discussion. Simultaneously, the Royal Academy of San Fernando sought to document and revive Spanish antiquities, from the remains of ancient Rome to the remnants of medieval Islamic polities in Spain, such as the Alhambra of Granada. While San Fernando promoted, over time, a more austere classicism, it simultaneously elevated early modern Spanish artistic production in general. The Spanish statesman and writer Gaspar Melchor de Jovellanos addressed the academy in 1781 on the history of Spanish painting, emphasizing the patronage of the Habsburg Felipe IV as the impetus behind Spain's golden age in the visual arts and elevating Diego Velázquez as Spain's greatest artist.[10] Such a promotion and reuse of the past for agendas in the present can be viewed as the production of Spanish national heritage—one that would gradually shape and be shaped by Creole views of collectivity in the Americas.

INDUSTRY AND SOCIABILITY

Bourbon attempts to improve Spain's economy included the promotion of industry in the empire through various means. In his 1774 *Discurso sobre el fomento de la industria popular* (Discourse on the promotion of popular industry), the Spanish statesman and economist Pedro Rodríguez, conde de Campomanes (1723–1802), outlined strategies for boosting the national economy. Central to these efforts would be the promotion of "popular industry" to foster industriousness, utility, and public well-being, and to subdue "injurious and vulgar opinion . . . [and] . . . disorderly passions."[11] The task of fostering popular industry in Spain would involve participation of the various *justicias* (justices), *cabildos* (town councils), and *intendentes*

(intendants) in their respective towns, as well as bishops and the ecclesiastical community. Advancing this objective, he writes, "would be quite useless if the provinces do not have a well-educated and patriotic body that will accommodate these and other ideas in whole or in part to the situation, climate, fruits, industry, and population relative to each province."[12] Areas near the seacoast where fishing served as a principal industry would benefit from the development of navigation and marine commerce. Agricultural provinces required study of books on plant cultivation, including the history of Arab agricultural practices in southern Spain. Where certain industries were already known, it was practical to promote and perfect them rather than to replace them with new ones.

The plan to renovate Spain's industry based on the particularities of location and local economic histories would require significant data collection and analysis. For this purpose, Campomanes argued for the establishment of a Sociedad Económica de Amigos del País (Economic Society of Friends of the Country) in each of Spain's provinces. He also refers to these as Patriotic Societies, specifying the elite character of the organizations. "The nobility, reduced to Patriotic Societies, which are proposed, will usefully consume in them their time . . . readying the gentlemen, clerics, and rich people . . . to devote themselves to making the observations and calculations required, or experiments, and to acquire other instructive knowledge."[13] The idea of "reducing" the nobility to such societies could be understood as a focusing of the elite on a common cause with implications for society's betterment and the economic growth of the Spanish nation rather than leaving them to their own narrow individual, familial, and corporate agendas.[14] In this sense, it implied a social leveling in public life, a common arena where one might distinguish oneself through meritorious deeds and civic accomplishments in the interest of the common good, albeit while still negotiating normative colonial hierarchies. This attempt to engage the urban elite collectively in the Spanish nation's progress suggests how the rationalization of the state would be constructed and orchestrated in multiple provinces and municipalities.

These civic developments in the eighteenth-century Spanish world, including the founding of Economic Societies in tandem with the general assimilation of rationalist thought, reshaped and were shaped by existing identities and subjectivities. In particular, such changes sought to foster the reconceptualization of the boundaries of self and one's relationship to

others within a community circumscribed by socioeconomic and racial hierarchies. As framed by the disciplines of history and anthropology, urban collectivity in the early modern Spanish world had long been conceived in religious terms as a Christian community bound together in moral unity in the mystical body of Mother Church.[15] The souls of the faithful were intertwined, even if some families possessed substantially more prestige and economic resources. Private individuals of means were expected to perform charitable acts and to participate in collective devotions that brought everyone equally before God. Reform agendas in the second half of the eighteenth century promoted a disassociation of the individual from this earlier communal conception and the seeking of salvation through individual merit. This new conception of the self connected urban elites to one another in different ways. These shifts generated sites for the discussion, practice, and performance of meritorious deeds valued collectively among a group of elites that increasingly distanced themselves, in certain cities and regions, from the baroque practices and the mentalities of commoners. Colonial economic societies became sites of interaction where topics such as the education of the youth, economic renovation, data and news gathering, monitoring the idleness of beggars, and seeking industries for recent immigrants became common goals within an arena that promoted meritorious distinction. The relativity of reform, as emphasized by Campomanes, meant that members of these new "Patriotic Societies" of distinguished subjects would engage the topics of agriculture, cattle breeding, fishing, factories, trade, population, and navigation in terms of their local significances while keeping an eye on a wider world of rational knowledge through correspondences with Madrid.

Print culture played an important role in generating this new form of elite public society in Spain and abroad. The Economic Societies printed and published regular *memorias* and *actas* for elite subscribers in which arts, sciences, and industry were thoroughly considered. The Society in Madrid acted as the central overseer of provincial societies, requiring regular correspondence, which became a model applied to the Americas. Society members voted to elect their positions of directors, censors, treasurers, and secretaries. Members were assumed to be people of education and of some means who could contribute to the society's endowment, a fund necessary to purchase books pertaining to political economy and other subjects.

Economic Societies first emerged in Spain in the Basque region in 1765 before appearing in Madrid (1775), Zaragoza (1776), Valencia (1778), León (1783), Seville (1775–1778), and over fifty-eight more towns in Spain by 1804. In the Spanish Americas, a similar society was chartered in the Real Sociedad Bascongada de Amigos del País of Mexico City in the 1770s. Sociedades Económicas appeared in Manila (1780–1781), Santiago de Cuba (1787), Quito (1791), Havana (1791), Lima (1793), and Santa Cruz de Mompox (1794), among others.[16] In 1791, twenty-seven Cuban *hacendados* (landowners) in Havana petitioned the Crown to form an Economic Society, a request quickly approved by Madrid.[17] Membership in the Havana Economic Society included Spanish royal officials, elite clergy, and the upper sectors of the bourgeoisie, such as planters, merchants, entrepreneurs, doctors, lawyers, priests, and professors. Captain General Luis de Las Casas became the Society's initial director and launched the *Papel Periódico de La Habana*, the city's first newspaper, in 1791.[18] In the decade of the 1790s, this publication frequently critiqued the "erroneous ideas" of Cubans and sought to spread suggestions for better practices and the embodiment of *las luces* (enlightenment).[19] The *Papel Periódico* reprinted news and mandates from the *Gazeta de Madrid*; informed readers on developments in the Atlantic world; printed scientific reports; featured studies on behavioral etiquette; published poems and literary extracts; contained news of arriving ships; and posted classified ads for the sale of houses, carriages, and slaves.

The Economic Society published semiannual *Memorias* reporting on the advances made by the organization. The 1817 edition reveals 208 subscribers in Havana, including Spanish officials, the city's bishop, doctors, military engineers, and Cuban *hacendados*.[20] In addition, subscribers are listed for the outlying provinces of Santo Espíritu, Puerto Príncipe, and Trinidad. This collective readership allowed for a means of exchanging ideas and information on "useful" improvements that we can suppose began to foster a sense of collective opinion or at least a mechanism of generating and cohering various types of discourse.[21] In the 1817 *Memorias* of the Havana Society, members read articles on the utility of botany and the classification system of Swedish botanist Carl Linnaeus. Arguments appear for the establishment of a professorship of Botany and Chemistry at the Seminary of San Carlos in Havana and for an Academy of Music.[22]

As this complex and negotiated colonial public sphere came to increasingly monitor the idleness of the lower social echelons in Havana, suggestions were made to royal officials for institutional interventions. In the 1790s, several Havana elites initiated and cosponsored the Casa de Beneficencia (House of Charity or Welfare), an institution designed "to collect beggars, educate orphans of both sexes, and instruct the youth in exercises adequate to their talents and circumstances."[23] On March 17, 1792, Captain General Luis de Las Casas (r. in Cuba 1791–1796), a Spanish reformist administrator, along with the Condesa de San Juan de Jaruco and the Marqueses de Casa Peñalver and de Cárdenas de Monte Hermoso, accompanied by signatures of additional residents, made a joint proposal for the new institution. In a letter to the king, Las Casas wrote: "the project of the *hacendados* and residents was directed to establish and provide an orphanage or Casa de Beneficencia for the internment, education, and instruction of the beggars and orphaned children, of both sexes."[24]

Local as well as royal patronage thus appears to have been integral to the founding of this Casa de Beneficencia for Havana. Las Casas's identification of the effort as the "project of the *hacendados*" attests to the extent of elite Creole involvement, an effort coordinated by a local *junta* (council) established in March of 1792. The *Memorias* of 1793 explained that "[this] Patriotic Body was the most adequate to implement a foundation that had its origin in Havana patriotism."[25] The institution would improve the nation's economy by disciplining orphaned and destitute bodies that could be formally schooled, taught to respect authority, and made into industrious, efficient producers.

The donations given by private residents for the Casa de Beneficencia of Havana can be seen within a larger context in the Spanish world of changing ideas and attitudes toward charity, the poor, and orphans. In baroque Catholicism, by contrast, charity was expressed within a Christian community that viewed the poor as symbols of Christ, even as a distinction existed between the deserving and undeserving poor. In the second half of the eighteenth century in the Spanish world, reformers adopted more aggressive stances against poverty and unrestrained charity. Rather than a constituent aspect of God's natural order, the poor came to be criticized for their idleness, as an entity that infested the industrious community and threatened disorder. As state-sponsored urban growth simultaneously produced increasing numbers of poor, vagrants, orphans,

and the mentally ill, Spain and its territories, along with other European nations, began to collect such disadvantaged urban dwellers into institutions to instill discipline and teach them the virtues of labor. Spanish reformers attacked traditional charity, citing its inefficiency and tendency to create professional vagrants.[26] In Mexico City, Archbishop Lorenzana endorsed the construction of a poorhouse known as the Hospicio de Pobres, which opened in 1774, to remove the poor from public spaces and instill in them a work ethic and respect for authority. This souring official view of the poor led to the institutionalization of charity and the founding of hospitals, workhouses, orphanages, and *las casas de beneficencia*. Benefactors of these institutions, reformers contended, would serve the community in meritorious ways far more economically efficiently than individual alms giving to beggars.[27]

The care of orphans in seventeenth-century Mexico City was a dedicated form of charity, as caretakers adopted and raised these disadvantaged members of society in their private homes without the mediation of church or state. Brian Larkin's examination of wills in eighteenth-century Mexico City reveals bequests to orphans ranging from small money gifts to entire estates. Such devoted charity helped donors achieve salvation and united the Christian community. As with beggars, the care of orphans increasingly became institutionalized in the latter half of the eighteenth century. Archbishop Lorenzana likewise founded the Cuna de Huérfanos (Cradle of Orphans) in Mexico City in 1766 to shelter and instruct the unfortunates in Christian teachings and give them trades, rendering them useful to society. He compelled benefactors to make donations by framing the issue as one of social responsibility and discouraging them from exorbitant spending on altarpieces and church adornment. Contributing to this civic institution would be both more economical and meritorious. Such projects of social reform reveal the intervention of the state as it sought to reconfigure social relations by mediating between and thus separating the wealthy from the poor.[28] As the state took charge of disciplining the bodies of orphans, beggars, and indigents, it encouraged a fiscal discipline in the elite, freeing them to cultivate their self-interest absolved from having to incorporate destitute social bodies into a mutual space of mystical Christian community.

The Casa de Beneficencia in Havana seems to have served as such a multipurpose charitable institution, tending to beggars and the poor of

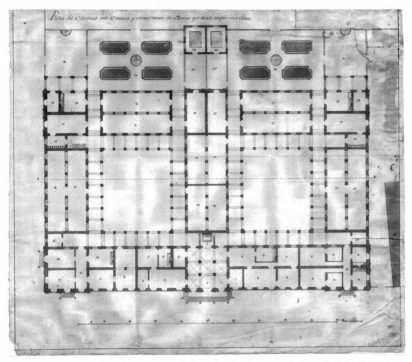

2.1 Francisco Vanvitelli, plan of the Casa de Beneficencia (House of Charity) of the City of
Havana, c. 1790s. 630 × 440 mm. Courtesy of the Instituto de Historia y Cultura Militar,
Archivo General Militar de Madrid, Spain.

both sexes. Designed by engineer Francisco Vanvitelli, the massive build-
ing complex was organized along a central axis with symmetrical dormi-
tories and instructional spaces (fig. 2.1).[29] Spatial order and uniformity
via the gridlike arrangement of architectural masses and voids communi-
cated the efficiency of the institution and must have served in ways that
require more research in the project to reorder indigent bodies. We can
imagine that interior courtyards and gardens would expose the disadvan-
taged to fresh air and nature, cleansing the health and improving moral
character. For the one-story façade, Vanvitelli co-opted classical revival
motifs of the triumphal arch in the central entryway and two symmetri-
cal, projecting end pavilions (fig. 2.2).[30] Imperial heraldry marked the cen-
tral doorway, proclaiming the building as a royal institution. Classicizing
window treatments, regular fenestration, unbroken cornices, and a con-
tinuous balustrade mirrored the order found in the plan and emphasized

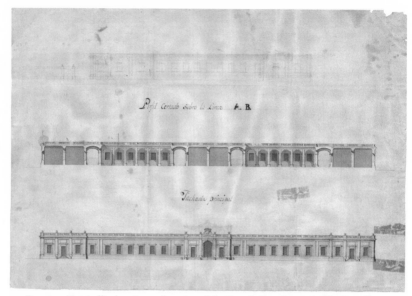

2.2 Francisco Vanvitelli, elevation and section of the Casa de Beneficencia of the City of Havana, c. 1790s. 630 × 440 mm. Courtesy of the Instituto de Historia y Cultura Militar, Archivo General Militar de Madrid, Spain.

the straight line, uninterrupted by baroque curves. These formal properties reveal reformist aesthetics, architectural massing, stylistic choices, and spatial arrangements that must have been regarded by some members of the elite as means to actualize abstract discussions about society's betterment.

Spanish royal officials in the Bourbon era commissioned portraits to commemorate their contributions to the public and associate themselves with the public works or civic institutions under their sponsorship. In one such portrait from the late eighteenth century by Juan del Río, Captain General Luis de Las Casas stands adjacent to an open window or doorway with a portion of the Casa de Beneficencia visible in the background (fig. 2.3; plate 5). By associating himself with this work in portraiture, the governor constructed a memory of his involvement with the project.[31] He also offers himself as an important mediator between the elite public and the socially destitute, which implies the obligations of potential benefactors. In the image, Las Casas points to an unfurled document that issues the command "Habaneros, Protect Humanity, Enlighten the Mother Country." The text along the lower portion of the painting identifies Las Casas as the founder of the city's Economic Society, *Papel Periódico*, and Pub-

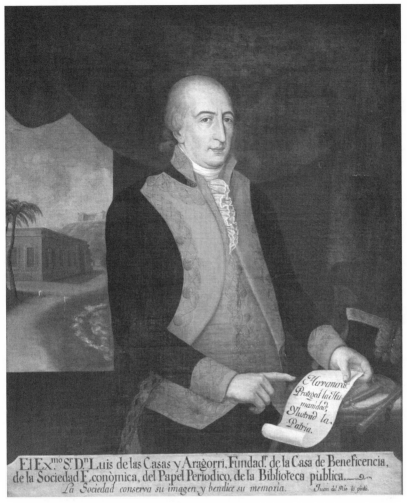

El Ex.^{mo} S. D. Luis de las Casas y Aragorri, Fundad. de la Casa de Beneficencia, de la Sociedad Económica, del Papel Periodico, de la Biblioteca pública. La Sociedad conserva su imagen, y bendice su memoria. Juan del Río lo pintó.

2.3 Juan del Río, *Portrait of Luis de Las Casas*, c. 1790s. Oil on canvas. Courtesy of the OHC.

lic Library. This portrait, and others like it, were socially coded on multiple levels, as they communicated not only the status of the royal official but also new social relationships between Spanish administrators, elite patrons, and civic works. The painting betrays a new vision of mediated civic benevolence constructed by the state and colonial elites.

The bulk of civic architecture in the late-eighteenth-century Spanish world was the product of military engineers with advanced drafting skills. Indeed, the importance of drawing pedagogy became an agenda

item for a reformist Spain. The responsibilities of the Economic Societies in the Spanish world included the establishment of schools of drawing, perceived as having positive effects on manufacturing, the arts, and society. Campomanes, in addition to his discourse concerning popular industry, wrote a *Discurso sobre la educación popular de los artesanos y su fomento* (Discourse on the popular education of artisans and its promotion; 1775) in which he argues for the essential importance of drawing to cultural and economic reform.[32] He states that where none exists, it is appropriate to establish a patriotic school of drawing in the care of the Economic Society.

To preface his argument, Campomanes first distinguishes between *arte* (art) and *oficio* (craft). Whereas the latter is taken to refer to the domain of the laborer who merely applies his body to the work, the production of art consisted of creating works according to established rules. Craft, on the contrary, did not require rules, only "pure imitation [and] natural disposition," learned through years of repetitive training and practice. Campomanes argues that, in reality, all art is craft, although the reverse is not true. By co-opting the rules, the practice of drawing, and the principles of *diseño* (design) known to the arts, the crafts could thus be elevated. Based on French models, the RASF in Madrid made rigorous instruction in drawing the foundation of artistic training. Yet it is important to note that the Spanish academy and various drawing schools were not founded principally to train artists, but to train craftsmen in drawing in order to improve manufacturing and diminish the educational role of the guilds.[33]

In his discussion, Campomanes cites the four books of drawing by Juan de Arfe y Villafañe in which rules of design are based on the proportions of the human body. The Arfe method is offered as a means to give apprentices and teachers a complete course in design that they apparently lacked at that time. Campomanes justifies his mandate for drawing instruction by citing its use by the legendary Spanish artists Francisco Pacheco, Vicente Carducho, and Antonio Palomino. The teaching of drawing would improve all the arts and crafts, even the art of war. In an art or craft that did not immediately need drawing, practitioners were nevertheless required to make use of it in order to "follow the path paved by the academy of the arts." Drawing schools should contain "books of the arts" in which prestigious designs could be found. Principles of design benefited

not only the arts and crafts but also all *fabricantes* (manufacturers) by bettering their discernment of an object's adherence to the rules of design. Even the nobility must have drawing instruction, Campomanes argues, in order to discern the furniture, carriages, paintings, buildings, fabrics, upholstery, and carpets of better taste and thus avoid being cheated in the things they purchased. At present, he insists, these items were being made according to the "whim of the artist," who usually works "destitute of rules." This urgent call for drawing instruction in reformist Spain had ripple effects in the Americas, where a number of drawing schools were founded in addition to the Royal Academy of San Carlos in Mexico City. The opening of the Academy of San Alejandro in Havana in 1818 by the intendant and director of the Economic Society Alejandro Ramírez began as such a school of drawing.

As the elite of Havana contributed to local improvements via the Economic Society, a broader spectrum of the educated and upper social echelons gathered to discuss the knowledge of the day. In the Spanish world, *tertulias* began as informal meetings among family friends at the end of the seventeenth century in Spain before expanding into broader social gatherings in the eighteenth century.[34] These events brought together elites, including royal officials, clergy, merchants, planters, professionals, and other educated people, to discuss such topics as science, philosophy, literature, the fine arts, and current events. Through these gatherings, women of the nobility became actively involved in Bourbon-era society. In the major cities of Madrid and Mexico, noblewomen held *tertulias* in their private homes, attended by the distinguished of the city or region.[35] While private *tertulias* became important means of spreading ideas and useful knowledge among elite groups, members of the emerging bourgeoisie, or middle classes, sought more public venues, including cafés that became sites in which subscribers to periodicals could read these publications aloud for debate and discussion. Still lower members of the social order, including muleteers, small shopkeepers, and craftsmen, could meet in taverns, paseos, parks, and elsewhere in public to engage in discussion of such loftier ideas and concepts.[36] Much research is needed on such social gatherings in Havana in the late eighteenth and early nineteenth centuries; however, *tertulias* and less elite forms of "enlightened" sociability certainly existed and functioned to incorporate more members of the society into the discussion of "useful" knowledge.

POLITICAL ECONOMY AND
THE SELF-INTERESTED INDIVIDUAL

The Bourbon promotion of economic efficiency, self-interest, and the self-regulated individual was reshaped by conditions in Havana. In 1791, Cuba's neighboring island, the French colony of Saint Domingue, erupted in what would become the only successful slave rebellion in Atlantic world history. As French planters fled, some seeking refuge in Cuba, a lawyer and Cuban planter, Francisco Arango y Parreño, observed the situation and responded with his *Discurso sobre la agricultura de La Habana y medios de fomentarla* (Discourse on the agriculture of Havana and means of developing it), submitted to the Spanish Crown in 1792.[37] With French sugar production in ruins and prices of the commodity rising between 1788 and 1795, Arango reacted to the slave insurrection on Saint Domingue with urgency and opportunism. He soon departed for Spain, where he successfully convinced the Spanish Crown to subsidize the development of the Cuban sugar industry.[38] Upon his return to the island, he began collaborating with Spanish Captain General Luis de Las Casas.[39] Visits to Jamaica to study British agricultural and industrial techniques were arranged for various Cuban elites, as Arango called for systematic innovation and elevating modern "interest and reason" over provincial "custom."[40] The historian Dale Tomich has argued that Arango employed Enlightenment rationalism to articulate a new political economy for Cuba, reconceptualizing "slave labor within the framework of free trade, individual self-interest, efficient management, and systematic technological innovation."[41] These efforts resulted in Spain's lifting of restrictions on the slave trade, which led to an abrupt increase in the number of African slave imports by the turn of the century.[42] Arango's efforts illustrate complex Creole negotiations of Spanish mercantilism in order to achieve desired economic policies for Cuba.

His retooling of the economic theory of Adam Smith helped generate the social transformations that were particular to early-nineteenth-century Cuba. These changes included Creole planters' sense of opportunity and economic ascendancy as well as the development of different views toward the Spanish. While the Spanish allowed for latitude toward Creole political economy, the Crown simultaneously reengineered an economic strat-

ification based on birthplace. As Louis A. Pérez notes, commercial practices divided the Havana elite: "Bourbon policy increased the strength of the mercantile/commercial sector, largely Spanish, over the agricultural/ranching sector, mostly Cuban, and in so doing, sharpened the distinctions between *peninsular* interests and creole ones."[43] Yet the rapid increase in the African population in Cuba based on Crown policy compelled Creoles to think of the Spanish as a necessary presence. Scholars of Cuban history have speculated about reasons for the persistence of Cuban loyalty to Spain in the nineteenth century. Some have argued that it was due to a fear of destabilizing the social order because of the growing African presence and anxieties over the thought of losing the protection of the Spanish military.[44] Others have noted that Cuba had formidable militias quite capable of suppressing slave uprisings and that the real reason for Cuban loyalty was the unofficial accommodation that had developed between Spanish administrators and Cuban producers by the early nineteenth century.[45]

Regardless of one's Cuban or Spanish birth, the assimilation of self-interest, free trade, managerial efficiency, and technological innovation could not be contemplated without concern for the adverse effects of progress, namely, the presence of more, potentially insurrectionist Africans on the island. As the Economic Society and its publications promoted more rationalist values in Havana, the colonial public turned its attention to concerns over the island's Africanization. The slave revolt that began on Saint Domingue in 1791 ultimately prevailed and ushered in the first African republic of Haiti in 1804. The example set by this insurrection and the very existence of Haiti, condemned by elite communities across the Atlantic world, powerfully shaped views toward people of African descent in Cuba among hegemonic groups. The rational management of the local black population became a reformist project that united Creole and Peninsular elites who staffed the Junta de Población Blanca, a special council founded in 1817 to monitor census data for population ratios of blacks to whites and to suggest strategies for the increase of the white population. Such efforts at socioracial management reshaped the contours of civic belonging and the construction of white elite selfhood in Havana. The ability to separate and manage blackness reinscribed and reified white identity, offering it as a more rational and stable construct.

RELIGIOUS REFORM AND THE
METAPHYSICAL LIMITS OF THE SELF

As royal officials and civic elites promoted a new subjectivity in the eighteenth-century Spanish world, so did reformers in the religious sphere. The historian Brian Larkin emphasizes epistemological and subjective shifts in the religious practices addressed by reformers, such as sacred immanence, performative and liturgical piety, and the creation of divine splendor.[46] Bishops and priests sought to revise the beliefs and practices of baroque Catholicism in ways that coincided with and complemented the objectives of rational reform. Larkin argues that at issue was the very nature of the sacred and a shift away from an outward and corporeal devotional piety that emphasized the inherent sacredness of religious objects, bodily gestures, visible veneration of saints, elaborate ritual, and the splendid artistic adornment of churches.

Baroque piety operated within a world of sacred immanence, the notion that the sacred could exist within physical objects or images, and these could guide the worshipper through religious experience.[47] Liturgical items, images of saints, altarpieces, and architectural spaces could, therefore, be spiritually charged and the sacred made manifest in tangible, kinesthetic reality. Elaboration of church interiors with exquisite adornments amplified and accentuated the intensity of the sacred. Larkin's study of wills confirms that the wealthy prioritized charitable donations to adorn sacred spaces in life and after death in order to ensure salvation, the very practice that reformers would seek to discourage as an impediment to economic efficiency. In the baroque religious imagination, splendid church interiors became microcosms of the heavenly kingdom. Sacred immanence operated under the assumption of the unity between sign and signified; for example, the image of a saint embodied, not just stood for, the saint's presence. Baroque Catholicism situated the body at the center of religious experience, as it was the entity that brought together in its sensorial capacities all of the trappings of baroque piety. Acts of affection toward representations of saints or sacred objects, the performance of symbolic gestures, the ingestion of the Eucharist, and the visual consumption of baroque adornment were activated and connected through bodily experience.

Reformed Catholicism in the Spanish world simplified and interiorized religious piety by deemphasizing the physical and palpable connection

with the divine. It stressed the essentially spiritual nature of God. Religious reformers passionately advocated for the pious to develop a more personal relationship with the sacred, relying less on exterior forms of veneration. To promote this new piety, reformers attacked the manifold objects, visual styles, and performative practices of baroque Catholicism and reconsidered ways to make piety visible and spatial. The body no longer served as the essential spiritual vehicle that required corporeal stimulation to metaphysically transcend. Thus the performance of bodily gestures, ritualized practices, and sumptuous decoration became limitations to spirituality, not its essential aids. Artistic adornment and architectural complexity required simplification, as these exterior forms of religious observance came to increasingly be seen as conventional signs, that is, standing in for but not so much embodying the sacred.

Reformed piety complemented secular reforms as it encouraged the reimagining of the self, promoting the restraint of bodily gestures in the veneration of the divine, the observance of greater silence and separation from other bodies in religious spaces, and an emotional detachment from the objects of sanctity. These reforms in religious practice supported aspects of eighteenth-century modernity, including economic rationality in the diminished spending on elaborate church decoration and the disciplining of the body in the interest of efficient production.[48] As reformed piety deemphasized the connection between individuals by mystical design, the faithful could be isolated, ontologically bounded, and made into reformed subjects. The historian Pamela Voekel has even argued that religious reform began to complement the aspirations of middle and elite sectors of society who viewed the social distinctions encoded in baroque ostentation as an obstacle to social ascendancy. Values of self-interest, good management, and other liberal political ideals became Christian virtues, while baroque practices became vice.[49] In Cuba, new conceptions of the self based on managerial efficiency and self-interest promoted by proponents of the sugar industry must have complemented the influx of religious reform values in the early nineteenth century. However, Larkin has insisted on the elite nature of these reforms and their limited reach. Reformist practices always struggled against the persuasion of baroque Catholicism, even among the elite. Furthermore, this epistemological and performative transition was never seamless, even where reformist practice seemed to be most in evidence. In Havana, baroque practices indeed continued, as

did elaborate bodily performances, such as those of the African *cabildos de naciones*, which likely offended the sensibilities of Catholic reformers.

While historians have examined the epistemological and subjective dimensions of religious reform in the eighteenth-century Spanish world, there is minimal, if any, work on the visual and spatial environments created to reshape the contours of religious experience with respect to reform.[50] Art and architectural historians have not, for the most part, considered how stylistic transitions in ecclesiastical architecture (from baroque to neoclassical) were related to these complex transformations within the Church and the eighteenth-century societies that they attempted to persuade. In the remainder of this chapter, I examine a few church alterations, ritual refinements, and the construction of a public cemetery in Havana that relate to these more conceptual shifts within ecclesiastical circles. These examples undoubtedly harbor much insight on the localization of reformist religious ideas in a Cuban context but also point to areas for future research in Spanish colonial art history in general.

The arrival of Bishop Espada in Cuba in 1802 ushered in a series of art and architectural projects that indicate the visual, audible, and performative expression of religious reform in Havana as well as efforts to reign in baroque piety.[51] In his "Edict of Bells," issued March 18, 1803, the bishop criticized excessive bell ringing in the city, which he equated to exorbitant spending on funerals.[52] He condemned the "vanity" of ringing bells for the passing of distinguished persons as well as the duration of public ringing, which indicated the time and day of community worship. Espada mandated that the sequence of bells rung for the morning's Ave María should be reduced from twenty-three minutes to three minutes, proposing a penalty tax for any infraction. Audible immoderation in bell ringing, according to the bishop, was "against the spirit of the Church and of public tranquillity, with grave detriment especially to the delicate situation of the infirm."[53]

In the realm of liturgical ritual and performance, Espada likewise promoted restraint, attempting to subdue religious imagery and public processions in the streets and plazas. He ordered crosses removed from various passageways in the city, along with objects that fostered superstition, and he prohibited fanatical penitential processions.[54] Espada's long tenure in the city (r. 1802–1832) as compared to the relatively brief duration of the captains general's reigns,[55] his writings, and his active involvement in so many new projects speak to his formidable presence as a proponent

of reform and a figure frequently involved in visual projects. Based on his patronage and ecclesiastical oversight, we can surmise that the bishop associated reformist piety with such elements as the freestanding column, urn, classical entablature, triumphal arch, and ancient temple form. In painting, the works he sponsored reveal devices to enhance naturalism, including chiaroscuro; linear perspective; color balance; and motifs such as classicizing drapery, archaic landscapes, classical temples, and figures in contrapposto. Christian scenes deemphasized the miraculous, and ritual spaces took on simplified appearances, presumably to promote a new, more interiorized piety that relied much less on external stimuli. All of these could be considered in relation to new conceptions of the conventional religious sign as a representation but not so much an embodiment of the sacred anymore, at least before certain audiences. However, the deployment of neoclassical genres must have contributed to a form of religious imagination that reformers did not anticipate. It rendered a complex Catholicism, entangled with older and newer forms of visuality and spatiality that did not consistently or uniformly produce the desired subjective experience or subject, but rather something new and unpredictable.

The bishop sponsored and promoted a number of major civic works in collaboration with members of the Economic Society, whose *Memorias* he subscribed to in 1817 and over which he briefly served as director. During the early years of his tenure in Havana, Espada advocated strongly for cemetery reform. In an exhortation of 1805, he condemned the "disastrous effects that have always been produced by the abuse of burying corpses in the churches."[56] The following year, the city inaugurated a new public cemetery for its *extramuros*, a work that contained religious iconography and classicizing frameworks that give us some idea of the bishop's thinking on the appropriate visuality to promote a reformed piety. It is also a work in which we see the adaptation of an international typology to the social conditions of a Spanish colonial society in the Americas.[57]

The cemetery was built one mile west of the city's western wall, a distancing from the lived city that was consistent with the belief of eighteenth-century reformers that living in close proximity to the deceased caused myriad illnesses. In 1787, the ministers of Charles III had ordered the end of burials in parish churches and the creation of suburban cemeteries. In Spain, these mandates resulted in the construction in 1804 of the General Cemetery of the North in Madrid, designed by the academ-

ic architect Juan de Villanueva.[58] Espada's 1805 regulations on interment in Havana strictly prohibited "all parish priests, lieutenants, and secular or regular ecclesiastics from making any burial in their respective churches, or in *ermitas* [small devotional chapels] and public or private chapels, oratories, or generally in any fenced or closed site where the faithful gather together to pray and celebrate the holy mysteries."[59] As a gesture of his resolve, the bishop provided 22,231 of the total cost of 46,878 pesos, the remainder being borne by the holdings of the *fábrica* of the cathedral.[60]

In promoting the cemetery to the public, reformers in Havana seem to have engaged in a heritage process in their emphasis on the correct reuse and indeed reinvention of a prestigious past as an intervention for the present. The Cuban physician Tomás Romay Chacón's "Speech on Tombs Outside of Towns" justified the cemetery by demonstrating its relationship to the known burial practices of ancient biblical, Mediterranean, and world history and of early and medieval Christendom.[61] He plumbed world cultures for examples, criticizing the Egyptians for conserving the deceased in their houses and temples out of "vanity." The noble Greeks, by contrast, buried their deceased at a distance from their towns. Romay Chacón lauded other world cultures for doing the same, including the Chinese, Japanese, Koreans, the kingdom of Siam and Mogol, the first inhabitants of the Canary Islands, and the empire of the Inca. The Mohammedans, although "submerged in barbarism and fanaticism" and preferring cremation, separated the ashes of the dead from their houses.[62]

Romay Chacón elevates the Roman model above all other world cultures, citing that Roman law absolutely prohibited burning or burying any corpse within the walls of Rome. He situates Havana in line with the first great cities of Christianity, including Alexandria and Constantinople. In these cities, Romay Chacón recounted, early Christians continued the Roman tradition of burial. Yet, regardless of severe prohibitions, royal corpses in the medieval basilicas of Spain were transferred to royal chapels out of "vanity." Gradually, ecclesiastical authorities and the Spanish monarchs began to prohibit this practice, and Romay Chacón gives a succession of bishops and kings responsible for more thoughtful burial procedures in the custom of the ancients.[63] Romay Chacón's elite audience in Havana thus received a thorough moral lesson in the historiography of cemetery reform with a biblical, classical, and global emphasis, which validated Havana by situating it in line with historic centers of civilization.

By an election of 1802, the Economic Society, then under the direction of Bishop Espada, recommended to the captain general that a new cemetery be built outside the city walls and gave 500 pesos for the architect's fee.[64] The captain general approved the disposition, and the Society decided unanimously to establish a cemetery on the most convenient site. The organization formed a plan, calculated costs, and obtained the authorization to build on the land between two piers, determined as the place of the best cross-ventilated winds.[65]

The Society's choice of architect speaks to transnational reconfigurations of neoclassical style in the early-nineteenth-century Atlantic world as well as Havana's position on the highway of trade, immigration, and professional maneuvering. The commission went to French architect Étienne-Sulpice (Stephen) Hallet (c. 1760–1825), who had recently arrived in Havana from the United States, where he had been at work on the project for the Capitol in Washington, DC. Born in Paris, Hallet was listed in 1785 in the *Almanach royal* as an "architect experienced in middle class buildings" and in the 1786 *Almanach des bâtiments* as a "qualified architect licensed by the city of Paris."[66] He had immigrated to America around 1790 and was Pierre L'Enfant's draftsman in Philadelphia in 1791. In the same year, Hallet submitted his first of five designs for the U.S. Capitol building to Thomas Jefferson. His numerous extant drawings reveal his versatility with French classical architecture and ability to accommodate the formal, spatial, and iconographical requirements of his commissions. The Capitol building commissioners discharged Hallet in 1794, and he departed Washington, DC, in 1796, bringing his knowledge and experience in French and United States classical architecture to Cuba around 1800.[67] It is important here to note this France–United States–Cuba architectural connection because it suggests that Madrid's Royal Academy of San Fernando cannot be automatically cited as the source of neoclassicism in the Spanish Americas, particularly after the end of the eighteenth century. The Atlantic world produced myriad classicisms via the representational requirements of various republican or imperial regimes, the ambitions of local elites, and the flow of opportunistic designers.

Havana's General Cemetery has been demolished, but French artist Pierre Toussaint Frédéric Mialhe's *View of the General Cemetery of the City of Havana*, a lithograph from 1839, represents the structure looking toward the main entrance (fig. 2.4). The print situates the viewer in the cemetery

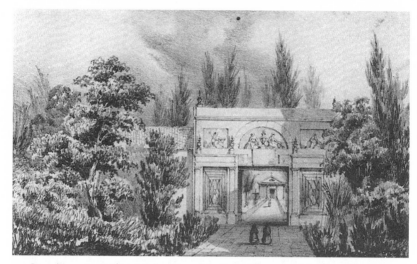

2.4 Pierre Toussaint Frédéric Mialhe, *View of the General Cemetery of the City of Havana*, 1839. Lithograph. Courtesy of HistoryMiami, Miami, Florida.

atrium facing the main entryway and surrounded by trees and vegetation. Bishop Espada hailed these "fragrant and funereal trees, which, in making a good effect on the senses, will contribute as well to the salubrity of the air in that enclosure and the surroundings."[68] A stone tile street 10 varas (27 feet, 2 inches) wide ran from the atrium to the main entryway. Designed in imitation of a triumphal arch, spanned by an austere post and lintel rather than a round arch, this gateway structure stretched three bays across with two rectangular, coffered panels flanked by Tuscan pilasters. In the attic story, a lunette framed allegorical figures of Time and Eternity in bronze relief. In concert with religious reform's de-emphasis on the cult of the saints, the imagery found within the cemetery consists of secular and religious allegory. In fact, no references to saints, who were central to baroque Catholicism, appeared throughout the entire cemetery. The work thus offers us an insight into the complicated translation of Catholic reform ideals into actual social spaces in the Americas.

Allegorical figures in lunettes were visual devices that Hallet would have seen in the work of such French architects as Claude-Nicolas Ledoux and Jean-Charles Delafosse and that he also employed for his Capitol elevations in Washington, DC, to symbolize republican ideals.[69] However, in the context of early-nineteenth-century Catholicism in Havana, allegory

could effectively construct universal meanings of sin, death, and resurrection.[70] The figure of Time, for example, a reminder of mortality, held a snake, possibly a caduceus, and wept, according to Romay Chacón, because of the corruptibility of man. The figure of Eternity extinguished a torch, indicating the cessation of life. Between these figures, a vase of perfume signified that "time destroys all and turns it into smoke."[71]

The allegorical imagery fronting the cemetery indicates the dual commitment of the new project to religious piety and scientific advances. In the attic story flanking the central lunette, horizontally oriented rectangular panels framed allegories of Religion and Medicine with their respective attributes. A gilded inscription on the gate reinforced the visual messages of these panels with the words "To Religion; To Public Health," giving the date of 1805. In an effort to demonstrate the dual patronage of church and state, underneath the allegory of Time was inscribed "El Marqués de Someruelos, Governor" (the temporal ruler) and under Eternity was "Juan de Espada, Bishop" (the spiritual authority).

The plan of the cemetery evinced values of absolute symmetry, and its materials made attempts to evoke Greco-Roman antiquity. Beyond the portal, Hallet designed the cemetery as a giant rectangle 150 varas (411 feet, 9 inches) north to south by 100 varas (274 feet, 9 inches) east to west, enclosed by a masonry wall with a ridge of worked ashlar.[72] This rectangular plan with an axial configuration and prominent entryway exemplified an international eighteenth-century cemetery typology well illustrated in the work of Richard Etlin.[73] The total surface area was 22,000 square varas (726,000 square feet), including the atrium, with a capacity inside for 4,600 burials. Abiel Abbot wrote, "It is a square enclosure, containing perhaps four or five acres. It is enclosed by a beautiful wall, plastered as smooth as the pavements of houses in this country, many of them not surpassed, for smoothness and hardness, by marble."[74] To underscore both rational order and Christian faith, Hallet divided the symmetrical rectangular space into four quadrants by intersecting roads that formed a monumental cross upon the ground. Tile made from a smooth slate stone covered the streets, identified by Romay Chacón as the "country stone of San Miguel" from the place in Cuba where it was quarried.[75] At each of the four corners of the rectangular layout stood obelisks of imitation black jasper. Next to these were ossuaries, depositories for exhumed and unidentified bones. On the short cross-axis, two pyramids of the same material as

the obelisks could be found at either end. Pyramids and obelisks, evocative of Egyptian antiquity and widespread in European and American neoclassicism as well as in Freemasonry, suggest a nascent antiquarian interest in Havana. In their simplicity, these forms evoked restraint, moderation, and the universal power of God, a force that could be known better through inner meditation than from external exuberance.

Hallet's most overt and archaeological statement of antiquity came with the cemetery chapel that appears as a fusion of the Spanish colonial *ermita* (small devotional chapel) and the Greco-Roman temple form. Centered in the north wall, on axis with the entryway, the cemetery chapel possessed a portico supported by four Tuscan columns and described by Romay Chacón as "similar to the old temples."[76] Sustaining the theme of resurrection, the chapel pediment bore a lunette with an inscription in Latin: "For the present behold me resting in the dust, Job VI. Rather the Lord resuscitates me on the final day, Joann. VII."[77] The portico and the chapel exterior were painted a light yellow with black striations to resemble marble, adding to the antique allusions. The door of the chapel bore the Latin inscription that shored up the connection between salvation and civic achievement: "Blessed are the dead that die in the Lord: because they go accompanied by their works. Apoc."[78] Inside the chapel, an altar made from the stone of San Miguel was positioned symmetrically against the far wall and fashioned in the shape of a tomb with steps. A monochromatic crucifix of ebony and ivory sat on the altar, and in the center of the frontal, two golden and striated pilasters flanked a golden engraving of a cross and halo. Centered in the floor of the chapel was an eternal flame; additional allegorical references to eternity fused Christian iconography with classical revival.[79]

For the chapel's back wall, Bishop Espada commissioned the Brescian painter Giuseppe (or José) Perovani (1765–1835), who had come to Cuba via Philadelphia around 1801, to paint frescoes of allegorical figures and Christian narrative scenes. Describing Perovani's now-lost Resurrection scene, Romay Chacón notes an angel with a trumpet telling the souls: "Rise up, ye dead, and come to justice."[80] To the angel's right, souls departed from their graves; to its left, the damned were shown horrified by their fate.[81] Over the door and the two lateral windows, Perovani painted images of the three theological virtues: Faith, Hope, and Charity. The conglomeration of classical references skillfully adapted to a Christian context

sanctified Greco-Roman antiquity and offered its allegorical content and simplified aesthetics as a guiding language for reformed piety.

The arrangement of graves within the cemetery reveals the adaptation of an eighteenth-century cemetery typology, described by Etlin, to the representational requirements of late colonial Cuban society. In the cemetery's internal arrangement of burials, Bishop Espada demanded "good order . . . [and] to avoid confusion and disputes, certain classifications of persons [will be made] according to their political and ecclesiastical rights . . . There will be three stretches [of land within the cemetery] proportioned to the number of three classes: first, middle, and common."[82] This organization situated the most important graves closest to the sanctuary chapel, positioning members of the most salient institutions and of colonial society closest to the main altar and metaphorically to God. Espada divided the cemetery into three tiers, corresponding to the three classes: "the first, the two immediate sides of the chapel; the second, the two corresponding sides down to the midpoint of the cemetery; and the third, the remaining half of it."[83] Directly in front of the chapel portico and to either side of the long axial walkway, a sequence of graves were found dedicated to the hierarchy of the church: bishops of Havana, ecclesiastical dignitaries, the *benemeritus* of the church, and the canons of the cathedral. Graves to the walkway's left were dedicated to the hierarchy of the state: captains general, the *benemeritus*, and the judges. Directly behind the ecclesiastical group, occupying an area 40 varas (110 feet) across from east to west, were the graves of the parish priests as well as the regular and secular clergy by order of their station within the church. Behind the senior members of state, also in an area 40 varas across, were the graves of the first or highest nobility according to their title.

Richard A. Etlin has argued that extramural cemeteries were a means of rationalizing death and reforming public health, but also became spaces for the definition of civic virtue.[84] Suburban cemeteries served as a utopian double of the lived city, in which, in the case of Havana, a representation of ideal colonial social hierarchy could be fixed and immortalized. In the Havana cemetery, the echelon of elite burials was followed by those for the lesser nobility in the second tier or "all of the most honored persons of the city, who will pay a modest cost for it in addition to that for an ordinary tomb."[85] The third tier served "the common class of honest persons of the union of our faithful."[86] Bishop Espada also specified that *pardos* (mixed

Spaniard and African) and *morenos* (blacks) were to be buried together in the cemetery along with lower-rank whites.[87] Although the bishop does not mention slaves, the four ossuaries in each corner may have been used for their remains. This arrangement of burials reveals the inclusive ideology of reformers while manifesting the specific types of exclusionary practices characteristic of Spanish colonial societies. The recollected symbolic meaning of traveling from a profane to a sacred altar space down an axial expanse in the holy sanctuary sanctified this hierarchy and spoke of its perpetuation even after death. As the anthropologist Michael C. Kearl has suggested, in the age of Enlightenment, the cemetery became "sociologically didactic."[88] It expressed and reinforced society's social aspirations, underlying structure, and mythical relationships to the past that supported private desires for future urban development.[89]

Bishop Espada's patronage at the Havana cathedral provides additional insight into his ideas about the appropriate visuality for promoting reformed piety. The bishop ordered exuberant side altars replaced with those that evinced greater aesthetic restraint; the latter were made of mahogany and incorporated freestanding columns, cornices with dentils, urns, and pediment—all trimmed in gold leaf (fig. 2.5).[90] He commissioned a new main altar, installed in 1828, consisting of eight Corinthian columns rising from an elevated octagonal base of marble configured in a circle and supporting a circular dome (fig. 2.6). The altar frontal below consisted of a solid piece of Carrara marble with small engaged columns flanking a central relief of the Last Supper carved by a sculptor with the last name Bianchini under the direction of Antonio Solá.[91] The main altarpiece extolled the universal role of the Church and its commitment to temporal reform by appropriating the Greek tholos (the geometrically round temple), symbolic of the union between cosmotheological and terrestrial order.[92] Espada may have been attempting to replicate in Havana the quite similar tholos-inspired high altar canopy of the basilica of El Escorial by Jacome da Trezzo (c. 1563–1584), which must have taken its inspiration from Donato Bramante's Il Tempietto in Rome. As the Renaissance art historian Jack Freiberg has argued, the early modern Spanish monarchs Ferdinand II and Isabella I, commissioned Il Tempietto for the convent at San Pietro in Montorio to memorialize the site of the Apostle Peter's martyrdom and assert Spain's political presence in the Eternal city (see fig. 3.14).[93] Espada's use of this form in Havana seems to forge a Span-

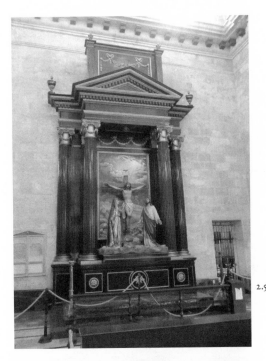

2.5 Anonymous, side altar, Cathedral of Havana, early nineteenth century. Mahogany and green granite. Photograph by the author.

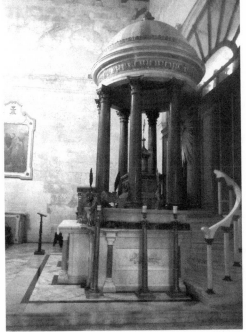

2.6 Bianchini, Antonio Solá, et al., high altar, Cathedral of Havana, c. 1828. Marble and Egyptian porphyry. Photograph by the author.

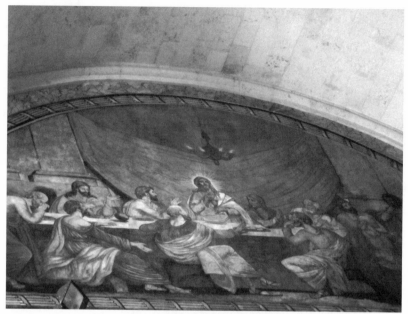

2.7 José Perovani and Jean-Baptiste Vermay, *The Last Supper*, early nineteenth century. Fresco, north lunette of the sanctuary, Cathedral of Havana. Photograph by the author. Reproduced courtesy of the OHC.

ish monarchical, imperial, and national link, thus affirming his presence as bishop and elevating his see in Cuba by recourse to a prestigious formal genealogy.

Frescoes adorning the sanctuary have received no analysis as to what they might reveal about the effort to translate pictorial narrative painting into an acceptable expression for religious reform. Espada first commissioned Perovani, followed by the French expatriate artist Jean-Baptiste Vermay, to complete these paintings; however, we are unclear on the precise extent of each artist's contribution. The fresco of the Last Supper for the north lunette of the sanctuary (c. 1808–1815) depicts Christ and the apostles seated at a table against an austere classical background (fig. 2.7; plate 6). The figure of Christ sits in the center of the horizontal table beneath a chandelier. Above him, a red cloak, symbolizing his sacrifice, is stretched against an austere wall between two monumental pilasters.[94] The disciples flank him on either side wearing red and yellow cloaks, evoking Roman togas that contrast with his white drapery, symbolic of peace and purity. The use of compositional symmetry and balance, the drapery on the fig-

ures, and the Tuscan pilasters on either side of Christ situate this sacred subject firmly on classical ground.[95]

We need much more research on the range of visual forms and aesthetics in the Spanish Americas that were expected to serve religious reforms where they were implemented. Such shifts in pious devotion should not be taken as a displacement of the baroque, but perhaps as a reconfiguration in some cases. How colonial audiences received these changes—acquiescing to, negotiating, or contesting them—and the relation between a particular response and social rank are important areas for future investigation. From these few examples in Havana, we see that the visualization in art and architecture of a reformed Catholicism involved a careful selection and reconfiguration of visual exemplars from European antiquity to construct and validate the performance of a restrained piety. This effort must have become entangled with multiple rationalist, empiricist, and materialist values in Havana as in other urban contexts in the eighteenth- and early-nineteenth-century Spanish world, just as it was compromised by its collision with baroque practices, which produced something new.

FÉLIX VARELA, CONVENTIONAL LANGUAGE, AND THE IDEA OF TASTE

Havana's elite and middle-class youth received exposure to European Enlightenment rationalism through multiple sources, including local institutions of higher learning that prepared them for professional careers in fields like law and medicine. The city's two academic centers in the early nineteenth century included the Royal and Pontifical University of St. Jerome, also called the University of Havana, which opened in 1728, and the Royal Seminary of San Carlos y San Ambrosio. An important figure in shaping curriculum at San Carlos was José Agustín Caballero (1762–1835), a priest and professor who was named director of the institution in 1794. In his writings and teaching, Caballero attempted to reconcile Christian humanism with contemporary methods that emphasized experience and experimentation.[96] His *Philosophia Electiva* synthesized Scholastic principles with aspects of rationalist thought found in the works of John Locke, Étienne Bonnot de Condillac, and Francis Bacon. His philosophy and teaching, however, remained within

epistemological limits circumscribed by the Spanish Inquisition, which emphasized less politically incendiary aspects of "enlightened" thinkers. Caballero advocated the introduction of the "native tongue" (Castilian) in university studies instead of the Latin traditionally used at San Carlos, thus attempting to naturalize modern thought in Cuba.[97] After the Jesuit expulsion of 1767, Cuban elites acquired an education at either the University of Havana or the more progressive Seminary of San Carlos, studying with Caballero.[98]

Early-nineteenth-century Havana found a strong clerical advocate for education in the Basque bishop Espada. Educated at the University of Salamanca in Spain, Espada became versed in eighteenth-century European rationalism prior to taking holy orders.[99] In Cuba, he promoted educational reform, sponsoring the son of a wealthy Cuban family, Bernardo O'Gavan, to study rational developments in Spain. When O'Gavan returned to the island, he proposed reforms based on Johann Heinrich Pestalozzi's pedagogical thought, which sparked a confrontation with the Inquisition. The Holy Office objected to O'Gavan's mention of Bonnot de Condillac and Locke in his proposal, along with the cost of the proposed reforms. The Lancasterian system of mutual education was finally adopted in Cuba as a compromise, although with limited success.[100]

Espada appointed the Cuban-born priest and intellectual Félix Varela to the *cátedra de la constitución* (professorship of constitutional studies) and introduced courses on constitutional law in 1821. The notes for Varela's course, titled *Observaciones sobre la constitución política de la monarquía española* (Observations on the political constitution of the Spanish monarchy), were published the same year. Pledging support of the Constitution of 1812, Varela states in his *Observaciones*, "Effectively, by nature, all men have equal rights and liberties."[101] He embraced empirical thought and experimentation, introducing Descartes, Cartesian logic, and eclectic philosophy to the curriculum of the University of Havana, where he began teaching in 1811. He was a contributing member of the colonial public, and his name appears among the subscribers to the Economic Society *Memorias* of 1817.[102]

In 1819, Varela published *Miscelánea filosófica* (Miscellaneous philosophy), in which he deals with philosophical matters as diverse as sensibility, ideology, conventional language, taste, and the imitation of nature in the arts. As with eighteenth-century intellectuals in Europe, Varela asserted that

human knowledge and cognition came from experience, that which could be perceived through the senses. Existence was known solely through sensations, and passion was an impediment to reason. These writings reveal the influence of eighteenth-century religious reform as well as a rationalist's attempt to reconcile thinking and existence with the configuration of the human-made world, which communicated to people through signs. In *Miscelánea filosófica*, the author writes: "In the present state of our knowledge, all acquired through sensations, and closely attached to signs, it is impossible to think without their help. . . . To think is the same as to use signs, and to think well is to use signs correctly."[103]

Varela's thought offers important insights on how certain members of the Cuban elite were instructed to view, perceive, and understand symbolic objects in the urban language of early-nineteenth-century Havana. In particular, he argues that as language was composed of signs, and signs were configured within language by convention, then society had the obligation to monitor and reform the "well-invented character of signs."[104] As examples of cultures' configuration of signs he cites the *jeroglíficos* (hieroglyphs) of the Egyptians, Chinese, and Japanese. If Cuba suffered from social and cultural backwardness, one step toward progress would be through signs and their reformulation. While Varela's use of theory seems to have been directed more toward textual language and verbal rhetoric, his inclusion of artistic considerations and his theory of signs and epistemology indicate that he must have mused on the "well-invented" character of visual forms.

Varela's understanding of taste reveals his familiarity with discourses on the subject in eighteenth-century Europe. Intellectuals such as David Hume (1711–1776), Alexander Gerard (1728–1795), Immanuel Kant (1724–1804), and Edmund Burke (1729–1797) promoted the idea that the individual could cultivate taste in order to discern the differences between gradations of beauty, such as delicate, sublime, and picturesque.[105] In David Hume's essay "Of the Standard of Taste" (1757), the author argued, "It is natural for us to seek a standard of taste; a rule, by which the various sentiments of men may be reconciled; at least, a decision afforded, confirming one sentiment, and condemning another."[106] Eighteenth-century theorists of taste, while differing in some of their interpretations, generally held that an individual could cultivate a strong "faculty of taste." Ideas about taste in the Hispanic world resemble dis-

courses in Northern Europe insofar as they seem to lend themselves to discussions on the construction of individual subjectivity. While discussions of taste made claims to a universal standard, the discernment of taste was a highly individual experience that required self-discipline, self-training, and self-application. It isolated the individual yet connected her or him to a larger community of tasteful neighbors. Still, the operation of taste in the relationship between humans and material objects in the eighteenth- and early-nineteenth-century Spanish world has scarcely been studied.[107]

In Cuba, Félix Varela equated taste with the reform of the senses. He identified "good taste" as a "norm of perfection, owing all its merit to its conformity with nature."[108] The artist must imitate the noble and majestic simplicity found in nature in order to create modern works because nature could be too complex, and thus overwhelm the senses.[109] This dilemma was precisely the problem, wrote Varela, with "old architecture," as it "abounded in complicated adornments that confounded the view and required much time for analyzing."[110] This architecture, therefore, conflicted with that of the Egyptians, Greeks, and Romans, who operated more in accordance with the simplicity of nature. Such visual complications, avoided by the ancients, were a "vice" in the "centuries of poor taste."[111] For Varela, "the taste of antiquity avoided much of this vice," as taste was "acquired and rectified by the study, practice, and imitation of the good models, achieving in this way the delicacy and correction that are their principal properties."[112] He conceptualizes a relationship between perception and conception, positing the perfect society as one whose logic and ideology were in accordance with the principles found in nature. He champions Francis Bacon for having "the most exact ideology," taking "ideology" to signify "ideas that form a whole."[113] The individual's opportunity for internal self-improvement came where the senses met with the external world, mainly society and its abundant forms of communication. The visual arts played an essential role in cultivating the senses and thus could improve society, rendering it more in tune with nature's design. These writings by Varela generated understandings of taste, classicism, and the role of the visual arts in society within the collegiate community of Havana in the opening decades of the nineteenth century as royal officials, senior clerics, and local elites endorsed various visual improvements.

THE ACADEMY AND CONTESTED
AESTHETIC REGIMES

In early-nineteenth-century Havana, architectural planning was primarily the domain of military engineers and master builders, while painting and sculpture were in the hands of non-academically trained artists. The occasional master from Europe, such as Perovani, would enter the bustling seaport and find work for royal, ecclesiastical, or private patrons and may have instructed apprentices. Yet the majority of Havana's late-eighteenth- and early-nineteenth-century artists learned their trade in workshops regulated by a guild system.[114] These artists supplied churches with devotional images and objects and the Havana elite with portraits, mural paintings, architectural ornamentation, and other decorative forms. For the most part, it appears that they were lower-middle-class *libertos* (free people of color) who dominated many of the trades and lesser-paid vocations in Havana. Such crafts included the occupations of mason, carpenter, coachman, shipbuilder, painter, sculptor, shoemaker, laundress, and market woman. A substantial degree of social mobility is attested to by the fact that *libertos* also became physicians, attorneys, writers, musicians, and poets.[115]

In Havana, a prolific late-eighteenth-century painter was José Nicolás de la Escalera y Domínguez (1734–1804), known for portraiture and religious works. Identified by some as a man of color,[116] Escalera left a relatively large corpus of identifiable works on account of the growing wealth and commercial activity of late-eighteenth-century Cuba. His portraits share in the conventions of pose common in Cuba, New Spain, and Europe, including the three-quarter turn, the presence of heraldry, and the inclusion of text identifying the sitter and translated through local aesthetics and sensibilities. Cuban scholars often cite the Spanish master Bartolomé Esteban Murillo (1617–1682) as an influence for Escalera's religious work in its compositional drama, gesturing figures, use of emotive colors, and celestial settings—work that predates, for the most part, the influx of religious reform in Havana. The conventions of Counter-Reformation baroque painting are also seen in his *Holy Trinity* where Christ and God the Father recline on a blue orb representing the power of the Trinity over the world, amid putti and on axis with the dove of the Holy Spirit (fig. 2.8; plate 7). The blue orb of the world, along with the background and Christ's cloak, establish a primary color scheme furthering the numerology

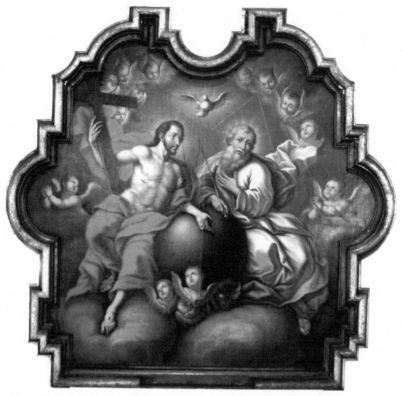

2.8 José Nicolás de la Escalera, *Holy Trinity*, c. 1800. Oil on panel. Courtesy of the Museo Nacional de Bellas Artes, Havana, Cuba.

of threes. However, blue orbs in this painting and in the context of colonial Cuba might also have connoted the Spanish king's divinely mandated power over the colonial realm.

A painter who claimed to be of African ancestry in Cuba during this period was Vicente Escobar y Flores (1757–1834), baptized in Havana's main parish church in 1762.[117] Escobar maintained a workshop and trained disciples, including Juan del Río.[118] Escobar was born to a militia captain in the Battalion of Pardos and a mother who was listed as a Cuban Creole white. By Spain's colonial caste system, this parentage would make him a *morisco*, but his baptismal records indicate him as a *pardo*. His portraiture earned Escobar the recognition of Cuba's Captain General Francisco Dionisio Vives (served in Cuba 1824–1832), who apparently sent him to Spain, where he was named Painter of the Royal Chamber at the Prado

in Madrid on March 6, 1827. Upon his death, however, Escobar's race had been elevated and listed as white, meaning that his accomplishments as a painter earned him the prestige and status necessary to whiten his blood.[119] Such an example reveals the actual fluidity of race and its ambivalent relationship to *calidad*, which could be enhanced by one's achievements.

In portraiture, Escobar focused extensively on facial features, developing a consistent repertoire of expressions. Many of his portraits reveal great attention to the sitter's clothing and various material accompaniments. While portraiture in Spanish colonial America has been viewed as a reflection of a society,[120] it more effectively can be understood as actively constructing the identities of that society.[121] Thus we can look upon Escobar's portraiture as an important part of colonial social discourse in late colonial Havana that operated, I suggest, through Bhabha's colonial mimicry. The elite established an image of exemplarity through portraiture as through social performances in urban space, which set standards for imitation by the lower social echelons. Through portraiture in colonial society, sitters could immortalize their claims to *limpieza de sangre* and elevate their *calidad*, visually fixing themselves as members of the Christian and commercial community differentiated from the lower social echelons. Escobar used chiaroscuro sparingly, leading to an overall sense of optical flatness in his works. He executed at least one signed portrait of the king, which must have resembled works displayed publicly on such occasions as the 1812 constitution reading in the Plaza de Armas.[122] However, most of Escobar's portraits would have been viewed in the *salas* (living rooms) and *aposentos* (bedrooms) of private houses. Private citizens regarded their familial portraits in private spaces and made them available to public eyes during *tertulias*, personal visits, and other social functions.

Escobar's works include a portrait of the successful musician Jackes Quiroga, an oil painting on fabric probably from the late eighteenth century. The work captures an affluent man of color seated in a proud and dignified posture (fig. 2.9). The subject's attributes include a piece of musical score, a woodwind instrument, and a rider's whip, which communicate his noble profession and relative life of leisure. His dark brown skin, combined with his clothing and accoutrements, identify him as belonging to an ascendant *liberto* community. Quiroga's fine dress and the glimpse of expensive furnishings further reinforce the sitter's elevated position within his society, validated through standards of elite portrai-

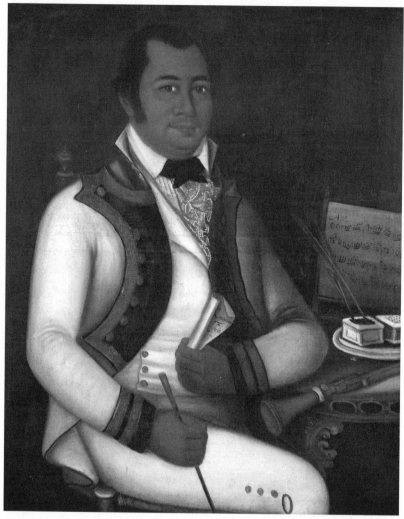

2.9 Vicente Escobar, *Portrait of Jackes Quiroga*, c. 1800. Oil on canvas. Courtesy of the Museo Óscar María de Rojas, Cárdenas City, Cuba.

ture in the Atlantic world. In his hand, Quiroga holds a scrolled piece of paper upon which one can make out in writing "Escovar fecit" (Escobar made it). The painter's depiction of Quiroga intimately clutching this paper bearing Escobar's name in proximity to Quiroga's seemingly ongoing work of a musical score unites the two men as artists of African descent in Havana. The work could even allude metonymically to the

upwardly mobile society of *libertos* and a pride in artistic achievements among this community.

Escobar's portraits of whites, or *españoles*, include that of Tomás Mateo Cervantes, whose oil-on-canvas portrait (c. 1800) represents the man in formal dress against a background of red drapery with a suspended tassel (fig. 2.10). A white lace cravat contrasts the darkness of his coat; against his hip rests a sword, a conventional element of Euro-American elite portraiture. At the top left of the canvas, a family coat of arms identifies him as a member of the titled nobility, and a horizontal band of text along the bottom of the painting articulates the sitter's identity and achievements. Both of these elements, coat of arms and text, are missing from Escobar's portrait of the musician Jackes Quiroga. This difference may stem from the fact that Quiroga subverted the paradigm of *limpieza de sangre* or that his relative lack of Spanishness meant that his family lacked a prestigious title. However, Quiroga's portrait possesses much more intimacy and immediacy as a result, by comparison with that of Mateo Cervantes, which again might derive from the social links between artist and subject.

An initiative to found an academy of visual arts in colonial Cuba, in concert with the royal academies of Spain or the Royal Academy of San Carlos of Mexico City, began in the early nineteenth century. In 1813, Pedro Abad y Villarreal, *catedrático interino* (temporary professor) of mathematics at the Seminary of San Carlos in Havana, proposed to the captain general the establishment of an "Academy of Architecture," appropriating the idea of the academy as a national, state-sponsored, and reformist institution to stress its importance for Havana. He writes, "The object of the fine arts of design is the imitation of beautiful nature" and that architecture should be based on "the elegance and simplicity of the character of the three orders of Greek architecture."[123] He stressed that the establishment of such an academy would not only have a beautifying effect on buildings of all classes but also produce knowledge that would benefit other areas of concern to the Crown, including agriculture, industry, and commerce.

In his proposed plan of study for this academy, Abad y Villarreal proposed courses in Arithmetic, Geometry, and "drawing of the five orders, Tuscan, Doric, Ionic, Corinthian, and Composite."[124] His language betrays a reliance on Vitruvius's *Ten Books on Architecture*, a translation of which was produced by José Ortiz y Sanz in Madrid in 1787. Abad y Villarreal

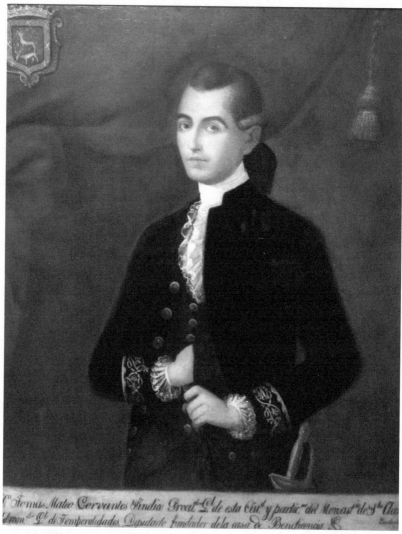

2.10 Vicente Escobar, *Portrait of Don Tomás Mateo Cervantes*, c. 1800. Oil on canvas. Courtesy of the Daytona Beach Museum of Arts and Sciences, Daytona Beach, Florida.

stresses the use of appropriate materials, economy of practice, and distribution of interior and exterior spaces according to *las reglas* (the rules). He recommends above all that students learn the maxims of the "good architects . . . *commodity*, *strength*, and *beauty*."[125] These values, which Abad y Villarreal firmly underlines in the document, are drawn from Vitruvius's treatise. Abad y Villarreal's invocation of them speaks to the cultural

authority that Vitruvius had begun to assume in matters of architecture in Cuba as in many parts of the Atlantic world. His case also provides an example of Creole elites petitioning the colonial governor for an academy of visual arts, rather than one being imposed from above by royal officials in the Americas or Spain.

While Abad y Villarreal's proposal for an academy did not come to fruition, the arrival in Havana of a French academic painter in 1815 paved the way for the founding of the first drawing school in the city. Amid the socioeconomic changes in Cuba brought about by the sugar industry, and in the wake of the revolutionary war and the first colonial empire period in France, Jean-Baptiste Vermay arrived in Havana from Louisiana in 1815.[126] A French painter formerly in the service of the Napoleonic state and a student of Jacques-Louis David, Vermay fled France after the emperor's defeat at Waterloo. Under Napoleon, he had worked in portraiture and history painting, exhibiting in the Parisian Salon of 1808, 1810, 1814, and 1815.[127] As Perovani had left for Mexico, Bishop Espada commissioned Vermay to finish the frescoes in the cathedral.

Soon after his arrival, the Economic Society, headed by Spanish Intendente Alejandro Ramírez, appointed Vermay as director of a new drawing school in 1818. This school would fulfill Campomanes's prescriptions for the empire and impart the very skill that the Havana elite increasingly thought lacking in colonial painting. It would eventually be known as the Academy of Drawing and Painting of San Alejandro, after the intendant. As an academically trained artist, Vermay considered drawing foundational to the more noble practice of painting. Early classes at San Alejandro were held in the Convent of St. Augustine, and instruction of students was supplemented by rigorous public examinations.[128] Ten years after the academy opened, the results of one year's exams were recorded by Ramón de la Sagra: "The 8th day of this month [July 1828], we have observed the progress of the pupils of drawing, under the direction of the industrious Señor Vermay: nothing is left to be desired with respect to the exactitude of the copies, the smoothness in the handling of the pencil, the intelligence in the disposition and in the tone of the shadows; indubitably capable youths will emerge from this academy, qualified to make useful applications of drawing."[129]

From the perspective of the elite public in Havana, the Academy of San Alejandro represented a needed improvement in the fostering of *buen gus-*

to in the city. However, the provocative 1831 essay by the Cuban professor José Antonio Saco raises questions about perceptions of the academy as a bastion against the dominance of *libertos* in the visual arts. In Saco's essay "The Arts Are in the Hands of the People of Color," the author argues that "among the enormous evils that this [African] race has brought to our land is that they have alienated our white population from the arts. In this deplorable situation," he continues, "no white Cuban could be expected to devote himself to the arts," because the mere fact of embracing them was taken to mean that he renounced the privileges of his class.[130] Saco, therefore, argues that cultural modernity would only come with the whitening of the arts and frames the issue as a conscious struggle for cultural control. Such sentiments suggest an elite society of self-conscious *ilustrados* (enlightened ones) in Havana who increasingly defined *buen gusto* as academic art based on a system of drawing, and identified popular painting as a foil associated with people of African descent. These conditions also suggest that in addition to considerations of secular and religious reform, it is impossible to fully understand late colonial classicism in visual and other forms in Havana without considering the racial politics of a nineteenth-century slave society in the wake of the Haitian Revolution and the rise of the sugar industry.[131]

The crisis of cultural authority felt in Saco's writing can be seen as related to a more comprehensive agenda to offset the rising population of African descent in Cuba. As early as the 1790s, the plantocracy in Havana grappled with ways to manage the human contradictions of the sugar industry: a need for increased African slave labor and a concern for the growing number of Africans on the island. Unabashedly, they sought to undo the privileges bestowed on people of African descent in Cuba by Charles III after the Seven Years' War.[132] Saco's writing suggests a desire by members of the Havana elite to actively separate white and black cultural spheres, to rationalize race, and to define *buen gusto* as an exclusively white domain with Greco-Roman revival classicism as its primary referent.

The academy adopted admission standards in concert with the Economic Society's racial concerns. In 1817, the Society negotiated admittance in ways that foreshadowed Saco's later essay:

The need was discussed to establish a set of rules, which would guard us against the inconvenience of having to admit all kinds of students: they

must all be white, of known parents, and they must have a good education. Our friend Duarte took this occasion to insist on the backwardness of the arts and crafts in our country, a fact which he attributed to the abuse they have suffered at the hands of the colored population; once in the hands of the colored population, the arts and crafts were abandoned by the white population because they did not want to enter into contact with the colored population.[133]

This passage likewise alludes to the perceived dominance of people of African descent over the visual arts in late colonial Cuba and a concerted attempt by the Havana elite to separate white and black artistic production by founding a drawing school. To put these designs into perspective, it should be noted that the Royal Academy of San Carlos in Mexico City allowed Indian artisans to receive instruction in drawing during night classes.[134] At the Havana academy, the strict prohibition against racial others receiving any drawing instruction at all speaks to the intensifying racial discrimination of an early-nineteenth-century plantation society in the Spanish Caribbean and the efforts to find a visual language to represent its interests.

Jean-Baptiste Vermay's *Portrait of a Man* (1819), oil on canvas, demonstrates departures in conventions and aesthetics from the work of Escobar (fig. 2.11). In this portrait, Vermay eschews the coat of arms and drapery in favor of a picture of the sitter holding a book in a contemplative pose. Lacking the outward pomp and posturing of comparable portraiture in Havana, this image of an anonymous man presents a cultivated and moderated individual, emphasizing his inner, intellectual world of knowledge and reason. The glowing light, the man's casual pose and ruffled hair, and his white skin are attempts to indicate a thinker, one whose virtue and social status come from merit rather than noble titles, and from self-cultivation rather than outward performance. Vermay's portrait perhaps captures both the reformist values the artist brought to Havana from France and those that had begun to take root in the city.

If Vermay's portrait captured the modernity of its sitter by appropriation of French conventions of "natural" representation in portraiture, we can perhaps consider that it was informed by and functioned within social developments in early-nineteenth-century Havana as recorded by the colonial press. As subscribers to local newspapers negotiated the urban spaces of the city, they received information in the press about behav-

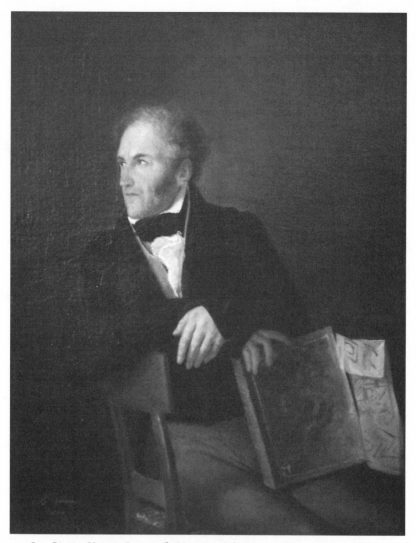

2.11 Jean-Baptiste Vermay, *Portrait of a Man*, 1819. Oil on canvas. Courtesy of the Museo
Nacional de Bellas Artes, Havana, Cuba.

ioral etiquette in various social spaces. The *Papel Periódico* of September 18,
1800, featured an article on the Coliseo, a theater on the Alameda de Pau-
la built at the end of the eighteenth century. The story instructed theater-
goers on acceptable manners in the use of the space. Orchestra seats,
for example, were designated for "persons of distinction," requiring that
one wear one's military outfit as a sign of status.[135] The theatergoer would

regard theatrical performances with "silence and composure," only conversing during intermission. Attendees were prohibited from communicating with actors on stage by either words or signs. No one should raise her or his voice during performances; and anyone caught disturbing the tranquillity and attention of the theatrical proceedings would be arrested and conducted to the city jail.[136]

The *Papel Periódico* in the early nineteenth century promoted state-sponsored taste and tasteful living among an elite group of subscribers.[137] The paper published poetry that was read and discussed at *tertulias* designed to elevate attendees to the "rank of good taste."[138] Articles appear on customs and courtesy, instructing their readers on "the modern taste."[139] On March 29, 1801, the paper printed an article on living with restraint titled "Regulation of Life for the Men of Form," which asserted that "the men of form regularly have better judgment than others" and never go badly dressed or go out badly groomed because "talent is not found under a humble exterior."[140] Men of form had the obligation to be good gentlemen, regardless of their lofty reputations. They could have a library with shelves of exquisite mahogany and books bound of Moroccan leather so long as they dedicated themselves to "reading what the works contain."[141] This articulation of a "man of form" gave shape and behavioral prescriptions to the practice of reformist selfhood to subscribers of the *Papel Periódico*. Such social discourses capture the importance of visual appearance in public space, protocols for dress, and an emphasis on self-cultivation as required of a reformed city dweller. They also raise questions about the role of the state in reproducing desired subjectivities, social relations, and behaviors, as they question the ability of local societies to contest and negotiate these prescriptions, instead producing their own societies of taste.

Fashioning Heritage on the Colonial Plaza de Armas

Historians have named Bishop Espada as the driving force behind El Templete, the monument commemorating the site where, according to tradition, the Spanish conquistadors founded Havana under a ceiba tree in 1519. The Basque president in 1943, José Antonio de Aguirre, framed the work as a *jugarreta* (dirty trick) on Captain General Francisco Dionisio Vives. He suggested that in a subversive move, the bishop erected a reproduction of the legendary tree of Guernica in the Basque Country—a sign of regional liberty—to express his support for constitutionalism in Havana and his contempt for the absolutist rule of Ferdinand VII. Although the monument pays homage to the king through various signs, the "dirty trick" came with counterhegemonic rhetoric of civic and regional autonomy. This reading by itself, while part of the larger phenomenon, is narrowly conceived. Even if the bishop were the only patron responsible for the work, he would have possessed additional motives, such as promoting reformed piety, education, and local awareness of Cuba's unique history within the Spanish Empire, as well as Masonic agendas. Yet Espada was not the sole patron. In fact, he seems to have financed only the paintings. The architectonic and sculptural elements were partially paid for by the Spanish state under the authority of Captain General Francisco Dionisio Vives, who invited a group of Havana elites to supplement the cost. We can interpret this

effort, to some extent, as another example of an institutionalized civic gesture: a monument mediated by the state, directed toward public education, and supported by donations from the civic elite. Yet there was much more at stake here in terms of the reshaping of collective memory via architecture, image, and space. Members of church, state, and elite were performing heritage work on the site, reusing the past to support identities in the present and to negotiate a complex and contradictory situation in 1828.

This making of heritage on the colonial Plaza de Armas in 1827–1828 must, therefore, be situated within the development of a complex late colonial modernity in Cuba. That is, the work came into being in the midst of transformations that suggest the emergence of a community of elite, pro-reform individuals who had begun to seek collective self-representation. This type of late colonial self-fashioning seems to have compelled the appraisal of heritage resources in Cuba in concert with developments in the broader Spanish world. Yet Cuba's persistent loyalty to Spain in the first half of the nineteenth century complicates this search for a local heritage. What could images of Indians, conquistadors, and ceiba trees signify in Cuba during this period if heritage served church, state, and elite? I submit that this question is not easily answered by recourse to Creole patriotism. While Creoles surely understood the notion of patriotism in this period in local ways, they were actively collaborating with Peninsulars to the benefit of both parties. Fears of slave insurrection and phobias over the growing number of Africans in the city impacted the ideas and behavior of all elite whites. Creole elites, furthermore, imagined themselves through the imperial veil: they were part of the fabric of empire as well. Peninsulars in turn responded to the Cuban setting and negotiated its culture and space in their own ways. The anthropologist Aihwa Ong has advanced the idea of "flexible citizenship," and it is one that appears useful to understanding the complexities of empire and locality in Cuba at that time. She defines the term as "the cultural logics of capitalist accumulation, travel, and displacement that induce subjects to respond fluidly and opportunistically to changing political-economic conditions."[1] This construction of heritage at Havana's foundational site cannot be laid at the feet of any one individual or group. It was the product of late colonial society in Havana and registers multiple opportunistic negotiations and constructions of the present by recourse to an imagined past.

THE CEIBA TREE IN THE CUBAN
CULTURAL LANDSCAPE

This making of heritage out of Havana's foundational ceiba tree requires a serious look at the history of this type of tree as a symbolic resource. Early encounters between Europeans and the American landscape became important moments whereby nature was inscribed into European colonial discourses. As Neil Evernden has argued, such encounters between humans and nature led to nature's socialization, the "social creation of nature" whereby natural objects take on human significances.[2] No period evidence exists to conclusively validate that the Spanish conquistadors held the first Christian Mass and *cabildo* of the city under a ceiba tree on the site of what would become the main plaza of Havana. Rather, for the purposes of this study, I argue that this symbolic ceiba is the transcultural product of the pre-Hispanic and early modern Caribbean. Because of the tree's multivocality and wide appeal, it became an ideal heritage resource for patrons on the plaza in the 1820s.

The scientific name *Ceiba pentandra* and the more colloquial designation "silk-cotton tree" or "Kapok tree" refer to an arboreal species with fibrous threads in its seedpods and a large swollen trunk used as a means of storing water in dry areas.[3] The ceiba tree grows equally well in the Americas, Africa, and Asia, with some geographical variation. On open savannahs, the trees can reach a great vertical height, while near forests, ceibas often develop lower, spreading branches. Ceiba trunks can be thorn covered or smooth and are often buttressed, more or less, by roots. The ceiba easily adapts to aquatic situations and often grows equally well near the edges of streams, rivers, and other bodies of water. Ceiba wood is soft and coarse and does not seem to have acquired much commercial value for the Spanish during the colonial period.[4]

Some of the earliest textual information on human uses of ceiba trees in Cuba and the Caribbean comes from the work of early Spanish chroniclers. In 1494, Spaniards on the island of Española, or Hispaniola (modern Haiti and the Dominican Republic), described trees bearing "wool," a possible reference to the "silk-cotton" threads of ceiba seedpods. The word *ceiba* may have come from a Taíno word, adopted by the Spanish for "canoe," as whole trunks were hollowed out by Amerindians and used to make multiperson boats.[5] Gonzalo Fernández de Oviedo y Valdés (1478–

1557), a historian and colonial governor of Santo Domingo, informed the Spanish king of various arboreal species in his *Natural History of the West Indies* of 1526. Fernández de Oviedo noted a general category of "big trees" with similar features to the ceiba. He wrote that Indians carved out large trees to build *canoas* (dugouts) big enough to carry multiple men. His text describes a specimen with "three roots or parts in the form of a triangle, something like a tripod . . . the three tremendous trunks or feet came together and formed a single tree or trunk. The lowest limbs of the tree were higher than the tower of San Román of the city of Toledo."[6] Fernández de Oviedo supplies a drawing in his text near the description of a "tripod tree" (fig. 3.1), perhaps the earliest visual representation of a ceiba by a European in the Americas. The drawing depicts three roots rising to a long vertical trunk, surrounded by a continuous vine and supporting branches that fork outward at the top. Among other early Spanish chroniclers, José de Acosta included "the cedros [cedars], and ceibas" as some of the "great trees of the Indies" in his *Historia natural y moral de las Indias* (1590). As does Fernández de Oviedo, Acosta specifies that they were "ceibas out of which the Indians carved *canoas*, which are boats made of one piece."[7]

Spanish chroniclers captured how prominent trees in the Caribbean had supernatural significance and uses for Amerindians. Fray Ramón Pané, in *An Account of the Antiquities of the Indians* (completed in 1498), reported how the indigenous people of the Antilles made *zemis* (representations of gods) out of tree wood. The process began with subjective interactions between humans and trees, whereupon a large tree "instructed" a Native man to summon a *behique* (shaman, medicine man, or religious specialist). The *behique* arrived and prepared *cohoba* (a psychoactive plant concoction) for the tree, at which point, Pané relates, the tree "turned into an idol or devil."[8] The shaman then cut the tree down and fashioned it into a sacred statue, a *zemi*. The site of this event became a sacred space thereafter, and the *zemi* was placed into a house fashioned for the site, which became a votive shrine. People made pilgrimages to the shrine, whereupon the village lord would use the *zemi* sculpture as a divining tool to predict victories over enemies and other future events.[9]

Spanish colonizers may have appropriated the ceiba tree based on its significance to Amerindian religious beliefs, spatial practices, or urban planning during the process of colonization. The Taíno and Ciboney in Cuba left few architectural remains and suffered decimation by conta-

¶ Aruoles grandes. Cap.lxxviij.

¶ En tierra firme ay tan grandes aruo
les que si yo hablasse en parte que no ouiesse tantos testigos de
vista/con temo2 lo osaria de3ir. Digo que a vna legua del Da-
rien o cibdad de scã Maria del antigua passa vn rio harto ancho z muy
hondo que se llama el Cuti z los Indios teniã vn aruol gruesso atrauesi-
sado de parte a parte / que tomaua todo el dicho rio / po2 el qual passa-
ron muchas ve3es algunos que en aquellas partes hã estado que ago-
ra estan en esta co2te/z yo assi mismo. El ql era muy gruesso z muy luen-
go z como dias auia que estaua alli / y vase aba2ando

enel medio dl/z avn que passauan po2 encima/era en vn
trecho del/dãdo el agua cerca dela rodilla. Po2 lo qual
ago2a tres años enel año de.M.d.xxij.seyendo yo justi
cia po2.U.M.en aquella cibdad bi3e echar otro aruol
poco mas ba2o del suso dicho/que atrauesso todo el di-
cho rio z sob2o dela otra parte mas de cincuenta pies/z
muy gruesso z quedo encima del agua mas õ dos codos
z al caer que cayo derribo otros aruoles z ramas delos
q estauã del otro cabo y descub2io ciertas parras delas
que atras se hi3o menctõ de muy buenas huuas negras
delas quales comimos muchas/mas de cincuenta hom
b2es q alli estauamos. Tenia este aruol po2 lo mas grue
sso del mas de die3 z seys palmos/po a respecto de otros
muchos que en aquella tierra ay/era muy delgado/po2
que los indios dela costa z puincia de Cartajena ba3en
Canoas q son las varcas en que ellos nauegan tan grã
des que en algunas van ciento/z cieto z treynta hõb2es
y son de vna pieça z aruol solo: y de traues al ancho de-
llas/cabe muy holgadamente vna pipa o bota quedan
do a cada lado õlla lugar po2 do pueda muy biê passar
la gente dela canoa. E algunas son tan anchas q tienen
die3 z do3e palmos de ancho:z las traen z nauegan con
dos velas/q son la maestra y õl triquete. Las quales ve
las ellos ba3en de muy buen algodon. ¶ El mayo2 ar-
uol que yo he visto en aquellas partes ni en otras/fue en
la p2ouincia de Guaturo / el Cacique dela qual estan-
do rebelado dela obidiencia y seruicio de.U.M.yo fuy
a buscarle y le p2ndi/z passando cõ la gête q comigo yua
po2 vna sierra muy alta z muy llena de aruoles /enlo al
to della topamos vn aruol entre los otros/q tenia tres

gious diseases, overwork, and extermination; those who survived remained on the margins of Spanish settlements or took refuge in the uncolonized areas of the island.[10] Spanish utilization of Amerindian views of the ceiba's significance as a colonial practice could have taken place at religious and political levels. As the Taíno found the tree to be an intermediary between humans and the divine, from the Spanish perspective, various aspects of the ceiba may have evoked the Passion of Christ, including the spines of the tree's trunk, the pinkish-white wood, and its branching patterns that often form a cross shape. Samuel Edgerton has described such Spanish practices as "expedient selection," the active choosing of certain items or aspects of two religious systems that form convenient parallels that can be used to facilitate the conversion of the dominated group to Christianity or the acceptance of Spanish rule.[11]

In terms of political appropriations of the ceiba by Spanish colonizers in general, the tree appears in the conquest narrative of Bernal Díaz del Castillo, the writer who followed Hernán Cortés in his assault on the Aztec civilization. The author recounts the Spanish use of the tree as a means of taking possession of lands around the indigenous village of Champotón: "Then Cortés took possession of that land for the King, performing the act in His Majesty's name. He did it in this way: he drew his sword, and, as a sign of possession, *made three cuts in a large silk-cotton tree which stood in that great courtyard*, and cried that if any person should raise an objection he would defend the King's right with his sword and his shield, which he held in his other hand" (emphasis added).[12] Just as indigenous rulers politicized the ceiba by using it to mark a central area of Champotón, Cortés appropriated the tree as an act of colonization with spatial significance. Inscribing it with three cuts, of possible religious significance, the conquistador claimed not only the tree but also the area around it, the indigenous polity, subjugating it to the king's authority.

Elsewhere in Central America, the use of the ceiba tree in Mesoamerican religion and politics is well documented among the Maya, who held the tree to be sacred. The Maya viewed the ceiba as a physical manifestation of the Wacah Chan, an axis bridging the watery underworld to the terrestrial sphere and, ultimately, to the upper heavenly regions.[13] Hence the Maya planted the ceiba tree or pieces of it at ceremonial sites or in the center of cities and settlements. The historian Enrique Polonsky Celcer claimed the Spanish quickly adapted the ceiba to colonial town plan-

ning in Central America, citing a royal mandate: "The ceiba appears in our history as founder of towns; under the spell of its branches the people gathered and its extensive shade opens the limits of the public plazas; one could say it is the first building, the center of the community, and for that reason, Carlos V dictated a decree that towns should be founded around a ceiba, knowing that it gathered people and traditionally protected the markets."[14] Indeed, the Spanish use of trees in town founding, situating them in the main plaza of the nascent settlement, in Iberia and the Americas may represent a larger pattern. The geographer Kit Anderson argues that ceibas became "plaza trees" in colonial Guatemala for multiple reasons: to provide shade and as acts of appropriation due to the ceiba's pre-Hispanic associations. When the Spanish forcefully relocated the indigenous villagers of Jocotenango, for example, to the new colonial capital of Guatemala City in 1769, Spanish authorities planted a ceiba in the new location. Later, the tree became the focus of the annual festival of the town, as the indigenous people transformed it into an altar.[15]

In early colonial Cuba, the first set of municipal ordinances in use by the Spanish indicate the presence of the ceiba tree in the central plaza. The Ordenanzas de Cáceres of 1573 state that African slaves caught carrying weapons would, upon the second offense, have the weapons confiscated and be given "twenty lashes at the ceiba or picota or at the door of the jail."[16] The significance here is that the options given for using a ceiba tree, a *picota* (a public post in a Spanish colonial plaza for the punishment of criminals), or the door of the jail for corporal discipline is combined with the fact that these ordinances were intended for many towns. It suggests the possibility that numerous Cuban colonial towns had ceibas in their main plazas and that they were sometimes used as sites for public punishments, particularly for punitive measures against blacks. The Ordenanzas de Cáceres at least suggest a colonial urban pattern of ceiba trees on plazas in Cuba that dates to the sixteenth century.

This passage of the early civic ordinances also raises questions about the importance of the ceiba tree itself to populations of African descent in Cuba, based on the integral presence of Africans and their descendants in Cuban colonial history and the significance of the sacred tree tradition as found in the literature on the African Diaspora. In West Africa, the Yoruba people venerate a formidable tree known as the *iroko*, often considered the African teak tree. They consider this tree as an object

endowed with supernatural power, or *asé*. Diviners and shamans visit the *iroko* to foretell the future or to ask favors or solicit curses, as the tree is considered a deity, or *òrìsà*.[17] According to the anthropologist Alma Gottlieb, the Beng culture of West Africa highly reveres the ceiba tree and uses it to define town centers and the courtyards of a village chief's house.[18] Thus, some new African arrivals in Cuba could have been preconditioned to seeing ceibas or prominent trees as sacred objects and as indispensable within an urban landscape.[19]

In her 1954 book *El monte*, the Cuban anthropologist and folklorist Lydia Cabrera devotes an entire chapter to the ceiba tree and its spiritual and cultural significance to the various Afro-Cuban "informants" she interviewed. In these accounts, Cabrera recorded beliefs of both Yoruba and Congo origin. While numerous Afro-Cubans of Yoruba descent considered the ceiba a saint and closely related to the *iroko* (a tree deity) in Africa, those of Congo descent referred to the tree as *nkunia casa Sambi* (tree house of God).[20] These findings, which will be examined further in chapter 5, suggest that incoming African slaves were active remakers of social spaces in their appropriation of natural and cultural landscapes in the Americas as a means for cultural survival, empowerment, and the negotiation of Spanish power structures. They also suggest that Africans and their descendants in Cuba were active contributors to the collective significance of the ceiba in colonial Cuba—an even more complex heritage process that will be addressed later.

URBAN COMMUNITY AND CIVIC MEMORIALIZATION

A 1691 drawing of a section of Havana by Juan Síscara depicts a large tree on the east side of the Plaza de Armas in the general location where the symbolic ceiba tree stands today (fig. 3.2). Síscara does not cite the tree in the legend for his plan. However, the tree's singular presence (there are no other trees depicted) in proximity to important buildings, such as the Castillo de la Real Fuerza (called Castillo de Fuerza Vieja in the legend to the plan), the main parish church, and various civic structures, draws attention to the tree as a feature of the main plaza. Indeed, its denotation here might relate to the pattern of "plaza trees" identified from early Spanish colonial times by the cultural geographer Kit Anderson. Thus the plan at least suggests the

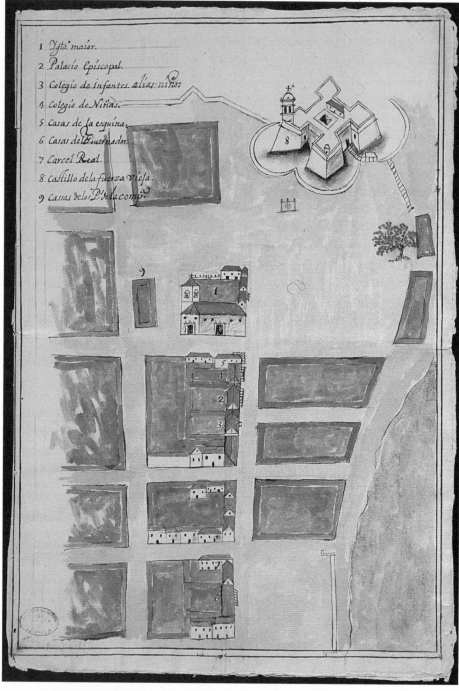

1 Ygła maior.
2 Palacio Episcopal.
3 Colegio de Infantes. alias: niños
4 Colegio de Niñas.
5 Casas de ła esquina.
6 Casas del Gouernador.
7 Carcel Real.
8 Castillo de la fuerza vieja.
9 Cassas de los P. de la comp.ª

3.2 Juan Síscara, plan of the section of the City of Havana corresponding to the Old Fortress and houses of government, 1691. Courtesy of the Archivo General de Indias, Seville, Spain.

presence of a tree in this location in the 1690s, which begs the question of whether or not the city's foundational narrative existed at this time.

By the late eighteenth century, Cuban historians, such as José Martín Félix de Arrate, had inscribed this narrative into the history of the island (see quote from him in introduction, n. 28). Arrate refers to a memorial stone erected by Captain General Cagigal de la Vega in compensation for ordering the ceiba tree removed, as its roots compromised the nearby fortification wall.

For the 1754 monument, the anonymous sculptor crafted a stylized ceiba in a triangular pillar that begins in a circular base, giving rise to a vertical stone shaft (see fig. I.2). Three stone volutes, imitating the ceiba's buttressed trunk, are situated beneath an entablature followed by three more volutes and the primary axis. A small entablature crowns the pillar supporting a statue of the Virgin and Child (fig. 3.3).[21] The curvilinear stylistic features along the pillar's shaft and its religious consecration of the site of historical events situated the work within the familiar baroque language of emotive forms and divine explanations already extant in the city.

Near the pillar's base, a sculptural relief of a tree with no leaves appears within a rectangular framework (fig. 3.4). This relief image, in its simplified forms, resembles Fernández de Oviedo's sketch from the early sixteenth century in its three conspicuous roots. If his sketch provided a model for this later sculptural relief, it suggests an effort to appropriate the stuff of the early conquest era to lend a deeper sense of historical authenticity to the site.

If the icon of the ceiba without leaves seems suggestive of a tree's death, it would represent a theme appropriate to Cagigal's memorialization of the felled tree. Yet there may have been additional agendas at work related to seventeenth- and eighteenth-century discourses concerning the loss of the Cuban forest. By the 1750s, the area surrounding Havana had become heavily deforested due to the timber requirements of the Crown's shipbuilding industry and the need for wood fuel to fire boiling houses on sugar plantations. Captain General Cagigal de la Vega advanced conservation efforts during his administration by limiting the harvesting of large trees and mandating that where trees were removed others should be replanted. The governor advised strongly against the "abuse of the forests" and attempted to curtail the excessive consumption of wood by local farmers.[22]

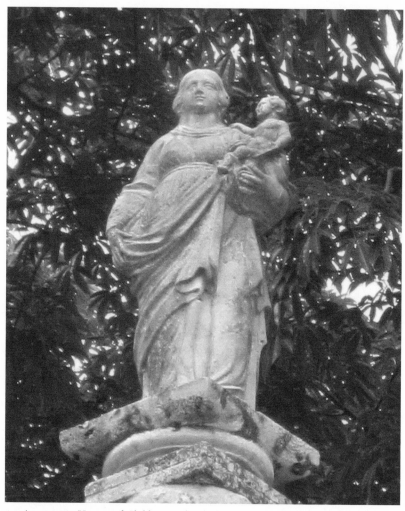

3.3 Anonymous, Virgin and Child statue, detail of ceiba tree memorial, 1754. Plaza de Armas, Havana, Cuba. Photograph by the author.

While Cagigal's report mentions the scarcity of such tree species as *cedro* (cedar), *sabicú, caoba* (mahogany), *yaba, chicharrón*, and *ocuje*, he did not specifically refer to the ceiba.[23] Perhaps its absence from this discussion owes something to its relative nonexistence in Spanish colonial commercial enterprise. In a trip to the Havana-Matanzas district in 1828, the traveler Abiel Abbot wrote that the ceiba was primarily used for ornamenting the landscape. He noted that "almost every estate reserves one or more of

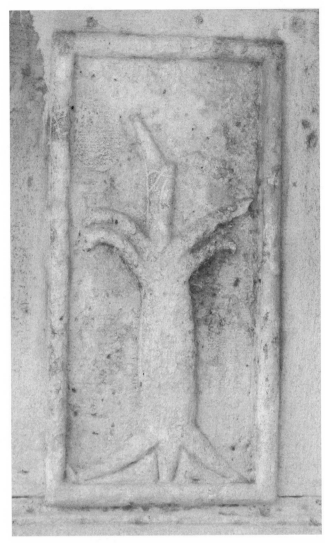

3.4 Anonymous, ceiba tree relief, detail of ceiba tree memorial, 1754. Plaza de Armas, Havana, Cuba. Photograph by the author.

these trees, in some favorable situation to gratify the eye." Beyond its beauty, Abbot noted, "it answers no other human purpose, it is neither timber nor fuel. The cotton, however . . . which it yields in a very scanty crop, is sometimes used to stuff a pillow."[24]

Even if the ceiba was absent from the deforestation controversies of the 1750s because of its limited use, Captain General Cagigal de la Vega ordered three young ceibas planted in the Plaza de Armas to flank the

new pillar of 1754.[25] The new trees must have modeled the replanting mandates in the Havana-Matanzas district and served to green the plaza. This installation of the trees and the sculpture also created an early heritage monument to the tree, a deliberate use of the seemingly imagined past to promote civic solidarity and the governor's prestige. To recondition the knowledge of the historic site, detailed inscriptions in Latin and Spanish were mounted on the pillar to educate audiences on the historical narrative.

While a broader range of contemporary conditions in 1754 that might have informed the construction of a heritage monument are more or less obscure, the existence of the memorial suggests the development of relationships between history and collective memory on the plaza by this time. The archaeologist Tadhg O'Keeffe frames history as a narratological construct that supplies an alphabetic line, which locates the past within the larger domain of memory.[26] "[C]ollective memory is always historical (or narratological) and is always the product of some program of being-reminded. . . . [We] have no collective capacity to share memories that are not in some way externally programmed for us."[27] Considering civic monuments as the discursive construction of memory suggests that heritage is a process of writing, rewriting, or negotiating the past in the production of collective memory in the present, rather than merely serving as a representation of memory or a mnemonic aid. The effort to reshape memory is one that aims to produce a received heritage that will underpin certain identities in the present. The 1691 Síscara plan alludes to the possibility that the ceiba tree foundational story was operative at the end of the seventeenth century in forging place identities, narratives of belonging to the plaza, the city, and the island by virtue of a constructed connectedness to an imagined past. The Spanish governor surely memorialized the site for his own purposes, to insinuate himself into a local memory. Did Cagigal de la Vega introduce the ceiba tree narrative or capitalize upon and reshape an extant memory? If the latter, and as O'Keeffe emphasizes, any lingering memories regarding the significance of this site underwent a narratological revision in 1754, whereupon perhaps diffuse associations were given greater specificity or sharper focus through a politically oriented reformulation via sculptural devices, texts, and performances.

This construction or reshaping of collective memory in Havana in 1754 took place not only within a local setting but also within the larg-

er cultural matrix of the Spanish world. In particular, the inclusion of a statue of the Virgin and Child atop the 1754 pillar seems to have been an appropriation of one of Spain's most venerated devotions, Our Lady of the Pillar in Zaragoza. According to legend, St. James the Greater, one of the Twelve Apostles of Christ, was preaching the Gospel on January 2, AD 40, in today's Zaragoza, then pagan Caesaraugusta. As he prayed in despair by the banks of the Ebro River, the Virgin Mary miraculously appeared to James and his group and gave him a column or pillar. The pillar, carried by angels and surmounted by an image of Mary, marked the site where James was to found a chapel, a place to house the pillar and the Virgin's image thereafter. The Basilica of Our Lady of the Pillar in Zaragoza represents the entrance of Christianity into Spain. Thus the icon of the Virgin on the pillar already carried important foundational associations for audiences in the Spanish world and could have worked to valorize events in Cuba by conflating them with the origins of Spanish Christianity. Francisco de Goya y Lucientes (1746–1828) appropriated this Marian devotion in more than one painting of the subject, including a work in the Museum of Zaragoza finished by 1774 (fig. 3.5).[28] As eighteenth-century academies sought to explore Spain's unique history within the more universal narrative of Greco-Roman antiquity, Havana seems to have been in the practice of co-opting established devotions in Spain to validate its own distinctive past.

By November 18, 1827, workers had begun a project to restore the ceiba memorial of 1754 and to construct a new monument. The effort was apparently to "clear the wood huts that hid [the pillar of 1754], having a very bad effect on the view in such a principal place."[29] Captain General Francisco Dionisio Vives (r. 1823–1832) emphasized the geometry that would govern the new memorial to the ceiba tree, "after having thought very carefully about what would be the most appropriate way to make a monument of noble architecture, worthy of the object [the 1754 pillar and/or the ceiba tree] and of cultured Havana."[30] Vives sent approval to the *ayuntamiento* of the designs for the new monument drawn by his secretary, Antonio María de la Torre y Cárdenas, yet no such plans have surfaced in the archives of Spain or Cuba.

Although little documentation has come forward that would reveal private or official discussions of the work, certain public transcripts do exist, including the description that the captain general ordered released in the

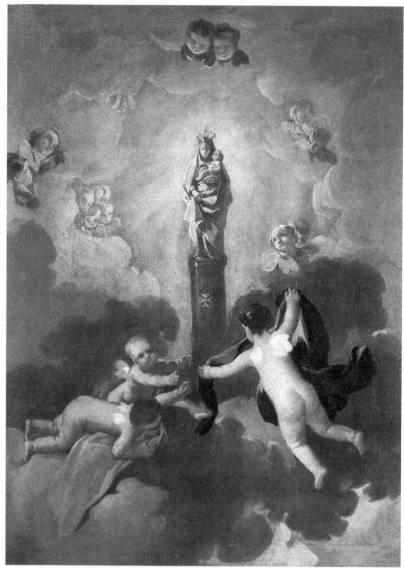

3.5 Francisco de Goya, *The Virgin of the Pillar*, 1774. Oil on canvas. Courtesy of the Museo de Zaragoza, Spain.

Diario in November of 1827. The "obelisk" of 1754 would be respected, "conserving its old form absolutely" and its inscriptions, the governor reassured the public.[31] Behind the older monument would be erected "a portico with its pediment, supported by six columns of the Doric order of six

varas in height [16.5 feet]: in the frieze among the triglyphs and metopes, attributes of the Royal American Order of Isabel the Catholic will be sculpted."[32] This temple-like structure described by Vives today occupies a rectangular space enclosed by iron railings and gates supported by stone pillars (see fig. I.1). Each pillar carries stone spheres on pedestals with larger piers topped by stone urns at each corner, and these urns each support cast bronze pineapples (fig. 3.6). Yet the monument we see today differs markedly from that completed in March of 1828. In the mid-nineteenth century, when O'Reilly Street was broadened to accommodate the expansion of military barracks in the vicinity, the monument was scaled back and the rectangular perimeter fence was substantially reduced.[33]

A nineteenth-century image by the French printmaker Pierre Toussaint Frédéric Mialhe depicts something of El Templete's original appearance prior to the remodeling (fig. 3.7). The visitor would have entered the rectangular space from the west through a gateway inspired by the form of the Roman triumphal arch. The archway defined the central axis, on line with the 1754 pillar, of a symmetrical and geometrically determined space. Directly across a rectangular green or garden space, embedded on axis into the eastern wall, the small Greco-Roman revival portico fronting a quasi-cubical building faced the gateway; it was 11 varas (c. 30 feet) high from base to the top of the pediment and 12 varas (c. 33 feet) across at the base. The temple-like structure sustained the linear clarity established by the other elements of the larger program.

The temple revival building, reminiscent of the chapel built for the General Cemetery of Havana, is set on a rectangular base approached by three shallow steps, which extended around the three sides of the portico, evoking the stereobate and stylobate of Greek temples (see fig. I.3). The unbroken entablature consists of twelve triglyphs and eleven metopes, with pointed guttae resembling arrowheads and sculptural relief emblems beneath each triglyph. The pediment contains a bronze plaque with dedicatory inscriptions, and six columns set on plinths support the entablature, with doubled columns at the lateral ends creating three prominent intercolumniations. The architect, Antonio María de la Torre y Cárdenas, designed three doorways situated symmetrically between the intercolumnar spaces.[34] The doorways, flanked by pilasters, possess simple door surrounds with minimal molding. The designer situated pilasters at each of the four corners of the outer wall, flanking

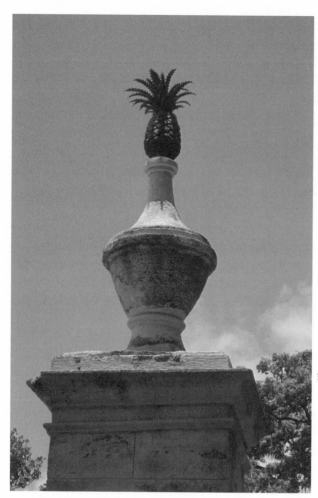

3.6 Francisco Mañón et al., cast bronze pineapple, 1827–1828. El Templete, Plaza de Armas, Havana, Cuba. Photograph by the author.

two lateral sidewalls consisting of flat, unadorned surfaces. A twentieth-century photograph in the Cuban Heritage Collection of the University of Miami Library illustrates that the entire memorial was likely white-washed during periods of its history to give it the appearance of antique marble (fig. 3.8). At its inauguration, this work would have been the most archaeologically correct revival of ancient Greco-Roman architecture within the city's *intramuros*.

The financing of El Templete reveals an attempt by colonial officials to return much of the cost to the elite residents of the main parish. While Captain General Vives pledged one thousand pesos for the project, the

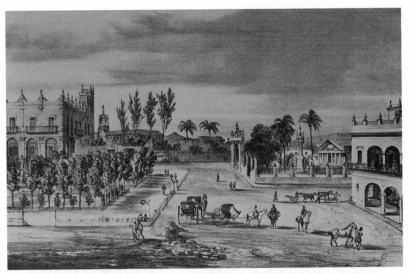

3.7 Pierre Toussaint Frédéric Mialhe, *View of the Templete and Part of the Plaza de Armas*, c. 1842. Lithograph. Courtesy of HistoryMiami, Miami, Florida.

city's *ayuntamiento* established a commission composed of Juan Montalvo y Castillo, Enrique Disdier y Síndico, and Narciso García de Mora with the object of "gathering the amounts with which well-to-do neighbors voluntarily want to contribute to make such a necessary work possible."[35] Vives made a statement expressing his confidence in the citizens' altruism: "[B]y the evidence that I have always received about the generosity of this neighborhood, I am counting on the fact that immediately the fourteen thousand pesos for the budget will be secured."[36]

As already seen in the Casa de Beneficencia commission and the General Cemetery, members of the elite public and wealthy citizens of Havana sought to demonstrate their civic-mindedness and concern for the public good via sponsorship of public works in a nascent system of institutionalized charity. In the case of El Templete, donors would also have the opportunity to have their donations made publicly visible via the colonial press. The official coordinator of the project, Spanish Regidor Francisco Rodríguez Cabrera, would direct the donated funds to a specific need in the new work. Each Monday from November 1827 until the monument's completion, the amount gathered from private residents and the purpose to which the funds were to be put would be "revealed to the public" in the *Diario*.[37] Private donors could thus receive recognition in a public forum of their

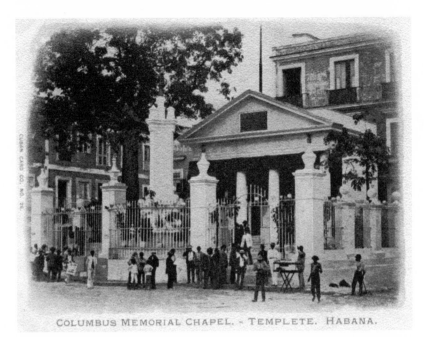

COLUMBUS MEMORIAL CHAPEL. - TEMPLETE. HABANA.

3.8 *Columbus Memorial Chapel—El Templete, Habana,* Cuban Card Co., no. 28, c. 1930.
Postcard. Havana, Cuba. Courtesy of the University of Miami Libraries Cuban Heritage
Collection, Coral Gables, Florida.

sacrifices for the common good and affirm their commitment to ostensi-
bly preserving civic memory in Havana. We can view this practice as a new
form of elite self-fashioning in addition to the possession of a townhome,
acquisition of noble titles, the construction of a chapel in the local church,
and the performance of charitable deeds in private. This form of institu-
tionalized giving for posterity earned the elite donor recognition within
the arena of the meritorious public.

This local recognition of one's civic commitment was overlaid with a
sign of fidelity to the Crown. The arch of the iron entryway possessed a
banner reading "The ever-faithful city of Havana." To visually construct
a message of Cuban loyalty, the arch included a coat of arms of the city
composed of a golden key flanked by three castles surmounted by a crown.
The tan patina of the shield and crown complemented the castles and
key, which were covered with smelted gold. Along the sides of the shield,
two bronze palms and two branches (one laurel and one olive) extended
upward from the mullion. This arrangement signified Havana's loyalty

within the imperial orbit, symbolically constructing both union and hierarchy. Private funds were expended to finance this casting, completed by Francisco Mañón, a local metalsmith and "natural" of Havana.[38]

The ceiba tree pillar of 1754, referred to in this case by Cabrera as "*la pirámide*" (the pyramid), had been restored and surrounded by several stone posts suspending an iron chain. A new inscription was added that ranked those responsible for the new monument and read: "Religion—Ferdinand 7—Escmo. Ayuntamiento—Vives—Espada—Pinillos—Laborde."[39] The mention of Pinillos referred to Cuban-born Claudio Martínez de Pinillos, conde de Villanueva (1782–1853), who occupied the important post of intendant in Cuba and replaced Alejandro Ramírez in 1821. By 1828, Pinillos had no doubt forged strong alliances with Creole planters.[40] A new image of Our Lady of the Pillar was fashioned to crown the older monument, replacing one of "Gothic character."[41] The emblems of the current administration officially stamped the pillar, shoring up the civic authority maintained between Captain General Cagigal in 1754 and Captain General Vives in 1828 and situating the older pillar within a new framework of taste. This retention of an older monument, the visual principles of which somewhat contradicted the newer one, is less significant in terms of artistic style and much more so in terms of heritage. Retaining the older pillar amplified the heritage expression by co-opting a tangible and phenomenological aspect of the past in support of claims in the present.

The sculptural program of the Templete's entablature brought together a number of signs that furthered the theme of union between Cuba and Spain. Emblems in the eleven metopes are contained within circular rings in stone relief. If read from left to right, the emblems consist of: (1) a bow and quiver of arrows; (2) a cursive *F* and the letter *o* in superscript, the abbreviation for "Fernando," or Ferdinand VII; (3) a crown uniting two orbs; (4) a bow and quiver of arrows; (5) a cursive *F* with an *o*; (6) a crown uniting two orbs; (7) a 7 and an *o* in superscript; (8) a bow and quiver of arrows; (9) a crown uniting two orbs; (10) a 7 and an *o*; and (11) a bow and quiver of arrows (figs. 3.9 and 3.10). In Cabrera's March 16 article in the *Diario*, he explained the crown and orbs as "two united worlds and a crown that embraces them" and wrote that the signs, when taken together, "symbolize our intimate and faithful union with the mother country."[42] Combining a bow and arrows (a long-established symbol of the New World), emblems of Ferdinand VII, and a symbol of the Old and New

3.9 Bow and quiver of arrows, detail of metope relief sculpture, 1827–1828. El Templete, Plaza de Armas, Havana, Cuba. Photograph by the author.

3.10 Crowned orbs, detail of metope relief sculpture, 1827–1828. El Templete, Plaza de Armas, Havana, Cuba. Photograph by the author.

Worlds united within a Doric frieze could be seen as authenticating Cuba's place within the Spanish Empire. Above the entablature, the pediment contained a gray-colored granite slab 2 1/3 varas (6.42 feet) long and 1 1/3 varas (3.67 feet) wide with an inscription in gilded bronze letters:

> Reigning the Señor Don. Ferdinand VII
> Being President and Governor
> Don Francisco Dionisio Vives
> The Most Loyal. Havana. Religious and Peaceful
> Erected this simple monument

Decorating the site where in the year *1519*
They celebrated the first Mass and cabildo
The Bishop Dn. Juan José Díaz de Espada,
Solemnized the same august Sacrifice
The 19th Day of March, 1828.[43]

The pediment plaque furthered the theme of Havana's loyalty and denoted the work's most powerful patrons as servants of the Spanish Crown.

TYPOLOGY AND EMBODIED SPACE

Interpreting the 1828 monument on the Plaza de Armas requires some consideration of the development of an early-nineteenth-century type known as a "*templete.*" This particular architectural typology appears to have lacked consistency in its definition in the Spanish world and may have been influenced by multiple sources, including oratories, small shrines, and other structures in early modern Europe and the Americas as well as eighteenth- and nineteenth-century civic memorials. The existence of small devotional shrines in medieval and early modern Spain could be associated with miracles, supplications for divine mercy, and other purposes.[44] In the royal monastery of Guadalupe, a small vaulted structure with a square-shaped plan occupies the main cloister in a central location with openings on four sides. Similar outdoor chapel-like buildings could be found in ecclesiastical enclosures in the early Spanish colonial Americas, such as the *posa* chapels built for early missions and embedded into the four corners of *atrios* (square ceremonial spaces before mission churches). These structures served didactic purposes in ritualized contexts with imagery along various sides interfaced by audiences under proselytization, providing space for priests to instruct indigenous neophytes (fig. 3.11). Open chapels served similar functions in the era of missionization, operating as outdoor oratories that were innovated, we believe, to accommodate an indigenous American propensity for outdoor worship.[45] These vaulted structures are typically found before open areas in which Natives would stand while awaiting baptism or listening to priestly sermons or instructions.

In colonial Cuba, *ermitas* (small devotional chapels) served to indoctrinate communities into the Christian faith. These structures could be where a permanent diocesan representative could not, sometimes occupy-

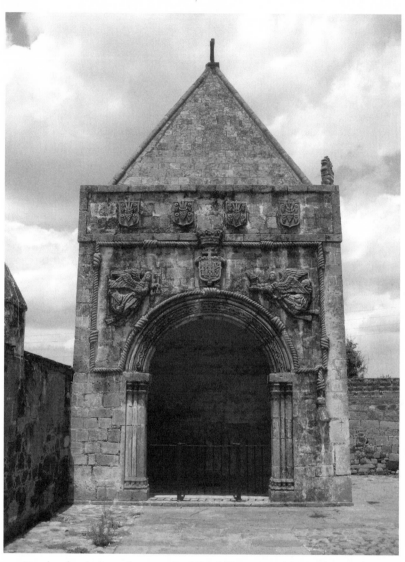

3.11 *Posa* chapel, early sixteenth century. San Miguel, Huejotzingo, Mexico. Photograph ©
Robert McIntosh.

ing extremely rural areas and attended by itinerant priests. *Ermitas* served African and Afro-Cuban communities and *barrios* (neighborhoods) throughout the colonial period, as the Crown required that all people of African descent in the empire, slave or free, receive baptism and be accepted into the Christian faith.[46] Thus, we can think that *ermitas* in Cuba carried significance for people of the lower social echelons.

The typology of El Templete was perhaps informed by this Iberian tradition of small devotional chapels or shrines. However, certain early modern conceptual paradigms in published form would also have been available to the monument's architectural designer. The Cuban military engineer Antonio María de la Torre y Cárdenas was born in Havana and promoted through the ranks of the Creole militias. He reached the level of coronel and served twenty years as secretary of the Superior Civil Government of the Island.[47] As an engineer in Havana, de la Torre worked as a draftsman, planner, and assessor, producing a number of drawings of the city in the service of Spanish administrators. He operated within a Spanish Empire that valued military engineers for the drafting and mathematical skills that made them valuable overseas, especially in coastal cities of geostrategic importance to the Spanish.

De la Torre does not appear to have traveled to Spain or Europe, likely training with local Spanish or Creole military engineers and gathering knowledge about the European classical tradition in architecture through contact with senior engineers, pattern books, architectural treatises, and prints.[48] By the early nineteenth century, a large volume of architectural drawings had been produced in both the Spanish and Mexico City academies. The catalogue, *La Academia de San Carlos y los constructores del Neoclásico: Primer catálogo de dibujo arquitectónico, 1779–1843*, exhibits some of the wealth of architectural draftsmanship undertaken at the Royal Academy of San Carlos in Mexico City in those years.[49] The drawings produced by professors and students reveal an insistence on a rigorous, meticulous study of Greco-Roman antiquity and European early modern classicism, and on the notion of building type itself. Utilizing various antique typologies and vocabularies, draftsmen of the Novo-Hispanic academy formulated plans for hospitals, *cuarteles* (barracks), commemorative monuments, *entrada* arches, palaces, churches, cathedrals, funerary monuments, fountains, chapels, and town halls through plans, elevations, and sections that exhibit a more rigorous classicism. This profusion of types reveals an

3.12 José María Arrozpide, *Façade of a "Templete,"* 1791. Ink on paper, 14 × 19 in. (36 × 49 cm). Academia de San Carlos, Mexico City, Mexico.

effort both to categorize and to subject the architecture of the empire to an encyclopedic ordering.

Among the number of types from the catalogue of drawings in the Mexico City academy, the *"templete"* appears multiple times.[50] Of the six examples given, all have the quality of being centralized structures of exacting symmetry on all sides. Each is fronted by porticos on all four sides and is square in plan. While all possess a crossing dome, one by José María Pulgar from 1792 is a plan that suggests an internally round portico evocative of the Greek *tholos* (a perfectly round temple). Among the works is a red ink drawing by José María Arrozpide from 1791 titled *Façade of a "Templete,"* a plan and elevation for a centralized building with a triumphal arch profile (fig. 3.12). Giant order Corinthian engaged columns decorate the structure with its cross-shaped plan surmounted by a central dome. The function of this building is not specified; however, such "little temples" may have been understood to be inherently multifunctional in order to serve both civic and religious contexts.

The conceptualization of this building type and its actualization in Havana possess at least four interconnected and important aspects in the

development of early modern architecture in Europe and the Americas: the adaptation of humanist theory to the built environment, the eighteenth-century idea of architectural typology, the invention of the historic monument, and the emphasis on revisionist aesthetics as conforming to natural principles.[51] Of the lessons housed in the treatises of Vitruvius, Serlio, Alberti, and Palladio, perhaps the most overarching was the need to adapt the humanist principles of the ancients to contemporary building. Vitruvius's illustration of the modular proportions of the human body—later used by Leonardo da Vinci—that form units and rational proportions upon which architecture could be based provided an important visualization for this thinking. The application of humanist ideas to architecture in early modern Europe and the Americas could, therefore, be said not only to embody divine principles of God's universe but also to encode the body itself into architectonic space. Interfacing with this space allowed the ideal and presumably male observer to more fully self-realize, rehearsing the embodiment of perfection.

As El Templete in Havana was an invented type in the eighteenth-century Atlantic world, perhaps informed by earlier prerationalist typologies, the notion of human invention itself was thought by eighteenth-century architectural theorists to reveal the presence of reason. Furthermore, theorists traced architecture's origins to a hypothetical, primordial model, a "primitive hut," a moment at which humans extrapolated architecture from nature and a cultural construct dealt with at length by Joseph Rykwert.[52] More precisely, Rykwert examines the idea of the first house as a myth of origination in Western architecture, a work located in manufactured lost paradise. I would submit that a constructed memory of something lost charges the heritage imagination, as ceremonies attempt to recapture a memory that supposedly eludes the contemporary population.

In France, the priest and theorist Marc-Antoine Laugier (1713–1769) promoted his idea of the "primitive hut" in *Essai sur l'architecture* of 1755. He postulated how the first architecture was found in nature and copied by the Greeks, a concept derived from the notion of a primordial building fostered by Vitruvius.[53] In the frontispiece for Laugier's work, a print appears of an allegorical female figure representing architectural genius pointing to a primordial building made naturally of trees in the form of a post, lintel, and pediment (fig. 3.13). Laugier's theory posited architecture's origin in the principles of nature and underscored human reason in

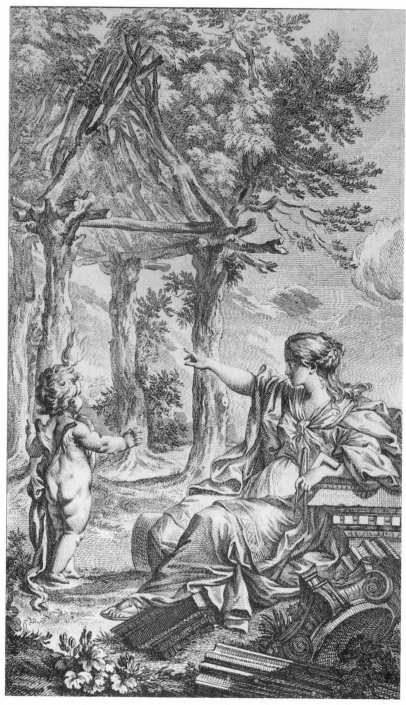

3.13 Charles Eisen, frontispiece to *Essai sur l'architecture* by Marc-Antoine Laugier, 1755.

the ability to imitate nature's example. Conversely, Antoine-Chrystostome Quatremère de Quincy (1755–1849), named the perpetual secretary of the Academy of Fine Arts in Paris in 1816, would later argue that Laugier's theory diminished human inventive capacity by suggesting that architecture already existed in the primitive hut, copied by early humans. Rather, Quatremère contended that humans extrapolated from the principles of nature to invent the first architecture independent of an a priori model, transforming natural language into social language.[54]

For European theoreticians, the trabeated system of the post and lintel spoke a language of strength, natural beauty, functionality, and tectonic transparency that many found absent in the architecture of early modern Europe.[55] British interest in ancient architectural classicism was entangled with notions of the Picturesque, a mentality initially employed in English gardens. The English Picturesque movement situated classical temples in the pastoral landscape with the assumption of their narrative capacity, their ability to teach and morally uplift the educated viewer. The Spanish world likewise knew a temple-garden pattern, as in the Royal Botanical Garden in Madrid, begun by Charles III. This work possesses numerous classical pavilions designed by some of the Spanish capital's leading architects, such as Ventura Rodríguez and Juan de Villanueva. Transnational pollination from the idea of the English Picturesque is a possibility, while classical revival temples in the Spanish botanical garden reinforced the idea of a knowable order of the natural world. The pairing of nature and culture in El Templete could, therefore, have triggered multiple eighteenth-century ideas about nature's appropriation in architecture, including the creation of social language from natural principles, the idea of narrating origins, the classification of nature, and the manifestation of reason.

Spain's interest in revising its own history in the eighteenth century may have pervaded the selection of certain examples of early modern classicism for study and dissemination in academic circles. In the archive of the Royal Academy of San Fernando in Madrid, a document pertaining to architecture employs the term *templete* to describe Il Tempietto by Donato Bramante (fig. 3.14).[56] This centralized structure served as a small chapel and martyrium for St. Peter with a compact geometry and ideal proportions based on the tholos possessing a 360-degree portico with a Tuscan Doric treatment. In its centrality and absolute symmetry, the work likely provided an important prototype for the "*templetes*" found in the Mexican

3.14 Donato Bramante, Il Tempietto, 1502. San Pietro in Montorio, Rome. © Vanni Archive/
Art Resource, New York.

3.15 Andrea Palladio, *Il Tempietto*. Woodcut. In *I quattro libri dell'architettura*, 1570.

academy catalogue. The prestige of Il Tempietto as one of the great works of Italian sixteenth-century classicism and its discussion in eighteenth-century academic circles in Europe would have made it a well-known model that traveled through the work of Andrea Palladio. Il Tempietto appears in Palladio's *Four Books on Architecture* from 1570 as a woodcut plate (fig. 3.15).[57] However, the art historian Jack Freiberg has argued compellingly that the Catholic kings of Spain commissioned Il Tempietto in the sixteenth century for a monastery owned by the Spanish monarchy. This connection suggests that the work's careful study by the Royal Academy of San Fernando was strongly related to Spain's nationalist preoccupations with history in the eighteenth century.[58]

In Havana, Antonio María de la Torre y Cárdenas would have seen Il Tempietto in Spanish translations of Palladio and known of its sixteenth-century Spanish patronage. In 1797, José Ortiz y Sanz provided a translation of Palladio's *Four Books*[59] that must have been in the possession of the mathematics professor Pedro Abad y Villarreal in 1813 when he petitioned to found an Academy of Architecture. Such works circulated in the Atlantic world, and senior clergy, Spanish officials, military engineers, and private residents would have had access to these treatises. In 1791, the Economic Society opened a public library in Havana, and an inventory of its collection of September 18, 1828, lists the following works: *Los diez libros de arquitectura*, by M. Vitruvio Polion, translated by D. José Ortiz y Sanz (Madrid, 1787); *Tratado de la pintura*, by Leonardo da Vinci (Madrid, 1784); and *Reglas de cinco órdenes d'arquitectura*, by M. Jacques Daroris de Vignola (Paris, 1792).[60] Also among its holdings were chapters of the *Recopilación de las leyes de Indias* reprinted in 1793, which contained the famous ordinances on town planning modeled heavily on Vitruvius.

If de la Torre consulted Il Tempietto as a potential model for El Templete, then perhaps the attempt was like that of the 1754 monument's connection to the Virgin of the Pillar of Zaragoza. In an age of increased historical self-awareness related to nationalist identifications, Cuban elites required a sense of their own history within Spanish heritage. This type of imitation and retooling is well known in the history of Spanish colonial art, where established models in Spain and Europe were appropriated and reworked in the Americas without loss of the idea of originality.[61] The original prototype might be thought to have been divinely or ratio-

nally inspired; therefore, its local adaptation would still have been seen as a unique and distinctive expression.

The typological connection between Il Tempietto in Rome and El Templete in Havana is that of the small commemorative temple. However, Bramante's memorial invoked the power of relics with the claim that a shaft embedded in the central axis of the structure held a piece of the cross upon which Peter was crucified upside down.[62] Both works thus commemorated sites of epic historical events that preserved some essential link to the material past, whether cross or tree. Yet in terms of form and typology, significant differences can be found between the two structures. El Templete, for example, cannot be considered a centralized building. Its one portico facing the plaza and attached to a rectangular *cella*-like space is more reminiscent of the urban Roman temple type, such as the Temple of Portunus in Rome of the second century BC. Yet El Templete does closely resemble Il Tempietto in some of its classical elements, including the three shallow steps and Doric entablature supported by plain Tuscan columns with Attic bases and roughly identical capitals. The Doric entablatures are comparable as well, with triglyphs and metopes in the frieze beneath a cornice, elements common in the Tuscan Doric work of Palladio, among others.

In addition to viewing architectural classicism in books, de la Torre must have had ample access to Stephen Hallet's temple-like chapel structure for the General Cemetery of Havana, completed in 1806. The spatial arrangement of the cemetery in which the French architect embedded the neoclassical chapel into the far wall of an enclosed rectangular space on axis with a triumphal arch entrance mirrored El Templete's original plan. Yet in his description of the cemetery, the Cuban physician Tomás Romay Chacón describes the cemetery's chapel as "similar to the old temples" rather than as a "*templete*."[63] The chapel structure likewise possessed a Tuscan Doric portico attached to a rectangular or cubical structure designed to house an altar and painted imagery. Even today, the overall appearance of El Templete from the plaza, with its gated, fenced enclosure and a temple-like memorial looming behind a tree, resembles something of an urban cemetery.

To the Tuscan Doric style of El Templete, the choice of elements from certain architectural orders carried symbolic significance for early modern treatise writers and architects. As James Ackerman has pointed out, Sebastiano Serlio considered the Tuscan order the most rustic and stron-

gest, and therefore suitable for fortresses, city gates, castles, prisons, and other buildings associated with war.[64] Serlio also highlights the practice by which "the ancients matched the orders expressively to the personality and physique of their gods."[65] The Italian treatise writer encouraged modern makers of religious architecture to consider this practice when adorning buildings to God and the saints, and in "profane edifices, whether public or private, to men according to their rank and profession."[66] De la Torre's choice of the Tuscan Doric could thus have evoked a sense of the rustic, primitive nature of the city's foundational site in the sixteenth century and the strength and masculinity of the Spanish conquistadors. Indeed, the discourses of the captain general betray a perception that the building's portico was to be in the "Doric" style, the most foundational of the Greek orders and gendered masculine.[67]

The production of neoclassical architecture in eighteenth-century Europe and the Americas frequently involved the recombination of classical elements into new forms that departed from the dictates of ancient and early modern treatise writers. In de la Torre's classicizing design for the monument, the portico possesses one such anomalous aspect: the set of double columns positioned at the lateral ends (see fig. I.3). As Vitruvius based the ancient temple on a modular system, like the human body, one half a columnar width became a standard of measure to ensure proportions. In terms of the height of the columns, El Templete maintained a 1:7 ratio as specified by Vitruvius for the Doric order.[68] Metopes were to be one columnar width long on each side, forming a perfect square. However, in El Templete, because de la Torre doubled the columns and made them 1 1/2 columns wide at the base, the metope directly above had to be stretched to center the triglyphs over each column as mandated for the Doric (see fig. 3.9). Thus, the two most lateral metopes form rectangular shapes in contrast to the squares within the central length of the frieze.

The Cuban architect and architectural historian Joaquín Weiss classifies El Templete as deriving from the tetrastyle temple of antiquity, meaning that it possessed four columns in its portico.[69] The author thus implies that we should treat the double columns as if combined, but this approach ignores an important anomaly. Why would the engineer not simplify the actual number of columns to four and make the portico less wide? Stephen Hallet's temple structure for the General Cemetery had a freestanding portico, supported by the four columns necessary to qualify as a more pre-

cisely tetrastyle temple. I submit that de la Torre may have been unable to reduce the width of the building and portico because of negotiations with the author of the history paintings, Jean-Baptiste Vermay. Consultation between painter, architect, and patrons could have resulted in compromises based on the width requirements of Vermay's large inauguration scene in relation to his paintings of the first Mass and *cabildo*. Thus by keeping the portico at this width and using only four columns, the architect may have feared that not enough of the entablature would be supported, resulting in its cracking and perhaps structural failure. However, while this portico treatment compromised the classical rigor of the whole, according to Vitruvius, perhaps de la Torre valued the double columns situated at the corners of a façade as a decorative device that could allude to early modern Italian architecture. Andrea Palladio, for example, used a similar motif at the corners in several works, including his famous Basilica in Vicenza (1549–1617). Indeed, such a motif actually appears at the lateral ends of the Casa de Gobierno across the plaza, which creates a strong visual communication with El Templete (see fig. 1.11).

In the appearance of this columnar pattern on the captain general's residence, the choice of double columns may have resulted from state censorship. While Hallet's classicizing cemetery chapel bore a closer approximation to the Vitruvian standard, it was located in a space for the dead. The location of El Templete on the plaza of the city across from the governor's palace, the architectural face of the king and his overseas representatives, may have called for less of a pure antiquity. Architectural neoclassicism was widely used in Europe and the Americas by the 1820s to represent autonomous national republics. Perhaps the purist translation of the Greco-Roman temple became ideologically problematic and was too much associated with a political trajectory that Captain General Vives aimed to avert in Cuba. It may, therefore, have been deemed inappropriate for the main plaza. Doubling the columns on the memorial created a visual resonance with the Casa de Gobierno, perhaps circumventing republican associations, and tying the new work into a local architectural syntax of colonial governance and imperial supremacy.

If we take El Templete's entire portico into account as an architectural rhetoric, the double columnar element has other transatlantic connections. This particular intercolumnar treatment resembles that of the basilica façade at El Escorial in the Courtyard of the Kings near Madrid,

3.16 Juan Bautista de Toledo and Juan de Herrera, Basilica of El Escorial from the Courtyard of the Kings, Madrid, Spain, c. 1563–1584. Art Resource, New York.

Spain. Here, a roughly identical columnar spacing flanks three arched entryways (fig. 3.16). This relationship appears more precisely symbolic, as the façade at El Escorial has been taken to evoke the Temple of Solomon in Jerusalem. In fact, the very layout of El Escorial in terms of its perimeter massing and interior basilica on axis and at the rear of the larger plan resembles numerous illustrations of the hypothetical configuration of Solomon's Temple, a hallowed biblical prototype (fig. 3.17). These images typically denote a perimeter wall that forms a compound, with the temple structure often centralized or at least geometri-

3.17 Comparative images of the Temple of Solomon (above) and El Escorial (below), according to the Cistercian Spanish theologian Juan Caramuel y Lobkowitz. From *Architectura civil recta y obliqua: Considerada y dibuxada en el Templo de Ierusalen . . . promovida a suma perfeccion en el templo y palacio de S. Lorenço cerca del Escurial*, 3 vols. (Vigevano, 1678), Vol. 3, illustrations A and H.

cally configured within the larger plan. At El Escorial, a statue sculpted by Juan Bautista Monegro (1545–1621) surmounts each column and represents one of six Old Testament kings of Judah, who either built the Temple of Jerusalem or destroyed those of pagan rulers. These kings are Jehoshaphat and Manasseh on the outer flanks, Hezekiah and Josiah in the outer middle, and David and Solomon in the center. The historian Jorge Cañizares-Esguerra has emphasized the importance of the typological imagination in the early modern age of European imperial expansion as a practice by which contemporary events were explained by recourse to Old Testament prefiguration.[70] In the context of El Escorial, typology is used to support both doctrinal and imperial claims to the preeminence of the Spanish Catholic monarchy, while Philip II as an architect of empire could be seen as prefigured by builders of the Temple of Jerusalem.

Stylistic connections between the façade of the Courtyard of the Kings at El Escorial and El Templete in Havana suggest an attempt to authorize the Cuban monument via powerful rhetoric within the Spanish Empire, but also to situate it within a tradition of the Temple of Jerusalem. A common reference within Freemasonry, Solomon's Temple may have been an important image for Bishop Espada. Indeed, the containment of the temple structure within a larger stone enclosure, as at the Havana cemetery, brings to mind the musings on the Jerusalem temple form as known in prints. The Vatican issued an attack on Bishop Espada in 1815 for the practice of Freemasonry and recalled him to Rome for punitive measures, but he was too ill to make the journey.[71] After some years passed, the charges seem to have been forgotten.

Freemasonry had become well established in Cuba by 1828. By 1798, Santiago de Cuba on the island's eastern side saw the foundation of two lodges, and by December 17, 1804, a lodge was formed in Havana known as Le Temple des Vertus Théologales. The Grand Lodge of Pennsylvania expedited the first patent letter for Havana's earliest lodge. Its first Venerable Master was Joseph Cerneau, who was called a revolutionary character by Captain General Salvador del Muro y Salazar, marqués de Someruelos. Early separatist conspirators in Cuba seemed to have had ties to the lodges, such as Román de la Luz and Joaquín de Infante. The latter authored the first constitution for an independent republic of Cuba in 1812, the year the Cortes of Cádiz approved a constitution for

Spain. The Royal Cédula of January 19, 1814, made Freemasonry a crime in all Spanish dominions and may have led to Espada's indictment. It also seems to have driven Masonic association into secrecy in Cuba. Masonry, nevertheless, persisted on the island with La Gran Logia de la Louisiana authorizing the Unión Fraternal lodge in Havana in 1818; the Gran Logia de Pennsylvania sanctioning the lodges Unión de Regla, La Fidelidad Habanera, and Benevolencia in Santiago de Cuba between 1810 and 1820; and the Gran Logia de Carolina del Sur approving Ameridad in Havana in 1821.[72] The Bolivarian conspiracy of 1823 known as Soles y Rayos de Bolívar is thought to have begun in a lodge of the same name founded by an ex-colonel in the armies of Simón Bolívar and José Francisco Lemus.[73] Thus El Templete's formal connections to musings on Solomon's temple may have offered more than cultural prestige. It could have served as an important beacon of solidarity to subversive communities of Masons in Cuba, many of whom seem to have advocated for Spanish or Cuban constitutionalism, if not complete independence from Spain.

In a less liberal and more official vein, El Templete forged genealogical linkages between Havana, Madrid, Jerusalem, and even Rome via Il Tempietto, which could have served both an imperial agenda and a liberal one, as will be addressed in chapter 4. Either way, the objective seems to have been to create a stand-alone civic paradigm, akin to what Stuart Hall has referred to as "The Heritage," an expression endowed with supreme moral authority and derived from a shared past.[74] El Templete can thus be viewed as a local, Atlantic, and transcultural type, one informed by biblical typology, Spanish colonial history, and the notion of type itself as rooted in the theories of the European Enlightenment. The conceptualization of El Templete as a primitive hut revealing the human capacity for reason coexisted with the notion of type as configured within the Christian typological imagination.

In addition to these European sources, there is another, more immediate source for the double columnar motif in Havana that has gone largely unmentioned in relationship to El Templete.[75] One of the oldest civic memorials in the city is a small stone monument commemorating María de Cepero y Nieto, a young girl in the sixteenth century apparently killed by a pirate's cannonball that crashed into the main parish church on the Plaza de Armas where the girl was observing the Mass (fig. 3.18). The

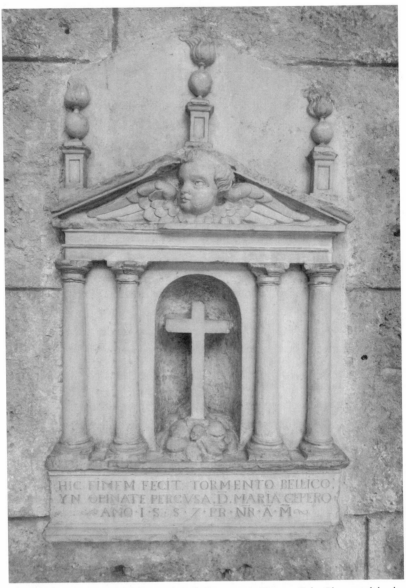

3.18 Anonymous, memorial to Doña María de Cepero, 1557. Havana, Cuba. Photograph by the author.

memorial consists of a sculptural relief depicting a small temple façade set on a platform bearing a Latin inscription honoring the girl's death and reading: "Casually injured by a weapon, here died D. María Cepero in the year 1557."[76] From the inscribed horizontal band, three steps rise to the temple portico. The anonymous sculptor, likely familiar with Italian vocabularies, carved two sets of double columns pushed to the lateral sides. In the center, an arched niche, almost the height of the portico, frames a Latin cross rising from a mound of stones, symbolizing Golgotha and the Crucifixion. The Tuscan columns, all set on plinths with bases supporting an abacus, hold up an entablature with open architrave and frieze separated by a horizontal belt course. In the pediment, the head of a child occupies the center and is mounted on wings, which extend laterally into the tapering corners of the triangular space. The head projects slightly outside the framework, giving the dynamic impression of the soul of a child ascending. The pediment is then crowned by three stone balusters situated symmetrically, each supporting a flaming cannonball indicating the instrument of the child's death.[77]

This sixteenth-century Cuban monument betrays early conceptions of Havana as a city: a stronghold symbolized by the trabeated forms of European classicism and a place that preserved Christianity at its core. It was a city at a dangerous crossroads and a precarious colonial outpost, yet one worth defending, a place where even innocents might be martyred for the larger Christian cause. Both symbolically and formally, this little memorial was a civic ancestor to El Templete and could possibly have influenced de la Torre's treatment of the latter's portico, as a layering of local history.

In terms of how audiences were expected to view El Templete in 1828, we can glean something from the abundant newspaper articles released around the time of its inauguration. In spite of the work's incorporation of the earlier 1754 pillar and its departures from Vitruvian dictates, subscribers to the *Diario de La Habana* read articles in March of 1828 about El Templete that extolled its *buen gusto*.[78] The press noted the work's similarity to *los templos antiguos* (the old temples), evoked by its beauty, decency, solidity, exactitude, and perfection.[79] The *Diario* proclaimed that El Templete would educate future generations on the city's foundational moments with "taste, propriety, and erudition."[80] The author framed the entire monument as tasteful, including the baroque aesthetics of the 1754 pillar and the

eclectic blend of antique references in architecture, such as the double columns. The rhetoric of taste thus overcame any perceived disparities found in El Templete's style in order to promote the work as a singular exemplar of artistic perfection. The writer uses the monument to persuade his readers to view themselves as belonging to a community of tasteful citizens that lived in a modernizing city of high culture. *Buen gusto* was thus a sociocultural phenomenon that may have contributed to the broader project of imperial reform to elevate various regions, as it could be possessed by local elites in their effort to negotiate the roughness of the past in order to construct a legible modernity in the present.[81]

How audiences would have interpreted the new work must have been conditioned by writings in the *Diario* as well as their experiences of its architecture. As an embodied space and phenomenal encounter, El Templete needs to be situated within the spatiality of the Plaza de Armas as it appeared after 1791. The Bourbon royal palaces dominated the plaza with massive portals and sweeping façades bounding the northwestern and western sides of the space.[82] These formidable structures overcame the buildings around them by sheer size and impressed human bodies by their scale, forcing colonial subjects to experience the grandeur, majesty, and universality of the Spanish monarch. The experience of the palaces reshaped colonial subjectivity by imposing a sense of human subservience to the power, knowledge, and vast network of the Bourbon Empire. El Templete, by contrast, offered an alternative architectural framework for engagement by the colonial subject. While stamped with the king's authority and framed as an imperial monument, the work allows the body to inhabit a space rigorously configured by humanist principles of modularity, which promoted the body itself as a standard of nature from which architecture could be designed and built. The monument thus encouraged the emergence of an individual subjectivity complementing values of self-interest, reformed piety, civic consciousness, and reason that were then circulating in Havana.[83] Nineteenth-century visitors could learn the history of their city at El Templete, pass underneath a classical portico, and view history paintings on the site of the honored events while experiencing a space that recast the meaning of being in the plaza. The work offered more individualized views of the collectivity embodied in plaza space. In essence, the plaza could now encourage the formation of a bounded individual

who understood him- or herself as a member of a public community of increasingly atomized and civic-minded residents.

PAINTINGS IN PUBLIC

El Templete's architectural forms allowed for a simulated experience of Greco-Roman antiquity and promoted a reformed subjectivity. Yet as a type, an object, or more broadly, a heritage, the monument could have been understood in diverse ways based on a heterogeneous audience. Inside the work, three detailed and complex history paintings reconstructed the foundational narrative of the site and commemorated the elite public who sponsored the work (see figs. I.4–I.6). This program of paintings was crucial to the process of heritage, in that the three large canvases were consciously constructed to link past and present on the site of alleged events and in tandem with architecture and urban space. These paintings transformed the monument into a device for the construction of the self by reconditioning self-expression/self-conception in plaza space and creating a new way of seeing—in effect, a heritage gaze.[84]

In an article on El Templete, the *Diario de La Habana* of March 27, 1828, proclaimed: "The histories, the traditions, and the same oratory would almost remain mute if these large monuments did not speak to man in indelible signs and characters."[85] Here, the colonial press posits the monument as language, capturing not only something of Félix Varela's lectures on the social utility of well-formed signs but also a sudden interest in educating the public through exhibitions of history painting. It suggests a Cuban adaptation of the general objectives of the French painter and art theorist Charles Le Brun (1619–1690) in the establishment of the French royal academy to generate a legible and universal language of the visual arts that would serve in the production of imperial and national propaganda.

The paradigm of civic history established by El Templete as an authoritative architectural type received a more nuanced and subjective translation into the space of local society via the history paintings within. Jean-Baptiste Vermay's three canvases, displayed permanently on the plaza, brought a public viewership of history paintings to Havana reminiscent of the Parisian Salon. As the Salon served to generate public opinion on the visual arts in the late eighteenth century and promote imperial propaganda

in the early nineteenth under Napoleon, it also constructed an edifying space for all classes of spectators.[86] El Templete likewise promoted a new type of viewership as a public and collective act. The work combined eighteenth-century ideas about the didactic role of monuments and their transparency to the past with those on the function of painting in public space. Influences of the French academy on Vermay are evident in the preference for public exhibition and the acknowledgment of a hierarchy of genres. The academy placed history painting above portraiture, landscape, and still life for its legibility of historical narrative, propagandistic potential, and perceived ability to uplift society by teaching moral lessons. Jacques-Louis David had strongly advocated for public exhibition during the revolutionary years in France, considering it "the return of the arts to their true purpose, which is to serve morality and to elevate the soul."[87] An artist's works should be submitted "to the judgment of the public, and . . . expect in return only those rewards which public approval will bestow."[88]

David criticized patterns of private patronage whereby the arts were "denied to the rest of society" and imagined an arena to enlighten the public and "improve its taste."[89] In early-nineteenth-century Havana, works of art were viewed in religious buildings, in private houses at such occasions as *tertulias*, or in the political displays of royal officials. Thus, the new monument to the ceiba tree introduced a novel form of public arts viewership to the city that took into account the sense of collectivity constructed through daily social patterns and regular political performances on the plaza.[90] Rather than serving as a rotating space for any paintings, however, the designers of El Templete intended only three works to permanently occupy a specific arrangement within the monument. In contrast to the French Salon's prerevolutionary objective to foster critical opinion in a freethinking public, the installation of these three paintings in Havana functioned to constrain opinion by virtue of the fixed nature of the images and their propagandistic coordination. El Templete was no Salon at all, in the sense of late-eighteenth-century Paris. Rather, it bears much more of a relationship to Napoleon's use of imagery during Vermay's tenure in Paris.

Analysis of this arrangement enhances our understanding of the complex spatial and visual construction of the past on the site, which engaged the spectator in a calculated progression through space. Walking beneath the lofted bronze pineapples and through the triumphal arch, the visitor approached the 1754 pillar, a stylized tree form "in the same place that

it [the original tree] was cut down."[91] The work transmuted the space of nature into the space of culture, sanctified by the statue of the Virgin and Child. Beyond the arch, the viewer approached a replica of an antique temple, what the *Diario* hailed as "a model of magnificence, perfection of form, and beauty."[92] The temple could, therefore, be appraised as a stylistic advance over the 1754 pillar that the press referred to as "of Gothic construction,"[93] establishing an experience of cultural progression through space.

Beneath the portico, the spectator encountered three doorways, once open but fitted with mahogany doors after the 1840s. In the *Diario*, Francisco Rodríguez Cabrera begins by describing Vermay's painting of the first *cabildo*, which he indicates was mounted on the viewer's left upon entering the small building.[94] At the ceremony on March 19, 1828, it is doubtful that the inauguration painting was complete, as Vermay must have made preparatory sketches or mental notes for it at the event itself. The following analysis will consider both the descriptions from Cabrera's March 16 article in the *Diario* and the visual context later in 1828 or 1829 when Vermay finally completed and installed the inauguration painting.

The First Cabildo pictorially reconstructs the historical episode when the Spanish conquerors held the official town council meeting of San Cristóbal de La Habana in 1519 (see fig. I.4). Anchoring the events to time and space is an image of the foundational ceiba tree that dominates the upper third of the canvas with its canopy and divides the pictorial space into three horizontal registers, with the canopy above, hills and sky in the center, and human figures below. Centered in the lowest register, echoing the uprightness and strength of the ceiba, is the bearded figure of the conquistador Diego Velázquez, whose eye level is just above the horizon line of the composition. To reconstruct the event, Vermay could have availed himself of eighteenth- and early-nineteenth-century Cuban histories, such as the works of Pedro Agustín Morell de Santa Cruz (1694–1768), Ignacio Urrutia y Montoya (1735–1795), José Martín Félix de Arrate (1701–1765), and Antonio José Valdés (1780–1850), each of whom narrated the conquistador's founding of Havana.[95]

The selection of certain aspects of local history by a European academic artist to produce pictorial narratives relevant to local audiences could be seen in early-nineteenth-century Mexico City associated with the Royal Academy of San Carlos. Rafael Ximeno y Planes (1759–1825), a Spanish

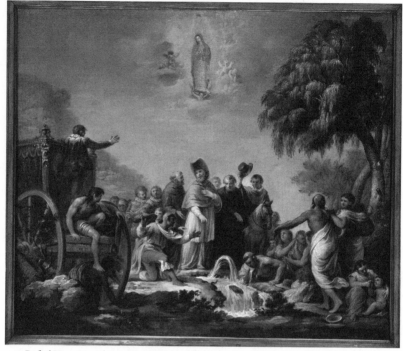

3.19 Rafael Ximeno y Planes, *The Miracle of the Well*, 1809. Oil on canvas. Photograph ©
Museo Nacional de Arte, Mexico City, Mexico.

painter, academician, and director of painting at San Carlos, was commissioned to paint *The Miracle of the Well* for a chapel in the Palace of Mining in Mexico City, a work he finished by 1809 (fig. 3.19). The painting depicts the visit of Bishop Juan de Zumárraga (r. 1528–1547) and an entourage of clergy and Indians to the site where Juan Diego witnesses the third apparition of the Virgin of Guadalupe in 1531. So that Juan Diego would be reminded of the exact location, a well of healing waters miraculously sprang from the earth. The scene draws attention to specific historical actors and divine entities: the Virgin of Guadalupe hovering overhead and Bishop Zumárraga directly beneath her commanding centrality on earth. Juan Diego is also on the scene, accented with bright red pants, along with a host of Indians, mestizos, and a man of African descent at lower left. The image reveals the inclusive spirit of the Bourbon Reforms in the interest of fomenting industry, making the Virgin of Guadalupe the patron saint of all people of New Spain. The art historian Luisa Elena Alcalá has addressed

this work as part of a process of codifying the image of the Indian as a good Christian and draws attention to how the painting reworks the cult iconography of this devotion.[96] I would argue that the work belongs to a process of late colonial heritage as well, in addition to questions of artistic genre, style, and the representation of the Indian. It was a cultivated regionalism on the part of Bourbon reformers, a visual effort to construct a sense of place by articulating a collective past and subjecting previous narratives to revision.

In Vermay's scene of the first *cabildo*, we find a subject focusing much less on miracles and more on the concrete facts of town foundation. Indeed, religious reformers like Espada sought to de-emphasize miraculous stories and to situate civil and religious narratives on rational ground. Standing beside Velázquez and before the tree trunk is a figure of a priest, identified by Cabrera as the Dominican friar Bartolomé de Las Casas, who authored an important tract to the Spanish Crown in defense of the Indians.[97] The union of conquistador and priest under the ceiba underscored a natural union between church and state that existed from the first moments of colonial government. The conqueror wears luxurious worldly clothes in comparison to the humble priestly robes of Las Casas. The masculine bearing, graceful manners, and willfulness of Velázquez partake of pictorial conventions in Havana's full-figure colonial male portraiture. The main attribute of Velázquez is a wooden staff that he holds in his right hand, resembling or perhaps obscuring a sword. The sword and staff became important accoutrements of European and American regal portraiture and particularly those of Spanish American conquistadors. Such elements symbolized the conqueror's masculinity, military strength, and ability to found and father the new colonial city.

Vermay configures the head of Velázquez along a horizontal axis defined by the profiles of seventeen other Spaniards who occupy the foreground and background of the canvas's lowest register. This configuration of officials along a frieze-like horizontal line recalls antique conventions and perhaps connotes the ideal of horizontal civic association promoted by the Economic Society. The viewer's gaze generally meets that of the painted figures, placing contemporary populations in the scene among the city founders. The vertical-horizontal configuration of the ceiba tree's trunk and canopy echoes the trabeated architecture of El Templete's portico, suggesting the primordial landscape soon to be made into cultural space.

Simultaneously, the cross shape could be read as an indication of Christ's presence at these events, underscoring the Divine Providence guiding the conquest. Velázquez's red sash identifies him as an agent of Castile and possibly a member of the order of Santiago. His body shifts on the sand-colored ground in a contrapposto pose of antiquity, as the artist further unifies the scene through modeling and color balance to create a sense of gravitas and stability. These effects encoded the visual properties that Bishop Espada would have associated with religious reform, as developed in the frescoes of the Havana cathedral sanctuary.

In the bottom left of the canvas of *The First Cabildo*, Vermay depicts an Amerindian mother and child who gaze upward at Velázquez and the group of men standing above them. The mother, covered in a brown garment, kneels and looks up nervously while restraining her nude and standing child. Cabrera noted "the timidity of the child who is guided by an Indian when s/he sees the Spaniards."[98] As the curious and innocent child motions toward the group of Europeans, his or her arm crosses the staff carried by Velázquez, visually connecting the two figures. The brownish red skin, scant clothing, curvaceous and introverted character of the Indian figures contrast with the white, richly clothed, trabeated, and extroverted bearing of the Spaniards. These indigenous figures provide references to the island in its primitive state, which is actively being liberated through the civilization brought by the conquistadors. They also reveal a feminizing of the American landscape in general, standing in for the land itself and thus its availability for European masculinizing possession and exploitation.[99]

The gazes and gesturing of the figures in *The First Cabildo* generate directional lines that lead the viewer's eye to the right and toward Vermay's next painting, *The Inauguration of El Templete*, an oil on canvas completed sometime in 1828 or 1829 (see fig. I.6). The work meets the preceding canvas of the first *cabildo* seamlessly at the corner, indicating the coordinated measurements between the paintings and the monument's architecture. Vermay composed the scene as a quasi group portrait of civic elites, allowing audiences to compare nineteenth-century dignitaries to their sixteenth-century predecessors. The much larger figural grouping follows the horizontal line of figures established in *The First Cabildo*, a linear element that is continued further into the painting *The First Mass* (fig. 3.20; plate 8). The inauguration group is composed of elite clergy, a number of non-Spanish foreigners, Peninsular administrators and military officials,

3.20 Interior of El Templete with views of *The First Mass* and *The Inauguration of El Templete* by Jean-Baptiste Vermay. Photo by the author. Reproduced courtesy of the OHC.

members of Havana's Creole nobility, and elite women and children—all of whom stand, kneel, or sit to witness Bishop Espada's benediction of El Templete on March 19, 1828.

Vermay sets the scene within the new rectangular enclosure indicated by the stone and iron railing surrounding the exclusive crowd, with other figures situated outside and staring through the bars. Depictions of the Casa de Correos and the Castillo de la Real Fuerza establish a civic pride and situate the scene on the east side of the plaza. The temple structure within El Templete is slightly visible on the far right as the focal point of the entire group. The 1754 Cagigal pillar stands prominently to the left and is encircled with numerous figures standing next to or leaning against the stone monument. The artist thus constructs an allegory of progression from the primitive space of trees, Indians, conquistadors, and virgin landscape to a highly populated nineteenth-century city with its stone ceiba tree monuments, architecture, and refined and well-clothed residents. The sharp rise in the number of figures from the sixteenth-century setting to the nineteenth-century one portrays the growth of the kind of populous and industrious modern city encouraged by Bourbon reformers.

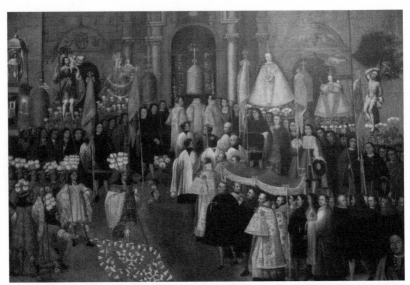

3.21 Cuzco school, *Return of the Procession*, Corpus Christi series, c. 1675–1680. Oil on canvas. 89 3/16 × 127 9/16 in. (226.5 × 324 cm). Museo de Arte Religioso, Arzobispado del Cusco, Peru, and Art Resource, New York.

The representation of urban communities in association with their civic environments has a long history in the Spanish world, particularly in the Americas. The historian Richard L. Kagan has attributed this phenomenon, in part, to the precedence that *civitas* (the human element of cities) has always played over *urbs* (the physical fabric of the urban).[100] Indeed, in Vermay's inauguration scene, the human element arrests the viewer's attention while being framed by the subordinate but nevertheless symbolic urban fabric. The two are offered as interconnected. The representation of such figural groups in the Spanish colonial Americas became an important means of validating the *policía* of a city and the functionality of the *polis*, as well as an effort to render the colonial social hierarchy as stable, predictable, and wedded to the represented space of social life. The work of the art historian Carolyn Dean on Cuzco's Corpus Christi paintings in the Viceroyalty of Peru has framed such images of urban collectivity as part of a discourse on indigenous identity, while the works simultaneously served to depict social hierarchies.[101] In the Spanish viceroyalties, such images also included depictions of religious festivals and observances, devotional proceedings, burials, weddings, *entradas* (entrances of the viceroy), oath-swearing ceremonies, saintly blessings, and general urban views. One image

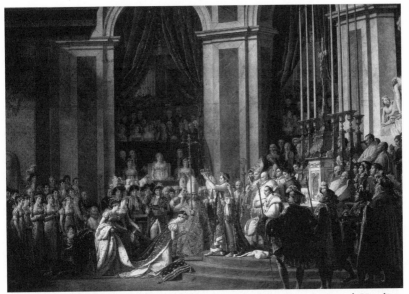

3.22 Jacques-Louis David, *The Coronation of the Emperor and Empress*, or *Le Sacre de Napoléon*, 1805–1807. Oil on canvas. Gianni Dagli Orti/The Art Archive at Art Resource, New York.

from the Cuzco series, *Return of the Procession* (c. 1675–1680), depicts the festival climax (fig. 3.21). Members of the city's ecclesiastical and municipal councils, along with indigenous militia, are each dressed in their identifying outfits, underscoring the importance of clothing in communicating social and political hierarchy in the Spanish colonial city as well as the role of group portraits in idealizing social stratification.[102] Such images are also multivocal in that, as Dean points out, they not only reify colonial order but reveal complex negotiations by local elite and subaltern communities who co-opted the symbolic economy of colonialism to advance their own agendas. Likewise, Vermay's inauguration scene depicts a complex urban community of Creole and Peninsular elites in which similar negotiations for power and prominence were active daily.

In terms of European precedents, scholars have compared Vermay's painting of the inauguration ceremony of El Templete to Jacques-Louis David's *Coronation of the Emperor and Empress*, also known as *Le Sacre de Napoléon*, completed in 1807 (fig. 3.22; plate 9).[103] Vermay must have known of this work, as he was active in Paris at the time and exhibited in the Salon of 1808. The two paintings are consistent in their massive size, focus on contemporary ritual acts as political propaganda, and horizon-

tal configuration depicting a crowd that regards an event taking place to the viewer's right. Todd Porterfield and Susan L. Siegfried have argued that *Le Sacre* employs the "performative subject" as opposed to the open-ended narratives of French revolutionary history painting.[104] In David's work, Napoleon crowns Josephine as witnessed by a distinguished crowd of royals, nobles, and elite clergy, including the pope, with portrait likenesses rendered faithfully by the artist in what served as an epoch-making image. Porterfield and Siegfried suggest that the image represents a refutation of the principles underlying the *exemplum virtutis* (virtuous example) embodied by earlier, revolutionary-era history paintings, indeed by David himself, such as the *Oath of the Horatii* of 1784. Previous such works incited the public to engage in the active interpretation of the moral messages within, thus sharpening the subject's reason. In contrast, *Le Sacre* effectively blocks critical thinking by making the coronation scene accessible but severely restricting any interpretations contrary to the supremacy of Napoleon.[105] While Vermay's *Inauguration of El Templete* likewise constructs the specific, performative moment, it is inscribed with multiple, competing messages about the nature of the colonial city, its human population, and the relative value of the island's authority figures. Furthermore, the main subject of the work is not an emperor, but a monument by and for the public, even if the Spanish king's presence is implied via signs and material references.[106] In this mode, Vermay elevates the church, the state, and the elite public through a nineteenth-century construction of heritage.

The author J. de la Luz de Léon long ago criticized Vermay's handling of the inauguration scene, denouncing the artist's technical ability compared to David's. She based this analysis on Vermay's insistence on making the figures life size, as did David, and thus preventing himself from being able to attain the requisite width to achieve the sense of space, depth, atmosphere, perspective, and grandeur that characterizes David's work in Paris.[107] Rather than a technical failure, however, one might consider that Vermay had to negotiate the demands placed on him by multiple patrons who required visibility in the painting. He compresses his figures, but arranges them in a rigid horizontal configuration of myriad overlapping bodies, which may have served to connect the work to antique typologies. The entire scene conceptually resembles the Panathenaic frieze of the Parthenon or the Roman Ara Pacis; in the latter, the frieze is more cramped with

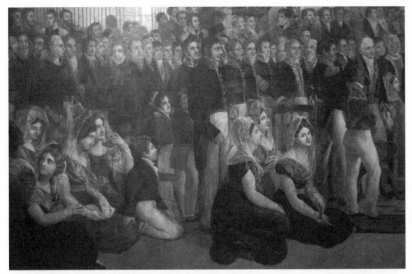

3.23 Jean-Baptiste Vermay, women and children, detail of *The Inauguration of El Templete*, c. 1828–1829. Oil on canvas. El Templete, Plaza de Armas, Havana, Cuba. Reproduced courtesy of the OHC.

bodies that overlap to animate and naturalize the figures. Such allusions would lend a deeper air of antiquity and further privilege the members of the public whose portraits appear in the painting.

The female figures along the lower register on the ground, with their serious, emotionless expressions and white drapery, bring to mind Roman matrons (fig. 3.23). A number of the female figures and even some of the men in the inauguration scene exhibit the Greek profile familiar to eighteenth- and nineteenth-century Euro-American painting. In continuing the horizontal line established by the conquistadors in the sixteenth-century scene, the compositional organization of the inauguration expresses a seamless continuity between past and present, constructing a heritage based on actual nineteenth-century likenesses and comparing their relationships to foundational figures from the past. Such illusionism can be related to that showcased in the contemporary diorama and panorama theaters of Paris with which Vermay was no doubt familiar.[108] He had, in fact, been commissioned in 1827 by the Economic Society of Havana to design a diorama theater for the city and to paint the interior with illusionistic scenes.[109] A hurricane destroyed this structure in 1846, and the content of the paintings is currently unknown. Yet at least one print depicts the

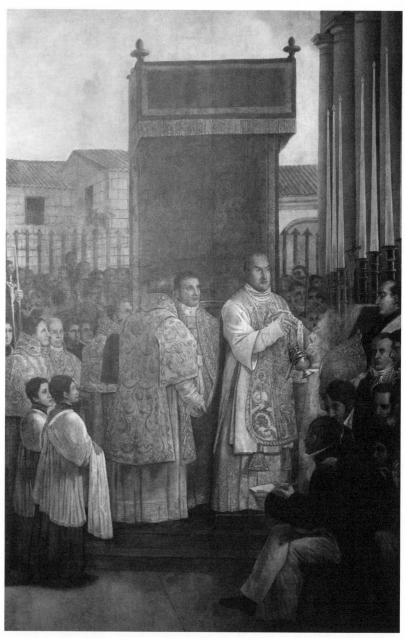

3.24 Jean-Baptiste Vermay, portrait of Bishop Espada and self-portrait of Jean-Baptiste Vermay with El Templete in the background, detail of *The Inauguration of El Templete*, c. 1828–1829. Oil on canvas. El Templete, Plaza de Armas, Havana, Cuba. Reproduced courtesy of the OHC.

Havana Diorama Theater with a neoclassical façade and three grand doorways similar to El Templete.[110]

At the far right of the inauguration painting, nearest the temple structure, Vermay includes local representatives of the church. Bishop Espada, in white pontifical vestments, stands upon a wooden platform and swings a burning censer as he conducts the Mass (fig. 3.24). Having removed his miter, he reads from the open book of scripture on the stand in front of him. The artist elevates Espada as the most prominent figure in the ecclesiastical group and surrounds him with members of the elite clergy. Mario Lescano Abella, in his 1928 book on El Templete, identified many of the figures in the inauguration painting, although he never cites the sources of his information. Among this clerical group, Lescano Abella finds the canon Juan Bernardo O'Gavan, Pedro Gordillo, and José María Reina, who was also the schoolmaster and canon of the Church of La Merced.[111] The ecclesiastical figures all wear white and gold vestments, and the group surrounding Espada stands before a vertical red and gold canopy resembling elements of David's *Le Sacre*. Only two of the men's faces are fully visible, including that of Espada, as one priest turns his head completely away from the viewer. To the right of this group, the painter allows us to glimpse four columns and some of the entablature of El Templete behind a series of seven large candles flanking a small crucifix, symbolizing the perfection of the spirit. Seven candles and a crucifix also appear in David's painting positioned on the high altar at Notre Dame. The platform elevates Espada above all other figures, situating him closest to the shrine, and denoting his importance by hieratic scale in a painting financed by the bishop himself.

Directly below the figure of the bishop, Vermay depicts himself seated on a wooden chair with his legs crossed, wearing white trousers, a dark coat, and dark shoes. In this self-portrait, the artist studies the gathered crowd intently as he makes sketches on sheets of white paper in preparation for the final painting. Vermay thus narrates himself in the act of academic artistic practice, demonstrating drawing to the spectator and lending a greater prestige to the painting as a whole. Behind the artist stands Pascual Pluma, consul of Tuscany; Ramón de la Sagra, director of the Botanical Garden; and Guillermo Lobé, consul of Holland, according to Lescano Abella's identifications. Vermay's self-portrait perhaps takes its inspiration from Jacques-Louis David's inclusion of himself in the rafters above Napoleon's coronation, sketching the scene below. One of the men

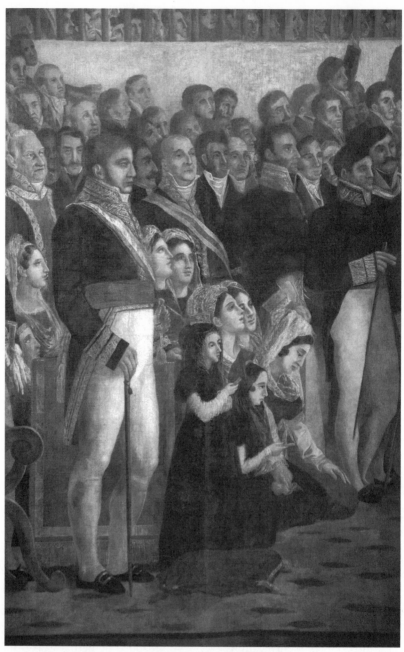

3.25 Jean-Baptiste Vermay, portrait of Captain General Francisco Dionisio Vives with his family, detail of *The Inauguration of El Templete*, c. 1828–1829. Oil on canvas. El Templete, Plaza de Armas, Havana, Cuba. Reproduced courtesy of the OHC.

behind Vermay seems to touch his shoulder, perhaps to suggest the artist as part of the elite public. His contributions to the visual arts of Havana after having been resident in the city for thirteen years and the execution of these paintings for El Templete earned Vermay an induction into the Economic Society by an Act of the Assembly on June 3, 1828.[112] This self-portrait of the artist sketching also heralds the new drawing school in Havana and demonstrates to current and future students the preeminence of drawing as an essential exercise in the great achievement of a history painting.

In the center of the inauguration painting, Vermay includes the figure of Captain General Francisco Dionisio Vives standing on a fine rug rolled out in his honor (fig. 3.25). He clasps his hat under his left arm and supports himself with a staff that appears almost identical to the one held by the figure of Velázquez in the painting of the first *cabildo*. The uniforms of Velázquez and Vives bear similar colors, creating a visual link between the island's first Spanish governor and its present one. Dressed in his decorated military uniform and wearing the blue and white sash of the order of Charles III, Vives regards the inaugural proceedings with a stern expression. His two daughters, dressed in black, stand and kneel below him and are joined by other women, possibly the wife of Vives, a governess, or servants. The group of male figures standing in the immediate vicinity of Governor Vives, most of them likely representing Peninsular officials, wear formal clothing and military uniforms with indications of rank (fig. 3.26). Lescano Abella identifies portraits of military officials, including that of the subinspector general of the military, Melchior Aymerich; general treasurer of the army, Próspero Amador García; colonel of militias, José Marín Herrera; colonel of dragoons, José de Acosta; colonel Martín Aróstegui; brigadier José Cadavar; and subinspector of engineers, Antonio Arango. The island's Spanish administration was likewise represented by portraits of the *alcalde* (mayor) of the city, Próspero Amador Díaz; intendant of provinces, Tomás Agustín Cervantes; the *regidores* (town aldermen), Antonio Ponce de León, José María Chacón, Andrés de Zayas, and José Francisco Rodríguez, whose article appears in the March 16, 1828, *Diario de La Habana*; the secretary of the government and architect of El Templete, Antonio María de la Torre; the director of the plaza, Manuel Molina; the auditor, José Sedano; the censor of the university, José María Calvo; and the notary public, Martín Ferrety.[113] This figural grouping posi-

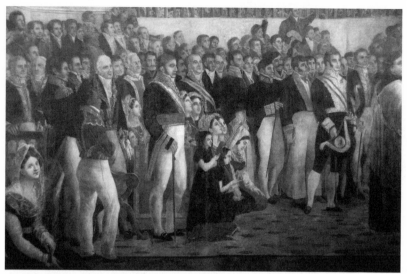

3.26 Jean-Baptiste Vermay, men, women, and children surrounding Captain General Vives, detail of *The Inauguration of El Templete*, c. 1828–1829. Oil on canvas. El Templete, Plaza de Armas, Havana, Cuba. Reproduced courtesy of the OHC.

tioned a large number of Peninsulars closest to El Templete, perhaps connoting the superior reason of Europeans.

To the left of this cadre of mostly Spanish officials, Vermay depicts a less-decorated but well-dressed group of men who likely represent Havana's Creole nobility (fig. 3.27). These figures extend backward toward the entrance and wrap around the prominent Cagigal pillar. Among this group, Lescano Abella finds portraits of the Cuban-born intendant Claudio Martínez de Pinillos, the conde de Villanueva, along with a number of *condes* (counts): of Fernandina, Cañongo, O'Reilly, Casa Bayona, and San Juan de Jaruco; Francisco Arango y Parreño; and the marqués de Prado Ameno. Yet the work does more than elevate specific individuals within the elite public; it also champions the existence of the public itself. The painting bears witness to Havana's *ilustrados*, whose firm grasp on the history of the site and elevated taste make them civic paragons of reason and modernity. As the painting of the first Mass speaks to the inherent superiority of Christianity before paganism in the sixteenth century, so reason, taste, and modernity are offered as the inevitable purview of the city's lettered elites. Their cultural authority rests firmly on the ancestral ground of the past, as reconfigured in the nineteenth-century present.

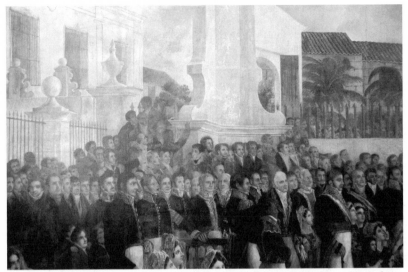

3.27 Jean-Baptiste Vermay, men gathered around the ceiba tree memorial of 1754, detail of *The Inauguration of El Templete*, c. 1828–1829. Oil on canvas. El Templete, Plaza de Armas, Havana, Cuba. Reproduced courtesy of the OHC.

Vermay's positioning of the figures of women and children—seated, standing, or slightly kneeling on the ground in the lowest register on the left half of the canvas—echoes the position of the Native woman and child in the *cabildo* painting (see fig. 3.23). According to Lescano Abella, among these figures are representations of the wives of Jean-Baptiste Vermay, Gonzalo O'Farrill y Herrera, Montalvo, and de la Torre y Cárdenas.[114] A group of eight women dressed in dark green, red, and brown dresses with lacelike shawls sit or kneel in varying positions with sober, despondent, or vacant expressions. While the pictorial subordination of these women underscores their inferiority to the male figures, their inclusion in the work speaks to the assertive role of elite women in Bourbon-era society, particularly as the hostesses of fashionable *tertulias*.[115] Their presence, more specifically, as elite white women in proximity to children offers pure family lineage as an urban ideal.

This massive group portrait, framed physically within the classicizing architecture and buoyed by references to hallowed historical events, offered immense prestige to those whose likenesses appeared in the work.[116] In *Cecilia Valdés*, the nineteenth-century novel by Cirilo Villaverde, the author includes a scene at the Philharmonic Society ball in

Havana, set in 1830, where the elite, including titled nobility, mingled in an atmosphere of fine art. "There as well were the Chacón sisters," the author writes, "whose beauty earned them a place in the great canvas painted by Vermay to perpetuate the memory of the Mass celebrated at the inauguration of the Templete in the Plaza de Armas."[117] This passage underscores how elite identity in early-nineteenth-century Havana had been drawn into a new kind of public arena through affirmation of one's association with civic improvements.

As Bishop Espada censes the monument in the inauguration painting, he creates an indexical line that guides the viewer's eye to the painting *The First Mass*, an oil on canvas completed c. 1827 (see fig. I.5). The painting again transports the audience to the sixteenth-century town-founding event, this time emphasizing the city's religious origins. Beneath the massive canopy of a ceiba tree, a group of Spaniards gather in a circular arrangement as Bartolomé de Las Casas conducts a solemn Mass. In the press, Cabrera praised the artist's faithful construction of the tropical setting: "The ceiba under whose shade the altar appears, the parrot that rests in its top branches, the thorns and prickly pear trees scattered upon the ground, a clear and cloudless horizon at the time of the rising sun in the east—all indicate that the scene happened on the shore of the sea of some country near the equator."[118] The Dominican priest wears a red vestment appropriate to the transubstantiation of the Mass and stands with hands lifted in prayer directly in front of the ceiba tree's formidable trunk. Behind him, to his left, a cross is visible against the bark of the ceiba along with a white candle and a book of the Gospels arranged on a table draped in white cloth. The altar treatment symbolizes sanctity and purity and conceptually mirrors Bishop Espada's altar in the inauguration painting. In the space beyond, the water line of today's Havana harbor defines the horizon out of which the verdant hills rise, empty of any signs of human settlement. Organized in the same symmetrical manner as in the painting of the first *cabildo*, the ceiba tree becomes a central axis. The artist decorates the sides, foreground, and upper tree canopy with flora and fauna indicative of the tropical Americas, including the red parrot perched among the tree's branches.

Standing around the tree and the altar in a circular configuration are the pious Spaniards, expressing their devotion. Vermay's treatment of illusionistic space and figures with their backs turned to the viewer heightens

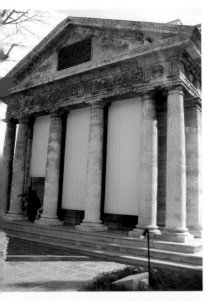

1 Antonio María de la Torre et al., portico, detail of
El Templete, 1827–1828. Plaza de Armas, Havana, Cuba.
Photograph by the author.

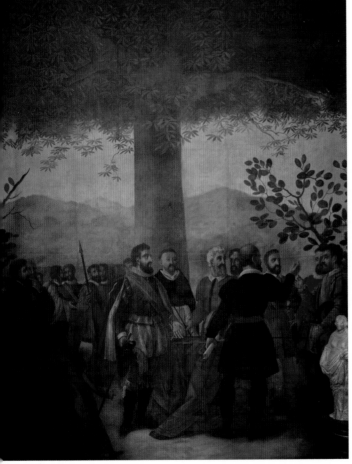

2 Jean-Baptiste Vermay,
The First Cabildo, c.
1827–1828. Oil on canvas,
approximately 13.75 × 11
ft. El Templete, Plaza de
Armas, Havana, Cuba.
Reproduced courtesy of
the Oficina del Historia-
dor de la Ciudad de La
Habana (hereafter OHC).

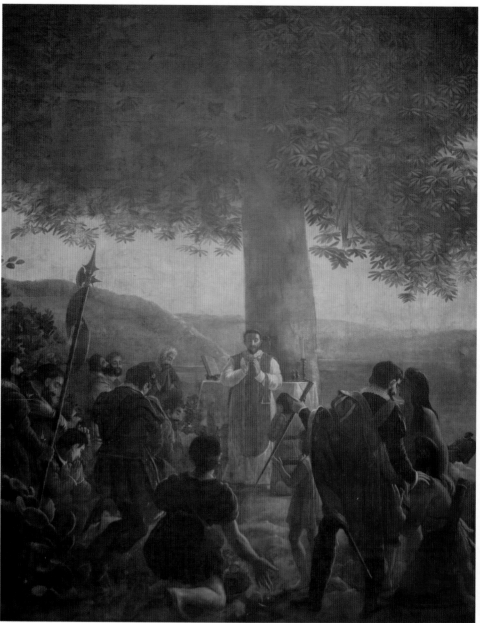

3 Jean-Baptiste Vermay, *The First Mass*, c. 1827–1828. Oil on canvas, approximately 13.75 × 11 ft. El Templete, Plaza de Armas, Havana, Cuba. Reproduced courtesy of the OHC.

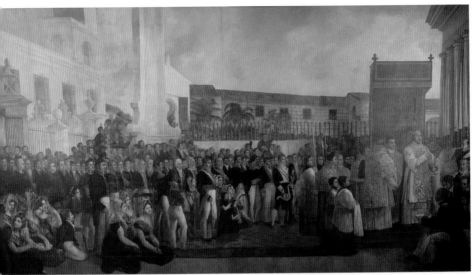

Jean-Baptiste Vermay, *The Inauguration of El Templete*, c. 1828–1829. Oil on canvas, approximately 13.75 × 30 ft. El Templete, Plaza de Armas, Havana, Cuba. Reproduced courtesy of the OHC.

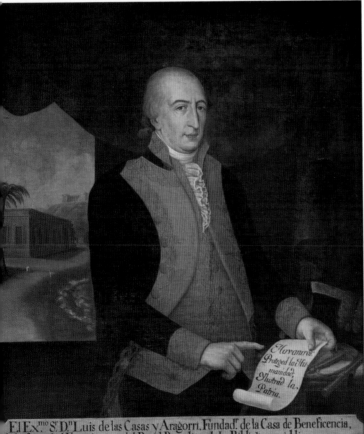

El Ex.^{mo} S.^r D.ⁿ Luis de las Casas y Aragorri, Fundad.^r de la Casa de Beneficencia, de la Sociedad Econòmica, del Papel Periodico, de la Biblioteca pùblica. La Sociedad conserva su imagen, y bendice su memoria. Juan del Río lo pintó.

5 Juan del Río, *Portrait of Luis de Las Casas*, c. 1790s. Oil on canvas. Courtesy of the OHC.

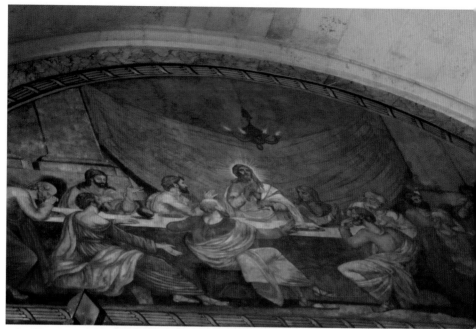

6 José Perovani and Jean-Baptiste Vermay, *The Last Supper*, early nineteenth century. Fresco, north lunette of the sanctuary, Cathedral of Havana. Photograph by the author. Reproduced courtesy of the OHC.

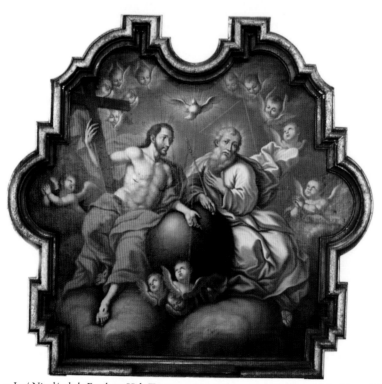

7 José Nicolás de la Escalera, *Holy Trinity*, c. 1800. Oil on panel. Courtesy of the Museo Nacional de Bellas Artes, Havana, Cuba.

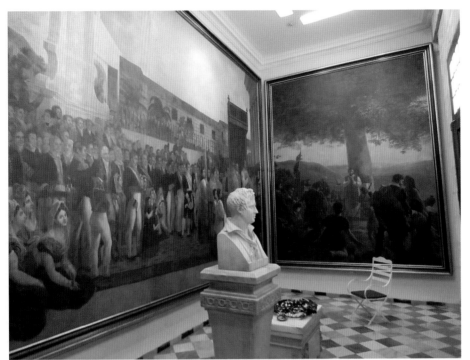

8 Interior of El Templete with views of *The First Mass* and *The Inauguration of El Templete* by Jean-Baptiste Vermay. Photo by the author. Reproduced courtesy of the OHC.

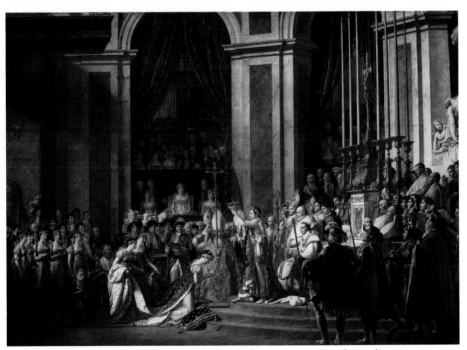

9 Jacques-Louis David, *The Coronation of the Emperor and Empress*, or *Le Sacre de Napoléon*, 1805–1807. Oil on canvas. Gianni Dagli Orti/The Art Archive at Art Resource, New York.

10 Jean-Baptiste Vermay, Amerindian woman and child in the presence of the conquistador Diego Velázquez, detail of *The First Cabildo*, c. 1827–1828. Oil on canvas. El Templete, Plaza de Armas, Havana, Cuba. Reproduced courtesy of the OHC.

1 Jean-Baptiste Vermay, *morena* domestic servant/slave with white women and child, detail of *The Inauguration of El Templete*, c. 1828–1829. Oil on canvas. El Templete, Plaza de Armas, Havana, Cuba. Reproduced courtesy of the OHC.

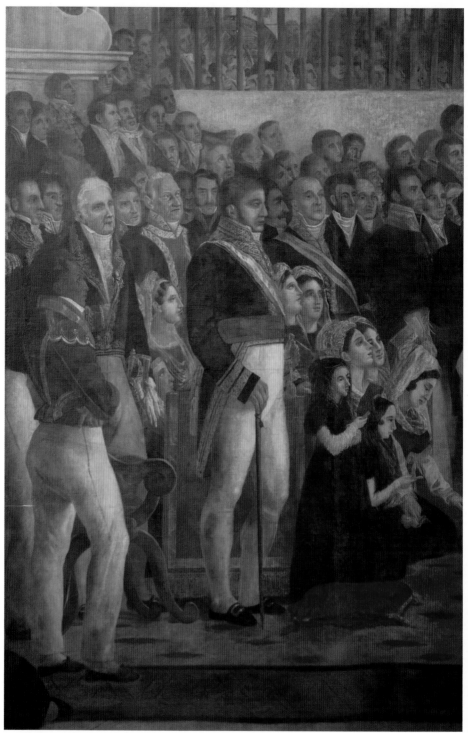

12 Jean-Baptiste Vermay, *pardo* militiaman standing alongside Captain General Vives, detail of *The Inauguration of El Templete*, c. 1828–1829. Oil on canvas. El Templete, Plaza de Armas, Havana, Cuba. Reproduced courtesy of the OHC.

the illusion of viewer participation in the event. One Spaniard in the foreground surrenders with passion to the spiritual power of the moment and falls to his knees with his hands outstretched. This figure, combined with Vermay's departures from the linear precision of David's painting style, reveals the impact of trends in early-nineteenth-century romanticism such as that found in the work of the Spanish painter Francisco José de Goya y Lucientes (1746–1828) or the Frenchman Théodore Géricault (1791–1824).

The conquistador Diego Velázquez reappears in *The First Mass*, as identified by the *Diario*, his back turned to the viewer and wearing the same red cape and sash on top of a blue uniform. He again stands contrapposto and reaches his right arm downward, placing his right hand on the shoulder of a prostrate Amerindian figure, identifiable by his long black hair and bare torso, in the pose of an orant. As if struck by the inherent truth of the Christian faith, the indigenous man is directed by Velázquez, who motions toward the altar while holding a familiar wooden staff in his left hand. A second Indian figure stands on the right side of the conquistador and likewise expresses reverence, as two indigenous children stand directly in front of Velázquez with raised arms and a third kneels in prayer before Bartolomé de Las Casas as if receiving the host. Vermay thus surrounds Velázquez with Amerindians in the scene, casting him in the role of a benevolent patriarch, whose concern is for their spiritual well-being. The *Diario de La Habana* praised the conquistador's "respectable and noble attitude . . . [and] affability with the Indians that he has at his side, in the action of approaching the altar with one of them, or explaining to him that which was being performed."[119] The Cuban historian Arrate ennobled Velázquez as a "reputable and rich person of great prudence and affability in the management and commissions that he had obtained."[120] Even though the Native figures are seemingly male in *The First Mass*, their curvilinear bodies evoke the visual lines that reformers associated with the baroque landscape, irrational passions, femininity, and the *castas*. The Spanish conquistadors again embody the serious, sober, and trabeated forms of neoclassicism, expressing their masculinity, inherent reason, and morality. Cabrera praises Vermay's creative genius: "The other group is composed of ten Spaniards hearing the Mass, well marked by their clothing and facial features, and in them is so admirable the fertile invention of the artist in the quality and success of the execution, because while all are pervaded by the same feelings, piety, and devotion, all manifest different expressions."[121]

Considered together, the paintings by Vermay in El Templete provide not only a colonial mise-en-scène for the founding and commemoration of the city but also an allegory of the journey from the natural and primitive to the rational, cultured, and refined. Visually, whether the spectator begins on the left or the right of the painted program, the first human figures in the sequence are Amerindians. From the location of the Indian figures on the outer margins, the eye on either side passes to the group of Spaniards under the ceiba tree, and both scenes of the sixteenth-century events draw the eye back to the inauguration scene. The painting of the first Mass likewise possesses directional lines created by the extended finger of Velázquez to the upper left, drawing one's attention back to the temple structure in the adjacent painting. As the inauguration scene stands on axis with the entire program and is farthest to the east, a profane-to-sacred directionality derived from religious architecture, this grand canvas is the ultimate destination for the viewer.

In the viewer's arrival at this scene, she or he charts the effects of human agency on Cuban history. From a living ceiba to the baroque pillar to the neoclassical hut, and from Indians and conquistadors to nineteenth-century *ilustrados*, the viewer discerns the ability of Spaniards and Cubans to extrapolate from the laws of nature in order to produce a civilized and "enlightened" nineteenth-century city. The content of the works thus validates the city's cultural modernity, its aesthetic refinement and level of education, and the agency of the upper-bourgeois male observer. The spatial and visual program affirmed his privileged gaze and celebrated his reason, vision, and *buen gusto*. The visual relationships between the painted elements in the monument and the framework of neoclassical architecture brought enlightened technologies of communication to bear on the construction of heritage. These technologies of space and visualization offer social relationships and cultural paradigms as objective and universal knowledge in an effort to codify political and social relations for multiple individuals and groups.[122]

REINSCRIBING COLUMBUS

While visiting El Templete in 1828, the observer received the image of another European historical figure in the bust of Christopher Columbus (fig. 3.28). Commissioned by Bishop Espada the same year and executed by

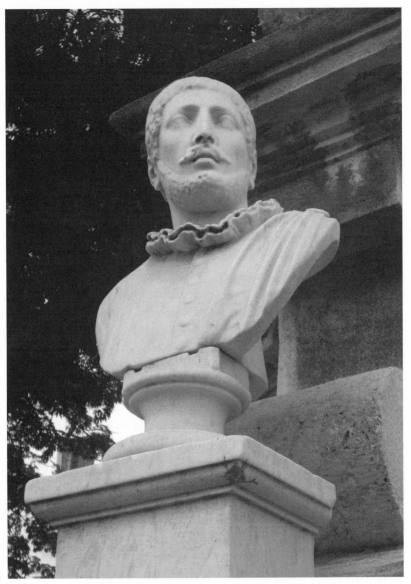

3.28 Anonymous, bust of Christopher Columbus, c. 1828. El Templete, Plaza de Armas, Havana, Cuba. Photograph by the author.

an unknown sculptor, the bust, as well as its inclusion, signals the Havana elite's understanding of Columbus as a mediating figure in the narrative of the Spanish Conquest that dominates the site. If we can imagine the bust situated at the center of the larger spatial program and mounted on the 1754 pillar facing the plaza as it is today, the noble and constructed visage of Columbus served as part of a central axis, literally and metaphorically. It was the turning point around which one revolved physically and narratively while contemplating the European and American dualities of Atlantic world history.

The appearance of this bust must have established an engaging juxtaposition between an ideal figure of an immortal Columbus and the late-eighteenth-century arrival in Havana of Columbus's mortal remains. Upon the French invasion of Saint Domingue in 1795, the alleged bodies of Christopher Columbus and his son, Diego, were brought to Havana from the city of Santo Domingo (modern capital of the Dominican Republic), where they had rested since 1536. The remains arrived on January 15, 1796, and Columbus's ashes were placed in an urn. This vessel was then put in a wall niche near the entrance of the Havana cathedral, to the left of the chancel.[123] Over the niche, a slab of stone was elaborately carved with a relief bust of Columbus crowned by a laurel wreath.[124]

Whether Havana received the actual remains of Columbus is uncertain. Several sites, including Seville, Spain; Santo Domingo, Dominican Republic; and Havana, Cuba, claim to house at least portions of the admiral's body. Yet the effort expended on securing the remains and commemorating Columbus reveals a reactivation of sixteenth-century historical figures to construct heritage and underpin identities in the present. For the Spanish Empire, invoking Columbus could reassert Spain's control of the hemisphere, as the Spanish Catholic kings had funded his voyage and claimed his "discoveries." Columbus validated the Spanish enterprise by playing the role of a pivotal figure. Yet, for Cubans, he could become the arbiter between European and American civilization in many ways, authorizing that Havana had received an elevated cultural standard. Filtered through the nineteenth-century classical imagination, Columbus's status as an Italian spoke a language of cultural authority.[125] As culture bearer, he graces El Templete in this metaphorical mediating position, right where one would enter and exit the memorial.

The white marble portrait bust donated by Bishop Espada for El Templete consists of a head and partial torso with a ruffled shirt, suggesting sixteenth-century finery.[126] The style of the hair, bearded face, and clothing connects this figure to Vermay's images of conquistadors within El Templete's paintings. The bust glorifies Columbus, his body reconstituted through ideal sculpture, raising his memory to the status of academic art and thus resonating against the many classical accoutrements of the monument.

As in visual art, Cuban historians wove Columbus firmly into local history, even though the admiral had scarcely visited the island.[127] Cuba's eighteenth-century bishop and historian Pedro Agustín Morell de Santa Cruz narrates the exploits of Diego Velázquez and Pánfilo de Narváez in the conquest of Cuba, but he begins with Columbus's arrival in the Caribbean. Even though the admiral was dead by the time of Cuba's conquest, he becomes an important and obligatory part of the providential narrative of the Spanish Christianization of the New World. Morell de Santa Cruz claims that Christopher Columbus was tall of body and that all aspects of his persona "breathed a noble air."[128] He was affable, humane with his domestics, jocular with his friends, and treated all as equals. Columbus had a magnanimous heart, practiced much circumspection and prudence in his conduct, and was always without ostentation. From this account, it appears that a foundation in civility was necessary to overcome the actual turmoil and brutality of the Spanish Conquest. Furthermore, Columbus appeared to possess the modes of civility and reformist behavior that late colonial Cubans hoped to encourage in society.

Through a complex spatial and visual sequence, El Templete served the interests of multiple patrons and allowed the nineteenth-century observer to consider her- or himself as belonging to, residing in, or visiting a reformed city. The monument served as a didactic tool, shaping collective memory while it reinforced the forgetting of certain more insidious aspects of the conquest. Yet this construction of a public or civic heritage, this reuse of the past in the service of the present, was presented to a heterogeneous audience. The heritage monument of 1828, which was aimed at constructing a certain type of new colonial subject, possessed an inherent dissonance, a fracturing of meaning and use. The visual syntax of the painted program could be reassembled in disparate ways based on the viewer's identity.

The remaining chapters map areas of potential signification in the heritage monuments to the ceiba tree during and after 1828, based on the presence of disparate audiences and a variety of social, political, economic, and cultural factors. In the collapse of Spain's viceregal system on the American mainland, the question of loyalty became a crucial issue in Cuba. Spanish censorship and suspicion abounded. Simultaneously, local elites expressed a discernible sense of belonging to Cuba, a *cubanidad*, albeit within the imperial orbit. The escalating population of African descent and stirrings of slave insurrection became a crisis of social control for the white elite. Into this complex spectrum of overlapping alliances come the heritage monuments to the ceiba tree in 1828, complex works operating within different but interconnected ideological frameworks and revealing the presence of multiple voices.

The Dissonance of
Colonial Heritage

The role of the Plaza de Armas in shaping views of normative authority, the contested nature of colonial society, and various threats to Spanish imperial rule in Cuba compel us to ask questions regarding El Templete's range of meanings for disparate audiences and the ambivalence of these audiences toward its myriad signs. While certain particular identities of church, state, and elite may have been underwritten by the work, it is important to consider El Templete as operating in the production of colonial ideology in general. The constructs of imperial versus local power and identity existed in complicated relationships to one another and, at times, seemed to function together within a complex late colonial situation. Such conditions speak to the potential for multiple uses of heritage in El Templete, an idea put forward by Brian Graham, G. J. Ashworth, and J. E. Tunbridge in *A Geography of Heritage*. The authors query, "Who decides what is heritage, and whose heritage is it? More simply put, can the past be 'owned' and, if so, who 'owns' it, what do we mean by 'own', and who reconciles conflicting claims to such ownership?"[1] These authors argue that "dissonance" appears to be intrinsic to heritage expressions in general, but especially to those made within multicultural societies; and dissonance is taken to mean a "discordance or lack of agreement and consistency as to the meaning of heritage."[2]

Following the rebellions of the mainland, Captain General Francisco Dionisio Vives asserted royal authority over the plaza and city of Havana through multiple means in an effort to ensure Cuban loyalty to Spain. El Templete became an important propaganda vehicle for the governor and an effort to inscribe his memory into colonial urban space. As numerous scholars have argued, Bishop Espada's agenda ran contrary to that of Vives in the former's attempt to express his allegiance to constitutional and regional liberties. This absolutism-constitutionalism struggle, while significant, is not in itself a complete analysis of the visual and spatial agency of El Templete. What of the bishop's efforts to instill reformist religious values in the city? Did his alleged involvement in Freemasonry have a civic, if cryptic, face? What of the multifaceted interests of an elite viewing public in Havana, a collective but by no means unified voice? How do we contextualize a heritage expression within such a complex society and contested historical moment, with the aftermath of revolution on the mainland and the rising slave population in Havana? In this chapter, I consider the multiple, entangled meanings within El Templete, a dissonance bound up with heritage and generated on the plaza in 1828. The expression of a colonial modernity in this case became a complex place-bound representation that allows us to more fully understand what has been categorized as a late colonial neoclassicism. Indeed, the foundational narrative itself can be seen as deriving from the representational functions of the plaza and its promotion of collective imagining within a fluctuating colonial spatial order.

THE CRISIS OF EMPIRE

The monument to Havana's foundational moment in 1828 on the main plaza was erected amid extreme political turbulence in late-eighteenth- and early-nineteenth-century Europe and America. The independence wars of mainland American colonies in the second and third decades of the nineteenth century disrupted the Spanish Empire enormously and raised questions about the notion of sovereignty. By 1827, Cuba and Puerto Rico stood as Spain's only remaining colonial possessions in the Americas. The meteoric rise of the sugar industry and abrupt shifts in Spain's economic policies toward the island reshaped Cuba's commercial situation within the Atlantic world. Pierre Nora's discussion of the construction of *lieux de*

mémoire (sites of memory) as responses to the social disruptions wrought by industrialization appears relevant here.[3] The rise of new wealth from the sugar industry in Cuba, imperial disintegration, increased Atlantic world commerce and traffic, and the intensifying politics of a slave society seem to have generated a social, political, and psychological climate in which stable and predictable connections to an ancestral past would serve to quell certain anxieties and reestablish imperial authority.

According to the nineteenth-century Cuban historian Francisco Calcagno, Captain General Francisco Dionisio Vives was born in North Africa in the city of Oran, which was under Spanish rule from 1732 to 1792.[4] He served in the campaign against the French Republic until the lieutenant general of the Spanish army Gonzalo O'Farrill y Herrera ordered him to Tuscany in 1806, having already achieved the rank of marshal. When Vives resigned the governorship of Cataluña, the Crown assigned him to Cuba, apparently despite his disgust. He arrived as captain general on March 2, 1823, and would serve until May 15, 1832. Perhaps contributing to his alleged disdain for the new American appointment, Governor Vives would have found himself in one of the most challenging political situations faced by a Cuban captain general to that time.

We can imagine Vives arriving in Cuba with a degree of skepticism toward Americans. After a decade of insurrection in the viceroyalty of New Spain, the Spanish monarch formally recognized the autonomous nation of Mexico on September 27, 1821. Meanwhile, in South America, the revolutionary leader Simón Bolívar inspired a widespread series of insurrections that left him president of a union of Latin American nations called Gran Colombia by 1825. Early-nineteenth-century Cuba had also experienced the fluctuating tide of Spanish politics. During King Ferdinand VII's house arrest in France throughout the Napoleonic occupation of Spain (1808–1813), the Spanish Cortes in exile in Cádiz had drafted and ratified the Spanish Constitution of 1812. With Napoleon ousted by 1815, Ferdinand reinstated himself as absolute Spanish monarch and promptly abolished the new social contract. When Spanish troops mutinied against the king in 1820, officials reinstated the Constitution of 1812, but only briefly.

In Cuba, the reinstated constitution was received in mixed ways. As Larry Jensen has argued, the reception of constitutionalism among the Havana elite "was born of a peculiar blend of idealism and self-interest:

admiration for the theoretical basis of constitutionalism mixed with fear of political innovation, an ironical coincidence of a new assertive 'American-ism' and a deepened identification with peninsular politics."[5] We could say that elite Cubans were differentiated somewhat in their political views on a spectrum from liberal innovators like Félix Varela to the many staunch-ly conservative Creole planters. The plantocracy generally abhorred politi-cal radicalism, as scholars have supposed, over the issue of slavery and the possibility of destabilizing the socioeconomic order from which planters benefited by collaboration with royal officials. In 1823, Cuban representa-tives of the Spanish mercantile sector and Varela, representing the interests of Cuban producers, were sent to Spain to advocate for Cuba before the Cortes. Things quickly went awry. Ferdinand VII succeeded in convinc-ing Louis XVIII of France to restore him as absolute monarch, abolish-ing the Constitution of 1812 once again. Varela, who had voted to depose Ferdinand, was forced to flee. The following year he arrived in the United States, where he would live out the rest of his life in exile, writing on behalf of Cuban independence.[6]

As a Caribbean island at the crossroads of Atlantic world traffic in material things, ideas, and people, Cuba was porous to the insurrec-tionist movements of the late eighteenth and early nineteenth centuries and the pervasiveness of Americanizing revolutionary imagery. In the wake of the North American, French, and Haitian Revolutions, Span-ish administrators in Cuba began to uncover plots of rebellion. In 1810, authorities discovered an independence movement composed of two aristocrats, a white officer, and black militia members that was propos-ing a constitution that would maintain slavery and keep whites in power. The group appropriated the island's pre-Hispanic past by devising a flag with an Indian woman entwined in a tobacco leaf.[7] In the early 1820s, the Spanish uncovered a Cuban section of Simón Bolívar's revolution-ary movement known as Soles y Rayos de Bolívar, organized through local Masonic lodges and led by José Francisco Lemus, a former military officer in Colombia.[8] The group intended to join an invading force of Bolívar's troops from Venezuela, topple the Spanish regime, and estab-lish an independent state to be called Cubanacán, appropriating an Amerindian word for Cuba. Bolívar himself spent a considerable part of 1816 in Haiti, receiving aid from Haitian president Alexandre Pétion.[9] The fact that the South American revolutionary took refuge on the

neighboring island in the 1810s would likely have alarmed most members of the Havana plantocracy.

Creole and Peninsular elites both shared in the fear of slave insurrection. In 1812, colonial authorities uncovered a planned slave rebellion led by a free man of color, José Antonio Aponte. The plot would unite various groups of slaves and *libertos* (free blacks) in an uprising against the Spanish regime and the Cuban oligarchy.[10] A carpenter, cabinetmaker, sculptor, devotee of the Virgen of Remedios, and former member of the Battalion of Loyal Morenos of Havana, Aponte lived in the Afro-Cuban neighborhoods of Havana's *barrios extramuros*. Based on documents of his interrogation by the authorities, we have descriptions of items seized from his residence. Among other things, he possessed a "book of architecture" and a "book of paintings" on which the authorities rigorously questioned him. The book of paintings contained seventy-two plates of disparate imagery, including icons, allegories, figures, and verses, which reveal Aponte's figurative and textual reconfigurations of a wide array of Atlantic World imagery and ideas relating to revolutionary events.[11] His drawings included Velona, the Roman deity of war; black soldiers; and a lion with a flag symbolizing the fatherland, "which is pictured as an Indian woman [held] in the arms of four other Indians, another woman with two drums, and another [drum?] turned around to face Mairel [Mariel?], which is how this Indian used to be called."[12] Aponte also depicted the Haitian rebel Toussaint L'Ouverture, Ethiopian royalty, and the Virgin of Regla. These images can effectively be viewed as subaltern or counterhegemonic productions of heritage, that is, efforts to manipulate collective heritage resources in ways that served the liberation of lower socioeconomic groups.

Spanish officials ultimately executed Aponte and his leading co-conspirators for their roles in the plot and placed their severed heads in cages near entrances to the city as a warning. The association between revolutionary activities in Cuba and Amerindian imagery is striking and suggests that elite appropriations of the Indian figure in a civic context in 1828 could have been a reaction against its use by revolutionary-minded subversives. The Indian figures in El Templete in their compliant interactions with the Spanish conquistadors could be seen, in this context, as an effort to present an image of a passive and deradicalized Indian to counter the use of this figure among rebels. The heritage of the Indian in late colonial

Cuba was thus contested, as manifested in tensions between official and quotidian appropriations.

In 1823, Captain General Vives and the Spanish administration in Havana confronted imperial disintegration, new American republics, an ambivalent attitude toward constitutionalism in Cuba, and the threat of slave insurrection in one of the last Spanish colonies in the hemisphere. Upon arrival, Vives immediately expressed his resolve to maintain order and allegiance, which was well expressed in the statement, "The time of illusion has passed; men no longer sacrifice themselves for mere theories."[13] While the Creole elite in Havana would continue to enjoy an unprecedented amount of economic privileges from Spain, the governor immediately curbed a variety of liberties, including instituting a comprehensive censorship of the colonial press.[14] The urgency with which Vives must have felt compelled to maintain political stability and social order may paradoxically account for his support of El Templete. The monument's visual and spatial feature could well be viewed as a construction of imperial heritage via certain configurations of visual narrative in an effort to establish a sense of imperial place and to reconstruct civic memory. As an imperial heritage, El Templete would, for Crown officials, sway interpretations of contemporary events and construct loyal subjectivity.

.

RHETORICS OF PATERNALISM

The captain general's dedication of the new memorial to the saint's day of Spanish queen María Josefa Amalia and to the recent victory of King Ferdinand VII over a liberal faction in Cataluña reveals an initial effort to inscribe El Templete as a testament to Cuban obedience. Authors for the *Diario de La Habana* showered the work with imperial propaganda in March and April 1828. These writings aimed not only to promote the monument's classicism and content but also to contextualize it for the elite reader and spectator. Articles explained the significance of El Templete's iconography and placed visual references within a certain repertoire of imperial signs. This discourse reinscribed the reformed subjectivity promoted by the memorial. It applied a paternalistic rhetoric and encouraged readers to see the monument's signs as validating a political theory that posited the king as head of an imperial body.[15] In this writing, loyalty becomes the natural order of things. Through inaugural festivities and

press coverage, Spanish authorities appropriated the alleged foundational site to stage a symbolic reconquest of the island.

As El Templete's inauguration drew closer in March of 1828, the propaganda intensified and the Plaza de Armas was transformed into a theater of civic spectacle, as was customary upon official occasions. Authorities ordered colonial residents with houses on the plaza to decorate their balconies and windows with *cortinajes vistosos* (decorative curtains).[16] Workers erected stages, platforms, and ephemeral triumphal arches and illuminated the Casas de Gobierno and Correos with candles and colored glass. Allegorical images representing Havana's piety and loyalty to the king were mounted on the Castillo de la Real Fuerza. Two plaques bearing sonnets hung from the Castillo de la Real Fuerza and the Casa de Gobierno, each extolling the piety and faithfulness of the city and proclaiming the Divine Providence that guided both the Spanish Conquest and Havana's prosperity.[17]

In the effort to reinscribe the city's foundational site with imperial meaning, the ceiba tree could become an imperial metaphor, as it had served the Spanish since the sixteenth century. The early modern relationship between king and vassals, as Alejandro Cañeque has shown, involved the conceptualization of natural mutuality.[18] Such a hierarchical order is articulated through the metaphor of a tree in a plate from *Rhetórica Christiana* created in 1579 by the Franciscan missionary, historian, and linguist Diego de Valadés and known as *Hierarchia Temporalis* (fig. 4.1). The image depicts a tree divided into multiple hierarchical registers created by its branches, which represent the various ranks of the Spanish Empire's secular authorities. In the center at the treetop is an image of the emperor seated on a throne. Lateral branches support regional kings of Europe, with the viceroy, the king's representative abroad, on the next level down. The "Governor" and "Auditor" flank the viceroy, with additional officials on the branches below.

At the base of the tree stands an allegorical figure of "Family," who addresses a succession of "Fathers" who approach with raised hands and pleading expressions. To the far right, we find "Mother," seated and nursing her infant child. In the register below the scene, in the metaphorical underworld, demons torment mortals condemned to damnation. The image overall constructs a natural, hierarchical order of the Spanish Empire via the metaphor of the tree and suggests the maintenance of secu-

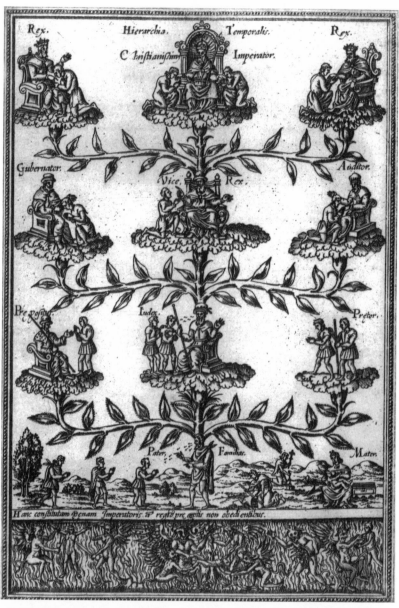

4.1 *Hierarchia Temporalis*, from *Rhetórica Christiana*, by Diego de Valadés, 1579. Courtesy of the Nettie Lee Benson Latin American Collection, University of Texas Libraries, The University of Texas at Austin.

lar order as an important path to salvation. By linking the emperor to the nuclear family, the image suggests a political symmetry between the imperial court and the family household. It establishes a chain of paternalistic authority, offering the emperor as the greatest father of all on earth and the temporal equivalent to God the Father in Heaven.

The widespread use of tree imagery within Christendom could contribute levels of sanctity to the use of the tree as a metaphor in an imperial and Catholic context. The art historian Simon Schama illustrates how early Christianity in Europe co-opted "pagan cults of nature" in the opening centuries of the first millennia to aid in conversion.[19] The cycles of the botanical world were paired with the theology of original sin, the sacrifice of Christ, and his resurrection. Genesis 2:9 identifies two trees in the Garden of Eden, the Tree of Knowledge of Good and Evil responsible for the fall of mankind and the Tree of Life, which became the path to salvation. A tenth-century Legend of the True Cross tells of the seeds of Edenic trees that, once ingested by Adam, supplied wood for Noah's ark, the rod of Moses, Solomon's temple, Joseph's workshop, and, ultimately, the cross of Christ.

In the Christian era, the Tree of Jesse became a common genealogical device used to express relationships between Old and New Testaments. The father of King David, Jesse served as a direct ancestor for Christ. In a stained-glass window in Chartres Cathedral, made in 1145, the tree sprouts from the loins of Jesse and forms a sacred family tree, culminating in the Passion. In fourteenth-century Italy, the crucifixion became fused with the tree motif and its ability to signify lineage in at least one particular case. Taddeo Gaddi's *The Tree of Life* (c. 1360), a fresco in the refectory at Santa Croce in Florence, Italy, utilizes the tree to connect Christ to the twelve apostles (fig. 4.2). In this scene, among other late medieval and early Renaissance representations, the human actors neatly inhabit a horizontal space created by a tree canopy that dominates the picture plane above.[20]

In Havana's El Templete, Spanish authorities employed the tree as a metaphor for the connectedness and organic relationships between civic, sacred, natural, and temporal worlds from the 1754 pillar to the 1828 monument. The two works more lucidly linked the arboreal symbolism of the site to divine and secular genealogy, political organization, and social structure. The multiple references to the original ceiba tree on the

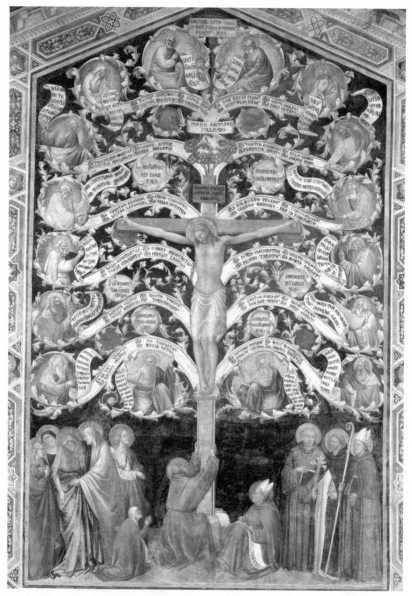

4.2 Taddeo Gaddi, *The Tree of Life*, c. 1360. Fresco, refectory, Sta. Croce, Florence, Italy. Scala/Art Resource, New York.

site in sculptural, painted, and architectural form could reinforce the natural and divinely ordained Spanish rulership of the island. An article in the *Diario de La Habana* of March 19 framed El Templete as a testament to Cuba's inevitable place within the imperial family and honored the city for respecting its Spanish ancestors. The author offered the new memorial as empirical proof of Cuba's Spanish patriotism, for the monument would serve as a beacon of stability in a world of upheaval, elevating reason over unrestrained passions: "[The monument will] present to the naturals of this beautiful country and to the foreigners that visit its shores, that simple but majestic building that in the middle of the horrors of political convulsions and in opposition to the torrent of romantic passions, daughters of our century, will elevate the love of one's country and loyalty."[21] Future generations would look back on this building and say, "My parents and my grandfathers . . . conceived this idea and carried it out; and we grow vain from descending from such illustrious lineage."[22]

And as for the mutinous brethren of the mainland, the author utterly condemns their treachery and vice: "Those denaturalized children of our country, who instead of offering monuments like this worthy of virtue and enlightenment, launched themselves into the arena, insulting . . . those to whom they owe their civilization and their glory."[23] All across the Americas, the children of empire had chosen "patricide," causing an offense to nature herself. Passages in the *Diario* cite locations of major revolutionary movements of the 1820s in areas under former viceregal control. References to the nobler sixteenth-century cities of Cortés and Columbus, once loyal to the Crown, constructed an image of Havana as fulfilling the promise of the Spanish Conquest.

The invocation of Christopher Columbus called upon the admiral's normative force in the narration of Europe's presumed civilizing role in the Americas, a figure exalted by eighteenth-century Cuban historians and represented in the marble bust at El Templete donated by Bishop Espada. The narration of Columbus recalled an Eden, a lost paradise, when the promise of Spanish Empire was fresh and untarnished by dissident thought. As El Templete imitated the forms of nature and synthesized them into a legible abstract language, so it cemented and gave "solidity" to Spain's colonial dominion. The rebels of the mainland, however, having disrespected the fundamental principles of nature, were left to fend for themselves:

We leave these gullibles to frenetically follow the path that leads to the deep abyss into which they are going to sink, or better, we beg Providence to stop them immediately and make them reflect "upon what they are and what they could be": and we happily turn our eyes to this island privileged with nature . . . while we, despising the suggestions of a false enlighten-ment . . . give on this day an evident proof of . . . how firm is our resolution not to contradict these principles.[24]

The inauguration ceremony for El Templete interrupted colonial urban life for three straight days and used the plaza, its new monument, and the press to articulate a revised vision of loyalty in an age of rebellion. Captain General Vives utilized public readership, communal gathering, imperial performances, and new expressions of political universality as a monumen-tal deterrent from thoughts of disloyalty and rebellion.[25]

HERITAGE AND COLONIAL PRACTICE

From the beginning of the conquest and colonization of the Americas, the Spanish deployed history as a discursive genre to construct and sus-tain colonial ideology. The existence of the indigenous population of the Americas perplexed sixteenth-century European intellectuals, who could find it neither in the writings of classical authors nor in biblical texts. Thus the construction of history from a European point of view could be found at the heart of Spanish colonial practice from the beginning, as the colo-nizers tried to explain the origin of the Indians throughout the early mod-ern period, tying it to biblical or classical narratives.[26]

In the more concrete arena of colonial space, missionaries and civic authorities deployed historical genres to create the sense of a natural suc-cession of power structures. Samuel Edgerton has argued that the Francis-cans in sixteenth-century New Spain created "theaters of conversion" by synthesizing visual forms of both Native and European significance into colonial expressions.[27] The Amerindian "world tree," thought of as a point of origination among Native populations, was fused with the Christian cross in the form of the numerous sculpted crosses found in the colonial *atrios* (courtyards) of sixteenth-century Franciscan missions. Conceptu-ally, the tree could represent the Tree of Jesse, convincing Native popula-tions that their own narratives of origination were merely confused ver-

sions of the universal Christian story that redeemed all mankind. Through the *atrio* and its imagery, the early friars created a communal space for the indoctrination of Amerindians. Jaime Lara has studied these sixteenth-century conversion practices with respect to medieval eschatology, a narrative genre that employed a belief in the apocalypse.[28] The use of the tree as metaphor by sixteenth-century Franciscans in New Spain does not imply a direct connection to El Templete in Havana. Rather, it reveals the strategic use of nature as Spanish colonial practice for its place within historical narratives of origination and ancestry, a process that began in the sixteenth century.

In the urban sphere, colonial authorities used the grand entrance of viceroys, the performance known as the *entrada*, to reconfigure history for the legitimization of colonial power. Seventeenth-century Mexico City's leading intelligentsia designed ephemeral *entrada* triumphal arches, such as the two designed by Sor Juana Inés de la Cruz and Carlos Sigüenza y Góngora for the event in 1680. Sor Juana describes the narrative function of the allegory on the arch of her design in *Neptuno alegórico* (1680).[29] Carlos Sigüenza y Góngora likewise discusses the iconography of his arch design and its narrative function in *Teatro de virtudes políticas* (1680).[30] The arches described contained images of both Aztec rulers and Spanish colonial viceroys, offering the king's representative in New Spain as the natural successor to former indigenous royalty. This practice represents dissonant heritage in the lack of agreement as to its significance before multiple audiences, including the colonial population composed of many indigenous and mestizo members, the viceregal court, the viceroy himself, and the Creole and Peninsular elite. Yet this lack of agreement over the significance of the past as a resource for the present in Mexico City was directly related to the proposed function of the arches themselves: to overcome a difference of vision by deploying a powerful rhetoric of imperial sameness. As the viceroy performed an oath during a formal ceremony at the culmination of the *entrada* to uphold the political virtues exemplified by the arches, he effectively activated the arches' reinscription of history and performed the coherence and compatibility of dual traditions.

The contextualization of El Templete in the colonial press as a testament to Spanish colonial rule based on the authority of nature and Spanish ancestry found visual reinforcement in the way certain elements within the larger program were deployed and could be interpreted together.

In this respect, the memorial functioned very much like the *entrada* arch to work out the contradictions of the colonial past in an effort to visually authorize the contemporary governor. In El Templete, the spectator first views and travels around the 1754 pillar that refers to the mid-eighteenth-century governor Cagigal, who first felled the ceiba tree. This pillar reappears in the inauguration painting in honor of Cagigal and also stands on a parallel axis to the standing portrait of Francisco Dionisio Vives, whose name is inscribed throughout the memorial. The work privileges Vives and visually connects him to the prior governor Cagigal as well as the conquistador Diego Velázquez.[31]

In *The First Cabildo* and its narrative on the foundation of civic authority in Havana, Velázquez occupies a central position, as does Vives in the inauguration scene. The two powerful figures are united by their possession of secular authority, Velázquez serving as first governor of Cuba in the sixteenth century. The red band around the waist of Vives resembles the red sash across the chest of Velázquez. Vermay also links the portrait of Vives and both images of Velázquez by the attributes of each figure (see figs. I.4, I.5, and 3.25). In the paintings of both the first Mass and the first *cabildo*, Velázquez holds a brown staff with a gray tassel near the top. In the inaugural scene, Vives supports himself, having just risen from his seat, with a near-identical staff. Not only did the staff represent power, virility, and masculine virtues in the conventions of early modern male portraiture, but it literally served as a ritual object passed from one political head to the next and symbolized the authority to govern a town.[32]

This visual connection between the captain general and the conquistador endowed the former with immense prestige within this context, suggesting his possession of the virtues of Velázquez that had been extolled by multiple writers.[33] Furthermore, within the framework of the primitive, protean, and culturally authentic construct of tree and temple, Velázquez is offered as a foundational figure from which Vives derives his nineteenth-century authority. The prestige of antiquity and the human agency suggested in the transformation of nature into culture privileges Governor Vives by offering his rule as having fulfilled the promise of the sixteenth-century civilizing of the American landscape.

Spain's fervent interest in its own history in the eighteenth and early nineteenth centuries led to a veritable cult of the *benemeritus* (national hero), past and present.[34] This distinction encompassed the recipi-

ent's place within a long succession of distinguished Spaniards, an honor bestowed upon Vives no less than twice in his career. The governor's prominent place in the paintings within this historic monument and his visual connections to past rulers render his campaign to stifle rebellion as natural and ordained. These historical associations, taken in tandem with other images and symbols in the memorial, construct a vision of Spain's inevitable rule in the Americas. The royal initials, the crowned orbs, and the bow and quiver of arrows offer Vives as a hero of imperial unification, one that would never allow Cuba to fall into the great abyss of rebellion and patricide.

BOTANY AND IMPERIAL SPACE

The sculptural and pictorial references to plants in El Templete and even the planting of flora on the grounds of the memorial can be viewed in the context of botanical classification and the production of imperial knowledge in the eighteenth- and early-nineteenth-century Spanish world. Six bronze pineapples on the monument's main piers, two giant representations of a ceiba tree in each Vermay painting, and the myriad other plants that appear in these pictures elevated the island's flora, perfecting it through fine art. As these representations championed the primacy of nature, they implied its mastery from certain points of view. Indeed, Spanish authorities and Cuban elite society each had a stake in rendering visible and knowable the island's rich botanical variety as Economic Societies in the Spanish world actively pursued the assimilation of Spanish and European scientific methods.

The bronze pineapples positioned upon neoclassical urns represented one of Cuba's chief agricultural products in the nineteenth century (see fig. 3.6). Their presence in the memorial thus alludes to the utilitarian and commercial goals of early modern Spanish natural history. Scholars have increasingly viewed Spain's and Portugal's eighteenth-century appropriation of the system of binomial nomenclature invented by the Swedish botanist, zoologist, and physician Carl Linnaeus (1707–1778) as a tool of empire to control agricultural commodities and territory.[35] The Spanish monarchy's support of fifty-seven botanical expeditions overseas between 1760 and 1808 led to the production of natural history representations that could be returned to Madrid for study and archiving.

The language of the Linnaean system provided imperial discourses with a consistent and "efficient" code for use by the European center, allowing botanical species, climate, and soil conditions to be recorded without much regard for local contingencies, including Amerindian or Creole terminology and explanations of natural history. Daniela Bleichmar has persuasively argued that the white background that typically surrounded such botanical images functioned in the production of homogenized European knowledge, deliberately separating plants from their local settings.[36] Such images thus made the "useful" resources of the empire visible, according to her argument, complementing broader projects to visualize and render legible the imperial realm. The use of Linnaean taxonomy attempted to standardize European botanical study, reducing American varietals to the binomial system. These images effectively produced knowledge, but as Bleichmar argues, the visual terms of that knowledge production were crucial and must be considered in all of their subtleties for what they represent and what they leave blank, for constructing both recall and oblivion.

As scholars have suggested, Spanish officials, naturalists, and political theorists produced botanical knowledge through various means as a tool to consolidate power over territory and manipulate agriculture. These efforts compelled information gathering by royal officials overseas. In Havana, Francisco Dionisio Vives launched a comprehensive survey of the island known as the "Cuadro estadístico de la siempre fiel isla de Cuba, correspondiente al año de 1827" (Statistical picture of the everfaithful island of Cuba, corresponding to the year 1827).[37] The statistics of Vives, published in 1829, recorded data on Cuba's astronomical situation, climate, plants, animals, minerals, commerce, population, territorial divisions, natural features, and urban configurations. Throughout this text, utilitarian and economic objectives are much in evidence. The statistics included "precious woods," such as mahogany, cedar, and royal ebony, and "woods for construction," including *ácana*, *yaba*, *sabicú*, *chicharrón*, and ceiba. The ceiba is specified "for canoes, and as the tree most pursued by parasites, it is said that it is anti-electric, and its seed gives a very fine wool."[38] This understanding of the ceiba reveals little advance in its "utility" since the sixteenth century, a lack of commercial use value that speaks of the tree's use in greening and shading public spaces and its symbolic value for other purposes.

The statistics of 1827 consider the *piña* (pineapple) among the "first class [of] indigenous and exotic [fruits]." However, the specimen that receives the most attention is the *palma real* (royal palm), "without doubt the most appreciated tree that grows in the island of Cuba, for the utility that all its parts offer."[39] Buildings, canals, tables, and meals could be made out of this "very tasteful and nutritional" tree. In addition to the palm's variety and multi-utility, the plant also seems to have risen to the fore in the statistics for its function as a royal signifier. The designation in Cuba of the royal palm suggests a colonial practice of selecting a highly useful and ubiquitous natural landscape element to inscribe with a mark of the king's presence. Vermay positions a few royal palms above the portrait of Vives in the inauguration painting, which underscores the association of this tree with royal authority (see fig. I.6). However, the entire memorial offered magisterial views of Cuban flora that constructed a royalist gaze by affirming the imperial "utility" of such botanical resources on the island.

Efforts to study and categorize local flora had been under way in Havana since the late eighteenth century. From the 1790s onward, the Economic Society of the city made repeated attempts to assimilate the botanical practices of Europe, first by accumulating significant scientific works for the Society library. In the period of 1790–1805, some forty-five *noticias* (news items) on natural history appeared in the *Papel Periódico de La Habana*.[40] Interest in botany grew with the visit of the Portuguese naturalist Antonio Parra to Cuba from 1791 to 1793. Parra came to Madrid in 1789 to donate part of his collection to Pedro Franco Dávila, director of the Royal Cabinet of Natural History.[41] In Madrid, Antonio Parra was made a corresponding member of the Royal Botanical Garden and asked by the Spanish king to travel to Cuba to study its flora. The *Papel Periódico* of December 25, 1791, explained the benefits of natural history and announced the appointment of Parra, who was "eager to carry it out with the highest skill, and knowing that in this island there are great varieties of productions as useful as they are unknown in Europe, he invites all doctors, aficionados, and lovers of natural sciences to join with his efforts and to take part in such a laudable goal."[42]

In the early 1790s, Francisco Arango y Parreño had proposed the creation of a botanical garden for Havana.[43] Along with Nicolás Calvo de la Puerta, Arango also called for the foundation of a School of Chemistry and Botany to benefit the development of the sugar industry. Negotiations

continued throughout the 1790s and the first decade of the nineteenth century, led by the Economic Society. The Havana botanical garden would be sited in a spacious area located in the *extramuros*. Society members, particularly the physician Tomás Romay Chacón, advised that such a garden for the city would improve pharmaceutical knowledge, benefit commerce, and aid in the instruction of the youth.[44] Alexander von Humboldt's high-profile visit to Cuba in 1800 with the French naturalist and physician Aimé Bonpland further stimulated local interest in science, as did Humboldt's return trip in 1804.[45]

In 1817, Havana established its botanical garden and dedicated it to the Spanish king. Located on one side of the Paseo de Extramuros near the Campo de Marté, the garden was situated on an extension of land at an expense of 7,000 pesos. The site was equipped with a structure for the school of botany, professors' housing, an herbarium, a seed deposit, and lodging for the gardener.[46] The Society *Memorias* of 1817 promoted the Botanical Garden of Havana, asking, "How long can we ignore the nomenclature of the naturalists . . . ?"[47] The garden would serve the production of research, contributions to agriculture and medicine, and the education of the public by allowing *habaneros* to see Cuban flora through the order of the Linnaean system. The *Memorias* of 1817 assured the reader that participation in botanical science "does not require complicated instruments: [only] good eyes, and a right and wise opinion, is all that nature asks of the philosopher who wants to look at one of its most interesting realms."[48] Although specialists practiced botanical science, members of the public could engage in the perception of nature's identity and order, if only they would inform their mind and improve their visual discernment.

The historians Antonio Lafuente and Nuria Valverde have suggested that multiple types of botanical epistemology and practice developed in the Spanish world in the eighteenth and early nineteenth centuries, one emphasizing a homogeneous, imperial vision, articulated from Madrid, and the other focused more on the local variation found in the Americas.[49] Rather than a centralized Spanish effort to harness the empire's resources, "Creole political botany" became, in many ways, a reaction against European homogenization of botanical knowledge. Creoles emphasized the vast, almost incalculable variety of their native flora as a response to imperial domination.[50] Bleichmar has argued that this Creole reaction took

visual form in a transition from the representation of botanical specimens against a white negative space to imagery that endowed American plants with "local color," depicting them within American environments.[51] The Vermay paintings inside El Templete likewise situate Cuban flora within a larger natural ecology, thus tying it firmly to the Cuban land and, one could argue, resisting European efforts to homogenize and control Cuban botany.

This tension between Havana's ready adaptation of European nomenclature and Linnaean methodology and the potential role the Vermay imagery in El Templete played in contesting a homogenizing classification by returning plants to their local contexts could be offered as one of the anomalies and ambiguities of late colonial visual culture, at least in Cuba. El Templete clearly engaged its viewers in local flora, taking them from a rectangular, garden-like space to a series of paintings that might have gratified the trained eye (or provided the training) in its ability to distinguish between the various floral specimens on view. In the context of Cuba, it does not appear that elite Cuban Creoles embarked on complex, systematic, and sustained discourses critiquing European homogenizing science, as occurred in mainland contexts.[52] Indeed, the full effect of the adaptation of European science in Havana and the questions it raises regarding local responses and perhaps contestations of imperial visual culture require much more research.

ARBOREAL SETTINGS AND
CULTURAL AUTHENTICITY IN EUROPE
AND THE ATLANTIC WORLD

While El Templete could be viewed synchronically as a response to momentary events, it could also be seen diachronically as the expression of an evolving sense of Cuban identity. A strong pride of place and historical self-awareness had developed in Havana by the end of the eighteenth century as the island became an ascendant economic force in the Atlantic world. The dissonance of heritage in El Templete can therefore be registered as a tension between imperializing homogeny and a pride of distinctiveness, indeed a pride in the Atlantic world city. This scenario thus lends itself to the formation of Atlantic centers of capital accumulation that Creoles, Peninsulars, *pardos/as*, *morenos/as*, slaves, *libertos/as*, the English, the

Spanish, the French, and the United Statesians were all compelled to negotiate.[53] The memorialization of the ceiba tree site in 1754 and 1828 reveals the interplay between Spanish imperial agendas and local efforts to define cultural origins and sites of collective memory, to authenticate the city by construction of a classical past, and to equate locality with established and prestigious traditions.

In terms of the cultural authentication of Havana's ceiba tree site, an important, indeed archetypal town-founding narrative appears in European classical history as a potential model for the story in Havana: the contest between Athena and Poseidon. When the first king of Athens, Cecrops, began searching for a patron deity for his city-state, Poseidon, god of the seas, and Athena, goddess of wisdom and skill, presented themselves before the king, who demanded a gift for the Athenians. Poseidon struck the ground with his trident, but only salty water sprang forth. Athena then did likewise with her spear, creating a hole, into which she planted an olive branch. From Athena's act, an olive tree grew that symbolized peace and prosperity. Cecrops, most pleased by Athena's gift, declared her the new patron deity and gave her name to the city. The tree grew on the Acropolis, within the Erechtheion and across from the Parthenon, the great temple of Athena. When the citizens of Athens visited the cult statue of their patron goddess during the annual Panathenaic procession, we can imagine them walking past a symbolic olive tree that represented the city's foundations and the goddess's commitment to bring peace and prosperity to Athens.

The patrons and designers of El Templete must have looked to classical precedents in an effort to infuse Greco-Roman antiquity into the ceiba tree site and, by extension, the city of Havana. The Cuban poet José María Heredia celebrated the glory of ancient Athens in his early-1820s poetry.[54] Athena's olive tree, in its connection to civic sanctity and its place in the sacred ceremonial center of Athens, could be said to relate in some ways to the Plaza de Armas in Havana. The educated patrons and artist of El Templete, members of the elite public, and local Freemasons likely knew that the ancient Romans possessed complex town-founding rites, involving augurs who divined the appropriate place for the city.[55] Yet the notion of locating a sacred or predestined place to found a town or to resanctify one already founded had a long history in Europe and in Spain's overseas colonies in the form of sacred devotions.

Such narratives appear in association with the Virgin Mary miraculously incarnated from a tree or plant as a means to create a sense of place and to Christianize the landscape. These include the Virgins of Valvanera, Begoña, Aránzazu, and even Remedios, where the plant is an agave cactus.[56] Ten years after the Virgin Mary allegedly appeared to the Indian Juan Diego in 1531 on the hill of Tepeyac near Mexico City, she made another appearance to an Indian named Juan Diego Bernardino. In 1541, Bernardino went to fetch water from a healing river near the town of Ocotlán in an effort to cure his family of their recent illness. As an acolyte for local Franciscan missionaries, he was known for his Catholic piety. On the way to the water source, he encountered a beautiful woman upon a hill who directed him to the healing waters and told him that he would find an image of her in the nearby pine groves for use in the Franciscan mission. Realizing it was the Virgin Mary, Juan Diego convinced the missionaries that evening to accompany him to the pine grove. At sunset, the trees seemed to be engulfed in flames, although none were consumed. One in particular, an *ocote* tree, began to swell. When the onlookers opened it with a hatchet, they found the statue of the Virgin as the lady had said they would, and they carried it to the church of St. Lawrence, where they installed it on the main altar.[57] The importance of Ocotlán grew in eighteenth-century New Spain, when Juan Antonio de Oviedo, in his *Zodiaco mariano* of 1755, wrote of its shrine as one of the first Marian sanctuaries in the realm.[58]

In the eighteenth century, such devotions began to appear in lucid detail in Spanish American colonial painting. The narrative of Ocotlán's sacred devotion became a subject for the Novo-Hispanic painter Juan de Villalobos, whose *Miracle of Ocotlán* (c. 1723) depicts the statue of the Virgin situated at the top of a flaming *ocote* tree (fig. 4.3).[59] The supernatural drama, the stagelike quality of the shallow picture plane, and the gesturing of the figures reveal baroque conventions. At the base, the Virgin's parents venerate the miracle as fire emits from their chests, flowing into the tree and upward toward the Virgin's cult statue. Villalobos utilizes Tree of Jesse iconography to denote the parents of the Virgin and the importance of her lineage. In the background below, one views the hills of Tlaxcala and the plaza of Ocotlán, fronted by the Franciscan church where the icon will eventually come to rest. The placement of divine actors and miraculous moments within actual colonial settings in paintings became

4.3 Juan de Villalobos, *Miracle of Ocotlán*, c. 1723. Sanctuary of Ocotlán, Tlaxcala, Mexico.

increasingly common in the eighteenth-century Spanish Americas, used here to underscore the sacred foundations of the town. The icon of the Virgin atop the *ocote* tree recalls the Virgin and Child in the statue surmounting the 1754 ceiba tree pillar in Havana as well as the Virgin of the Pillar in Zaragoza, Spain. All three belong to a baroque sensibility that

4.4 Manuel Caro, *Finding of the Virgin of Ocotlán*, 1781. Sanctuary of Ocotlán, Tlaxcala, Mexico.

consecrated, reconciled, and explained American place through miracle stories and sacred devotions.[60]

A work by Manuel Caro, *Finding of the Virgin of Ocotlán* (1781), reveals shifts in the artistic treatment of the same subject in New Spain. Here, the narrative is portrayed more academically, emphasizing "decorum" in its visual faithfulness to the narrative. Indians, friars, and urban residents appear in a scene bisected by a tree in which the Virgin stands (fig. 4.4). The evolution from imagining the Virgin and Child mounted atop the tree to one in which the same figures are found within the tree reflects an artist's faithfulness to the particularities of narrative. With the ascendancy of academic history painting in the Spanish world, a narrational literalism—as can also be seen in Rafael Ximeno y Planes's *The Miracle of the Well*—began to join the preference for otherworldly scenes suspended in time and space (see fig. 3.19). Nevertheless, the paintings by both Caro and Ximeno y Planes emphasize miracles, something that Espada may have been discouraging in Vermay's scene of the first Mass. Vermay's paintings seem to possess more restraint by comparison with Caro's Ocotlán scene, a work that one might say encourages outward bodily gesture by virtue of the gesticulations of the figures. These images thus belong to different religious and performative agendas, underscoring the relationship between early modern imagery and

the epistemologies and subjectivities it sought to cultivate in the phenomenal world.

While the pictorial narratives of the first Mass and first *cabildo* evince a visual restraint more aligned with religious reform than the Ocotlán paintings, they imply that the conquest of Cuba and the founding of Havana were divinely ordained. The tree appears to have been waiting on the invaders' arrival. The idea of a divinely ordained Spanish Conquest reinforced imperial control of the city and the island. Yet for anyone leaning toward the notion of Cuba as a *patria* in its own right, the narrative could operate in the construction of a sanctified sense of Cuban place.[61] The ceiba tree in both sixteenth-century scenes, with its pronounced cross shape, coded the landscape with Christianity, suggesting the ease with which the American land was civilized in Cuba. In this way, the paintings prefigure Havana's nineteenth-century commercial success in the triumph of the conquistadors.

The ceiba tree monuments could also have constructed a sense of cultural authenticity for Havana and the island of Cuba. The connection made by the Basque president Aguirre to the oak tree of Guernica in Spain's Basque Country raises questions about its appropriation in the memorials for Havana's plaza. Julio Caro Baroja refers to the oak of Guernica as "a superior symbol in the life of collectivity" in the Basque region.[62] Likely evolving out of pre-Christian tree festivals and rituals, this tree became a symbol of the integrity of the laws of Guernica in the fourteenth century, when King Enrique III of Castile met with Basque elders. Repeated attempts by the Spanish monarchs to impose more universal laws upon the Basque regions, from Enrique IV in the mid-fifteenth century to the Bourbon kings in the eighteenth, were met with a Basque insistence that regional customs and laws be respected. The oak of Guernica became synonymous with such resistance, the strength of local identity, and a pride of place. Civic oaks in the Basque Country performing similar functions in the center of towns existed at Avellaneda, Lujaondo, Larrazabal, Guerediaga, and Barajuen.[63]

In Anglophone contexts, the Guernica tree provided writers with a natural and romantic subject resonant of liberty. The English Romantic poet William Wordsworth celebrated the tradition of the Basque tree and its democratic spirit in 1810 with his poem "The Oak of Guernica," in which he wrote:

Oak of Guernica! Tree of holier power
Than that which in Dodona did enshrine . . .
a voice divine . . .
If nevermore within their shady round
Those lofty-minded Lawgivers shall meet,
Peasant and lord, in their appointed seat,
Guardians of Biscay's ancient liberty.[64]

Wordsworth recalled the sacred grove of the ancient Greek oracle of Dodona, where priests and priestesses interpreted the rustlings of the oak (or beech) in an effort to determine what actions to take. Overtones of the loss of liberty commingle with Romantic medieval imagery and a sense of the ancient past. The wide readership for Wordsworth's poetry on both sides of the Atlantic allowed this medieval sign of regional autonomy to circulate in a larger world of exchange.

The Basque region also witnessed the pairing of temple and tree after the advent of the Enlightenment. Around 1826, a Sala de Juntas (council hall) in the form of a Greco-Roman revival temple was built adjacent to the oak of Guernica (fig. 4.5). The building that stands there today consists of a Corinthian order portico eight columns across and two columns deep. The pediment above contains an elaborate sculptural relief of the Guernica tree, surrounded by emblems of strength, abundance, and Basqueness. Against the lower portico wall, eight pilasters, or engaged Corinthian columns, flank sculptural reliefs in medallions on the second level and seats below. These seats suggest a place where members of the Guernica assembly would sit at meetings in front of the tree. In spite of their difference in architectural orders and columnar quantity, the Sala de Juntas in Guernica and El Templete in Havana relate conceptually in a temple-tree formula.

Bishop Espada's natal, ethnic, and cultural connections to the Basque Country and his reformist agenda suggest that a connection between these buildings is probable, as the Basque president contended. The inspiration that the Guernica tree generated beyond Spain, as evidenced by Wordsworth's poem, and the traffic of ideas in the Atlantic world indicate the possibility of a transmission to Cuba of news about the commemoration of the Basque tree in 1826. However, a broader use of trees to signify ideals of liberty in this era can be found elsewhere.

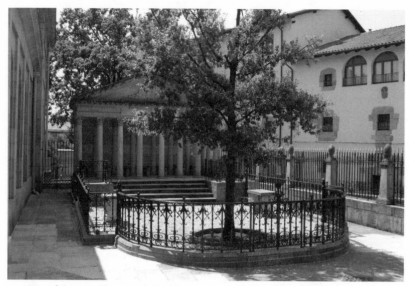

4.5 *Tree of Guernica*. Photograph. Building constructed c. 1826. Photograph © James Louie.

In the Age of Revolution, the "Tree of Liberty" seems to have begun with Boston's famous elm and others like it in the British North American colonies. Used for public gatherings, such trees became symbols of community and, according to the historian Alfred F. Young, were "sites of resistance" in stimulating opposition to the British Empire.[65] Young stresses that in the popular politics of the American Revolution, the liberty tree became indispensable as an urban space and a collective signifier and was eventually adapted by revolutionaries in France. First appropriated by the Sons of Liberty in 1765, a great elm tree in Boston became the site of protests, such as the hanging of British tax collectors in effigy, and a sign of a revolutionary cause.[66] Eventually, the liberty tree began to circulate through the Atlantic World via prints, such as *The Bostonians Paying the Excise-Man, or Tarring and Feathering* (fig. 4.6), first printed in 1774.

Closer to Cuba, references to the liberty tree appear in association with Toussaint L'Ouverture, the leader of the successful slave insurrection in Saint Domingue. Deceived, arrested, and exiled to prison in France in 1802, L'Ouverture stated upon his departure from the Caribbean, "In overthrowing me, you have cut down in San Domingo only the trunk of the tree of liberty of the blacks. It will spring up again by the roots, for they are numerous and deep."[67] This passage affirms a Caribbean circulation of the

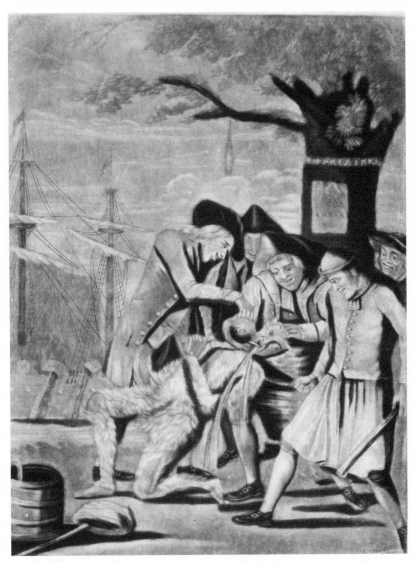

4.6 *The Bostonians Paying the Excise-Man, or Tarring and Feathering.* Printed by Robert Sayer and John Bennett, London, October 31, 1774. Mezzotint. Library of Congress Prints and Photographs Division, Washington, DC.

important revolutionary signifier, and people of all social ranks in Cuba must have had some knowledge of the liberty tree idea, given its prominence in the Atlantic world even well into the nineteenth century.

In the United States and France, liberty trees and liberty poles became sites of assembly, stages for representation, and images in the symbolic economy of revolution. The liberty tree could also be conceived in architectonic terms in association with democratic freedoms. In Thomas Paine's 1775 poem "Liberty Tree," the author writes:

Unmindful of names or distinctions they came,
For freemen like brothers agree:
With one spirit endow'd, they one friendship pursued,
And their temple was Liberty Tree.[68]

Paine's metaphorical equation of tree with temple implies its existence as a social space. A sense of collectivity surrounding the tree resonates in another line, "In defense of *our* Liberty Tree" (emphasis mine). At the very least, Paine's writing here relates to broader discursive efforts in this period to will the liberty tree into a collective sign resonant of the revolutionary cause.

Such revolutionary ideas seem to have made their way easily through Spanish imperial boundaries. Texts and imagery disseminated signs that if not immediately recognized by authorities as revolutionary in content, could be appropriated for local subversive purposes. Such a role for Atlantic imagery is attested to by the *libro de pinturas* (book of pictures) found in the possession of José Antonio Aponte in Havana along with other items in his apartment, including images of Toussaint L'Ouverture and George Washington. Insular boundaries did not stop the traffic in Atlantic ideas, texts, and imagery, nor did Cubans remain introspective. In the 1820s, a Cuban professor, José Antonio Saco, among others, traveled to Philadelphia, Pennsylvania, where Félix Varela resided within a growing Cuban exile community. Saco came and went from the United States and Cuba in these years, and surely would have been exposed to a host of expressions, including liberty tree/liberty pole imagery and practices.[69] A vigorous contraband trade on the eastern parts of the island facilitated interchange between the United States and Cuba, an exchange institutionalized by the Spanish declaration of free trade in 1819.[70] People of African descent also traveled and moved around the Atlantic world in response to revolutionary change, transporting all sorts of knowledge.[71]

We cannot rule out the possibility that the Spanish authorities sought to use El Templete as a means of deradicalizing the ceiba tree and suppressing potential associations with the tree of liberty. Yet Espada and others may indeed have conspired to subvert this effort and turn the representation toward, if not revolutionary ends, then constitutional ones. Thus El Templete could be seen as a subversive effort to construct a space of constitutional monarchy within reactionary absolutism, that is, to democratize the plaza as a revival of the spirit of 1812.[72] However, these considerations tend to slide back into binary readings, and the monument seems to have done much more than mediate two agendas.

PATRIOTIC ANCESTORS AND THE FIGURE OF THE INDIAN

While the *Diario de La Habana* suggested that El Templete evoked an antiquity comparable to that of the Aztec and the Inca, the indigenous population of Cuba left no stone architecture that could be invoked as a reminder of a heroic past.[73] Pre-Hispanic civilizations had become important resources for national representation in mainland contexts. Thus monumentalizing the foundational ceiba tree invented an otherwise nonexistent antiquity for Cuba in comparison to the emerging nations of the mainland. The combination of tree and temple in Havana, a trope of human inventive capacity in the work of French architectural theorists and perhaps related to the notion of perfected signs in Varela's thinking, stressed the ascendancy of reason in the city and lent a deeper sense of cultural authenticity to the theme of town founding.

If Cuba's unique history could be located in the island's pre-Hispanic past, then Vermay's inclusion of Indian figures in the paintings of the first Mass and first *cabildo* advanced with images what late-eighteenth-century historiography did with texts.[74] The Cuban historians José Martín Félix de Arrate (1701–1765) and Ignacio de Urrutia y Montoya (1735–1795) both include the Indian figure in their respective works. In Arrate's *Llave del Nuevo Mundo*, the author recounts the indigenous origins of the island's name, Cubanacán, along with the nature of Cuba's pre-Hispanic inhabitants. On the character of the Indians of Cuba, Arrate writes, "They were of peaceful, docile, and bashful nature, very reverent with the superiors, [and] of great ability and aptitude in the instructions of the faith."[75] Arrate

used sources on the Indian from New Spain, drawing on such Spanish chroniclers and eighteenth-century writers as Antonio de Solís, Antonio de Herrera, and Bernal Díaz del Castillo.[76] He uses Juan de Torquemada's *Monarquía indiana* (1615) to give an account of the first state of the world and the barbaric peoples who conducted blood sacrifices.[77] Arrate assures the reader, nevertheless, that the Indians of Cuba did not practice such diabolical rituals, instead living in "beautiful indolence."[78]

The Cuban historian Ignacio de Urrutia y Montoya's *Teatro histórico*, published in 1789, also reported on the Indians of Cuba.[79] Educated in both New Spain and Havana, Urrutia y Montoya cites some of the same authors as Arrate, including Herrera and Torquemada, along with José de Acosta.[80] He likewise wrote of Cuba's peaceful Indians, but focused considerable attention on their origins, citing Gregorio García's *Origen de los indios del Nuevo Mundo* of 1607.[81] He writes that the Indians of Cuba knew of a universal flood and that they possessed "principles of the true religion."[82] Cañizares-Esguerra has argued that such eighteenth-century histories represent the emergence of a "patriotic epistemology" in Spanish America that attempts to humanize Indians by suggesting that they were part of the biblical story of Genesis and thus easily converted to Christianity.[83] If Indians were human, that is, descended from Adam and Eve, it validated American civilization in the face of eighteenth-century Northern European attacks on Spain and the Spanish Americas in the writings of such figures as George-Louis Leclerc, comte de Buffon; Cornelius de Pauw; and William Robertson. I do not suggest that an identical process was under way in eighteenth-century Cuba, yet some of the same themes and arguments about the Indian seem to have been advanced by Cuban writers.

The appropriation of Gregorio García's *Origen de los indios del Nuevo Mundo* (1607) by the Cuban historian Urrutia y Montoya also lends itself to an attempt to cleanse racial mixing in Cuba. García's work set out to affirm that Spanish-Indian mixing in the New World could be viewed as a redemptive process: the problems of Indian blood could be redeemed through Spanish intermarriage and gradual "whitening."[84] The author based this assertion on the theory that Indians did not descend from the Jews because it was possible that they had arrived in the New World prior to the death of Christ. Therefore, their lineage was unblemished. Historians view this argument as an attempt to suggest that the large number

of mestizos in the Americas could achieve a status equaling Spaniards if their blood contained a majority of Spanish traces. If Urrutia y Montoya deployed García to argue that *mestizaje* in Cuba could be viewed as a similar redemptive process, he was borrowing heavily from a theory constructed to apply to mainland contexts where the issue of Spanish-Indian mixing was far more salient. Yet in Cuba, the thought of blood mixing in general surely evoked the Spanish-African mixture that elite whites increasingly abhorred. In turn, if Vermay used historians such as Urrutia y Montoya to construct his pictorial narratives in 1828, he may have composed what the elite would have viewed as an acceptable racial mixture, that of Spaniard-Indian, to counter fears of Spaniard-African mixtures, as will be addressed further in the next chapter.

The Cuban historian Antonio J. Valdés (1780–1850), in his *Historia de la isla de Cuba y en especial de La Habana* (1813), likewise sympathized with the Indian in his narration of the encounter between the conquistador Diego Velázquez and the recalcitrant Taíno named Hatuey who rebelled against the Spanish invaders. The historian indicts the conquistador for terrorizing the inhabitants of the island, yet reminds the reader about the nature of the early Spanish conquerors. "Velázquez, following the cruel principles of those times, as distinct from the enlightenment of our days, considered him [Hatuey] as a slave that had brought arms against his Lord; and condemned him to the flames."[85] Here, Valdés not only further humanizes the Indian but also contextualizes the cruelty of the conquistadors and goes on to describe Velázquez as a man of tremendous military and political merits. This cleansing of the conquest worked to construct a picture of Cuba as resting firmly on rational foundations of the Spanish-Indian interaction that might justify an early-nineteenth-century elite viewer living with the contradictions of agricultural abundance and a socially fraught slave society.

Reflections on pre-Hispanic antiquity in Havana were further promoted by early-nineteenth-century Cuban literature. The poetry of José María Heredia, born in Santiago de Cuba in 1803, contains a rich array of writings dedicated to the antiquity of Europe and America, the history of the early modern world, and contemporary political events and figures.[86] Heredia studied at the University of Havana in 1818 and the University of Mexico in 1820. While in Havana, he apparently became a close friend of Jean-Baptiste Vermay.[87] In New Spain, his work reveals the assimilation of

compassion toward the Indian in such poems as "En el Teocalli de Cholula" (In the Teocalli of Cholula), a work that recounts the vicious slaughter of the innocent residents of the indigenous city of Cholula by the Spanish conquistadors. His writing assumed political overtones, praising the reestablishment of the Spanish constitution in 1820, championing the outbreak of the Greek struggle for independence against the Ottoman Turks in 1821, and juxtaposing independence-minded and romanticizing poems with reflections on the ancient origins of the Aztec people, as found in his "Oda de los habitantes de Anáhuac" (Ode to the inhabitants of Anáhuac; 1822). He returned to Havana in 1821 but was forced into exile in 1823 for his involvement in the Bolivarian conspiracy Los Soles y Rayos de Bolívar. While most of his work was published in Mexico and the United States, and I am unaware of the circulation of his poems in Cuba, where they were considered controversial, Heredia's poetry reveals the liberal thinking of a literary figure who knew Vermay and composed his work from a wide variety of discursive sources in the Atlantic world.

Within the two conquistador-Indian/town-founding scenes by Vermay, the artist seems to both humanize the Indian and allude to Spanish-Indian racial mixing. The conquistador Velázquez compassionately guides an Indian man in the painting of the first Mass and stands just to the right of an Indian mother and child in that of the first *cabildo*. In this vignette, the wooden staff of Velázquez crosses the Indian child's body as the child pivots to his left toward the conquistador and seems to raise his finger upward as if gesturing in curiosity (fig. 4.7; plate 10). Notably, the skin tones of these three figures differ substantially. In contrast to the pale skin tone of the conquistador, that of the indigenous mother possesses a maroon shade. The skin color of the child, however, is lighter than hers yet darker than that of Velázquez. The spatial proximity of these figures within the *cabildo* painting, their interactive directional lines, and their different skin tones suggest that Vermay's work engages the topic of racial lineage. He seems to offer the child as the mestizo/a, the crossed offspring of a Spaniard and an Indian, whose blood has been "whitened" by partial European parentage.[88] The position of these figures on the flank of the larger three-part painting series locates a point of racial origination for Cuba as a place where Spaniards began a process of redeeming Indian blood through intermarriage. Once again, this vignette could allude to an acceptable miscegenation, perhaps to calm elite fears about Spanish-African mixing.

4.7 Jean-Baptiste Vermay, Amerindian woman and child in the presence of the conquistador Diego Velázquez, detail of *The First Cabildo*, c. 1827–1828. Oil on canvas. El Templete, Plaza de Armas, Havana, Cuba. Reproduced courtesy of the OHC.

4.8 Luis de Mena, *Caste Painting*, c. 1750. Oil on canvas. Courtesy of the Museo de América, Madrid. Erich Lessing/Art Resource, New York.

Vermay's construction of this quasi-familial triad of disparate racial types resembles something of the more formalized eighteenth-century *casta* painting genre in New Spain that dealt specifically with racial mixing. This genre addressed the human complexity of viceregal Mexico City as images of exotica for European consumers, as attempts to bring visual order to the various racial types in colonial society, and perhaps as images associated with local pride.[89] The paintings typically appeared as single installments and sometimes as larger series, which invariably begin with

Spanish-Indian mixing. Luis de Mena's *Caste Painting* (c. 1750), oil on canvas, presents a sequence of eight *casta* paintings in two central registers revealing eight and one-half of the usual sixteen vignettes. The scenes represent different racial mixtures among individuals of disparate categorization signified by divergent skin tones (fig. 4.8). In the first installment, a Spanish woman of pale skin has procreated with an Indian of maroon skin to produce a mestizo child whose hands and face reveal his skin to be lighter than his father's yet darker than his mother's. The painting visually and textually articulates various peregrinations through the *sistema de castas* (caste system), as in the next vignette when a Spaniard and a mestizo produce a *castizo*. Yet the series reveals that Spanish blood can be redeemed upon its mixture with Indian blood, in the demonstrated ability to arrive back at Spaniard after several generations. The series makes clear, however, that African blood stains the family's *limpieza de sangre* indefinitely, as there is no returning to Spaniard once tainted in this way.

Vermay's allusions to Indian-Spaniard mixing in the two sixteenth-century scenes for El Templete offer a mixture thought to be redeemable by the *casta* system precisely to elevate *limpieza de sangre*. His works, within the larger classicizing program, speak with confidence on the ability to locate racial order, as expressed in essential terms. Not only did such images further the ordering objectives of the Spanish state, it made subjects highly legible within their racial castes. Furthermore, the artist constructs the theme of whitening within the framework of reason and ascending civilization, suggesting that Indian blood can and would be overcome by the arrangement of the overwhelming lightness of the skin tones in the inauguration scene representing individuals who were classified legally as whites. If the paintings are read together, the racial trajectory seems clear. Indian blood spent a very brief time circulating through the veins of Cuban elites historically, soon to give way to Spanish whiteness. Yet its historic presence could be used as a means of distinguishing Creoles from Peninsulars. African blood, on the other hand, is nowhere to be found in the city's early moments.

This celebration of racial whiteness seems to be coupled tightly with a pride in the city, as seen in the physical fabric of the work. In 1820, the Englishman Robert Jameson noted a Creole ontological connection to the Cuban land: "In Cuba . . . the *Hacendados*, or great proprietors, are, almost generally, natives of the island; their ancestors were born there; it

is their country, in the full sense of the word, in which they live and in which they hope to die."[90] The theme of antiquity embodied by classicism is echoed in Jameson's observation about the link between Cuban *hacendados* and their ancestors, ultimately the Spanish conquistadors. Prestigious titles could be acquired by Creole elites who claimed direct descent from the Spanish conquerors. Since the conquest, Creoles dominated the *cabildo* and possessed the right to distribute public lands, which the Bourbons eliminated in 1729.[91] El Templete thus offers the first *cabildo* as a statement on the antiquity of Creole agency. If read by this Creole audience, the images suggest that the conquistadors' natural right to rule validated not Spanish imperial authority, but Creole entitlement to land and independent self-action.

A week after the monument's inauguration, an article of March 27, 1828, in the *Diario de La Habana* advanced the civic modernity of Havana. Entitled "Something More on the New Monument Erected on the Plaza de Armas," the passage read: "The island of Cuba, in the progress of its laws, of its customs, and of its wealth, has already begun to be elevated to the rank of the most cultured towns of Europe; the extension of its commerce and of its relations can be felt in the most remote countries of the world, natural consequences of its privileged situation, climate, and political conduct of its inhabitants."[92] Here classicism becomes more than a sign of European dominion and is transmuted into a language that elevates a geographically privileged Atlantic world city of robust commerce and high culture. Expressions of loyalty were couched within an elite utterance of collective pride in the city's modernity, as measured against a European paradigm. El Templete reconstructed the past to advance so many different claims: imperial validity, the authenticity of place, and the inevitability of Cuban elite racial purity.[93] Classicism could thus homogenize, standardize, and then particularize as it was refracted through the multitudinous demands of a complex colonial society.

THE ROMANCE OF CUBAN FLORA

In contrast to the scientific precision in viewing nature found in the statistics sponsored by Captain General Vives and other practices related to what has been called an imperial biopolitics or Creole botany, Cuban poetry around the turn of the century reveals neoclassical and roman-

ticist leanings in various "patriotic" expressions of Cuban nature. In the poems of Manuel de Zequeira y Arango (1760–1846) and Manuel Justo de Rubalcava (1763–1805), the authors situate the island's flora within discourses of classical antiquity that thoroughly romanticize the Cuban land.[94] In Zequeira y Arango's poem "Oda a la piña/Ode to the Pineapple," the author explores the antiquity of the fruit by locating it in the fertile lands of Vesta, the Roman goddess of hearth, home, and family.[95] Splendidly dressed and plumed, the pineapple was "embroidered" by Ceres, the Roman goddess of agriculture. The pineapple's nectar soothed the pains of Venus, and she called out to Ganymede, "The pineapple . . . the fragrant pineapple; in my gardens it is cultivated; by the hands of my nymphs."[96] The poet invokes Mother Nature to "Save happy Havana!" and exalts her for providing "the honey-colored nectar of the pineapple."[97] Jupiter, the king of gods, never struck pineapple fields with lightning, nor did Belona, the goddess of war, allow human blood to be spilled in them. Throughout the poem, Zequeira y Arango speaks to the pineapple in the second person, offering in the final stanza, "And so the aurora with divine breath; Sprouting pearls that curdle in your breast; Keep your splendor, so that you can be; The pomp of my Patria."[98]

Regardless of the fact that the pineapple is a plant indigenous to South America first encountered by a European in the person of Christopher Columbus in 1493, Manuel de Zequeira y Arango must demonstrate that Mediterranean deities protected and utilized this American fruit in ancient times. The Eurocentric framework for the American sign authorizes it, while the poet simultaneously offers the pineapple as an indispensable symbol of Cuban patriotism. In a similar vein, Manuel Justo de Rubalcava's poem "El tabaco" posits another product of Cuban agriculture, its *yerba indiana* (Indian grass), in relationship to the Roman god of wine, Bacchus; the Greek goddess of the evening star, Hesper; the hallowed Mt. Parnassus; and the Roman god of the sun, Apollo.[99] He writes, "Of Cuba the enjoyable productions! . . . In honor of the Patria and of Pomona [Roman goddess of fruitful abundance]."[100] The fact that tobacco did not exist for Europeans prior to the conquest of the Americas does not deter the poet. Rubalcava, like his contemporary Zequeira y Arango, constructs a new knowledge that underpins identities in the present by co-opting European antiquity as a foundation for a Cuban pride of place. We

can imagine how viewing ceiba trees, cacti, and pineapples in El Templete, framed within a larger program of Greco-Roman classical revival, functioned in similar ways. Classicism valorized the familiar within a discourse of European antiquity.

The Cuban poet José María Heredia also wrote on the subject of nature, frequently exploring the natural implications of Cuba's geography. In "La estación de los Nortes" (The season of the North), the author outlines the pitfalls of the island's climatic zone, from outbreaks of yellow fever, to humidity, to "the rigor of August."[101] Nevertheless, he contrasts the weather of his homeland to "the climates of sad Europe"[102] that include the vicious north winds that render the land naked, which is then covered with snow. To Cuba, Heredia expresses, "I will happily sing my love, my homeland, of the beauty of your face and of your soul, and your ineffable love and my fortune."[103] Another poem, "Al sol," probes the intensity of Cuba's sunlight, its tropical heat, its vibrant colors, and the palms and oranges that it nourishes. The sun poem avoids mention of Europe, however, and instead elevates American antiquity:

> As in the fields of ancient Persia,
> Your altar glistened; as in Cuzco
> The Inca and their people respected you.
> The Inca! Who, on pronouncing your name,
> If you were not born evil,
> Will be able to stop the crying . . . ?
> Simple and pure,
> Of its creatures in the most sublime
> Adoring the author of the universe
> That people of brothers,
> Lifted up to you their innocent hands.[104]

Heredia's work suggests the Cuban poet's search for a pan-American antiquity that forecast the writings of José Martí half a century later. As Cuba had no pre-Columbian remains, when patriotic sentiments grew more intense, the island's intellectuals turned their view to the great civilizations of Mexico and Peru as well as to Europe. The search for José Martí's "our America"[105] seems to have its beginnings in such discourses, yet European antiquity and classicism still served as a conceptual support for Cuban identity in 1828, as it did in other parts of the Americas.

The heritage dissonance in El Templete speaks to multiple uses and significations of legible signs. Spain reinforced its power over the island in this period via urban spatial reconstructions, intensified propaganda, greater censorship of the press, botanical science, and other forms of classification and record keeping. Yet civil society offered an empowered space for assimilation, whereby local and civic projects could flourish with elite Creole engagement. Clearly, Creole/Peninsular, local/imperial identity cannot be completely disentangled. Nevertheless, what we can call Cuban patriotic reuses of a broad European and Atlantic past informed new, invented traditions intended to serve the present elite community. The need to carve out regionalist, localist, and civic representation can be seen as a Cuban sword with an alternate edge. While one group could inherit the island's earth, its land, its agriculture, another would have to be managed, surveyed, and systematically disinherited. If Creole elites could express their belonging to the fraternity of the European Enlightenment in their own terms, they could also turn its terms of meaning against their own societies in a convoluted attempt at racial reconstruction.

Sugar, Slavery, and Disinheritance

The heritage process to which the foundational ceiba tree site in Havana belonged employed neoclassical architecture, history painting, and ideal sculpture to reify both the imperial status quo and a sense of Cuban place. Yet these forms operated within colonial society and could function in the establishment of normative social relations. The social ideologies constructed by the imagery and architectural space of El Templete in 1828 merit consideration for how heritage, constructed by the fine arts, became a cultural tool of hegemonic groups. The social context of "high" cultural production during and after the so-called Enlightenment and the role of the arts in maintaining a revised status quo have been dealt with by a number of scholars.[1] In the context of early-nineteenth-century heritage production in Havana, the neoclassical architecture, history painting, and ideal sculpture became integral to the production of not only cultural but also social knowledge. The heritage of the ceiba tree thus belonged to a project of rigorous social differentiation driven by the increasingly bitter politics of race as a result of the sugar industry, slavery, and demographic shifts.

El Templete became not only a struggle for the possession of signs, such as Indians, conquistadors, and Greco-Roman revival temples, but also a means of supercoding them through academic classicism. The perceived Africanization of the island, which was of such concern to royal officials and

social elites, led to an intensifying need among this elite to rationally delineate race, lineage, and *calidad* in order to maintain the social hierarchy and the hegemony of masters over slaves. Architecture and visual representation had mediated colonial social relations, reasserted hierarchies, and validated reality for centuries at this point, as was Spanish colonial practice.[2] Yet the epistemological and subjective transformations compelled by reform and modernity required new modes of rational expression, resulting in a paradigmatic place for academic classicism as a tool of social control wielded by the "custodians of the classical."

El Templete's ability to make myriad international forms locally relevant testifies to processes by which Atlantic societies reshaped late colonial classicism for local purposes. The tension between the particular and the universal suggests a transcultural product in which local things were situated within a validating language, just as classicism was made locally relevant. By the 1827 census, reprinted in Alexander von Humboldt's *The Island of Cuba: A Political Essay*, the population consisted of a total of 311,051 whites, 106,494 free people of color, and 286,942 slaves, for a total of 704,487 individuals.[3] Although the accuracy of these numbers is not entirely certain, as not all individuals were counted, they do suggest that Africans and their descendants composed almost 56 percent of the island's population by this time. Within the colonial city, blacks occupied many of the same social spaces as whites, including plazas, churches, private houses, and promenades. Increasingly relegated to the *barrios extramuros*, people of African descent inhabited such areas as Jesús María, La Salud, and S. Lazaro, marked on a plan of Havana from 1829 (fig. 5.1). These extramural neighborhoods were populated by a large percentage of *libertos*, slaves, and African *cabildos de naciones*, which were banished from the *intramuros* in the 1790s. Black communities could also be found in great concentration in the town of Regla on a peninsula across the harbor from Havana, where they worked as shipwrights, mariners, and dockworkers. The growing wealth from the sugar industry, the rising black population, the issue over fine arts as the cultural property of whites—these all generated conditions that called for a reassessment of the ceiba tree memorials' purpose and signification. The rise of the sugar industry, the Africanization panic of the early nineteenth century, and the significance of ceiba trees to people of African descent in Cuba suggest the need to look for an expanded dissonance in El Templete.

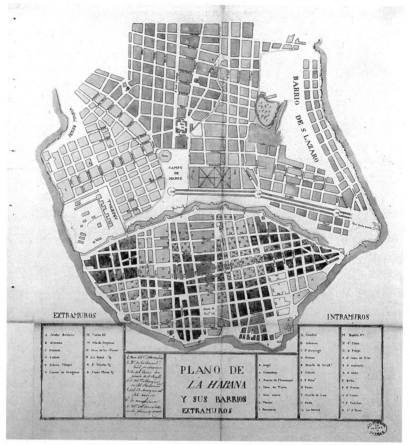

5.1 Anonymous, plan of Havana and its neighborhoods outside the walls, 1829. Courtesy of the Archivo General de Indias, Seville, Spain.

As the scholars of heritage Brian Graham, G. J. Ashworth, and J. E. Tunbridge intone, the practice of disinheritance emerges from "the zero-sum characteristics of heritage, all of which belongs to someone and logically, therefore, not to someone else. The creation of any heritage actively or potentially disinherits or excludes those who do not subscribe to, or are embraced within, the terms of meaning defining that heritage."[4] As addressed in previous chapters, the "terms of meaning" for the ceiba tree site after 1754 included approved and elite historical narratives rendered as texts, objects, and images through colonial newspapers, histories, the fine arts, architecture, and spatial arrangements appropriating academic ideas.

Neoclassical architecture, history painting, and ideal sculpture could serve to elevate Havana to "the rank of the towns of Europe," but how could they also serve to construct the social ranks within the colonial city?

El Templete as part of a process of disinheriting was certainly complex, for entangled in this heritage expression were various efforts to simultaneously include and exclude. The transcultural nature of Cuban forms made up of numerous intertwined Spanish, Amerindian, African, and Creole threads suggests that the ceiba tree monuments, as the products of the entire society over time, built upon collective historical experiences that conditioned multiple receptions of forms. Thus the disinheritance of the African required a substantial reworking of African cultural memory in Cuba. Perhaps this dynamic is where the cultural authority of classicism became most important, as part of a symbolic agenda intended to reorder and conceptually manage Cuban visual culture in the service of elite interests.

We are not entirely sure how often El Templete's iron gates were opened for public viewing following its inauguration, nor what members of society were allowed inside. The North American traveler Samuel Hazard wrote in 1871 that "only once a year is it [El Templete] open to the public, and that is on the 16th of November, the feast of San Cristobal."[5] This account identifies the feast day of the city's patron saint Aggayú as the only day of the year for public access, the date corresponding to today's ritual celebration. However, Hazard's account reveals little about the use of the monument in general throughout the nineteenth century. We can be relatively certain, nevertheless, that the city's elite, including members of the Economic Society and Creole intelligentsia, the captain general, the bishop and elite clergy, and important members of the Cuban plantocracy could have entered El Templete to view the paintings following the completion of the work.[6] Even if members of the general public were never allowed into the work at all, they saw the Greco-Roman revival structure, the ceiba tree(s) replanted shortly after 1828, and such details as the bronze pineapple sculptures and bust of Columbus. Descriptions of at least two of the paintings were published in the *Diario de La Habana* for elite subscribers,[7] and word of mouth could have conveyed impressions of the works to members of middle and lower society. Therefore, at present, we can assume an elite viewership for El Templete and speculate on its significance if a broader section of the nineteenth-century population was likewise allowed inside.

Michel-Rolph Trouillot has defined the term "slave society" as a society dependent on slavery for its economic, social, and cultural organization.[8] The Havana elite could not have been what they were without slaves working among them, nor would certain representational forms and visual practices have been promoted and sustained were it not for a need to maintain the ideologies of a slave society. Cuban colonial life, economy, society, and politics were enmeshed with the issues of slavery, daily social practice, and the reification of the pervasive ideology of white dominance. Intellectual abstractions regarding population were formulated in relation to slavery, while in everyday life, slaves tended to their masters' households and drove their owners in carriages. Beyond slavery, *libertos/as* (free blacks) interacted with whites on a daily basis and served as market women, midwives, and seamstresses.[9] Thus the presence of Africans in early-nineteenth-century Havana was highly tangible to the white elite. Blacks were not merely abstractions in the city. Yet abstractions could be formulated to manage black populations and to craft social spaces of white supremacy. Demographic shifts caused by the Haitian Revolution and persistent fears that a similar event could occur in Cuba produced increased social anxieties for white elites. This level of angst revived older conceptions of race and drove the production of new ones, applying Enlightenment rationalism that may have changed the perception of race for the painter, patrons, and audiences of El Templete. The paradigm of whiteness came under threat like never before and required new means of spatial and visual reinforcement in daily life. I propose that the heritage of the ceiba tree in 1828 attests to the extent that whiteness became an indispensable element in the elite conceptualization of a reformed subjectivity in Cuba by this time, if not earlier.

LA POBLACIÓN BLANCA AND THE NEW TOWN

As discussed in chapter 4, the use of the Indian figure and suggestions of miscegenation within the Vermay paintings carried local relevance. The social paradigm of Spanish male whiteness was constructed, in a fluid and open process, against an ever-present "other" in the Americas as in Spain. With the rise of the early-nineteenth-century slave population in Cuba fed by the sugar industry's insatiable demands for labor, the age-old colonial obsession with whiteness or *limpieza de sangre* was reconceptualized under the pressures of modernization, insular geography, and geo-

political memory. The sugar industry and its human consequences com-
pelled a sense of urgency to promote and maintain phenotypic whiteness
in Havana. This reaction inflected the narrative of identity in El Tem-
plete with an agenda of racial cleansing and the reassertion of a revised
paradigm of *limpieza de sangre*, which led to the emergence of projects of
sociospatial restructuring.

As Campomanes argued, Economic Societies in the Spanish world
should aid economic renovation by focusing on local conditions. The
Havana Society's project to "whiten" the island of Cuba couched as a
social improvement became a particular concern of this association in
Cuba. On December 20, 1823, the physician Tomás Romay Chacón
read a report to the General Council of the Royal Economic Society
entitled "Report on the Necessity to Promote the White Population
on This Island."[10] In the document, Romay Chacón expresses "the grav-
ity and urgency of the assignment" with which he had been entrusted
by the Society. "It [the Society] tried to fulfill with great efficiency . . .
namely, what can and should be done quickly within the limits permit-
ted by our laws."[11] Throughout the 1820s and 1830s, Romay Chacón
would send similar reports and proposals to captains general, the king,
and the Junta de Población Blanca (Council of the White Population).
Established in Havana in 1817 by Captain General José Cienfuegos and
the Spanish intendant Alejandro Ramírez, the special Junta commit-
ted itself to studying census figures, documenting the effects of a ris-
ing black population, proposing solutions, and communicating with
Madrid. Co-opting the extant program of founding new towns in Bour-
bon Spain and the Americas, members of the Junta stressed the urgency
of creating new white settlements for immigrants from Catholic coun-
tries. The slave revolt in Saint Domingue received frequent mention as a
pretext for action.[12]

Anxieties over racial miscegenation and African rebellion in Cuba
became particularly acute, given the extent to which the black popula-
tion was integrated into the social fabric. Havana's high number of *libertos*
must have seemed more dangerous to elite whites than in parts of Spanish
America where individuals of African descent were proportionally fewer in
number compared to the white and mestizo populations. More integrated
free blacks could potentially undermine white blood purity. Furthermore,
the bulk of this population could have contributed substantially to inciting

insurrectionist activity, as they might decide to help their brethren in slavery achieve freedom through radical means.

The Spanish attempt to stimulate the nation's economy through a program of *nuevas poblaciones* (new towns) became the principal instrument used by the Junta de Población Blanca in Havana to attempt to offset the number of blacks on the island. This effort built on initiatives begun in eighteenth-century Cuba with the Crown's endeavor to found new towns, resulting in the creation of the town of Santa María del Rosario, for example, financed by the landowning Bayona family and situated outside of Havana to the southeast.[13] This town and others like it fulfilled objectives similar to those of their counterparts in Spain: to settle, populate, and regulate the agricultural hinterland. Yet the new towns program that emerged in Cuba in the 1790s, following the Haitian Revolution, began to take on a more concerted racial agenda. Francisco Arango y Parreño, in his vision of political economy for Cuba, sought to establish villages for white immigrants and lessen the concentration of rural blacks, seen as the primary instigators of insurrection. Arango wrote, "It is necessary to proceed carefully—with the census figures in hand—in order that the number of Negroes may not only be prevented from exceeding that of the whites, but that it may not be permitted to equal that number."[14]

Stirrings of insurrection involving blacks in the first decades of the nineteenth century only validated such fears. Informed by the visual and verbal narratives of the successful revolutions in the United States, France, and Saint Domingue, many of these rebellious subjects in Cuba were indeed *libertos*. In 1795, the fifty-six-year-old *liberto* Nicolás Morales began organizing a movement that aimed to unite blacks and whites in working toward the abolition of taxes and the distribution of land to the poor. Betrayed by a mulatto militiaman, Morales and his fellow rebels were imprisoned by the state.[15] The 1810 independence movement that fashioned a flag bearing a figure of an Indian woman involved a number of *libertos* enrolled in the black militias. The authorities took additional measures to police black insurgence, including the creation of a volunteer white militia that co-opted young men from recently immigrated families.[16] Another *liberto*, the carpenter and former *pardo* militia member José Antonio Aponte, led the 1812 slave conspiracy. Such conspiracies must have confirmed to white authorities that the rising population of *libertos/as* and slaves posed an almost imminent threat to white hegemony.[17]

These concerns mobilized royal officials and members of the Junta de Población Blanca. By the end of 1817, the Junta was founded and Captain General Cienfuegos had received a royal *cédula* from Madrid authorizing the establishment of new towns for white immigrants. Permission came in response to a comprehensive plan laid before the Crown by the Cabildo, Consulado, and Economic Society in Havana. Addressed from King Ferdinand VII to the captain general and intendant of Cuba, the order stated:

> One of my most important possessions [Cuba] is . . . in a desert state and requires an increase of population for its general security and prosperity. Your exposition submits that after having weighed and considered a subject of such great importance, you have not been able to discover any other remedy for the existing evil than by granting encouragement to emigrants from Spain and the Canary Islands and thereby increase the white population, and further advise the principle to be extended to Europeans professing the Roman Catholic Religion and subjects of states with whom we are at peace and amity.[18]

This authorization followed upon the Real Cédula de Gracias (Royal Decree of Graces) of 1815, which sought to encourage Spanish settlement in Puerto Rico. Foreigners from Catholic nations would need to swear an oath of allegiance to all existing laws, and after five years' residence in Cuba, would gain all the rights and privileges of natural-born citizens.[19] Their children born on the island would be qualified for employment in the major corporate bodies and in the island's militia force. Foreign settlers were immune from any poll tax but would be taxed on their slaves. Each estate owner was exempt from tithes for the term of fifteen years, and for the same term, the payment of *alcabala* duty on the produce of their estates, but was forever exempt from export duties.

The issue of social and racial integration occupies a substantial portion of this decree. The Cuban governor would issue "letters of naturalization" to foreign settlers and these settlers would be "placed on the same footing as natural-born subjects."[20] As a Spanish population was preferable to a foreign one, the king instructed Cuba to forward the invitation to the mother country as well as the Balearic and Canary Islands. Reminiscent of the early days of Spanish colonization in the Americas, racial assimilation of the settlers' whiteness was strongly encouraged. "That amongst other things they [colonial governors] should always bear in mind to promote intermar-

riages with the colonists as much as possible and therefore direct them to those quarters where they may meet with females in order to encourage matrimonial connections."[21]

As with the program of *nuevas poblaciones* in Spain, new towns in Cuba throughout the eighteenth and early nineteenth centuries bore specific functions as part of their charter. Jesús del Monte (1708) and Bejucal (1745) supported tobacco cultivation; Alquízar (1799) would stimulate coffee production; Nuevitas (1775), Jaruco (1777), Bahía Honda (1779), and Santa Cruz (1800) would provide martial support at strategic points in an effort to protect Havana; and Caraballo (1803) would focus on the rearing of livestock. The existence of medicinal waters led to the founding of Madruga (1803); available quarries, to Calvario (1735); and the rehabilitation of a port, to Guantánamo (1820). The rise of the sugar industry in the late eighteenth and early nineteenth centuries generated 156 new towns, 58 percent of which were founded between 1792 and 1800.[22] The voice of Arango in this campaign was joined by that of the Conde de Jaruco y Mopox, who headed a commission that carried out surveys and studies in support of the building of new towns, along with roads and canals.[23]

Some of these new towns in late colonial Cuba, particularly those founded in the early nineteenth century, began to exhibit the Hippodamian grid. The urban ideal here in contrast to the more irregular layouts of conquistador towns in sixteenth-century Cuba reveals a gridiron arrangement of streets meeting at right angles with a geometrically defined plaza, usually in a central location. In an example inflected by baroque city design, a plan for the Cuban new town of San Fernando de Nuevitas depicts a series of squares and rectangular house blocks in a grid pattern with a four-block-square central plaza and diagonal promenades stretching away from this space at its corners in four different directions (fig. 5.2). The promenades each terminate in four identically sized rectangular plazas, and the plan reveals the eighteenth-century spatial ideals of order, utility, and decorum. Similarly, in a plan of the new town of Nueva Paz, Cuba, from 1804, the author configures the city as a great octagon with radiating main streets converging on a central Plaza Mayor. A plan just two years later configures Nueva Paz as a rigorous grid with square modules.[24] These nineteenth-century geometric and gridiron city plans suggest the adaptation of a revised template to reinforce urban order. Through the grid, reformers believed that urban spaces could be made to more efficiently

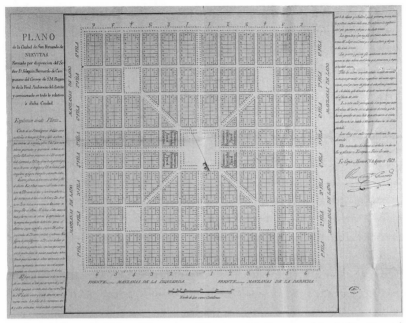

5.2 Joaquín Bernardo de Campuzano, plan of Nuevitas, 1818. Courtesy of the Archivo General de Indias, Seville, Spain.

facilitate commerce; improve sanitation; and render subjects more visible, quantifiable, and socially differentiated.

By the 1820s, plans for the new towns of this reformist type, programs to "whiten" the island, and efforts to adapt drawing and academic practices in the visual arts seemed to have intersected for the Havana elite at the issue of race. Political economy in late colonial Cuba, so dependent on slavery, must have reconfigured elite views of the colonial body politic. New town construction could potentially fix demographic and cultural problems, but what of the mounting social heterogeneity of the extant cities, particularly Havana? Thus town renewal and new forms of representation seem to have been conflated with the new towns project as a socioracial improvement for the Creole and Peninsular elite. Achieving predictable homogeneity would mitigate the stark reality of difference in a heterogeneous environment, which suggests that El Templete was the product of a revised social knowledge from elite perspectives. The patrons made heritage in this work to authenticate this knowledge and render its claims to social order stable and predictable. El Templete presented a

socially reformed colonial city from elite points of view and a teleological narrative leading toward an ideal future of affluent, self-aware whites living with fewer and better-managed blacks.

THE HISTORICAL ENCOUNTER
AS DISINHERITANCE

Vermay's inclusion of the Spanish and Indian encounter in the scenes of the first Mass and *cabildo* generated a predictable and stable Cuban foundational narrative that could have had multiple uses. Indeed, it operated to authorize things Cuban by focusing on the island's chapter in the larger narrative of the Spanish Conquest and drawing attention to Cuba's unique history within that imperial narrative. Yet, simultaneously, this narration of the Cuban past could be seen as building a bastion of white cultural heritage. It thereby operated to exclude people of African descent from full participation in the island's sanctioned history and perhaps even cleanse the ceiba tree of African meanings. If the history of Cuba began with a noble encounter between conquistador and Indian, then the island could join in the fraternity of Creoles who claimed an origination myth between the noble Cortés and Moctezuma, Pizarro and Atahualpa. The cultural authenticity of the ancient Greco-Roman temple and its theoretical origin in the tree affirmed this Cuban heritage and the exemplary racial origins projected by the city's elite. While African history in Cuba dates to the early sixteenth century, the paintings effectively purge Africa from Cuban history.

The absence of an African figure in the two foundational scenes cannot simply be explained as an attempt at historical accuracy, a reconstruction of a moment prior to the influx of African slaves. The Portuguese had opened the early modern transoceanic slave trade along the west coast of Africa by 1492, and African slaves were sold in Seville in the fifteenth century. African slaves had likely been in Iberia under the Romans and during the Islamic period. Early modern Sevillian *cofradías* (confraternities) of Africans supplied the model for the Cuban *cabildos de naciones*. The historian Lynne Guitar asserts that the Spanish brought Africans into the Americas with the first wave of conquistadors in Santo Domingo.[25] Thus Diego Velázquez could well have brought African slaves with him during the conquest of Cuba. Yet the Vermay paintings of the first Mass and *cabildo* exclude blacks from sixteenth-century history and position this exclu-

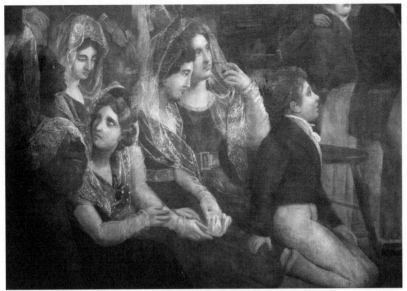

5.3 Jean-Baptiste Vermay, *morena* domestic servant/slave with white women and child, detail of *The Inauguration of El Templete*, c. 1828–1829. Oil on canvas. El Templete, Plaza de Armas, Havana, Cuba. Reproduced courtesy of the OHC.

sion within a larger symbolic program that champions the triumph of civilization over barbarism.

Among the female figures in the lower left of the canvas of the inauguration painting, Vermay includes a woman of African descent in similar dress as the white women nearby (fig. 5.3; plate 11). Any suggestions, via clothing, that this woman possesses the same *calidad* as the women around her are subverted by her dark skin tone, denoting a much lower status. The farthest figure from the bishop and El Templete, this woman likely represents an upper-class domestic slave or servant. The dark skin tone of the slave woman sharply contrasts with the pale skin of the white women and suggests that she is representative of a *morena* (black). As in the *casta* painting genre of New Spain, the modulation of skin tones assisted in the pictorial construction of social hierarchy in a Spanish colonial social spectrum dominated by whiteness.[26]

The figure of the *morena* slave woman appears suspended within a larger allegory that established Indians as redeemable and noble, conquistadors as righteous, and nineteenth-century elites as cultivated men of *buen gusto*. In her space of domesticity, suggested by the seated group of wom-

en and children, the *morena* figure seems startled and confused, with an expression similar to that of the child before her. Her reaction provokes a response from the white woman next to her, who turns and gives the *morena* a harsh glance and perhaps even a motioning gesture with her right hand as if to correct her behavior at the ceremony. More than a sign of white abilities to control slaves, this vignette singles out the *morena* as the only figure that appears visibly threatened by the ceremony and the meanings constructed by the monument. Her response signifies a dearth of rationality and a failed affirmation not because the new signs of the city are ill formed, but because her taste is uncultivated and her character debased. It seems from Vermay's representation that she cannot fully perceive the greatness nor understand the significance of the monument before her, at least with any measure of restraint. In the mind of reformers, it might have been argued that her fatal disjunction between internal character and external stimuli spawns this confused reaction. The presence of the domestic slave thus serves to conflate the whiteness elevated by the larger program and its paradigm of reason by providing a foil for both.

To more broadly situate the *morena*, we should consider the place of blacks within European "enlightened" discourses in the eighteenth century, as some of these were making an impact in Havana's educated circles. Eighteenth-century scientists such as Carl Linnaeus; Georges-Louis Leclerc, comte de Buffon (1707–1778); and Johann Friedrich Blumenbach (1752–1840) began the process of visual comparison between the various modes of humans, using primate juxtaposition to classify human anatomy.[27] The fascination with cultural and natural variety and the will to order has raised questions among scholars about how such inquiry related to or indeed participated in the racial prejudices of the time, as shared by the larger dominant societies of Europe and the colonial world.

The German professor Immanuel Kant appears as an important Enlightenment figure in the context of Havana, written about by Félix Varela y Morales in his *Miscelánea filosófica*. As Emmanuel Chukwudi Eze has shown, some of Kant's efforts to conjoin his idea of "physical geography" and "anthropology" made significant contributions to eighteenth-century theories of race.[28] In his work *Anthropology from a Pragmatic Point of View*, Kant exposes his ideas about human beings as moral agents, positing one's "personhood" as the ability to rise above mere causality to self-reflect and impose the ego, the "I," upon the world and thus will oneself

into being. Pragmatic anthropology encompassed the inner realm of human morality, while geographic studies focused on empirical aspects of humanity, such as physical and bodily characteristics as distributed in space. These two domains of study, for Kant, intersect in his ideas about race. He classifies humans according to skin color, dividing the lot by white (Europeans), yellow (Asians), black (Africans), and red (Amerindians). For Kant, each category possessed differing capacities for moral agency, distinguishing between those with the capacity for educating themselves (principally, Europeans) and others (in particular, Africans) who must be subjected to "training," by which Kant meant physical coercion and punishments.[29] As Eze states, Kant's mentality assumes that "'black,' is bad, evil, inferior, or a moral negation of 'white,' light, and goodness."[30] The black displays a significant lack of moral agency, in Kant's view, a disposition only validated by external appearance. In societies and situations in which white and black coexist, such as urban centers and plantations within the Atlantic world, Kant even advocated for more painful types of punishments (the use of a split cane instead of a whip). In this view, blacks would exist in a perpetual state of "training" from whites, who were the moral agents.

Vermay's positioning of the *morena* in her precise location within the inauguration painting and his articulation of her childlike reaction to the proceedings suggests an attempt to inscribe into the work "enlightened" discourses on the perceived lack of moral agency among blacks. Furthermore, the response of the white woman, who turns to correct the *morena*, underscores the role of whites in providing the necessary "training" for blacks in society and situations. It affirms an essential link between gender, race, and reason, and sharpens the viewer's discernment of the difference in reason between multiple populations within a space designed to allow whites to gain control of their inherent moral agency. Kant contended that Amerindians were beyond educating, and we might notice a resonance between the Amerindian woman from the *cabildo* painting and the *morena* in the inauguration painting, who both appear fearful and perplexed, as though not fully comprehending the civilizing events before them, in contrast to the knowing expressions on the male figures in both scenes. It is unclear if the Indian contributes anything to the suggested bloodline of Cubans or simply serves as a trope of local authenticity and difference from Europeans. Yet the broader program attempts to cement

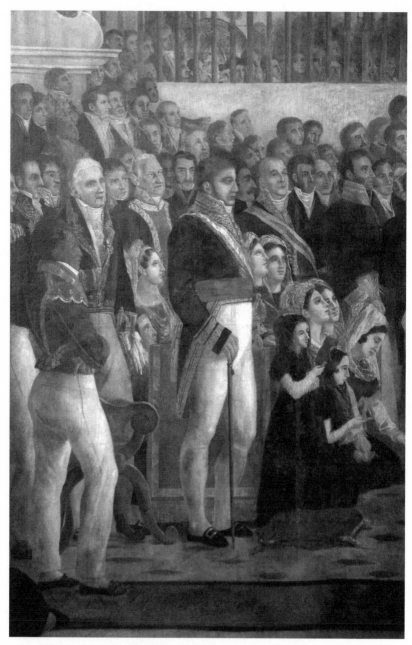

5.4 Jean-Baptiste Vermay, *pardo* militiaman standing alongside Captain General Vives, detail of *The Inauguration of El Templete*, c. 1828–1829. Oil on canvas. El Templete, Plaza de Armas, Havana, Cuba. Reproduced courtesy of the OHC.

the relationship between skin color and reason undergirded by the cultural authority of heritage.

According to the painted narrative, however, mixed-race males could embody reason and *buen gusto* more fully than their female counterparts. At the center of the inauguration painting, near the figure of Captain General Vives, a man with a brown skin tone stands in formal military dress (fig. 5.4; plate 12).[31] His status as a member of a local militia, denoted by his clothing, suggests him as a *liberto*. It is significant that his dark skin tone is a lighter shade of black or brown than that of the slave woman far to the left of him. By his posture and facial expression, he appears much more at ease and in tune with the social expectations and significance of the ceremony. These physiognomic, phenotypic, and gender differences function within the larger program to suggest a process of whitening and a gain in reason (male over female, white over black) as one ventures closer to the monument. As audiences visited El Templete and viewed the imagery, racial difference in relation to reason could be rehearsed and therefore more efficiently reinforced on the plaza.

The visual connections between sixteenth- and nineteenth-century scenes with respect to the inferior reason of non-Spaniards, whether African or Indian, did not serve to position whites and blacks on the same kind of temporal trajectory with the encounter between Spaniard and Indian. The latter appears as part of the narrative of Cuban civilization and capacity for reason, whereas the former appears strikingly disjointed. Whites and blacks are thus not integrated at all into a mutual historical trajectory. Rather, marginalized blacks are suspended and static within nineteenth-century cultural progress. While the childlike confusion of the Indians prompts tender and paternal gestures from the conquistador Diego Velázquez, the harsh appraisal given the *morena* by the white woman indicates that a similar assessment of potential nobility is not afforded the African female. In either case, they are eternally in need of "training," thus affixing their modernity to the progress of whites.

The figure of the *liberto* militiaman standing next to Vives presents a very different view of black reason. In contrast to the *morena*, the *liberto* stands confidently near the governor and faithfully regards the bishop's benediction of the monument. His body language communicates calm and restraint. While this contrast indicates male reason over the female

irrationality displayed by the slave woman, the *liberto*'s skin is also lighter than that of his female counterpart in the painting. This figural arrangement affirms that El Templete, as heritage, underpins the ideal of *limpieza de sangre* itself, alluding to the exemplarity of Spanish blood. As with the scene of the Amerindian mother and child at the first *cabildo* and the Indians in that of the first Mass, as one journeys toward the temple in this painted series, the skin color of the human figures becomes progressively whiter. Thus the encounter narrative at the root of the visual dialogue on human nature in the painted series manipulates a trope suggestive of miscegenation and the paradigm of Spanishness to return to a white paradigm in El Templete. In contrast to Mexico and Peru, colonial difference as found in the Indian racial category is more subdued in this Cuban expression, because of the anxieties toward the black population. It is tightly contained in various areas of the paintings and situated on historical trajectories in which Indianness vanishes and blends into whiteness. Blackness, however, stands outside of Spanish American history as a problem in the nineteenth century that must be negotiated, assessed, and constantly attended.

The social tensions of late colonial Cuba seem to have reshaped even racial classification. The historian Matt Childs argues that the situation led to the disappearance of the "Indian" racial category in early-nineteenth-century census figures in Havana.[32] As this absence of the Indian category is also found in census data from other provinces on the island, it does not seem to be due to a sudden epidemic or warfare. On the contrary, Childs argues that "as Cuba's population became increasingly divided along racial lines as a result of the slave trade, the 'Indian' population became collapsed into the category of white or mulatto."[33] This effort to see the Indian as white suggests a move beyond seventeenth-century efforts to offer Indian blood as redeemable through intermarriage with Spaniards. Rather, it indicates a complete whitening of the Indian in an effort to grow the white population in a situation that the elite perceived as one of racial crisis.

MARRIAGE, LINEAGE, AND *LA MORENA*

Urban attitudes toward blacks in Cuba were gradually reshaped by the rise of the nineteenth-century sugar industry, the Haitian Revolution, and various slave and *liberto* conspiracies in Cuba. This process was marked by

increased suspicion of black disloyalty, a concern for policing intermarriage and colonial sexual relations, and a more vigorous maintenance of *limpieza de sangre*. The historian María Elena Martínez has identified such a process at work in the early seventeenth century in central New Spain, following a foiled black conspiracy against Spaniards in the colony.[34] As in Havana, the racial order of Mexico City was made and reproduced by adherence to a *sistema de castas*, a classification system attuned to colonial hierarchies and based on the proportionality of Spanish, Native, and black blood.[35] Within this system, black blood most frequently meant a stain on lineage and blood purity. In part, this typically negative view toward blacks was a result of their association with slavery and often lingering connections with the "curse of Ham," a stained biblical lineage equated with perpetual servitude.[36] In the early sixteenth century, as the Crown's New Laws of 1542 declared Indians to be vassals in an effort to undercut the *encomienda* system that exploited Native labor, blacks became more associated with slavery. In contrast to Natives and mestizos who could present documents proving that their ancestors had been converted to Christianity, people of African descent generally could not validate such ancestry through the Spanish legal system. Thus the stain of blackness, its inherent ideological impurity, and Africans' association with slavery were stereotypes that circulated in the Spanish world and could be resuscitated and reinforced in times of social tension or economic transformation.

The image of the slave woman in the inauguration scene functioned on more levels than a commentary on the African female's place within a discourse on reason.[37] She is included in this public social grouping, but by virtue of her race is relegated to servitude. As domestic servants and slaves of African descent often bore a substantial amount of the effort to raise and nurture the children of the white elite in Havana, the most socially typical posture might have been to find the slave woman seated alongside a white child. However, she is spatially separated from the white boy in front of her by a group of seated white women. Perhaps the painting represents customs that prevailed in public; however, this placement could encode ideas about blacks in the domestic sphere and other genealogical associations.

The presence of the *morena* in the inauguration painting may have offered a sign of economic opportunity for Cuban planters. As the historian Digna Castañeda points out, few female slaves were brought to Cuba in the early years of the slave trade due to the ease with which male slaves

could be obtained and the confidence of Cuban slave owners in the perpetual existence of the slave trade.[38] In the early nineteenth century, however, under the pressure of British abolitionism, Cuban *hacendados* sought aggressively to import African female slaves to naturally reproduce their slave stocks. Francisco de Arango y Parreño, as *síndico* (receiver)[39] of the Havana Consulado, proposed that slave numbers could be increased if planters imported one-third female slaves to their estates. The Royal Decree of April 27, 1804, sought to compel estate owners to introduce more female slaves.[40] In addition to serving on plantations, the female African slaves performed roles for their masters in the city as nursemaids, midwives, cooks, seamstresses, laundresses, and concubines.[41] Female and male house slaves in Havana also tended to their masters' daily needs in public and private spaces.[42] The image of the slave woman in the El Templete painting naturalizes the presence of female slaves in Cuba and reinforces their compliance in the service of their masters.

By keeping the black woman at bay and positioning the group of white women and children beneath the line of Creole and Peninsular men, the painting constructed an image of the "noble" marriages of Havana and their white offspring. In October of 1805, the Council of the Indies issued the "Royal decree on marriages between persons of known nobility with members of the castes of negroes and mulattos." The decree stated that "in cases where persons of age and known nobility or known purity of blood attempt to marry with members of the castes, recourse should be taken to the Viceroys, Presidents, and Audiencias so that they grant or deny their permission."[43] The anthropologist Verena Stolcke discusses the interrelationships between the nineteenth-century regulation of marriage among whites and castes and "family honor," deemed integral by the Spanish authorities to social order in late colonial Cuba.[44] Children of noble families under twenty-five years of age required parental consent in order to marry down into the racially "impure" spectrum of *morenos/as* and *pardos/as*, and they faced the dreaded fate of financial disinheritance if they violated the "purity" of their family's blood and social status via tainted marriage. Parents brought cases of illegitimate unions before the Spanish authorities, who would rule either for or against the marriage's legitimacy. If, however, a white from a non-noble family married into the *castas*, they had no social standing to lose and thus fell outside the realm of prosecution.[45]

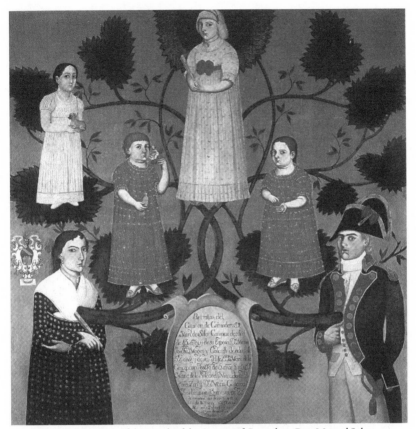

5.5 Anonymous, *Portrait of the Family of the Captain of Granaderos Don Manuel Solar Campero y Vega*, January 28, 1806. Oil on canvas, 82 × 80 in. (208 × 203.5 cm). Courtesy of the Colección Museo Soumaya. Fundación Carlos Slim, A.C., Mexico City, Mexico.

This obsession with racial order and the maintenance of *limpieza de sangre* was visualized on various levels in the Novo-Hispanic *casta* paintings. Family portraiture in the Spanish Americas also directly appropriated the tree as a genealogical metaphor for blood purity. The painting, titled *Portrait of the Family of the Captain of Granaderos Don Manuel Solar Campero y Vega* (1806), denotes a nuclear family's pure bloodline by positioning parents giving rise to a tree with children placed in its branches to naturalize and even sanctify genealogical connection by appropriation of the Tree of Jesse prototype and other models (fig. 5.5). Two tree limbs grow directly from the torsos of the noble man and his wife, who stand on either side of an escutcheon, draped over the tree, identifying the family's many surnames.

The branch further subdivides pictorial space as it entwines the figural scene and opens up compartments for the couple's four children, each connected to their parents by some position along the three limbs. The artist uses the starkly white skin of each family member with the tree as a metaphor of genealogical connection to reinforce the naturalness and stability of the family's *limpieza de sangre*.

A painting such as that of the captain and his family recalls an image by José María Gómez de Cervantes made in New Spain in 1810–1811. The image *Genealogy or Book of Family Records* consists of a family tree composed of circles containing various generations and united by a curvilinear tree limb with leaves.[46] The image contains a family tree, a summary of ancestors, and an index and, as such, bears witness to the purity of blood and legitimacy of birth of Gómez de Cervantes in support of his candidacy for the Order of Charles III, founded in 1771. As a Creole, having been nominated, Gómez de Cervantes faced a substantial burden of proof to qualify, one that the image seemingly performs. Peninsulars received preferences in such honorific titles. Through the diagram, Gómez de Cervantes could validate that he descended from a twelfth-century warrior of the Reconquista who did battle with the Moors in Spain when Alphonso VII was king. As such, the arboreal trope operated within a broad field of visual discourse, working to validate claims to noble status, prestigious genealogy, and pure bloodlines of the elites that employed them.

El Templete worked to construct elite blood purity as a sociohistorical paradigm inevitably realized by the divine hand of Providence and the will of Nature, the authority of heritage, and the progress of the nineteenth-century city. Such mythologies worked to assuage elite fears of family members marrying into the racially mixed *castas*, a fate that severely compromised social status. Elite patriarchal society imposed strict regulations on the ability of white women to move about the city, impulses that resulted in a situation in which white women could scarcely be found walking the streets of Havana.[47] The sudden increase in the population of African descent only exacerbated the fears of illegitimate liaisons and the perceived need to control white female sexuality. Such practices in the social sphere took on more imagined, utopic dimensions in heritage, where the past as a resource for the present also projected on the future community of the island's cities. Vermay's figural groupings of white men, women, and children resonate within the larger narrative of whiteness, reason, and progress

to cast the maintenance of blood purity as a fundamental requirement for building a new society.

The *liberto* figure standing faithfully alongside the captain general in the inauguration painting does so while wearing the uniform suggestive of his status as a member, or commander, in a colonial militia. While his clothing reflects distinction, Vermay positions the man's feet just to the left of the carpet occupied by the captain general's family in a gesture of the limits of inclusivity and power. The *liberto*'s clothing appears to be a mixture of various militia and civic uniform styles for people of African descent that served the city and his Spanish majesty in officially sanctioned ways.[48] The combination of white trousers and navy coat visually integrates the *liberto* into the larger group of white officials, perhaps only distinguished by his light brown skin tone, red epaulettes, and relatively smaller physical size, which temper his importance. I suggest that this figure functions as a metonym for colonial desire[49] in general—the disciplined desire of the militia-man to achieve civic recognition—as well as being metonymic of a larger population, likely that of the *liberto* community of Havana in general that served his majesty through militia or civic duties. The figure thus becomes both a civic role model for people of African descent and a means of alleviating white concerns about the violent and insurrectionist nature of blacks.

Free black populations could acquire considerable prestige from military service in Cuba, including the *fuero militar*, an exemption from prosecution in civilian courts and juridical status equal to white militiamen.[50] However, military service afforded more than advantages in litigation. It allowed people of African descent in the Spanish colonial world to demonstrate their loyalty to church and state and hence to mitigate white distrust of blacks and mulattos. Lacking the ancestral origins of Amerindians, blacks were viewed as potentially seditious because they had no natural love of country and had a tendency to be disloyal.[51] The noble stance of the *liberto* figure in Vermay's painting works to overcome these colonial stereotypes. His proximity to Vives and to El Templete affirms his discipline and loyalty to militia service, to the king, to the Catholic faith, and to the Christian community. As such, he offers a figure for all *pardo* and *moreno* militiamen to emulate, perhaps a loyalty rehearsed in the process

of viewing the paintings. His example works on the ambivalence of colonial mimicry, solidifying a social niche that male blacks aspired to within the white order.

If the *liberto* constructed a paradigm of free black identity in Havana, for a white audience, this image may have resonated with Cuban apprehensions over the very existence of the colored militia. Established by the military reforms of Charles III in the late eighteenth century, the decision in Madrid to arm people of African descent in colonial militias overseas generated anxieties in Cuba that must have only intensified following the Haitian Revolution. José Antonio Aponte's example, as a *liberto* and former captain of free black militias who spearheaded a widespread and foiled conspiracy in 1812, provided another reason for white elites to despise the black militias. The Vermay image of a compliant, loyal, and dutiful militiaman in the framework of natural order works against the negative image of potential black insurrection as emanating from the *liberto* militia. The figure may indeed be a reworking of the white memory of Aponte, attempting to overcome fears left over from the memory of the rebel leader.

While these two figures of African descent in the inauguration scene functioned to validate the socioracial hierarchy as a product of nature, they likewise worked to actively construct social ideology. The vignettes of both the slave woman and the militiaman provided stable social lines and ideal scenarios in a society where whites and blacks interacted daily. In the fictional world of El Templete, white women successfully kept domestic blacks in their place, and colored militiamen followed the noble example of white officials and elites without signs of insurrection. Unequal social relations are justified and social tensions reconciled. Heritage thus becomes a gaze, a way of looking at the present based on an ontological reorientation afforded by an imagined and constructed past.

THE PLURALIZING OF HERITAGE

The ceiba tree, real and represented, commands a central place in the symbolic program of El Templete. It creates a structuring device for two history paintings, and its 1754 memorial appears in the third. The tree is represented in the 1754 pillar itself, and various ceibas have stood in for the "original" tree on the site since 1828. The idea of the tree as metaphor of nature underpinned the cultural authenticity of the neoclassical temple

structure, and the tree has long served as a genealogical symbol for many world cultures. As already discussed, it could also serve as a potent sign of place and local ancestry. Yet what remains to be addressed at length is the contribution of Africans and their Creole descendants to the significance of the tree, particularly the ceiba, in Cuba and elsewhere in the Americas. These populations could make their own meanings of the ceiba and configure the tree within their own symbolic economies.[52]

In spite of the fact that known records have not come forward for when and how often El Templete would have been open to the public in the nineteenth century, the work before and after the scaling back of the memorial's enclosure has long possessed resolute iron gates. These gates mediated access not only to the prized history paintings within the monument but also to the site itself. Once an open domain to the public, the historic site after March of 1828 could be locked and access restricted. The twentieth-century photograph of El Templete from the Cuban Heritage Collection at the University of Miami reveals a group of Afro-Cuban men standing within and without the walls and railings of the monument, facing a photographer on the Plaza de Armas (see fig. 3.8). A lofty ceiba tree is visible to the left. While this site has housed multiple trees since 1828, the presence of a living ceiba representing the "original" tree forges a symbolic and phenomenological link to the past. Shortly after El Templete was inaugurated, at least one new ceiba tree was planted and thus physically contained within this enclosure of stone and iron.[53] Yet this new tree would also have been contained within the visual and verbal discourses, the "terms of meaning" deployed to commemorate the site. Thus the presence of the ceiba in the paintings and on the site was a form of physical and discursive enclosure, which suggests an effort to reshape the meaning of the tree before multiple audiences who could have made different meanings of the ceiba.

The political and social containment of the tree by the elite patrons of El Templete calls for a reexamination of its discursive role, given the multiple receptions of the ceiba by people of African descent in Cuba who so fully populated colonial urban spaces. In chapter 3, I briefly considered the subaltern meanings of the ceiba tree in the Cuban cultural landscape. To consider more specifically the ceiba's African and transcultural religious and social significance involves the challenges of dealing with a historically suppressed cultural voice. Sources that record African views of the ceiba in

Cuba and the Caribbean are scarce from the colonial period. We can, however, examine the parallels between scant colonial accounts of the tree's meaning to Africans and the more extensive research conducted in the twentieth century. Such considerations must, of course, be placed within the context of the social and institutional life of slaves in colonial Cuba.

The Scottish botanist James Macfadyen (1800–1850), a member of the Linnaean society of London, wrote in *The Flora of Jamaica*, published in 1837, of his observations about the ceiba tree on the neighboring Caribbean island:

> Perhaps no tree in the world has a more lofty and imposing appearance. . . . Even the untutored children of Africa are so struck with the majesty of its appearance that they designate it the *God-tree*, and account it sacrilege to injure it with the axe; so that, not unfrequently, not even fear of punishment will induce them to cut it down. Even in a state of decay, it is an object of their superstitious fears: they regard it as consecrated to evil spirits, whose favour they seek to conciliate by offerings placed at its base.[54]

The significance of Macfadyen's observation to scholarship on the African Diaspora cannot be overestimated. In this account, he records Afro-Jamaican understandings of the ceiba and ritual practices involving the tree that strike compelling chords with observations made in twentieth-century Cuba by the Cuban ethnographer Lydia Cabrera (1899–1991). Cabrera's book *El monte* (1954), a work on Afro-Cuban ritual and sacred narrative, contains an entire chapter on the ceiba tree.[55] This work, supplemented by more contemporary scholarship on Afro-Cuban religious beliefs and practices, reveals three areas that resonate with Macfadyen's account: the idea that ceibas possess supernatural force, or *aché*; that they are feared for their power; and that they are employed in ritualized religious practices.

The notion that the ceiba tree possesses a supernatural force can be found in a wide array of sources on the African Diaspora. Similar patterns of African American ceiba tree veneration in Cuba, Haiti, Jamaica, and Brazil—all former sites of plantation slavery—indicate a pan-Diasporic transcultural process. The ceiba tree and the American landscape were apparently interpreted through West African memory by incoming slaves and their descendants and recast to meet the spiritual needs of their communities.[56] In her fieldwork, Cabrera consulted various Afro-Cuban "informants" and found that numerous practitioners of

Santería and Palo Monte associate the ceiba with the divine.[57] In one particularly revealing statement, she recorded, "The ceiba is a saint: iroko."[58] The West African Yoruba *iroko* is considered not only a sacred tree but also an *òrìsà*, a deity that mediates between humans and the Yoruba Supreme Trinity.[59] The tree considered the *iroko* is a large hardwood varietal in tropical West Africa that resembles ceiba morphology in its buttressed trunk and great canopy. Thus if the ceiba was identified by incoming Africans in the early modern period as the *iroko*, it would have been elevated to a sacred status. Practitioners of Palo Monte in Cuba, a religious system heavily inflected by Diasporic memories of the Bantu-speaking region of the Congo, referred to the tree as *nkunia casa Sambi* (tree house of God).[60]

While it is unclear if the ceiba is considered an *oricha* (a Cuban word for the Yoruba deity known as an *òrìsà*), Cabrera recorded that Afro-Cubans regard the tree as a powerful repository of *aché* (known to the West African Yoruba as *asé*), an invisible force engaged with all divinities, humans, and things. Practitioners of Santería (the way of the saints), a transcultural religion in which Catholic saints become essentially interchangeable with select Yoruba *òrìsàs*, also associate the ceiba with an important *oricha* in the Afro-Cuban "pantheon" known as Changó. Identified by his fiery temperament, Changó is equated with lightning and syncretized with Santa Barbara. The ceiba tree, seldom struck by lightning due to its outward-spreading canopy, is believed to be a powerful source of *aché* in Cuba, sometimes inhabited by the intermediary *orichas*. In the 1930s, the Afro-Cuban intellectual Rómulo Lachatañeré (1909–1952), a contemporary of Lydia Cabrera and Fernando Ortiz, collected oral narratives on the ceiba tree that recounted it as having provided Obatalá, a creator deity that birthed the *orichas*, with wood to create a primordial *tablero*, an essential implement in divination. Others in Cuba associated the base of the ceiba tree with Olofin, an aspect of the Supreme Trinity residing above all *orichas*.[61]

In addition to regarding the ceiba tree as possessing supernatural power, Afro-Cuban religious devotees maintained a certain apprehension of the tree, according to Cabrera. Possessing the power to create and destroy, the ceiba spawned fear in some of Cabrera's informants, who claimed they would rather abandon their children to starve than fell and destroy a ceiba. Others believed that felling the tree would result in the deaths of loved ones.[62] These findings by Cabrera reveal continuity between the beliefs of twentieth-century Afro-Cubans in the vengeful power of the ceiba and

those of people of African descent in early-nineteenth-century Jamaica, as recorded by the Scottish botanist.

The third point from Macfadyen's 1837 account was that "the untutored children of Africa" in Jamaica used the tree in ritual practice, seeking to conciliate the tree's favor "by offerings placed at its base."[63] Twentieth-century research has recorded how Santería devotees would place offerings, or *ebbós*, at the base of the ceiba to persuade the tree to grant them favors. In Palo Monte, priests and priestesses, known as *paleros/as*, consider the ceiba a powerful ritual space, an *axis mundi* that channels spiritual energy downward and concentrates it in the terrestrial realm. These practitioners use the ceiba as a site for casting *ngangas*, spells meant to harm the intended victim. *Paleros/as* consummate the spell by leaving coins, rum, or other offerings at the tree's base, stabbing the ceiba with a knife on each side of the cardinal directions, and chanting the victim's name three times.[64] The ritual planting of a ceiba tree is considered a profound act of creation and blessing. Devotees often claim November 16 to be the optimal day to plant a ceiba, which is the day of Aggayú, the *oricha* syncretized with St. Christopher, who shares the same saint's day. Considered the father of Changó, Aggayú is the *oricha* of volcanoes who owns the Earth. The fact that November 16 also marks the birthday of the city, today celebrated at El Templete, and that St. Christopher is the patron saint of Havana, suggests the ceiba tree as a product of the "intermeshed transculturations" defined by Fernando Ortiz. The tree is the product of Cuban colonial and national society, informed by the converging of African, Amerindian, European, and Creole memories and cultural values. It is thus an early modern American cultural formation that has continued to possess relevance for contemporary audiences who use it to produce meanings in the present.

This continuity of the ceiba tree's significance in Cuba through time to people of African descent, and indeed to colonial and national societies, points to the negotiation and reconfiguration of the American landscape for African purposes within the context of slavery and colonialism. The American land was modified by incoming Africans not only in terms of practice but also in the invention of sacred narrative stories known as *pwataki*.[65] The scholar of Afro-Cuban culture Miguel Barnet describes these narratives as functional means by which practitioners of African Diaspora religions explain their American environments.[66] Santería devo-

tees understand most happenings in nature and society in relation to *pwat-aki*, a process in which, as Barnet argues, stories are molded to explain and "to suit changing conditions in society."[67] He states: "This is one of the most unusual and remarkable features of Afro-Cuban mythology. It demonstrates perfectly the force of the popular imagination and its capacity for substituting elements and even adapting philosophical values to suit new social situations."[68]

The fluid adaptability of Afro-Cuban sacred narrative allowed for a wide range of interpretive strategies for decoding, narrating, and contesting the objects and spatial practices of the city, as well as the opportunity for the colonial authorities and social elites to exploit Afro-Cuban understandings of urban objects. Based on the significance of the ceiba tree for populations of African descent in Cuba and the ability of these populations to reconfigure the meaning of the city for their own purposes and to define their modernities in their own terms, I propose that white authorities memorialized the ceiba tree in 1828 to communicate power and authority to these populations. Manipulating a presumed but perhaps not rigorously identified ambivalence toward the tree on the part of colonial audiences, royal officials, senior clergy, and urban elites in Havana generated a multivocal sign even more capable of carrying a resonance of sovereignty. African agency and awareness subjected imposed narrative frameworks to negotiation and contestation, substituted new meanings, and thus produced alternative significations out of such forms as El Templete. For example, what could a viewer of African descent make of the figure of Velázquez standing next to the ceiba tree and holding a wooden staff in the Vermay painting of the city's first *cabildo*? In Cuban Santería, the wooden staff is an important implement of a *babalawo*, a ritual diviner who communes with the *oricha* Orunla.[69]

These conditions would suggest that Spanish civil and ecclesiastical authorities likely knew of the significance of the ceiba tree for populations of African descent in late colonial Cuba and incorporated this knowledge into colonial governmentality. Bishop Espada seems to have observed African performances during his pastoral visit to the island in 1804.[70] Royal officials surely sent police and spies to monitor African and Afro-Cuban communities, and the whole of the city could see the annual performances of the *cabildos de naciones*. Archival research has not yielded lucid observations of African religious practices in

nineteenth-century Cuba, such as those recorded by Macfadyen in Jamaica. However, we must consider that authorities and elites could have taken the opportunity in El Templete to co-opt an object of symbolic and sacred significance for these populations even if whites did not understand what they were seeing. Furthermore, we must consider the extent to which African practices in Havana shaped those of whites by centuries of proximity and the cultural intertwine suggested by the theory of transculturation.

The closest accounts we have are the array of textual and visual records of *cabildos de naciones* processions.[71] These mutual-aid associations and religious fraternities of Africans, Creoles, and other groups provided a framework for people of African descent to engage in civic rituals. As described in chapter 1, such *cabildos* held celebrations on Sundays and important church feast days, the most elaborate and public of which was the January 6 celebration of Epiphany in Havana, also called El Día de Reyes, "the Day of Kings." *Cabildo* processions began in Havana's *barrios extramuros* and wound their way through the streets, eventually arriving at the Plaza de Armas. Here, the *cabildo* king would meet with the Spanish captain general to receive *aguinaldo* (an annual donation or gift) and an implied acknowledgment of the *cabildo* king's authority. Given the existence of the Plaza de Armas in Havana as a social and political center, the attention afforded the foundational ceiba tree in the late colonial period must also have been directed at these audiences. The conflation of the tree's supernatural power and *orichas* like Changó, who was thought to be a deified king, with the colonial governor's presence as the Spanish king's representative, as embodied by the plaza and eventually the royal palaces, could have generated a potent conflation of power to populations of African descent in the *cabildos*.

The appropriation of Afro-Cuban visual culture for political ends becomes more explicit or easily traced in the twentieth century. The anthropologist Ivor L. Miller has studied the pattern by which politicians in Cuba have appropriated symbols of Afro-Cuban religions and used them to their advantage in political rituals. As Miller argues, "Coded performances in the Caribbean political arena often have dual implications."[72] He cites Fidel Castro's January 1959 televised address to the Cuban nation, watched by millions around the world. During the speech, a white dove landed on Castro's shoulder and another on his rostrum, and remained

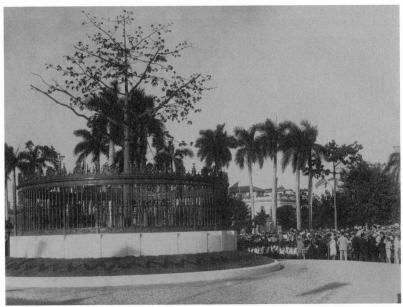

5.6 Secretaría de Obras Públicas. Tree of Brotherhood, dedicated February 24, 1928. Courtesy of the University of Miami Libraries Cuban Heritage Collection, Coral Gables, Florida.

there throughout his oration. While the Roman Catholic world would have associated this occurrence as a gift from the Holy Spirit, symbolized by the white dove, for *santeros/as*, the white dove evoked Obatalá, a deity of purity and justice that created the world and the *orichas*. By staging the spectacle of the white doves, Castro suggested himself to Afro-Cuban audiences as a ruler consecrated by the forces of Obatalá with a sanctioned ability to bring justice, peace, and innovation to the country.

Scholars have argued that in the early twentieth century, the Cuban republican government used the ceiba tree as Castro later used the doves for their multivalence and ability to communicate to populations of African descent. The Cuban ethnographer Rómulo Lachatañeré relates an incident involving Gerardo Machado, president of Cuba from 1925 to 1933. During the Sixth Pan-American Conference in Havana (1928), Machado christened the event with the inauguration of a newly reconstructed park, naming it the Parque de la Fraternidad (Park of Brotherhood). A ceiba tree was planted on inauguration day in the center of the park and surrounded with earth taken from the twenty-one republics represented in the conference (fig. 5.6). Lachatañeré observes:

In the same ornamentation of the park, palm trees had been utilized, which had clear symbolic meaning for Cubans, and especially *santeros*: the palm tree is where Changó found sanctuary for his anger. The Ceiba tree is one of the homes of Changó [. . .].

What could a *santero* deduce from this ceremony where with so many types of earth a Ceiba was planted, symbol of Changó, and precisely during the government of one of his "sons"? Again the deduction was logical. Changó had ordered the president to make this magic ceremony to protect him from his enemies, because at the time they were increasing in numbers. The truth is that five years later Machado was overthrown; but in the period of collecting this material, a stroller who passed by the Park of Fraternity in the light of dawn could find sacrifices for Changó deposited at the foot of the palms and at the now robust Ceiba.[73]

Machado's deliberate planting of the tree transposed civic and national solidarity and united Pan-American and national ideology with Afro-Cuban worldview, even if the president did not fully understand its implications. His actions raise questions about the history of political appropriations of civic trees in Havana. Machado's ceiba appeared in the Parque de la Fraternidad alongside the recently completed capital building, El Capitolio, finished in 1929. The combination of the temple to republican virtues with the tree of brotherhood recalls El Templete's construction of civic foundations and colonial community via commemorative temple and foundational tree. Machado's tree in 1928 could be said, on the one hand, to disavow El Templete by its position outside the area formerly bounded by colonial city walls that came down in 1863. On the other hand, the Parque ceiba seems likewise to have been part of a heritage process involving El Templete, co-opting the cultural authenticity embodied by the former work to communicate to a wide range of colonial audiences in validation of political figures in the present. Indeed, the 1928 inauguration of the Parque came in the centennial year of the colonial monument.

The plaza ceiba of 1828 and the Parque ceiba of 1928 are joined in Havana's tree history by a third ceiba likewise paired with an architectural structure and urban space. The sanctuary of the Virgin of Regla consists of a single-nave basilica located toward the tip of the peninsula occupied by the town of Regla that extends into Havana harbor. Directly across the bay from the Plaza de Armas, the sanctuary houses a legendary incarna-

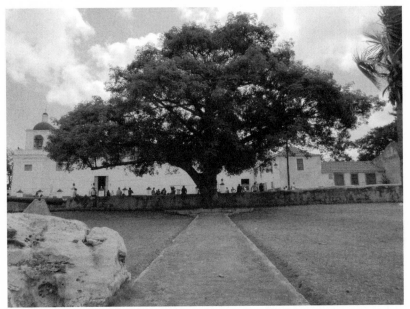

5.7 Ceiba tree of Regla, the tree alongside the Church of the Virgin of Regla, seen with the processional pathway leading out to the waterfront. Regla, Cuba. Photograph by the author.

tion of the Virgin Mary, conflated by her Afro-Cuban devotees with the Cuban *oricha* Yemayá, a female deity of the ocean.[74] The blue trim of the doors and windows of the church complements the rich blue of the robes worn by the statue of the Virgin in the sanctuary. A ceiba tree can today be found due south of the east-west orientation of the church, in a park that rises slightly from the road that separates it from the walkway along the seawall. In an annual ritual on September 8, devotees transport the statue of the Virgin of Regla from the sanctuary, out into the streets of Regla, to the ceiba tree alongside the church where she is circumambulated,[75] and finally down to the waters of the harbor before being returned to the church.[76] In this process, the Madonna/Yemayá blesses the inhabitants of the city, receives *aché* from and blesses the ceiba tree, and views her watery domain. In my visit to the site in 2011, a concrete ritual pathway could be found cutting through the park and encircling the ceiba tree, suggesting a recent effort, as early as the mid-1990s, to elevate the tree to the status of a civic ritual object by appropriation of concrete (fig. 5.7).

The town of Regla, a historically African and Afro-Cuban community, dates to the sixteenth century. Research remains to be done to determine

the age of the present structure and how long a ceiba tree has been situated alongside it. However, large influxes of Africans in the late colonial period grew the population of Regla, which had been the home of dockworkers, mariners, and shipwrights, hence the devotion's maritime connection. These incoming Yoruba and other groups likely recharged the Virgin's connection to the Yoruba ocean deity Yemoja. The first *cabildo*, a private Afro-Cuban organization independent of the Catholic Church, was founded toward the later nineteenth century. The African-born freed slave Ño Remigio Herrera, also known by his African name, Adechina, established the *cabildo* of the Virgin of Regla.[77] The history of the ceiba of Regla and its ritual use requires much more investigation. However, if it did exist in 1828, it would have belonged to a powerful devotion that may have actively informed African and Afro-Cuban views of the ceiba in relation to Catholic/*oricha* worship in the vicinity of Havana. Indeed, an image of the Virgin of Regla was among those images found in Aponte's "book of pictures." Such examples speak to the anthropologist Stephan Palmié's points about the mutually constituted and historically constructed nature of Afro-Cuban and Atlantic modernity.[78]

These various cases of making heritage from multiple points of view speak to the plurality of the phenomenon, the existence of plural heritages, and the agency of multiple populations to rework urban spaces, signs, and performances.[79] Heritage occurs, in these cases, within the city and within urban space in different locations to create and manage collective place identities. The ceibas of Havana have, over time, been selected as potent heritage resources based on Cuba's transcultural development, yet they are not the only such resources, as El Templete reveals. Local and imported heritage capital has supplied cultural representations to meet the demands of the present and to formulate paradigmatic expressions that can be passed on to an imagined future. The heritage expression that evolves from the demands of the present can then be reused, its cultural parameters reappropriated by subsequent generations, even if much of its original relevance is lost. Its resources are willed into being modern, as the present generation demonstrates the unquantifiable human ability to use the past as a social, political, and economic resource for the present.

EPILOGUE

The history of America from the Incas to the present must
be taught in its smallest detail, even if the Greek Archons go
untaught. Our own Greece is preferable to the Greece that is
not ours; we need it more. Statesmen who arise from the nation
must replace statesmen who are alien to it. Let the world be
grafted onto our republics, but we must be the trunk.

JOSÉ MARTÍ, "Nuestra América" (1891)

In the preceding epigraph, the Cuban poet José Martí
(1853–1895) employs arboreal and antique metaphors
to negotiate a strategy of making Cuban if not Pan-
American national heritage. In this passage written just years
before the end of Spanish rule on the island, Martí seems to
advance and develop the heritage work begun by the monu-
ments to Havana's foundational ceiba. Yet in this case, he dis-
tances the nation from Greco-Roman antiquity and its classi-
cism and offers a powerful alternative. El Templete suddenly
appears passé, but perhaps still relevant, as it could be said to
begin a process of spatializing nascent American identities
by couching them within an authorizing European antiqui-
ty. Martí heralds a moment when Cuba, and the republics of
America, must stand alone, supported by their own heritage,
which can only be found in its essence on native soil. His call
for a pedagogy that considers America in its smallest detail

alludes to a projected paradigm shift in Western education in the service of nation building. Perhaps the most striking aspect of this passage relevant to the present study is the poet's arboreal image, that of a tree trunk firmly rooted amid the ebb and flow of transatlantic, transnational, and global tides experienced as only island people know. The tree stands for Cuban national identity, strong, organic, and capable of absorbing difference without compromising the national character.

Although Havana's foundational ceiba reveals important lessons about heritage and late colonial visual culture, it speaks equally to the importance of urban space in the negotiation of late colonial identities. The Spanish Bourbons used the Plaza de Armas of Havana as a tool of late colonial reform in an effort to impose a more rigorous order on colonial society. With the rise of a colonial elite society, new agency emerged in the patronage of public works and in relationship to epistemological and subjective shifts. Over time, a more rigorous Greco-Roman revival classicism, or neoclassicism, came to be an authorizing language of cultural modernity appropriated by local elites in Havana. El Templete and its compound patronage reveal the making of heritage by multiple individuals and groups in an effort to solidify multiple claims to place and modernity. Yet this heritage reveals dissonance, a lack of agreement as to who possessed the most authority over the heritage site. Indeed, this site became a point at which contested late colonial politics at the local and imperial levels becomes visible to us. Heritage supported the captain general and the Spanish state in claims to social ordering and inevitable rulership, it reinforced Bishop Espada in religious reform and constitutionalism, and it underpinned the Havana elite public in offering an authorizing language of cultural modernity that established a legitimacy of place.

Heritage at the site of the foundational ceiba also became a more nuanced, nineteenth-century social discourse through the Vermay paintings. In concert with larger efforts, heritage could distinguish the local within the imperial while working to manage local subject populations. Heritage could reinforce colonial social ideology, which was responsive to the effects of slavery and sugar production. However, the multiple appropriations of the ceiba tree in Havana underscore the plurality of heritage, a phenomenon wielded by disparate individuals and groups in their claims to identity in urban space. Heritage is thus an act of communication and a process of engagement with the past and its material reminders. Heri-

tage sites are made so by action, by acting upon them, and this significance can be recharged through performance. Through rituals, the intangibility of heritage is given concrete form, identities are reinforced, and a sense of place is reestablished. The ongoing use of the ceiba tree and El Templete on November 16 in Havana performs this function, albeit in the production of twenty-first-century identities. El Templete still provides its audiences an experience of heritage and of ritual that restores collectivity and shapes collective memory related but not identical to the ways in which memory was inscribed at the site during colonial times. The tree, the temple, and the paintings all endow a gravitas of the ancient, the monumental, and the original that serves today as a heritage resource.

The history of Havana's foundational site after 1828 and to the present day would make for a fascinating study. However, it is a topic that would need to be considered along with many other forms of protonational and national representation and other forms of heritage that emerged in the nineteenth and twentieth centuries. Almost immediately following El Templete's completion, the work began to appear in prints along with numerous other buildings in nineteenth-century Havana, as can be seen in the work of Frédéric Mialhe.[1] This corpus of printed images, among others, speaks to at least one type of heritage process: an effort to reinscribe memory through the architecture of the city, aided by nineteenth-century technologies of vision such as lithography. As Laurajane Smith asserts, the process of heritage can be critically active and self-conscious, a means by which people not only negotiate identity and its attendant values but also challenge and attempt to redefine their "place" in the world.[2] Creole relationships to Havana and to Spain were continuously renegotiated throughout the colonial period as subaltern cultures responded to languages of power and itinerant Spaniards reacted to the local scene. The self-conscious and self-reflective use of the past to negotiate the present appears as a large-scale and long-range dynamic that continued to unfold in national contexts, as it does today.

In the twenty-first century, communities of African descent have enjoyed unprecedented freedoms to express historically cryptic belief systems, namely Santería, in public. The existence of the Asociación Cultural Yoruba de Cuba and its Santería museum, open to tourists near the Parque de la Fraternidad in Havana, perhaps attests to such governmental latitude. The devotion at Regla suggests the active reconstruction of a subaltern her-

itage that coexists and competes with the civic heritage just across the bay on the Plaza de Armas. These forms underscore the plurality of heritage and problematize, as noted by Ashworth and Graham, Pierre Bourdieu's notion of "cultural capital."[3] For Bourdieu, dominant ideologies generate specific heritages and place identities in an effort to advance political ideologies and support the structures of the state. Yet heritage assumes a variety of state-sponsored official and unofficial forms, a plurality of pasts, some of which subvert hegemonic narratives. Heritage thus emerges as a "diverse knowledge" changing across time and space, re-created by myriad groups within cities, regions, and nations to negotiate the present.

NOTES

INTRODUCTION

1. The narrative of Havana's founding by the Spanish conquistadors under a ceiba tree first appears in José Martín Félix de Arrate, *Llave del Nuevo Mundo*, 77–78.

2. My sincere gratitude goes to Joseph Ressler Hartman, M.A., Art History, University of North Texas (2011), for his exceptional work in the field and for returning with these valuable observations so lucidly documented.

3. Ortiz, "Social Phenomenon of 'Transculturation,'" 98.

4. Crowds of people visited throughout the morning, afternoon, and evening of November 16. Yet, according to Joe Hartman, no one seems to have gone inside El Templete to view the three history paintings on display there, executed by the French expatriate artist Jean-Baptiste Vermay between 1827 and 1829.

5. Studies of the religion and material culture of the African Diaspora that address the use of the ceiba tree in devotional rituals include Desmangles, *The Faces of the Gods*, 111; Voeks, *Sacred Leaves of Candomblé*, 20, 32, 161, 163; and Omari-Tunkara, *Manipulating the Sacred*, 93, 107.

6. The North American anthropologist Melville Herskovits (1895–1963) pioneered the notion of *acculturation*, a theory that when two cultures coexist, they combine while remaining fundamentally distinct; see Herskovits, *The Myth of the Negro Past*. The Cuban anthropologist Fernando Ortiz (1881–1969) argued against Herskovits's thinking via the notion of *transculturation*. In this view, some constituent elements of the parent cultures might be diminished, substituted, or completely lost; see Ortiz, "Social Phenomenon of 'Transculturation.'"

7. Aggayú is the *oricha* (orisha) of volcanoes who owns the Earth.

8. Nora, "Between Memory and History." The projection of a sense of permanence onto the social world to deny change is a phenomenon also taken up by Connerton in *How Societies Remember* and Lowenthal in *The Past Is a Foreign Country*.

9. Harvey, "History of Heritage," 19. Other important studies of heritage include Harvey, "'National' Identities and the Politics of Ancient Heritage"; Graham, Ashworth, and Tunbridge, *A Geography of Heritage*; and Laurajane Smith, *Uses of Heritage*. Earlier works on history and memory that have influenced recent scholarship on heritage include Lowenthal, *The Past Is a Foreign Country*; Connerton, *How Societies Remember*; and Halbwachs, *On Collective Memory*.

10. Graham and Howard, "Introduction: Heritage and Identity," 2.

11. For colonial discourse, I acknowledge seminal works such as Edward Said, *Orientalism*, and Franz Fanon, *Black Skin, White Masks*. See *Colonial Discourse and Post-Colonial Theory*, an important volume on the subject, edited by Williams and Chrisman.

12. Ashworth and Tunbridge, *Dissonant Heritage*. For the phenomenon of dissonance in heritage, see also Gillis, *Commemorations*; Hodgkin and Radstone, *Contested Pasts*; Smith, *Uses of Heritage*, 80–82; Moore and Whelan, *Heritage, Memory, and the Politics of Identity*.

13. The ambivalence between heritage and identity is the primary focus of the volume *The Ashgate Research Companion to Heritage and Identity*, edited by Graham and Howard. For relationships between heritage, place, and identity, see Ashworth and Graham, *Senses of Place: Senses of Time*; and Ashworth, Graham, and Tunbridge, *Pluralising Pasts*.

14. The idea of a multiplicity of cultural layers and their interaction within a cultural enunciation is related to the work of the literary theorist Mikhail Bakhtin. For his notions of heteroglossia and dialogism, see *The Dialogic Imagination: Four Essays*, compiled by Michael Holquist.

15. For an important critique of the notion of "hybridity" in Spanish colonial contexts, see Dean and Leibsohn, "Hybridity and Its Discontents."

16. Gruzinski, *The Mestizo Mind*.

17. For literature on place in general, see Cresswell, *Place: A Short Introduction*, and Jackson, *A Sense of Place, a Sense of Time*. For sources on the relationship between place and heritage, see Ashworth and Graham, *Senses of Place: Senses of Time*, and Ashworth, Graham, and Tunbridge, *Pluralising Pasts*.

18. The following sources address the idea of an emergent Creole patriotism, an identity affixed to the American land, in seventeenth- and eighteenth-century Spanish American contexts. O'Gorman, *Meditaciones sobre el criollismo*; Brading, *The First America* and "Patriotism and the Nation in the Spanish Empire." For the notion as originating in the sixteenth century, see Pagden, "Identity Formation in Spanish America."

19. Thomas B. F. Cummins and Joanne Rappaport discuss the production and maintenance of colonial ideology via a number of interconnected "spatial genres," including alphabetic literacy, visual images, architecture, and performative practices; see "The Reconfiguration of Civic and Sacred Spaces."

20. Michael Schreffler, in *The Art of Allegiance*, has examined the Spanish royal palace of Mexico City and the visual culture of viceregal power in the Spanish Americas.

21. This view could be considered in relationship to earlier conceptualizations of colonial discourse and its operation, as the definition of a "self-same" against an "other." See Fanon, *Black Skin, White Masks*; Foucault, *The Order of Things*; and Said, *Orientalism*. Homi Bhabha's more nuanced model of *mimicry* presents a

dynamic of power by which the colonizer compels the colonized to imitate the former's example in an effort to at least partially embody a normative model in a way that is "almost the same but not quite." According to Bhabha, this space of ambivalence is produced by the slippage that reinforces the partiality of the colonial subject. See Bhabha, "Of Mimicry and Man."

22. For sources on the Bourbon Reforms in the Spanish world, see Arnold, *Bureaucracy and Bureaucrats in Mexico City*; Brading, *Miners and Merchants in Bourbon Mexico*; Burkholder and Chandler, *From Impotence to Authority*; Deans-Smith, *Bureaucrats, Planters, and Workers*; and Paquette, *Enlightenment, Governance, and Reform in Spain*. For Spain under the Bourbons, see Lynch, *Bourbon Spain*.

23. Perhaps the most salient example of such an expression is the bronze *Equestrian Portrait of Charles IV* for Mexico City, by the sculptor Manuel Tolsá, 1803.

24. A tradition in Europe and the Americas, the saint's day consists of celebrating the day of the year associated with one's given name as it relates to the Catholic calendar of the saints.

25. This superior order was published in the *Diario de La Habana* (hereafter *DH*) on March 12, 1828, and also ran on March 13 and 14.

26. El Templete appears in numerous works of Cuban art, architecture, and urban history, including Luz de León, *Jean-Baptiste Vermay*, 33–42; Lescano Abella, *El primer centenario del Templete*; Pérez Cisneros, *Características de la evolución de la pintura en Cuba*, 49–50, and *La pintura colonial en Cuba*, 30; Valderrama y Peña and Vázquez Rodríguez, *La pintura y la escultura en Cuba*, 26–28; Roig de Leuchsenring, *La Habana: Apuntes históricos*, 3:7–14; Castro, "Arte cubano colonial," 283–295, citation on 311, and *El arte en Cuba*, 24, 41, and "Plazas y paseos de La Habana colonial," 320–321; Juan, *Pintura cubana*, 9, and *Pintura y grabado coloniales cubanos*, 18; Fernández Villa-Urrutia, "Las artes plásticas hasta el comienzo de la República," 115–160, 131–132; Rigol, *Apuntes sobre la pintura y el grabado en Cuba*, 101–102; Fernández-Santalices, *Las calles de La Habana intramuros*, 42–43; Segre, *La Plaza de Armas de La Habana*, 20–22; Weiss, *La arquitectura colonial cubana*, 387; Carley and Brizzi, *Cuba: 400 Years of Architectural Heritage*, 92; López Núñez, "Notas sobre la pintura colonial en Cuba," 58; Faivre d'Arcier, *Vermay, mensajero de las luces*, 133–161; and Alfonso López, "La Ceiba y el Templete." The monument also appears in numerous works on Cuban history, including Pezuela, *Historia de la isla de Cuba*, 1:237; Calcagno, *Diccionario biográfico cubano*, 263, 681; Pérez Beato, *Habana antigua*; Ortiz, *La hija cubana del iluminismo*, 55; García Pons, *El obispo Espada y su influencia en la cultura cubana*, 128–135; Figueroa y Miranda, *Religión y política en la Cuba del siglo XIX*, 195; Marrero, *Cuba: Economía y sociedad*, 13:24; Chateloin, *La Habana de Tacón*, 55–56; and Torres Cuevas, *Obispo de Espada*, 123–124.

27. "La Isla de Cuba, fiel á sus principios y á sus deberes, ha dado en este dia al orbe entero la última pruebe de su lealtad acendrada y de su patriotismo nunca des-

mentido. El monumento grandioso que se presenta hoy á la espectación pública, costeado por los habitantes de esta heróica capital, presentará á las generaciones venideras un recuerdo glorioso de las virtudes de sus antepasados." *DH*, March 16, 1828, 1. (Unless otherwise indicated, all translations are mine with suggestions by Nancy Warrington.)

28. "Hasta el año de 1753 se conservaba en ella robusta y frondosa ceiba en que, según tradición, al tiempo de poblarse la Habana se celebró bajo su sombra la primera misa y cabildo, noticia que pretendió perpetuar a la posteridad el Mariscal de Campo D. Francisco Cagigal de la Vega, gobernador de esta plaza, que dispuso levantar en el mismo sitio un padrón de piedra que conserve esta memoria." Arrate, *Llave del Nuevo Mundo*, 77–78. *Padrón* can also be translated as "inscribed column," which is equally appropriate for this monument.

29. A discussion of cultural modernity as the cultivation of the self, authentic experience, historical introspection, and imagination can be found in Gaonkar, *Alternative Modernities*, 1–23.

30. For a general survey of neoclassicism in the visual arts, see Irwin, *Neoclassicism*. For neoclassicism in the Spanish Americas, particularly New Spain, see Toussaint, *Arte colonial en México*; Charlot, *Mexican Art and the Academy of San Carlos*; Burke, "The Academy, Neoclassicism, and Independence"; Bailey, *Art of Colonial Latin America*, 204–206; Donahue-Wallace, *Art and Architecture of Viceregal Latin America*; Bocchetti, *La influencia clásica en América Latina*; and Niell and Widdifield, *Buen Gusto and Classicism in the Visual Cultures of Latin America*.

31. See *DH*, March 16, 1828, and March 27, 1828.

32. This view of the monument's significance is especially highlighted in Ortiz, *La hija cubana del iluminismo*, 55; García Pons, *El obispo Espada*, 128–135; Segre, *La Plaza de Armas*, 20; and Torres Cuevas, *Obispo de Espada: Papeles*, 123–124.

33. "Tocante a éste recordé la jugarreta que el mismo obispo vasco le hizo a los capitanes generales, disponiendo la construcción en esta ciudad del llamado Templete tras de la legendaria ceiba, que era signo y padrón de las libertades jurisdiccionales de la villa de San Cristóbal de La Habana; con lo cual frente al palacio del gobierno insular se alzó una aproximada reproducción del árbol de Guernica y de su Sala de Juntas, donde se simboliza la libertad nacional de su pueblo." García Pons, *El obispo Espada*, 130.

34. For views of modernity as unfolding and being expressed uniquely in a given locality, see Corbett, *The Modernity of English Art*; Gaonkar, *Alternative Modernities*; Araeen, Cubitt, and Sardar, *The Third Text Reader*; and Mercer, *Cosmopolitan Modernisms* and "Art History after Globalisation."

35. For Spanish American developments commensurate with what scholars have identified as patterns of modernity, see Silverblatt, *Modern Inquisitions*; Cañizares-Esguerra, *Nature, Empire, and Nation*; and Bleichmar, *Visible Empire*.

36. See Rajagopalan and Desai, *Colonial Frames, Nationalist Histories*; Mercer, "Art History after Globalisation"; Gaonkar, *Alternative Modernities*; and Araeen, Cubitt, and Sardar, *The Third Text Reader*.

37. For the importance of civil associations to reforms in the Spanish Bourbon Empire, see Paquette, *Enlightened Reform in Southern Europe and Its Atlantic Colonies*. For this new form of individual subjectivity in relation to religious reform, see Larkin, *The Very Nature of God*.

38. See Foucault, *Discipline and Punish*.

39. The Spanish statesman and economist Pedro Rodríguez, conde de Campomanes (1723–1802), advanced strategies for boosting the Spanish economy in his *Discurso sobre el fomento de la industria popular* (Discourse on the promotion of popular industry).

40. Trouillot, "The Anthropology of the State in the Age of Globalization."

41. Habermas, *The Structural Transformation of the Public Sphere*.

42. Michael Taussig's discussion of alterity in *Mimesis and Alterity*.

43. Engel, "Facing Boundaries."

44. Daniela Bleichmar discusses this dynamic within her larger study of natural history representation in the eighteenth-century Hispanic world; see Bleichmar, *Visible Empire*. Jorge Cañizares-Esguerra identifies a systematic critique of European historiography, which he terms a "Creole epistemology," in *How to Write the History of the New World* and a similar critique of European homogenizing science in *Nature, Empire, and Nation*.

45. Katzew and Deans-Smith, *Race and Classification*.

46. Fischer, *Modernity Disavowed*.

47. Colin Trodd and Rafael Cardoso Denis have examined the permeability of global academies of art to their local societies and geopolitical situations in *Art and the Academy in the Nineteenth Century*.

48. Gaonkar, *Alternative Modernities*, 6.

49. Henri Lefebvre has noted the construction of a "conceived space" of rational discourse that underscores the relationships between knowledge and power in *The Production of Space*. Michel Foucault identified such a relationship in *The Order of Things*, among other writings.

50. Bhabha, "Of Mimicry and Man."

51. The work of the art historian Karen Lang has shown the multifaceted ways in which national monuments signify the constructing of national community while also addressing an emerging sense of "unease" over social conflicts and growing dissatisfaction. See Lang, "Monumental Unease."

ONE ↔ THE PLAZA DE ARMAS AND SPATIAL REFORM

1. The British had also captured the Spanish colonial city of Manila in the Philippines at the end of the Seven Years' War.

2. The Spanish inaugurated the *flota* system soon after the completion of Havana's fortifications in the late sixteenth century. The harbor of Havana became a rendezvous point for the annual Spanish fleets departing from Nombre de Dios, Panama, and Veracruz, Mexico, on their way back to Spain. See Pérez Jr., *Cuba*, 36–38.

3. "Discurso del Ingeniero Silvestre de Abarca," Archivo Nacional de la República de Cuba (hereafter ARNAC), Asuntos Políticos, Legajo 1, Exp. 94, 1763.

4. See James C. Scott, *Seeing Like a State*. Also see Foucault, *Discipline and Punish*.

5. Trouillot, "The Anthropology of the State," 126.

6. Lefebvre, *The Production of Space*. Pierre Bourdieu advances a theory for the reproduction of social relations in everyday life in his *Outline on a Theory of Practice*.

7. See Pérez Jr., *Cuba*, 21–34.

8. The formal title of the laws was "Recopilación de Leyes de los Reynos de las Indias." For their content, see "Transcription of the Ordinances," 18–23.

9. See Kagan, *Urban Images*, 26–28.

10. This sense of the city as mediator between Spanish civilization and indigenous American disorder and immorality has an important precedent on the Iberian Peninsula in Roman conquest history as well as the Reconquista, the struggle to oust Islamic polities from the Iberian Peninsula. Kagan, *Urban Images*, 26.

11. The Plaza Nueva seems to have been laid out in the late sixteenth century around the time the Laws of the Indies were ratified.

12. See Fernández-Santalices, *Las calles de La Habana intramuros*.

13. Kagan, *Urban Images*, 1–18.

14. For a discussion of the sociospatial layout of Havana with respect to the relationship between parishes, social class, and race, see Johnson, *Social Transformation*, 21–24.

15. For *limpieza de sangre* and the Spanish *sistema de castas* in New Spain, see Cope, *Limits of Racial Domination*; and Martínez, "Black Blood of New Spain" and *Genealogical Fictions*. For an authoritative source on race in colonial Cuba, see Stolcke, *Marriage, Class and Colour*.

16. Magali Carrera, in *Imagining Identity in New Spain*, emphasizes the importance of visual culture in maintaining claims to *calidad*, viewing the colonial city as a performative space in which dress, images, and social behaviors constructed identity.

17. For a discussion of the complex historical meanings of heritage, see Littler and Naidoo, *The Politics of Heritage*, 2–5.

18. Barteet, "Colonial Contradictions."

19. For the morphology of the Havana colonial house, see Weiss, *La arquitectura colonial cubana*; Carley and Brizzi, *Cuba: 400 Years of Architectural Heritage*; and Llanes, *The Houses of Old Cuba*.

20. Villaverde, *Cecilia Valdés*, 64.

21. For the architecture of international cemetery reform, although much less focused on Spanish contexts, see Etlin, *The Architecture of Death*.

22. For such prints, see Mialhe, *La isla de Cuba pintoresca*. Also see Cueto, *Mialhe's Colonial Cuba*.

23. Humboldt, *The Island of Cuba*, 80.

24. Villaverde, *Cecilia Valdés*, 130.

25. See Ringrose, "A Setting for Royal Authority."

26. "Nota sobre la fábrica de Casa de Gobierno, la Plaza de Armas, y otros edificios . . . traslada . . . de 18 de mayo de 1773." ARNAC, Gobierno General, Legajo 321, Exp. 15512, 1774–1817.

27. Feijóo, *Teatro crítico universal*. A summary of the impact of Spanish Enlightenment essayists on urban projects is given by Jordi Oliveras Samitier in *Nuevas poblaciones*.

28. For the program of *nuevas poblaciones* (new towns) in eighteenth-century Spain, see Oliveras Samitier, *Nuevas poblaciones*.

29. See *La Habana vieja*.

30. For recent studies on Spanish imperial representation through architecture and urban space, see Schreffler, *The Art of Allegiance*, and Escobar, *The Plaza Mayor*. See also Rojas Mix, *La plaza mayor*, and Kostof, *The City Shaped*.

31. For the physical reconfiguration of Madrid under the Austrian Habsburgs, see Escobar, *The Plaza Mayor*.

32. Ibid., 196–197.

33. See Melero, "Juan de Villanueva"; Villanueva, "Hoy, 21 de julio de 1796."

34. For the reconstruction of the Plaza Mayor of Mexico City under the Bourbons, see Gutiérrez Haces, "The Eighteenth Century," 67. See also Donahue-Wallace, *Art and Architecture*, 228–232.

35. A wooden replica of this sculpture stood in the center of the Plaza Mayor from 1796 to 1803 while the bronze version was being completed. For the complex history of the sculpture and the discourses surrounding its inauguration, see Widdifield, "Manuel Tolsá's Equestrian Portrait of Charles IV," and Deans-Smith, "Manuel Tolsá's Equestrian Statue of Charles IV."

36. "Proyecto para la formacion de una Plaza en la Ciudad de la Havana, proporcionada a su inumenoso Vecindario, y a los magnificos edificios que los particulares van construyendo, con demostracion de la hermosura de ella y utilidades que se seguirán al Real servicio y al bien Publico." ARNAC, Gobierno General, Legajo 321, Exp. 15512, 1774–1817. The reconstruction of the plaza is discussed in Segre, *La Plaza de Armas*, 16–18. An extensive set of documents on the reconstruction of Havana's Plaza de Armas in the late eighteenth century can be found in Archivo General de Indias (hereafter AGI), Audiencia de Santo Domingo, Legajo 1986.

37. "todas uniformes en sus fachadas, para mayor hermosura." ARNAC, Gobierno General, Legajo 321, Exp. 15512, 1774–1817.

38. This building is now referred to by the City Historians' Office of Havana as the Palace of the Captains General, and the Casa de Correos as the Palace of the Second-in-Command.

39. "para utilidad y conveniencia de la Ciudad." ARNAC, Gobierno General, Legajo 321, Exp. 15512, 1774–1817.

40. "mucha incomodidad á indecencia imponderable." ARNAC, Gobierno General, Legajo 321, Exp. 15512, 1774–1817.

41. "proporcionados a la grandesa de esta Ciudad." Ibid.

42. Weiss, *La arquitectura colonial cubana*, 260–271. These structures are also analyzed in detail in Sánchez Agustí, *Edificios públicos de La Habana*, 43–52.

43. The art historian Charles Burroughs examines the rhetorical operation of the early modern palace façade in Italy, providing an analysis that offers perspective on the role of palace façades as visual rhetoric in the Spanish colonial Americas, including that of the later Bourbon Empire. See Burroughs, *The Italian Renaissance Palace Façade*.

44. Bhabha, "Of Mimicry and Man." For house forms in colonial Havana, see Carley and Brizzi, *Cuba*, and Llanes, *The Houses of Old Cuba*.

45. Foucault, *Discipline and Punish*. See also Jay, "Scopic Regimes of Modernity."

46. Scheffler, *The Art of Allegiance*, 12.

47. Architects, engineers, and builders frequently used the treatise of the Roman architect Vitruvius, particularly his postulates of "strength, comfort and beauty," to glean ancient Roman principles of functionality, utility, and aesthetics that could be translated into the eighteenth-century architectural designs. Vitruvius, *The Ten Books of Architecture*.

48. For the military reforms of Charles III in Cuba, see Kuethe, *Cuba, 1753–1815*, and Johnson, *Social Transformation*.

49. Magali Carrera has argued that the Bourbons sought to "delimit, structure, and manage the social habits and identities of the people." Carrera, *Imagining Identity in New Spain*, 107.

50. For the importance of such rituals in political performance, see Curcio-Nagy, *Great Festivals of Colonial Mexico City*.

51. Rodríguez O., *The Independence of Spanish America*.

52. Chasteen, *Americanos*, 90–92.

53. "Que la plaza principal de todos los pueblos de las Españas, en la que se celebre ó se haya celebrado ya este acto solemne, sea denominada en lo secusivo Plaza de la Constitución, y que se exprese así en una lápida erigida en la misma." See "Real orden, fecha Cádiz 14 agosto 1812, disponiendo que la plaza principal de todos los pueblos en que se haya promulgado la Constitución, sea denominada

Plaza de la Constitución, y que se exprese así en una lápida erigida en la misma." ARNAC, Asuntos Políticos, Legajo 13, Exp. 20, 1812.

54. The following description of the constitution reading of 1812 in Havana, along with various quotations, comes from the *Diario del Gobierno de La Habana* of July 22, 1812.

55. For theories of performance, see Constantino, "Latin American Performance Studies," and Conquergood, "Performance Studies."

56. With the expulsion of the Jesuit order in 1767, the cathedral was turned over to the city of Havana. In 1788, when Havana attained cathedral status, the building became the city's cathedral and the seat of the bishop. The plaza around the church grew from the eighteenth-century reclamation of this former swampy area, the terminus of the Zanja Real (Royal Aqueduct). For the Havana cathedral, see Roig de Leuchsenring, *Los monumentos nacionales de la República de Cuba*, and Weiss, *La arquitectura colonial cubana*, 252–255.

57. The concavity and convexity of the cathedral front gave the impression of unresolved tension, complexity, and emotionality, which recalls the work of Francesco Borromini on such Roman buildings as San Carlo alle Quattro Fontane, 1638–1641. The building became the cathedral once the city resembled certain aspects of the mother church of the Society of Jesus in Rome, Il Gesu, 1568–1580.

58. "vistosamente decorado y cubierto interiormente de alfombras . . . un magnífico dosel con el retrato de nuestro adorado monarca el Sr. D. Fernando VII." *Diario del Gobierno de La Habana*, July 22, 1812.

59 "voz alta é inteligible la Constitucion en presencia de un extraordinario concurso." Ibid.

60. Alejandro Cañeque describes the role of the viceroy in New Spain as a "living image" of the king and discusses understandings of monarchy predominantly in seventeenth-century New Spain. In the context of the late eighteenth century, conceptions of political order surely began to shift from earlier ideas with the Bourbon restructuring of the state. See Cañeque, *The King's Living Image*.

61. "suntuosamente adornado como el primero . . . Leida en él segunda vez la Constitución con las mismas formalidades y aparato." Ibid.

62. "para obsequiar à todos los que le habían acompañado." Ibid.

63. Ibid.

64. One of these Constitution of 1812 monuments appears to have survived in St. Augustine, Florida, on the former Spanish colonial plaza.

65. For secondary sources on the *cabildos de naciones*, see Howard, *Changing History*; and Childs, *The 1812 Aponte Rebellion*. The images produced about *cabildo* processions are discussed in David H. Brown, *Santería Enthroned*.

66. See Childs, "The Defects of Being a Black Creole."

67. For extensive descriptions and eyewitness accounts of the *cabildo* processions on the day of Epiphany, see Ortiz, "The Afro-Cuban Festival" and *Los cabildos y la fiesta afrocubanos*.

68. For the use of clothing as a system of social coding in the Spanish colonial Americas, see Meléndez, "Visualizing Difference." For the construction of meaning through lived experience in society, see Certeau, *The Practice of Everyday Life*. For the construction of identity as a discursive practice, see Hall, "Introduction: Who Needs 'Identity'?" For the role of the plaza in constructing social life, see Low, *On the Plaza*.

TWO ←→ CLASSICISM AND REFORMED SUBJECTIVITY

1. Cañizares-Esguerra, *Nature, Empire, and Nation*.

2. The exceptions are in Carrera, *Imagining Identity*, and Katzew, *Casta Painting*. For the adaptation of neoclassicism to Latin American contexts, see Niell and Widdifield, *Buen Gusto and Classicism*.

3. Trouillot encapsulates this process succinctly as two supporting dynamics of isolation and identification. In what he terms an "isolation effect," the modern state produces "atomized individualized subjects [that are] molded and modeled for governance as part of an undifferentiated but specific 'public.'" This dynamic of separating subjects by promoting individuality only to reunite them as a public complements an "identification effect," or "a realignment of the atomized subjectivities along collective lines within which individuals recognize themselves as the same." Trouillot, "The Anthropology of the State," 126.

4. Cañizares-Esguerra, *How to Write the History of the New World*.

5. Ibid., 11–59.

6. Bleichmar, *Visible Empire*.

7. See Miller and Reill, *Visions of Empire*; Koerner, *Linnaeus: Nature and Nation*; Williams, *Botanophilia in Eighteenth-Century France*; Lafuente and Valverde, "Linnaean Botany and Spanish Imperial Biopolitics"; and Bleichmar, *Visible Empire*.

8. The development of science as a way of seeing relates to such theoretical works as Jay, "Scopic Regimes of Modernity."

9. For the Botanical Garden of Havana, see Puig-Samper and Valero, *Historia del Jardín Botánico de La Habana*.

10. Tomlinson, "Painters and Patrons."

11. "la opinion injuriosa y vulgar . . . las pasiones desordenadas." Campomanes, *Discurso sobre el fomento de la industria popular*, 44–45.

12. "serían del todo inútiles si las Provincias carecen de un órgano instruido y patriótico que acomode estas y otras ideas en todo o en parte a la situación, clima, frutos, industria y población relativa de cada Provincia." Ibid., 102.

13. "La nobleza, reducida a Sociedades Patrióticas, cuales se proponen, consumirá en ellas útilmente el tiempo que le sobre de sus cuidados domésticos, alistándose los caballeros, eclesiásticos y gentes ricas . . . para dedicarse a hacer las observaciones y cálculos necesarios, o experimentos, y a adquirir los demás conocimientos instructivos." Ibid., 43.

14. For the importance of such civil associations to imperial reform, see Paquette, *Enlightened Reform*.

15. See Larkin, *The Very Nature of God*.

16. There were also societies in Guatemala (1795–1796), Buenos Aires (1801), and Santa Fé de Bogotá in 1801–1802. See Victor M. Uribe-Uran, "Birth of a Public Sphere," and Shafer, *Economic Societies*, 26, 48, 146, 151, 154, 156, 157, 168, 183, 208. For the Havana society, also see Álvarez Cuartero, *Elementos renovadores*; Kapcia, *Havana: The Making of Cuban Culture*; and Navarro, *Cuba, la isla de los ensayos*.

17. Thomas, *Cuba or the Pursuit of Freedom*, 77.

18. For the development of the Cuban colonial press, see Jensen, *Children of Colonial Despotism*; and in Central America, Dym, "Conceiving Central America." For the importance of collective readership of newspapers in the formation of national consciousness, see Anderson, *Imagined Communities*. For library collections in the United States, see Charno, *Latin American Newspapers*.

19. Arthur P. Whitaker's assertion that the Enlightenment in Latin America was a more holistic culture suggests that the "Enlightenment," in general, was never a single school of thought and thus was understood, articulated, and adapted in myriad ways from nation to nation and place to place in this period. Whitaker, "Changing and Unchanging Interpretations."

20. The subscription fees for this *Memorias* have not been recovered, but this cost alone would have largely excluded nonelite residents. *Memorias de la Sociedad Económica de La Habana: Colección primera que comprende doce números, correspondientes a los doce meses del año de 1817*, Benson Latin American Collection, University of Texas at Austin.

21. Anderson, *Imagined Communities*.

22. *Memorias*, 1817, 15, 17, 21–24.

23. "Constitución y progresos de la Casa de Beneficencia," *Memorias de la Real Sociedad Económica de La Havana*, 1793, 46. Marrero, *Cuba: Economía y sociedad*, 178.

24. "el proyecto de los hacendados y vecinos [estaba] dirigido a establecer y dotar un hospicio o Casa de Beneficencia para la reclusión, educación e instrucción de los mendigos y niños huérfanos, de ambos sexos . . ." Marrero, *Cuba: Economía y sociedad*, 179.

25. "el Cuerpo Patriótico era el mas adeqüado a llevar a efecto una fundación que tenía su origen en el patriotismo Havanero." "Constitución y progresos de la

Casa de Beneficencia," *Memorias de la Real Sociedad Económica de La Habana,* 1793, 46.

26. Shubert, "'Charity Properly Understood.'"

27. Larkin, *The Very Nature of God,* 146–147.

28. Ibid., 147.

29. The Casa de Beneficencia (Charity House) of Havana was demolished in the twentieth century.

30. The building was 63 varas wide, 100 varas long, and 15 varas high with an *azotea* (terraced roof).

31. For the practice of Spanish colonial viceroys associating themselves with civic works, see Engel, "Art and Viceregal Taste." Engel has argued that late colonial portraiture in the Spanish world became a vehicle for the commemoration and temporal ordering of the patrons of public works, revealing the interdependence of viceregal authority and civic government. Also see Engel, "Facing Boundaries."

32. Campomanes, *Discurso sobre la educación popular de los artesanos y su fomento,* 177–185.

33. For such schools of drawing, see Bédat, *La Real Academia de Bellas Artes de San Fernando,* 415–431.

34. For a succinct discussion of *tertulias* in the Spanish world, see Rodríguez, *Independence of Spanish America,* 39–42.

35. The role of women in Bourbon-era society is addressed in Pérez Sánchez and Sayre, *Goya and the Spirit of the Enlightenment.*

36. Ibid.

37. Arango y Parreño, *Discurso sobre la agricultura.*

38. See Tomich, "The Wealth of Empire," 60.

39. With the implementation of these reforms, lower-class Creoles and free people of color, many enjoying military retirement, were suddenly mandated to work on roads, bridges, and necessary infrastructure for large-scale sugar cultivation. The *fuero militar* (the right to have cases brought before a military court) of Charles III (died 1788) were not fully honored by his son, Charles IV. The historian Sherry Johnson argues that such broken contracts created increased hostilities among lower-class Creoles toward the planter elite and sharpened divisions within the Creole classes. Johnson, *Social Transformation,* 63.

40. Tomich, "The Wealth of Empire."

41. Ibid., 56.

42. Arango's concept of labor, like that of his Spanish contemporaries, derived much from Adam Smith's *Wealth of Nations.* Arango viewed labor as a natural, material process that produced useful goods. However, as Smith regarded slave labor as inefficient, technological innovation would both increase production and reduce the burden of labor. Management was linked to subjecthood, as authority had to be wielded over those who were incapable of subjectivity. For

Arango in Cuba, planters, as men of property, defined their status as colonial subjects based on their interests. Since slaves, for example, owned no property and thus had no interests, they were incapable of self-interested action. The link between property, selfhood, and self-interested action facilitated the emergence of the nineteenth-century planters' self-image as liberal subjects with a natural place in the colonial social order in Cuba and a legitimate place in the empire of Spain. However, Arango argued that refinements in behavior, especially regarding the treatment of slaves, would lead to higher productivity. Part of being a better producer rested on better slave management, and he envisioned a combination of the reciprocal obligations between master and slave found in Christianity with the idea of the "technically efficient organization of tasks." Tomich, "The Wealth of Empire," 74. Yet, as Tomich notes, the writing of Adam Smith produced an internally unified, consistent political economy, whereas Arango's treatise was ultimately unsystematic. Indicative of Cuba's colonial social structure, reproduction of productive relations rested almost entirely upon slavery and racial discrimination. As Louis A. Pérez observes, "In no other Spanish colony was the local economy so totally dependent on slavery; in no other Spanish colony did African slaves constitute so large a part of the population; in no other Spanish colony did the total population of color constitute a majority." Pérez, *Cuba*, 101.

43. Ibid., 52–53.
44. See Kuethe, *Cuba*, and Knight, "Origins of Wealth."
45. See Domínguez, *Insurrection or Loyalty*.
46. Larkin, *The Very Nature of God*.
47. See Maraval, *Culture of the Baroque*, and Stoichita, *Visionary Experience*.
48. See Larkin, *The Very Nature of God*, and Voekel, *Alone before God*, 1.
49. Voekel, *Alone before God*.
50. Brian Larkin includes a few illustrations with his text but does not systematically analyze any of the objects, images, or spaces they represent. Several sources have included neoclassical art and architecture for churches, but these are not narrated within the context of religious reform in any depth.
51. See Voekel, *Alone before God*.
52. Torres Cuevas, *Obispo de Espada: Papeles*, 157–158.
53. Ibid., 158.
54. Del Duca, "A Political Portrait," 123.
55. Captains general in Cuba tended to occupy office for a maximum of four to six years, with exceptions.
56. "Los funestos efectos que ha producido siempre el abuso de enterrar los cadaveres en las iglesias." See Juan José Díaz de Espada y Landa, "Exhortación a los fieles de la Havana, hecha por el Prelado Diocesano sobre el Cementerio General de ella, 1805," in Torres Cuevas, *Obispo de Espada: Papeles*, 193–194.

57. The historian Pamela Voekel, while addressing the cemetery of Veracruz, Mexico, does not address its visual or spatial qualities. For more analysis on the visuality of the Havana cemetery as well as its social function, see Niell, "Classical Architecture," 57–90. For the Havana cemetery in general, see Menocal, "Etienne-Sulpice Hallet."

58. Developments in Spain seem to have been influenced by architectural typologies of French cemetery reform. See Etlin, *The Architecture of Death*.

59. "todos los curas párrocos, tenientes, y eclesiásticos seculares ó regulares, hacer entierro alguno en dichas sus respectivas iglesias, ni tampoco en ermitas y capillas públicas ó particulares, oratorios, ni generalmente en sitio alguno cercado y cerrado donde se juntan los fieles para orar y celebrar los santos misterios." See "Reglamento del modo de verificarse los enterramientos en el cementerio general de La Habana, que dictó su reverendo Obispo el 2 de septiembre de 1805, y á que se prestó conforme el gobernador vice-real patronato en providencia del 10," in Garrigó, *Historia documentada*, Chap. 2, 11.

60. García Pons, *El obispo Espada*, 88–89.

61. Romay Chacón, "Discurso sobre las sepulturas fuera de los pueblos," 127–136.

62. "sumergidos en la barbarie y en el fanatismo." Ibid., 128.

63. Romay Chacón, *Obras completas*, 1:129–131.

64. Much of what we know about the cemetery's patronage, authorship, form, spatial organization, and structure comes from the 1827 retrospective description of Tomás Romay Chacón. See "Descripción del Cementerio General de La Habana," in Romay Chacón, *Obras completas*, 1:136.

65. After the British invasion of 1762, the laws of fortification did not permit construction directly adjacent to the city walls. Romay Chacón, *Obras completas*, 1:139. It is likely that Vitruvius's ideas or the Laws of the Indies were used in the selection of the site.

66. Scott, *Temple of Liberty*, 37.

67. Ibid., 37–43; Menocal, "Etienne-Sulpice Hallet."

68. "árboles fúnebres y olorosos, que haciendo un buen efecto en los sentidos, contribuirán además a la salubridad del aire en aquel recinto y alrededores." Torres Cuevas, *Obispo de Espada: Papeles*, 199.

69. Jean-Charles Delafosse was particularly known for his funerary and cemetery architecture in Paris. See Etlin, *The Architecture of Death*, 4, 73. For Claude-Nicolas Ledoux's use of such formal elements in various types of buildings, see Braham, *The Architecture of the French Enlightenment*, 162–163, 166, 168, 174; and Middleton and Watkin, *Neoclassical and 19th Century Architecture*, 1:148, 140–151.

70. The cemetery's design and ornamentation reveals an adaptation in Cuba of the reformist aesthetics promoted by religious reformers in the Spanish world and

described by historian Carlos Forment as "Civic Catholicism." Forment, *Democracy in Latin America*, 11–15.

71. "el tiempo todo lo destruye y convierte en humo." Romay Chacón, *Obras completas*, 1:141.

72. A vara is a linear unit of measurement equivalent to approximately 33 inches. See glossary in Hoberman and Socolow, *Countryside in Colonial Latin America*, 284.

73. See Etlin, *The Architecture of Death*.

74. Abbot, *Letters Written*, 121.

75. Romay Chacón, *Obras completas*, 1:141.

76. "semejante á los templos antiguos." Romay Chacón, *Obras completas*, 1:139.

77. "Ecce nunc in pulvere dormian, Job VI. Et ego resucitabo eum in novísimo die. Joann. VII." Ibid.

78. "Beati mortui qui in Domino moriuntur: opera enim illorum sequantur illos. Apoc." Ibid.

79. "lámpara encendida día y noche." Ibid.

80. "Surgite mortui et venit in judicium." Ibid., 140.

81. This arrangement closely followed the traditional Christian format of positioning the saved on the right hand of Christ and the damned on the left.

82. "buen órden . . . para evitar confusion y disputas, ciertas clasificaciones de personas según sus derechos políticos o eclesiásticos . . . Se harán tres tramos proporcionados al número de tres clases; primera, media y común." Espada, "Reglamento," in Garrigó, *Historia documentada*, 12.

83. "el primero, los dos lados inmediatos a la capilla; el segundo, los dos correspondientes hasta mitad del cementerio, y el tercero toda la otra mitad de él." Ibid.

84. Etlin, *The Architecture of Death*, 59.

85. "todas las personas mas honradas de la ciudad, que por ello pagarán una cosa moderada demás que por la sepultura ordinaria." Espada, "Reglamento," in Garrigó, *Historia documentada*, 12.

86. "para la clase común de personas honestas del gremio de nuestros fieles." Ibid.

87. Marrero, *Cuba: Economía y sociedad*, 12:89.

88. Kearl discusses cemeteries as rhetorical devices that convey the fundamental beliefs and values of a society, asserting the identity of its members and proclaiming their social aspirations. Kearl, *Endings*, 49.

89. The 1805 inaugural ceremony of the cemetery in Havana likewise constructed social hierarchy in similar ways as the 1812 constitution reading. See Niell, "Classical Architecture," 78–80.

90. There are eight or more such mahogany altarpieces from this era in the Havana Cathedral, yet they have received seemingly no study. A very similar neoclassical wooden altarpiece can be found on the upper level of the cathedral in Seville, Spain, functioning as a clock.

91. Roig de Leuchsenring, *Los monumentos nacionales*, 78–81. Although Roig puts the date for this altar at 1820, a document in the Cuban National Archives reveals negotiations surrounding the altar's installation in 1828. See "Minutá relacionada con el valor con que era llegado el altar de mármol destinado a la catedral de La Habana." ARNAC, Gobierno General, Legajo 559, Exp. 27370, 1828.

92. This marble high altar is mentioned in the document "Minutá relacionada con el valor con que era llegado el altar de mármol destinado a la catedral de La Habana." Ibid.

93. Freiberg, "Bramante's Tempietto."

94. Other such paintings might include Jacques-Louis David's *Oath of the Horatii* (1784–1785), oil on canvas, Louvre, Paris; *The Death of Socrates* (1787), oil on canvas, Metropolitan Museum of Art, New York; and *The Lictors Bring to Brutus the Bodies of His Sons* (1789), oil on canvas, Louvre, Paris.

95. Perovani's fresco better resembles Nicolas Poussin's *The Judgment of Solomon*, 1649, which portrays a scene of emotional intensity and action before a subdued classical background.

96. Born in Havana, Caballero studied at the Seminary of San Carlos and the University of Havana, where he received a doctoral degree in theology in 1785. He collaborated with Captain General Luis de Las Casas on public improvements, was a member of the delegation for education, and served as ecclesiastical censor of the *Papel Periódico de La Habana*. See Navia, *An Apostle for the Immigrants*, 38–39. For the local translation of "enlightened" thought in the Spanish American context, see also Lanning, *Eighteenth-Century Enlightenment*.

97. Del Duca, "A Political Portrait," 29–31.

98. See Caballero, "Proyecto de Gobierno Autonómico para Cuba" and *Obras*.

99. For a biography of Bishop Juan José Díaz de Espada y Landa, see García Pons, *El obispo Espada*; Figueroa y Miranda, *Religión y política*; and Torres Cuevas, *Obispo Espada*.

100. S. Fischer, *Modernity Disavowed*.

101. Varela y Morales, *Observaciones sobre la constitución política*, 11.

102. Real Sociedad Económica de Amigos del País de La Habana, *Memorias de . . . 1817*.

103. Varela y Morales, *Miscelánea filosófica*, 29.

104. "un carácter bien inventado." Ibid., 28.

105. Dickie, *The Century of Taste*, 3.

106. Hume, "Of the Standard of Taste," 109.

107. For taste as a sociocultural phenomenon in the Anglophone world, see Styles and Vickery, *Gender, Taste, and Material Culture*. Also see Brewer and Bermingham, *The Consumption of Culture*.

108. "buen gusto . . . norma de perfección, deben todo este mérito a su conformidad con la naturaleza." Varela y Morales, *Miscelánea filosófica*, 82.

109. Ibid., 82–89.

110. "La Arquitectura antigua abundaba en adornos complicados, que confundían la vista y necesitaban largo tiempo para analizarse." Ibid., 83.

111. "vicio . . . en los siglos de peor gusto." Ibid.

112. "Se adquiere y rectifica por el estudio, la práctica y la imitación de los buenos modelos, consiguiendo de este modo la delicadeza y corrección que son sus principales propiedades." Ibid., 109. According to the eighteenth-century French *Encyclopedie*, the soul derived pleasure from a balance of order and variety, as "bad taste in the arts is to enjoy only elaborate ornamentation and to be insensitive to beautiful nature." "Gothic architecture . . . offends our taste," because it was overornamented, tiring the eye and perplexing the soul. On the contrary, "Greek architecture . . . appears uniform, but has the kind of variety that makes us look with pleasure on an object." The artist played an important role in transporting taste internationally, as "good taste develops gradually in a nation that has hitherto lacked it because, little by little, men come under the influence of good artists." Diderot, d'Alembert, and others, *Encyclopedia*, 337–339, 341, 344, and 348.

113. Varela y Morales, *Miscelánea filosófica*, 43.

114. We know little of either workshop practices or guild regulations in Havana. For art production in late colonial Cuba, see Pérez Cisneros, *La pintura colonial en Cuba* and *Características*; Juan, *Pintura y grabado coloniales cubanos* and *Pintura cubana*; Villa-Urrutia, "Las artes plásticas"; Rigol, *Apuntes sobre la pintura y el grabado en Cuba*.

115. Brown, *Santería Enthroned*, 31; Childs, *The 1812 Aponte Rebellion*, 62–63, 66–67, 71. In addition to *The Last Supper*, Perovani and/or Vermay contributed to a *Christ Giving the Keys to St. Peter* just across from *The Last Supper* in the right lunette in the Havana cathedral and set within a seemingly Arcadian landscape with a temple and tholos situated upon a high ridge as though on an acropolis. In the central lunette is an *Assumption of the Virgin*, a scene of Mary with outstretched arms amid clouds, wearing heavy statuesque drapery.

116. For Escalera, see Pérez Cisneros, *Características*, 17–21; Juan, *Pintura y grabado*, 14–15; Rigol, *Apuntes sobre la pintura*, 60–61; and Villa-Urrutia, "Las artes plásticas," 119–123.

117. For Escobar, see Calcagno, *Diccionario biográfico cubano*, 258; Pérez Cisneros, *Características*, 28–32; Juan, *Pintura y grabado*, 15–17; Rigol, *Apuntes sobre la pintura*, 71–85; Villa-Urrutia, "Las artes plásticas," 123–126; and Bermúdez Rodríguez, "Vicente Escobar."

118. Another name that appears in Cuban colonial portraiture of this period is Felipe Fuentes, whose *Portrait of Don José Joaquin de Varona* (1786), oil on canvas, in a style quite similar to Escobar, hangs in Cuba's Museo Nacional de Bellas Artes in Havana today.

119. Calcagno, *Diccionario biográfico cubano*, 258. For the racial politics of painting in New Spain, see Deans-Smith, "Dishonor in the Hands of Indians, Spaniards, and Blacks."

120. For portraiture in colonial Latin America, see Benson, *Retratos*.

121. Carrera, *Imagining Identity in New Spain*.

122. This event is recounted in detail in the *Diario del Gobierno de La Habana*, July 22, 1812.

123. "El objeto de las bellas artes del diseño es la imitación de la bella naturaleza ... la elegancia y simplicidad del carácter de los tres órdenes de Arquitectura griega." ARNAC, Gobierno Superior Civil, Legajo 861, Exp. 29158, February 6, 1813.

124. "el dibujo de los cinco ordenes, toscano, dorico, jonico, corintio y compuesto." "Plano del estudio a una Academia de Arquitectura que presente el catedratico de Matematicas del Colegio Seminario de La Havana al Exmo. Sr. Presid. Gob. Y Capitan General." Ibid.

125. "los buenos arquitectos ... *comodidad, firmeza* y *hermosura*" (underlined in original). Ibid.

126. For Vermay and the Academy of San Alejandro, see Faivre d'Arcier, *Vermay*, and Luz de Léon, *Jean-Baptiste Vermay*.

127. *Catalogues of the Paris Salon, 1673 to 1881*, compiled by H. W. Janson (New York and London: Garland Publishing, 1977); catalogue for 1808, p. 91; 1810, p. 103; 1812, p. 102; 1815, pp. 95–96.

128. These methods of academic instruction were borrowed from the French model and incorporated by Spanish academicians at the Royal Academies of San Fernando in Madrid (1752) and San Carlos in Valencia (1768). Such practices were also employed by instructors at the Royal Academy of San Carlos of New Spain (1783). For the RASF, see Bédat, *La Real Academia*; for the RASC, see Brown, *La Academia de San Carlos*, and Charlot, *Mexican Art and the Academy of San Carlos*; for contemporary discussion of the RASC, see Deans-Smith, "'A Natural and Voluntary Dependence'"; on nineteenth-century art academies and academicism from a global perspective, see Cardoso Denis and Trodd, *Art and the Academy in the Nineteenth Century*; and for the cultural politics of the art academy in general, see Boime, "The Cultural Politics of the Art Academy."

129. Sagra, "Exámenes de dibujo de la academia," 18. Also see Romay Chacón, "Memoria que envio a la Real Sociedad Económica."

130. Saco, "The Arts Are in the Hands of the People of Color," 58–59.

131. Sibylle Fischer has viewed Saco's essay within the larger Atlantic world response to the Haitian Revolution and its impact on the cultures of slavery. See Fischer, *Modernity Disavowed*. For perspective on the cultural ramifications of the Haitian Revolution in the Atlantic world, see Geggus, *The Impact of the Haitian Revolution in the Atlantic World*.

132. See Landers, *Atlantic Creoles in the Age of Revolution*, 1–14, 138–174.

133. Junta Ordinaria, November 17, 1817, in Acuerdos de la Junta Ordinaria de la Real Sociedad Patriótica, book 6, MS sheets 67–68; quoted in Fischer, *Modernity Disavowed*, 74.

134. See Charlot, *Mexican Art*.

135. *Papel Periódico de La Habana* (hereafter *PPH*), September 18, 1800.

136. Ibid.

137. For details on the development of the *Diario de La Habana*, see Jensen, *Children of Colonial Despotism*.

138. "el rango del buen gusto." *PPH*, September 28, 1800.

139. "el gusto moderno." *PPH*, February 15, 1801.

140. "los hombres de forma regularmente tienen más juicio que los demás . . . el talento no se halla debajo de un exterior humilde." *PPH*, March 29, 1801. For a contemporary study on the relationship between taste and socioeconomic status, see Bourdieu, *Distinction*.

141. "leer lo que contienen las obras." *PPH*, March 29, 1801.

THREE •—• FASHIONING HERITAGE ON
THE COLONIAL PLAZA DE ARMAS

1. Ong, *Flexible Citizenship*, 6.

2. See Evernden, *The Social Creation of Nature*.

3. Portions of this chapter developed from my earlier article "The Emergence of the Ceiba Tree as Symbol in the Cuban Cultural Landscape."

4. Anderson, *Nature, Culture, and Big Old Trees*, 64–71.

5. Ibid., 65; also see Howe, "Some Photographs of the Silk-Cotton Tree."

6. Fernández de Oviedo, *Natural History of the West Indies*, 93. For Fernández de Oviedo's use of images to communicate information about the Americas, see Bleichmar, *Visible Empire*, 36.

7. Passage quoted in Acosta, *Historia natural y moral de las Indias*, 193. Also see Fernández de Oviedo y Valdés, *Historia general y natural de las Indias*, 1:305.

8. Acosta, *Historia Natural*, 193.

9. Pané, *An Account of the Antiquities*, 25–26.

10. Pérez, *Cuba*, 3–48.

11. See Edgerton, *Theaters of Conversion*.

12. Díaz del Castillo, *The Conquest of New Spain*, 71.

13. Schele and Freidel, *A Forest of Kings*, 85.

14. Polonsky Celcer, *Monografía antológica del árbol*. Cited in Anderson, *Nature, Culture*, 106.

15. Anderson, *Nature, Culture*, 107. For the use of trees in general in the colonial Americas, see Lawrence, *City Trees*, 94–132. New tree planting came with the Bourbon Reforms, as seen in the mandates of the Visitor General of New Spain

José de Gálvez, who arrived in 1765. Lawrence further suggests that plazas in Spanish North America were unplanted until the second half of the eighteenth century (see pp. 97–98 and 110, respectively).

16. Alonso de Cáceres came to Cuba at the end of 1573 and was commissioned by the Audiencia of Santo Domingo to draft civic regulations that were named the Ordenanzas de Cáceres. These ordinances gave organization to municipal government, establishing laws on how to deal with different subject populations, infractions, public works, merchant practices, Indian towns, and consumption of alcohol. See Pichardo, *Documentos para la historia de Cuba*, 112.

17. González-Wippler, *Santería*, 133–135, 242–243.

18. Gottlieb, *Under the Kapok Tree*, 19–21.

19. González-Wippler, *Santería*, 133–135.

20. Cabrera, *El monte*, 150–152.

21. The original statue of the Virgin and Child was replaced in the nineteenth century, according to the City Historian's Office. A sculpture alleged to be the original now stands inside El Templete.

22. Marrero, *Cuba: Economía y sociedad*, 12:20, 21–23.

23. Ibid.

24. Abbot, *Letters Written*, 10.

25. For the claim that Captain General Cagigal de la Vega planted three ceiba trees flanking the pillar in 1754, see Alcover, "La Misa, la Ceiba, y el Templete," 251–252; and Roig de Leuchsenring, *Apuntes históricos*, 3:9.

26. O'Keeffe, "Landscape and Memory." For the relationship between history and memory, see also Birth, "The Immanent Past."

27. Ibid., 5.

28. Goya apparently executed another work on the subject, *The Apostle St. James and His Disciples Adoring the Virgin of the Pillar*, which is in the private collection of the family of Espinosa de los Moneros Rosilló. Another early modern Spanish artist who painted this theme was Francisco Ximénez de la Maza, who painted a *Venida de la Virgen del Pilar* (*Coming of the Virgin of the Pillar*) by 1655.

29. "quitar las chozas de madera que lo ocultaban, haciendo muy mal efecto á la vista en tan principal parage." Vives, "Expediente sobre reedificación del Templete y obelisco donde se dijo la ira misa 1519 en la Plaza de Armas," *DH*, Sunday, November 18, 1827. ARNAC, Gobierno Superior Civil, Legajo 1, Exp. 48, 1827.

30. "después de haber meditado muy detenidamente lo que convenía, para que resulte un monumento de noble arquitectura, digno del objeto y de la culta Habana." Ibid.

31. Vives refers to the pillar of 1754 erected by Governor Cagigal de la Vega as "el obelisco" and expresses his desire to preserve the work, "conservando absolutamente su forma antigua." Ibid.

32. "un portico con su frontón, sostenido por seis columnas del órden dórico de seis varas de altura: en el friso entre los triglifos y por metopas van esculpidos los atributos de la Real órden Americana de Isabel la Católica." Ibid.

33. A number of documents and a plan from 1851 reveal an effort to reorganize the Cuartel de la Fuerza (Barracks of the Fuerza fortress), which involved modifications to El Templete. O'Reilly Street was enlarged and the monument scaled back to its current configuration. ARNAC, Gobierno Superior Civil, Legajo 15, Exp. 879, 1851.

34. Vitruvius, *The Ten Books on Architecture*, 120–122.

35. "recoger las cantidades con que voluntariamente quieran contribuir los vecinos pudientes para tan necesaria obra." Vives, "Expediente" (see n. 30 above).

36. "por las pruebas que siempre he recibido de la generosidad de este vecindario, cuento con que inmediatamente se completarán los catorce mil pesos á que asciende el presupuesto." Ibid.

37. Ibid.

38. *DH*, March 16, 1828, 2.

39. "Religión—Fernando 7—Escmo. Ayuntamiento—Vives—Espada—Pinillos—Laborde." Ibid., 2–4.

40. For a biography of Pinillos, see Ovilo y Otero, "Biografía del Excmo. señor don Claudio Martínez de Pinillos."

41. *DH*, March 16, 1828, 3.

42. "dos mundos unidos y una corona que los abraza" and "simbolizan la nuestra íntima y fiel union con la madre patria." Ibid.

43. "Reynando El Señor Don. Fernando VII
Siendo. Presidente Y Gobernador
Don Francisco Dionisio Vives
La Fidelísima. Habana. Religiosa. Y Pacífica.
Erigió. Este. Sencillo. Monumento.
Decorando. El. Sitio Donde El. Año de. 1519
Se Celebró. La. Primera. Misa. Y Cabildo.
El Obispo. Dn Juan José Díaz de Espada.
Solemnizó. E. Mismo. Agusto. Sacrificio.
El. Dia. 19. De. Marzo. De. 1828." Ibid.

44. Such small devotional shrines are discussed in Christian, *Local Religion in Sixteenth-Century Spain*.

45. For *posa* chapels and open chapels, see Edgerton, *Theaters of Conversion*.

46. The eighteenth-century bishop Pedro Agustín Morell de Santa Cruz mentions this function of *ermitas* in "El Obispo Morell de Santa Cruz oficializa los cabildos africanos donde nació la santería, convirtiéndolos en ermitas." Havana, December 6, 1755, in Marrero, *Cuba: Economía y sociedad*, 8:159–61.

47. Weiss, *La arquitectura colonial cubana*, 341.

48. For the broader range of European and American neoclassical architecture in the eighteenth and early nineteenth centuries, see Braham, *Architecture of the French Enlightenment*, and Irwin, *Neoclassicism*.

49. Rojas, *La Academia de San Carlos y los constructores del Neoclásico*.

50. Drawings for six different *"templetes,"* including a number of plans, sections, and elevations, can be found in the catalogue. Ibid., 76–77, 78, 95, 101, 122, 149, 241, 300.

51. For the early modern invention of the monument, see Choay, *Invention of the Historic Monument*. Also see Collins, *Changing Ideals in Modern Architecture*.

52. Rykwert, *On Adam's House in Paradise*.

53. Laugier, *Essai sur l'architecture*.

54. For a critical analysis of the work of Quatremère de Quincy, see Lavin, *Quatremère de Quincy and the Invention of a Modern Language of Architecture*.

55. Rosenblum, *Transformations in Late Eighteenth Century Art*, 141–142.

56. The Archivo-Biblioteca of the Real Academia de Bellas Artes de San Fernando houses documents that reveal multiple references to Bramante's Il Tempietto as a *"templete."* See "Por orden de S. A. Rl. el Sermo. Sor. Ynfante Dn. Carlos, y Dirección del Sor. Dn. Ysidro Velázquez, Director gral. de esta Rl. Academia se colocaron en las Salas de Arquitectura los Planos y dibujos que á continuación se expresan," 2-57-5, 1828, Madrid. Item no. 5 under "Sala 2a. de Arquitectura llamada la Conegera" reads: "Plantas del Templete que se halla en medio del claustro del convento de Sn. Pedro-in-Montorio en Roma, por dho Nabusia en 1827."

57. Palladio, *The Four Books on Architecture*.

58. Freiberg, "Bramante's Tempietto."

59. See Forniés, Pajuelo, and Martínez, *Renovación, crisis, continuismo*, 18–19.

60. AGI, Audiencia de Santo Domingo, Leg. 1340, No. 9, Folios 1–76. Also see Peraza Sarausa, *Historia de la Biblioteca de la Sociedad Económica de Amigos del País*.

61. On the subject of painting and originality in Novo-Hispanic painting, see Bargellini, "Originality and Invention in the Painting of New Spain."

62. See Freiberg, "Bramante's Tempietto."

63. "semejante á los templos antiguos." Romay Chacón, *Obras completas*, 1:139.

64. Ackerman, "The Tuscan/Rustic Order."

65. Ibid., 15.

66. Ibid.

67. The passage, again, reads: "un portico con su frontón, sostenido por seis columnas del órden dórico de seis varas de altura." ARNAC, Gobierno Superior Civil, Legajo 1, Exp. 48, 1827.

68. Vitruvius, *The Ten Books on Architecture*, 109–113.

69. Weiss, *La arquitectura colonial cubana*, 346.

70. See Cañizares-Esguerra, "Entangled Histories."

71. For the Vatican's attack on Espada, see Figueroa y Miranda, *Religión y política en la Cuba*. For the architecture of Freemasonry, see Curl, *The Art and Architecture of Freemasonry*, and Vidler, *The Writing of the Walls*.

72. Torres Cuevas, *Historia de la masonería cubana*.

73. Garrigó, *Historia documentada*.

74. Littler and Naidoo, *The Politics of Heritage*, 2.

75. Emilio Roig counts this work on the "monuments" of Havana, along with El Templete, but does not make an explicit link between the two works. Roig de Leuchsenring, *Apuntes históricos*, chap. 3.

76. Roig de Leuchsenring, *Apuntes históricos*, chap. 3, 7.

77. When the main parish church was demolished in 1777 to make way for the Marqués de la Torre's ambitious reconstruction plans for the plaza, the monument was transferred to the house of the old Cepero family on the corner of Obispo and Oficios Streets. It passed in 1914 to the National Museum, where it remained until 1937, when it was returned to the Plaza de Armas by the city historian and placed in the Palace of the Captain General, where it remains today, mounted to the wall of the lower interior gallery. Roig de Leuchsenring, *La Habana: Apuntes históricos*, chap. 3, 7; Castro, "Arte cubano colonial," 295.

78. See *DH*, March 16, 1828, and March 27, 1828.

79. Ibid.

80. *DH*, March 27, 1828.

81. For more discussions on the complexities of *buen gusto* in Spanish America, see Niell and Widdifield, *Buen Gusto and Classicism*.

82. The "royal palace" is a type that represents the presence of the king; it can be used for multiple administrative functions as well as a residence for the viceroy or captain general.

83. Umberto Eco identifies the semiotic operation of function in architecture as he argues that buildings denote or connote "functions to be fulfilled." See Eco, "Function and Sign."

84. For heritage as a way of seeing, as a gaze, see L. Smith, *Uses of Heritage*, 52.

85. *DH*, March 27, 1828.

86. McClellan, *Inventing the Louvre*.

87. Eitner, *Neoclassicism and Romanticism*, 112. See also Crow, *Painters and Public Life*.

88. Eitner, *Neoclassicism and Romanticism*, 112.

89. Ibid., 113.

90. No documents were found in the Archivo Nacional de Cuba or the Biblioteca Nacional José Martí, both in Havana, or in the Archivo General de Indias of Seville that reveal regulations regarding spectatorship of or restricted access to El Templete.

91. *DH*, March 16, 1828.

92. Ibid.

93. Ibid.

94. Ibid., 2.

95. See Arrate, *Llave del Nuevo Mundo*; Urrutia y Montoya, *Teatro histórico*; Morell de Santa Cruz, *Historia de la isla*; and Valdés, *Historia de la isla de Cuba*.

96. See Alcalá, "The Image of the Devout Indian," 248–249.

97. See Las Casas, *A Short Account of the Destruction of the Indies*.

98. "la timidez que manifiesta al ver los españoles el niño que conduce una India." *DH*, March 16, 1828, 3.

99. See Dean, "Savage Breast/Salvaged Breast."

100. Kagan, *Urban Images*.

101. Dean, *Inka Bodies and the Body of Christ*. Other salient examples in Spanish viceregal America of such group scenes in a civic context include the following by category: (1) religious festivals and observances: Manuel de Arellano, *Transfer of the Image and Inauguration of the Sanctuary of the Virgin of Guadalupe*, 1709; Anonymous, *El traslado de las monjas domínicas a su nuevo convento de Valladolid*, 1738; *Solemn Procession of Our Lady of Loreto to Mexico City*, after 1727, oil on canvas, Iglesia de San Pedro Zacatenco, Mexico; (2) devotional proceedings: José de Páez, *Mission of San Francisco, Barbarous Indians and the Lord of the Column*, 1746; Mariano Guerrero, *Fray Junípero Serra recibe el viático*, 1785; José Joaquín Magón, *Portada Erected in Cathedral of Puebla*, c. 1755; attributed to José Juárez, *Transfer of the Image of the Virgin of Guadalupe to the First Hermitage and Representation of the First Miracle*, c. 1653, oil on canvas, Museo de la Basílica de Guadalupe, Mexico City; Francisco Chihuantito, *Virgin of Montserrat*, 1693, oil on canvas, Iglesia de Chinchero, Cuzco, Peru; (3) burials or funerary ceremonies: Juan Zapaca Inga, *Burial of St. Francis of Assisi*, 1684; Basilio Pacheco, *Burial of St. Augustine*, 1742–46; (4) weddings: Anonymous, *Nuptials of Martín de Loyola with the Ñusta Beatriz and of Don Juan de Borja with Doña Lorenza Nusta de Loyola*, c. 1680, oil on canvas, Church of the Company of Jesus, Cuzco, Peru; (5) *entradas*: Anonymous, *Reception of the Viceroy in the Casas Reales of Chapultepec*, eighteenth century; Melchor Pérez de Holguín, "*The Arrival of Viceroy Morcillo in Potosí*, 1716; (6) urban views: Anonymous, *Procession in the Main Square of Lima*, end of seventeenth century/beginning of eighteenth, Church of La Soledad, Convent/Monastery of San Francisco, Lima, Peru. In the context of the colonial Andes, Maya Stanfield-Mazzi argues that donor portraiture in religious painting functioned to reify the donor's place in the Christian community; see "Cult, Countenance, and Community." We could view group portraiture such as that found in Vermay's inauguration painting as affirming the membership of those represented within the new public culture of

Havana that included commercial ideology, religious reform, and other aspects of reformed subjectivity.

102. On the role of clothing in constructing social hierarchy in the Spanish Americas, see M. Meléndez, "Visualizing Difference."

103. Luz de Léon, *Jean-Baptiste Vermay*, 39.

104. See Porterfield and Siegfried, *Staging Empire*, 115–121. For an earlier contextualization of the work in a political context, see Boime, *Art in the Age of Bonapartism*.

105. Porterfield and Siegfried, *Staging Empire*, 122–128.

106. Michael Schreffler's work on the agency of architecture and images in the exercise of Spanish viceregal power considers the medieval political philosophy that distinguished between the king's actual body and the monarch's body politic that was "readily representable." The existence of this notion of the king's "two bodies" suggests that urban materiality could have signified or indeed embodied royal authority in Europe and overseas territories actively ruled by the sovereign. See Schreffler, *The Art of Allegiance*, specific reference p. 10.

107. Luz de Léon, *Jean-Baptiste Vermay*, 39.

108. Boyer, *City of Collective Memory*, 165.

109. Faivre d'Arcier, *Vermay, mensajero de las luces*, 35.

110. Ibid.

111. A list of the attendees of the inauguration ceremony is given in Lescano Abella, *El primer centenario del Templete*, 28; Luz de Léon, *Jean-Baptiste Vermay*, 37; and García Pons, *El obispo Espada*, 132.

112. Act of the Assembly of the Economic Society of Friends of the Country, June 3, 1828. See Faivre d'Arcier, *Vermay, mensajero de las luces*, 154.

113. Lescano Abella, *El primer centenario del Templete*, 28.

114. Ibid.

115. Numerous *tertulias* are mentioned in the periodicals of late-eighteenth- and early-nineteenth-century Havana. For women in Bourbon-era society, see Pérez Sánchez and Sayre, *Goya and the Spirit of the Enlightenment*.

116. We still do not know who was allowed to enter and view the paintings upon their completion, nor how often the memorial was open for view.

117. Villaverde, *Cecilia Valdés*, 138.

118. "La seiba á cuya sombra aparece el altar, el papagayo que reposa en su copa; los abrojos y tunales esparcidos en el suelo, un horizonte claro y despejado al tiempo de elevarse el sol en el oriente, todo indica que la escena aconteció en la ribera del mar del algun país inmediato al Equator." *DH*, March 16, 1828, 2.

119. Arrate, *Llave del Nuevo Mundo*, 22.

120. Ibid.

121. "El otro grupo consta diez españoles oyendo la misa, bien marcados por su trage y facciones, y en ellos es tan admirable la fecunda invención del artista como

la propiedad y acierto en la ejecución, pues estando todos penetrados de unos mismos sentimientos, piedad y devoción, todos los manifiestan con diferentes espresiones." *DH*, March 16, 1828, 2–4.

122. This rewriting of the Spanish conquest of Cuba perhaps gives visual form to what historian Jorge Cañizares-Esguerra has argued about efforts by European intellectuals to revise conquest narratives by disavowing the eye-witness accounts of sixteenth-century chroniclers. See Cañizares-Esguerra, *How to Write the History of the New World*. Magali Carrera addresses complex transformations in the context of New Spain/Mexico from a loyalist to a nationalist subjectivity involving the trope of the body. See "From Royal Subject to Citizen."

123. Discourses on the transfer of Columbus's remains to Havana can be found in the following two documents: "Gobernador Habana sobre cenizas del Almirante Colón," AGI, Estado, 5A, No. 1, 1796; and "Arzobispo Santo Domingo sobre restos de Cristóbal Colón," AGI, Estado, 11A, N. 16, 1796. Also see Roig de Leuchsenring, *La Habana: Apuntes históricos*, Vol. 3, for the commemorative monument to Columbus in the Havana cathedral.

124. A drawing of this carving appears in Hazard, *Cuba with Pen and Pencil*, 123.

125. For Mexican intellectual understandings of Columbus in the mid-nineteenth century as a mediating figure between the Old World and the New, see Widdifield, *Embodiment of the National*, 83–90.

126. The statue is now mounted on the circular base of the 1754 pillar.

127. Morell de Santa Cruz, *Historia de la isla*; Urrutia y Montoya, *Teatro histórico*; Arrate, *Llave del Nuevo Mundo*.

128. Morell de Santa Cruz, *Historia de la isla*, 48.

FOUR ⊷ THE DISSONANCE OF COLONIAL HERITAGE

1. Graham, Ashworth, and Tunbridge, *A Geography of Heritage*, 24.

2. Ibid.

3. Nora, "Between Memory and History: *Les Lieux de Mémoire*," 235–237.

4. Calcagno, *Diccionario biográfico cubano*, 692–693.

5. Jensen, *Children of Colonial Despotism*, 83.

6. For a discussion of Varela's work in the United States, including his letters to Cuba written in exile, see Navia, *An Apostle for the Immigrants*.

7. Gott, *Cuba: A New History*, 48–52.

8. Ibid., 51. For a detailed account of the conspiracy, see Garrigó, *Historia documentada*.

9. See S. Fischer, "Bolívar in Haiti."

10. For the Aponte conspiracy, see Childs, *The 1812 Aponte Rebellion in Cuba*; José Luciano Franco, *La conspiración de Aponte, 1812*; and Palmié, *Wizards and Scientists*.

11. These books have never been recovered. The most systematic analysis of the content in the "book of paintings" is provided by Palmié in *Wizards and Scientists*, 79–158; Hernández in "Hacia una historia de lo imposible," 172–273; and Landers in *Atlantic Creoles*, 1–14, 138–174. For subversion and networks of communication in the Atlantic world, see Linebaugh and Rediker, *The Many-Headed Hydra*, and Julius Scott III, "The Common Wind."

12. Quote translated by Stephan Palmié from the descriptions of José Antonio Aponte's responses when being questioned by Spanish authorities about his *libro de pinturas* (book of pictures) in 1812. Palmié, *Wizards and Scientists*, 102.

13. Jensen, *Children of Colonial Despotism*, 88.

14. Ibid.

15. Cañeque, *The King's Living Image*.

16. *DH*, March 16, 1828.

17. Lescano Abella, *El primer centenario del Templete*, 14–21.

18. Cañeque, *The King's Living Image*.

19. Schama, *Landscape and Memory*, 214–226.

20. Giovanni da Modena's *Mystery of the Fall and Redemption of Man* (1420), in the church of San Petronio in Bologna, is another example. In this scene, figures are likewise organized horizontally beneath the tree canopy. Adam and Eve stand alongside Old Testament prophets on the thorny side of the tree cross, atoning for original sin. Meanwhile, the Virgin Mary holds a chalice and catches the blood of Jesus Christ on his right side beneath the leafy tree branches and alongside the apostles and church fathers. The tree here becomes a device that constructs a foundational space in the life of Christianity, a crossroads of fundamental opposites in Christian theology, sin and salvation, Old and New Testaments, death and life.

21. "presentará á los naturales de este hermoso país y á los estrangeros que visiten sus orillas, ese sencillo pero magestuoso edificio que en medio de los horrores de las convulsiones políticas y en oposición al torrente de las pasiones novelescas, hijas de nuestro siglo, elevarán el amor patrio y la lealtad." *DH*, March 27, 1828.

22. "'mis padres y mis abuelos . . . concibieron esta idea y la llevaron á cabo; y nosotros nos envanecemos de descender de tan ilustre progenie.'" Ibid.

23. "esos desnaturalizados hijos de nuestra patria, que en lugar de ofrecer monumentos dignos así de la virtud y la ilustración, se lanzen á la arena, insultando y llenando de baldones á los mismos á quienes debieran su civilización y su gloria?" Ibid.

24. "Dejemos á estos ilusos seguir frenéticos la senda que conduce á la profunda sima en que van á hundirse, ó más bien roguemos al Cielo los detenga de una vez y les haga xionar 'sobre lo que son y lo que podrían ser': y tornemos gustosos nuestros ojos hácia está Isla privilegiada de la naturaleza . . . mientras nosotros, despreciando las sugestiones de una falsa ilustración . . . damos en este día una prueba notoria de . . . cuán firme es nuestra resolución de no desmentir estos principios." Ibid.

25. Roland Barthes has emphasized the fluctuating meaning of urban space, which suggests the role of colonial monuments, objects, images, and performances as intervening in the production of meaning within a colonial city in an effort to reestablish authority and collective allegiances. Barthes, "Semiology and the Urban."

26. See Rabasa, *Inventing America*, and Mignolo, *The Darker Side of the Renaissance*.

27. Edgerton, *Theaters of Conversion*.

28. Lara, *City, Temple, Stage*.

29. Juana Inés de la Cruz, *Neptuno alegórico*.

30. Sigüenza y Góngora, *Teatro de virtudes políticas*.

31. Emily Engel argues that South American viceroys used portraiture to construct American aspects of their evolving identities. See Engel, "Facing Boundaries" and "Art and Viceregal Taste."

32. Vargaslugo, *Images of the Natives*, 438–441.

33. Among the writers who extol the virtues of the conquistador Diego Velázquez is Valdés, *Historia de la isla de Cuba*, 40.

34. The increase in interest in illustrious Spaniards can be attributed in part to the publications of Manuel José Quintana (1772–1857), including *Vidas de españoles célebres*.

35. See Bleichmar, *Visible Empire*; Lafuente and Valverde, "Linnaean Botany."

36. See Bleichmar, *Visible Empire*, 152–161.

37. See "Cuadro estadístico de la siempre fiel isla de Cuba, correspondiente al año de 1827 . . ."

38. Ibid., 10.

39. Ibid., 11.

40. Navarro, *Cuba, la isla de los ensayos*, 196.

41. Ibid., 214–215.

42. "quien deseoso de desempeñarla con el mayor acierto, y conociendo que en esta Isla hay grandes variedades de producciones tan útiles como desconocidas en Europa, convida á todos los facultativos, á los aficionados, á los amantes de las ciencias naturales, á juntar con él sus esfuerzos, y concurrir a tan loable fin." *Papel Periódico de La Habana*, December 24, 1791. See Navarro, *Cuba, la isla de los ensayos*, 215.

43. See Puig-Samper and Valero, *Historia del Jardín Botánico de La Habana*.

44. Navarro, *Cuba, la isla de los ensayos*, 216–217.

45. Alexander von Humboldt's observations on Cuba would eventually be published in 1826 in Paris in *The Island of Cuba: A Political Essay*.

46. Real Sociedad Económica, *Memorias de la Real Sociedad Económica de la Habana (1817)*, 420–421.

47. Ibid., 422.

48. "no exige instrumentos complicados: buenos ojos, y un juicio recto y sábido, es cuanto la naturaleza pide al filósofo que quiere conocerla en uno de sus reinos más interesantes." Real Sociedad Económica, *Memorias de la Real Sociedad Económica de la Habana (1817)*, 23–24.

49. See Lafuente and Valverde, "Linnaean Botany," and Bleichmar, *Visible Empire*. Also see Bleichmar, De Vos, Huffine, and Sheehan, *Science in the Spanish and Portuguese Empires*.

50. See Cañizares-Esguerra, *Nature, Empire, and Nation*.

51. Bleichmar, *Visible Empire*, 161–184.

52. The historian Jorge Cañizares-Esguerra has argued that Creole intellectuals in certain areas of Spanish America produced sustained critiques of European homogenizing science by emphasizing the variability and even microcosmic nature of their regional flora. See Cañizares-Esguerra, "How Derivative Was Humboldt?"

53. For the early modern Atlantic world city as a locus of identification, see Fay and von Morze, *Urban Identity and the Atlantic World*.

54. See Heredia, *Poesías completas*, 237–238.

55. Rykwert, *The Idea of a Town*.

56. Mexico City painter Cristóbal del Villalpando's *Virgin of Aránzazu*, a late-seventeenth-century oil on canvas, is addressed by Clara Bargellini in Rishel and Stratton-Pruitt, *The Arts in Latin America*, 374. Miguel Cabrera's painting *Virgin of Valvanera* (1762), oil on copper, is also discussed by Bargellini in the same volume on page 395.

57. Cuadriello, "Tierra de prodigios."

58. Ibid., 201.

59. Ibid., 206 and 209.

60. Other examples of tree as visual trope in the eighteenth-century Spanish Americas include the following works: *The Sacramental Tree of Life* (1753), oil on canvas, in the Parroquia de Santa Cruz, Tlaxcala, Mexico, discussed by Ilona Katzew as an illustration of the seven sacraments of the church in the article "'Remedo de la ya muerta América,'" 170–172; *Genealogical Tree of the Royal Line of Texcoco* (c. 1750), ink and watercolor on parchment, Texcoco, Mexico, in the Staatliche Museen zu Berlin, Ethnologisches Museum; and the *Codex Techialoyan García Granados* (mid-seventeenth–early eighteenth century), ink and pigment on amate paper, Central Mexico, in the Biblioteca Nacional del Museo de Antropología, INAH, Mexico City, discussed by Eduardo de Jesús Douglas as visual constructions of genealogy in the article "Our Fathers, Our Mothers." Luisa Elena Alcalá examines a Spanish *Christ of the Oak* (after 1753), oil on canvas, in the Iglesia de San Mateo, Cáceres, Spain, in which Christ appears in a tree being chopped down by a heathen Indian, which became a popular theme in churches

in Extremadura in the mid-eighteenth century. See Alcalá, "The Image of the Devout Indian," 228–229. These appropriations of the tree for multiple representational purposes may have been informed by local traditions as well as Enlightenment beliefs in the preeminence of nature.

61. For the notion of place, see T. Cresswell, *Place*, and Jackson, *A Sense of Place*.

62. "un símbolo superior en la vida de la colectividad." Baroja, *Ritos y mitos equívocos*.

63. Ibid., 366–367.

64. Wordsworth, "The Oak of Guernica."

65. Young, *Liberty Tree*, 325–327.

66. For analysis on the imagery and social practices surrounding the liberty tree in North America, see Schlesinger, "Liberty Tree: A Genealogy"; Cresswell, *The American Revolution in Drawings and Prints*, 273, 276, 403; Brigham, *Paul Revere's Engravings*, 26–31; Young and Fife with Janzen, *We the People*, xvi–xxi, 39, 62–63, 65; Campanella, *Republic of Shade*; D. H. Fischer, *Liberty and Freedom*, 19–36; and Young, *Liberty Tree*.

67. Garraway, *Tree of Liberty*.

68. Paine, "Liberty Tree," in *Thomas Paine Reader*, 63–64.

69. See Navia, *An Apostle for the Immigrants*.

70. See Pérez, *Cuba*, 72.

71. On the mobility of people of African descent during this era, see Landers, *Atlantic Creoles*.

72. The Cuban historian Eduardo Torres Cuevas has suggested that Espada was making a constitutional statement within absolutism. Torres Cuevas, *Obispo de Espada*.

73. *DH*, March 27, 1828.

74. An earlier version of the following passage on Cuban historiography was published by the College Art Association in the September 2013 issue of *The Art Bulletin*, under the title, "Rhetorics of Place and Empire in the Fountain Sculpture of 1830s Havana." For the Indian as a visual allegory of the Americas in late colonial and early national contexts, see Ades, *Art in Latin America*; Widdifield, *Embodiment of the National* and "El indio re-tratado"; Acevedo, "Entre la tradición alegórica y la narrativa factual"; and Carrera, "Affections of the Heart" and *Traveling from New Spain to Mexico*, 19–38. For the allegorical Indian in print culture, see Esparza Liberal, "La insurgencia de las imágenes."

75. "de humor pacífico, dóciles y vergonzosos, muy reverentes con los superiores, de grande habilidad y aptitud para las instrucciones de la fe." Arrate, *Llave del Nuevo Mundo*, 18.

76. Solís, *Historia de la conquista de México*; Herrera y Tordesillas, *Historia general de los hechos*; and Díaz del Castillo, *The Conquest of New Spain*.

77. Torquemada, *Monarquía indiana*.

78. "hermosa indolencia." Arrate, *Llave del Nuevo Mundo*, 19.

79. Urrutia y Montoya, *Teatro histórico*, 90.

80. Acosta, *Historia natural y moral*.

81. García, *Origen de los indios del Nuevo Mundo*.

82. "principios de la religión verdadera." Urrutia y Montoya, *Teatro histórico*, 90.

83. See Cañizares-Esguerra, *How to Write the History of the New World*, 11–59, 60–129. For the visualization of the Indian in art, see Katzew, "'That This Should Be Published.'" For further discourses on the Indian figure in the rise of Latin American nationalism, see Earle, "'Padres de la Patria,'" and *The Return of the Native*.

84. See García, *Origen de los indios*, and Martínez, "The Black Blood of New Spain."

85. "Velázquez siguiendo las bárbaras máximas de aquellos tiempos, tan distintas de la ilustración de nuestros días, le consideró como un esclavo que había hecho armas contra su Señor; y le condenó a las llamas." Valdés, *Historia de la isla de Cuba*, 41.

86. See Heredia, *Poesías completas*.

87. See Faivre d'Arcier, *Vermay*.

88. Doris Sommer has shown that nationalist discourses in Latin America frequently employ a trope of romance, marriage, and sexuality. See Sommer, *Foundational Fictions*.

89. For *casta* painting in New Spain, see Carrera, *Imagining Identity in New Spain*, and Katzew, *Casta Painting*.

90. Jameson, *Letters from the Havana*, 8.

91. Pérez, *Cuba*, 52.

92. "La isla de Cuba en el progreso de sus leyes, de sus costumbres y de su riqueza, empieza ya a elevarse al rango de los pueblos más cultos de Europa; la estensión de su comercio y de sus relaciones se hace sentir en los países más remotas del mundo; consecuencias naturales de su privilegiada situacion, clima y conducta política de sus moradores . . ." See "Alguna cosa más sobre el nuevo monumento erigido en la plaza de Armas," *DH*, Thursday, March 27, 1828, 1.

93. On the construction of common ancestors as mediation of present circumstances in Atlantic Francophone contexts, see Grigsby, "Revolutionary Sons, White Fathers."

94. See Zequeira y Arango and Rubalcava, *Poesías*.

95. Zequeira y Arango, "A la piña," in ibid., 191–194.

96. "La piña . . . la fragante piña; En mis pensiles sea cultivada; Por mano de mis ninfas." Ibid., 192.

97. "¡Salve feliz Havana! . . . el meloso néctar de la piña." Ibid., 193.

98. "Y así la aurora con divino aliento; Brotando perlas que en su seno cuaja; Conserve tu esplendor, para que seas; La pompa de mi Patria." Ibid., 194.

99. Rubalcava, "El tabaco," in ibid., 372.

100. "De Cuba las amenas producciones! . . . primero la verdad entona; En honor de la Patria y de Pomona." Ibid., 376.

101. Heredia, "La Estación de los Nortes," in *Poesías completas*, 156–158.
102. "las climas de triste Europa." Ibid., 157.
103. "cantaré feliz mi amor, mi patria, de tu rostro y de tu alma la hermosura, y tu amor inefable y mi ventura." Ibid., 158.
104. "Así en los campos de la antigua Persia / resplandeció tu altar; así en el Cuzco / los Incas y su pueblo te acataban. / Los Incas! ¿Quién, al pronunciar su nombre, / si no nació perverso, / podrá el llanto frenar . . . ? Sencillo y puro, / de sus criaturas en la mas sublime / adorando al autor del universo / aquel pueblo de hermanos, / alzaba a ti sus inocentes manos." Ibid., 163.
105. Martí, *José Martí: Selected Writings*, 288.

FIVE ⟶ SUGAR, SLAVERY, AND DISINHERITANCE

1. See Bourdieu, *Distinction*; Lefebvre, *The Production of Space*; and Foucault, *The Order of Things*.
2. See Cummins, "From Lies to Truth."
3. Humboldt, *The Island of Cuba*, 133.
4. Graham, Ashworth, and Tunbridge, *A Geography of Heritage*, 24.
5. Hazard, *Cuba with Pen and Pencil*, 105.
6. The consulted archival sources and *Diario de La Habana* articles make no mention of what types of people were allowed to view the paintings.
7. This author was unable to search the *Diario de La Habana* of later in 1828 and 1829 for articles on the third inauguration painting because of the prolonged closure of the Biblioteca Nacional José Martí in Havana and the lack of availability of these materials in the United States.
8. Trouillot, *Silencing the Past*, 18. For this society in Cuba, see Knight, *Slave Society in Cuba*.
9. For primary accounts that give some sense of the social space of slave society in nineteenth-century Cuba, see Gómez de Avellaneda y Arteaga, *"Sab" and "Autobiography"*; Manzano, *Autobiography of a Slave*; Hazard, *Cuba with Pen and Pencil*; Abbot, *Letters Written*; Jameson, *Letters from the Havana*; Martínez-Fernández, *Fighting Slavery in the Caribbean*.
10. Romay Chacón, "Informe sobre la necesidad de aumentar la población blanca en esta isla por el Dr. Tomás Romay, 18 de diciembre de 1823. Leido en la Sociedad Económica en Junta General de 20 de diciembre de 1823." *Obras completas*, 162–164.
11. ". . . de la gravedad y urgencia del encargo . . . procuró desempeñar con la mayor eficacia . . . á saber, lo que podía y debía hacerse de pronto dentro de los límites que permitían nuestras leyes." Ibid., 162.
12. Ibid., 139–180.
13. For a brief history of the town of Santa María del Rosario, see Gil, *La ciudad diminuta*.

14. Gott, *Cuba*, 54.
15. Ibid., 48.
16. Ibid., 49.
17. For the conspiracy of Aponte, see Geggus, *The Impact of the Haitian Revolution*; Childs, *The 1812 Aponte Rebellion in Cuba*; and Franco, *La conspiración de Aponte*.
18. This royal *cédula* was issued in Spanish, English, and French. This quotation gives the English version. *Real Cédula de 21 de Octubre de 1817, sobre aumentar la población blanca de la isla de Cuba.*
19. Ibid.
20. Ibid.
21. Ibid.
22. Brito, *El desarrollo urbano de Cienfuegos*, 26–28.
23. Ibid.
24. Ibid.
25. See Guitar, "Boiling It Down."
26. For the representation of race in eighteenth- and early-nineteenth-century New Spain, see Carrera, *Imagining Identity in New Spain*, and Katzew, *Casta Painting*.
27. For contributions to early modern theories of race, see Hannaford, *Race: The History of an Idea*, 188–189, 205–213.
28. See Eze, "The Color of Reason," 103–131. For race, art, and aesthetics, see Bindman, *Ape to Apollo*; Kant is addressed on pages 70–78.
29. Eze, "The Color of Reason," 116. Also see Kant, *Anthropology from a Pragmatic Point of View*.
30. Ibid., 117.
31. Kuethe, *Cuba, 1753–1815*, 75.
32. Childs, *The 1812 Aponte Rebellion in Cuba*, 56–57.
33. Ibid., 56.
34. Martínez, "The Black Blood of New Spain."
35. Ibid.
36. See Whitford, *The Curse of Ham*.
37. See Castañeda, "The Female Slave in Cuba," and Mena, "Stretching the Limits of Gendered Spaces."
38. Castañeda, "The Female Slave in Cuba."
39. As *síndico* of the Consulado of Havana, Arango was officially appointed to protect the rights of slaves in the city. Ibid., 154.
40. Ibid., 144.
41. Ibid., 144, 153.
42. For an illustrative account of master-slave relations in Havana and on plantations, see the slave narrative of Manzano, *Autobiography of a Slave*. See also Hazard, *Cuba with Pen and Pencil*; Abbot, *Letters Written*; and Jameson, *Letters from the Havana*. Although these travelers' accounts do not record the situation

from a Cuban perspective, they nevertheless could be valuable tools in capturing habitual facets of everyday life that Cuban writers might have taken for granted and not written explicitly about.

43. Stolcke, *Marriage, Class and Colour*, 12.

44. Ibid., 1–26.

45. For a comparative context in late colonial Mexico, see Seed, *To Love, Honor, and Obey*.

46. The image can be found in Fane, *Converging Cultures*, 97, and is the property of the Brooklyn Museum. Another such image associated with the Order of Charles III can be found in the collection of the Archivo Histórico Nacional, Estado—Carlos III, Exp. 1928-8, Num. 8 & 9, from 1825, and apparently validates the noble lineage of Francisco Dionisio Vives.

47. See Martínez-Fernández, *Fighting Slavery in the Caribbean*.

48. Pedro Deschamps Chapeaux describes *pardo* battalions dressed in white uniforms with green collars, gold buttons, and short black boots, later to be changed to white trousers, dress coat, waistcoat, green lapel and collar, and black boots. *Moreno* or *negro* units wore a flesh-colored waistcoat with blue lapel and collar, white buttons, flesh-colored tied white pants, black cap, and short black boots. See Chapeaux, *Los batallones de pardos y morenos*, 43–44.

49. Bhabha, "Of Mimicry and Man," 129.

50. Landers, *Atlantic Creoles*, 50.

51. Martínez, "The Black Blood of New Spain."

52. For this multivalent seeing among communities of African descent in the Americas, see the aforementioned scholarship on the African Diaspora in chapter 3, along with Gilroy, *The Black Atlantic*. For the subaltern negotiation of hegemonic structures, see J. C. Scott, *Domination and the Arts of Resistance*, and Mignolo, *Local Histories/Global Designs*.

53. The historian Antonio Miguel Alcover claims that upon completion of El Templete, the three ceiba trees that surrounded the 1754 pillar were cut down and two ceibas were planted for the new monument. See "La Misa, la Ceiba y el Templete," 252.

54. Macfadyen, *The Flora of Jamaica*, 92; cited in Howe, "Some Photographs of the Silk-Cotton Tree," 221.

55. Cabrera, *El monte*.

56. Desmangles, *The Faces of the Gods*, 111; Voeks, *Sacred Leaves of Candomblé*, 20, 32, 161, 163; and Omari-Tunkara, *Manipulating the Sacred*, 93, 107. The importance of the ceiba tree to the Cuba Abakuá Society is noted in D. H. Brown, *The Light Inside*, 36, 42, 193, and 195.

57. Cabrera, *El monte*; González-Wippler, *Santería*; and Reid, "The Yoruba in Cuba."

58. "La ceiba es un santo: iroko." Cabrera, *El monte*, 150.

59. The Yoruba Supreme Trinity consists of three deities, Olodumare, Olorun, and Olofin. Cros Sandoval, *Worldview, the Orichas, and Santería*, 84.
60. González-Wippler, *Santería*.
61. Cabrera, *El monte*, 150.
62. Ibid., 192–193.
63. Macfadyen, *The Flora of Jamaica*.
64. González-Wippler, *Santería*, 26.
65. For the *pwataki*, see Barnet, *Afro-Cuban Religions*, 3, 32.
66. Ibid., 3–8.
67. Ibid., 7.
68. Ibid., 8.
69. For the *babalawo*, see ibid., 28–30.
70. For Espada's pastoral visit of 1804, see Torres Cuevas, *Obispo de Espada: Papeles*, 178–191.
71. For accounts of the *cabildo* processions on the day of Epiphany, see Ortiz, "The Afro-Cuban Festival."
72. Miller, "Religious Symbolism," 30.
73. Quoted in Miller, "Religious Symbolism," 31–32.
74. See Barnet, *Afro-Cuban Religions*, 50–52; and Cabrera, *Yemayá y Ochún*.
75. Practitioners of Afro-Cuban religions are known to circumambulate the ceiba tree during religious rituals. See Cabrera, *El monte*.
76. Viarnes, "All Roads Lead to Yemayá."
77. See Brown, *Santería Enthroned*, 64–65.
78. Palmié, *Wizards and Scientists*, 123.
79. Ashworth, Graham, and Tunbridge, *Pluralising Pasts*.

EPILOGUE

1. See Cueto, *Mialhe's Colonial Cuba*.
2. L. Smith, *Uses of Heritage*, 6–7.
3. Ashworth and Graham, *Senses of Place*.

BIBLIOGRAPHY

ARCHIVES AND LIBRARIES

AGI (Archivo General de Indias), Seville.
ARABASF (Archivo de la Real Academia de Bellas Artes de San Fernando), Madrid.
ARNAC (Archivo Nacional de la República de Cuba), Havana.
BNJM (Biblioteca Nacional José Martí), Havana.
SEAP (Biblioteca de la Sociedad Económica de Amigos del País de
 La Habana), Havana.

PRINTED PRIMARY SOURCES

Abbot, Abiel. *Letters Written in the Interior of Cuba between the Mountains of Arcana, to the East, and of Cusco, to the West, in the Months of February, March, April, and May 1828.* Freeport, New York: Books for Library Presses, [1829] 1971.

Acosta, José de. *Historia natural y moral de las Indias.* Mexico City and Buenos Aires: Fondo de Cultura Económica, 1940.

Álvarez Cuartero, Izaskun. *Elementos renovadores en el crecimiento económico-social cubano: Las sociedades patrióticas (1783–1832).* Donostia, Spain: Real Sociedad Bascongada de los Amigos del Pais, 1994.

Arango y Parreño, Francisco de. *Discurso sobre la agricultura de La Habana y medios de fomentarla* (1792). In *Obras I,* 114–175. Havana: Dirección de Cultura, 1952.

Arrate, José Martín Félix de. *Llave del Nuevo Mundo: Antemural de las Indias Occidentales.* 4th ed. Havana: Cubana de la UNESCO, 1964.

Caballero, José Agustín. *Obras.* Compiled by Edelberto Leyva Lajara. Havana: Imagen Contemporánea, 1999.

———. "Proyecto de Gobierno Autonómico para Cuba." In *Documentos para la Historia de Cuba,* ed. Hortensia Pichardo, 211–216. Havana: Editorial Pueblo y Educación, [1811] 1984.

Calcagno, Francisco. *Diccionario biográfico cubano.* New York: Imprenta y Librería de N. Ponce de León, 1878.

Campomanes, Pedro Rodríguez, conde de. *Discurso sobre el fomento de la industria popular (1774); Discurso sobre la educación popular de los artesanos y su fomento*

(1775). Edited by John Reeder. Clásicos del Pensamiento Económico Español, 2. Madrid: Instituto de Estudios Fiscales, 1975.

Catalogues of the Paris Salon, 1673 to 1881. Compiled by H. W. Janson. New York: Garland Publishing, 1977.

"Cuadro estadístico de la siempre fiel isla de Cuba correspondiente al año de 1827, formado por una comisión de gefes y oficiales, de orden y bajo la dirección del escelentísimo señor capitán general Don Francisco Dionisio Vives; precedido de una descripción histórica, física, geográfica, y acompañada de cuantas notas son conducentes para la ilustración del cuadro." Havana: Oficina de las viudas de Arazoza y Soler, impresoras del Gobierno y Capitanía General, por S. M., 1829.

Díaz del Castillo, Bernal. *The Conquest of New Spain*. London: Penguin Books, 1963.

Diderot, Denis, Jean Le Rond d'Alembert, Nelly Schargo Hoyt, and Thomas Cassirer. *Encyclopedia; selections [by] Diderot, D'Alembert and a society of men of letters*. Indianapolis: Bobbs-Merrill, 1965.

"Discurso del Ingeniero Silvestre de Abarca sobre la defensa de la Plaza de La Habana, y sus castillos adyacentes hecho cuando se hallaba dirifiendo las obras de ella. Se ponen al margen algunas advertencias posteriores, según las circunstancias del día." Archivo Nacional de Cuba, Asuntos Políticos, Legajo 1, Exp. 94, 1763.

Feijóo, Benito Jerónimo. *Teatro crítico universal o discursos varios en todo género de materias, para desengaño de errores comunes*. Madrid: Editorial Castalia, 1986.

Fernández de Oviedo y Valdés, Gonzalo. *Historia general y natural de las Indias: Islas y tierra-firme del mar Océano*. Vol. 1. Asunción del Paraguay: Editorial Guaranía, 1959.

———. *Natural History of the West Indies*. Chapel Hill: University of North Carolina Press, [1526] 1959.

García, Gregorio. *Origen de los indios del Nuevo Mundo e Indias Occidentales*. Edited by Carlos Baciero. Madrid: Consejo Superior de Investigaciones Científicas, 2005.

Gómez de Avellaneda y Arteaga, Gertrudis. *"Sab" and "Autobiography."* Translated and edited by Nina M. Scott. Austin: University of Texas Press, 1993.

Hazard, Samuel. *Cuba with Pen and Pencil*. Hartford, CT: Hartford Publishing Company, 1871.

Heredia, José María. *Poesías completas*. Edited by Angel Aparicio Laurencio. Miami: Ediciones Universal, 1970.

Herrera y Tordesillas, Antonio de. *Historia general de los hechos de los castellanos en las islas i tierra firme del mar oceano*. Madrid: Imprenta Real de Nicolás Rodríguez, 1726–1728.

Humboldt, Alexander von. *The Island of Cuba: A Political Essay*. Translated by J. S. Thrasher. Princeton: Markus Wiener Publications and Kingston, Jamaica: Ian Randle Publishers, [1826] 2001.

Hume, David. "Of the Standard of Taste." In *Aesthetic Theories: Studies in the Philosophy of Art*, edited by Karl Aschenbrenner and Arnold Isenberg, 107–119. Englewood Cliffs, NJ: Prentice-Hall, [1757] 1965.

Infante, Joaquín. "Proyecto de Constitución para la Isla de Cuba." In *Documentos para la Historia de Cuba*, edited by Hortensia Pichardo, 253–260. Havana: Editorial Pueblo y Educación.

Jameson, Robert Francis. *Letters from the Havana, during the year 1820 containing an account of the present state of the island of Cuba, and observations on the slave trade.* London: Printed for John Miller, 1821.

Juana Inés de la Cruz, Sor. *Neptuno alegórico, océano de colores, simulacro político que erigió . . . Iglesia Metropolitana de Méjico en las lucidas alegóricas ideas de un arco triunfal que consagró obsequiosa y dedicó amante a la feliz entrada del . . . conde de Paredes, marqués de la Laguna . . . (1680).* Mexico City: Cátedra Letras Hispánicas, 2009.

Kant, Immanuel. *Anthropology from a Pragmatic Point of View.* Carbondale: Southern Illinois University Press, 1996.

———. *Critique of Judgment.* New York: Hafner Publishers, 1951.

La Habana vieja: Mapas y planos en los archivos de España: Castillo de la Fuerza, enero–marzo, 1985, La Habana. Madrid: Ministerio de Asuntos Exteriores de España, Dirección General de Relaciones Culturales, 1985.

Las Casas, Bartolomé de. *A Short Account of the Destruction of the Indies.* Edited and translated by Nigel Griffin. London and New York: Penguin Books, 1992.

Laugier, Marc-Antoine. *Essai sur l'architecture.* Farnborough, UK: Gregg Press, [1755] 1966.

Macfadyen, James. *The Flora of Jamaica.* N.p., 1837.

Manzano, Juan Francisco. *Autobiography of a Slave.* Introduction by Ivan A. Schulman, translated by Evelyn Picon Garfield. Reprint, Detroit: Wayne State University Press, [1840] 1996.

Martí, José. *José Martí: Selected Writings.* Edited and translated by Esther Allen. New York: Penguin Books, 2002.

Martínez-Fortún y Foyo, José A. *El Diario de La Habana en la mano: Índices y sumarios (años de 1812 a 1848).* Mimeographed ed. Havana: 1955.

Meléndez Valdés, Juan. *Poesías.* Madrid: Espasa-Calpe, 1955.

Mialhe, (Pierre Toussaint) Frédéric. *Isla de Cuba pintoresca.* Havana: Lito. de la R. I. Sociedad Patriótica, 1839–1848.

"Minutá relacionada con el valor con que era llegado el altar de mármol destinado a la catedral de La Habana." Archivo Nacional de Cuba, Gobierno General, Legajo 559, Exp. 27370, 1828.

Morell de Santa Cruz, Pedro Agustín. "El Obispo Morell de Santa Cruz oficializa los cabildos africanos donde nació la santería, convirtiéndolos en ermitas," Havana, December 6, 1755. In *Cuba: Economía y sociedad, del monopolio hacia la*

libertad comercial (1701–1763), edited by Levi Marrero, 8:159–161. Madrid: Editorial Playor, 1980.

———. *Historia de la isla y catedral de Cuba.* Havana: Imprenta "Cuba intelectual," 1929.

"Nota sobre la fábrica de Casa de Gobierno, la Plaza de Armas y otros edificios . . . traslada . . . de 18 de mayo de 1773." Archivo Nacional de Cuba, Gobierno General, Legajo 321, Exp. 15512, 1774–1817.

Ovilo y Otero, Manuel. "Biografía del Excmo. señor don Claudio Martínez de Pinillos, conde de Villanueva." In *El trono y la nobleza*, 4–20. Havana: Imprenta del Tiempo, 1851.

Paine, Thomas. "Liberty Tree." In *Thomas Paine Reader*, edited by Michael Foot and Isaac Kramnick, 63–64. New York: Penguin Books, 1987.

Palladio, Andrea. *The Four Books on Architecture.* Cambridge, MA: MIT Press, 1997.

Pané, Fray Ramón. *An Account of the Antiquities of the Indians.* Durham, NC: Duke University Press, 1999.

Pezuela, Jacobo de la. *Historia de la isla de Cuba.* Vol. 1. Madrid: Carlos Bailly-Baillière; New York: Baillière hermanos, 1868.

Pichardo, Hortensia. *Documentos para la historia de Cuba.* Havana: Editorial Pueblo y Educación, 1984.

"Proyecto para la formacion de una Plaza en la Ciudad de la Havana, proporcionada a su inmenso Vecindario, y a los magnificos edificios que los particulares van construyendo, con demostracion de la hermosura de ella y utilidades que se seguirán al Real servicio y al bien Publico." Archivo Nacional de Cuba, Gobierno General, Legajo 321, Exp. 15512, 1774–1817.

Quintana, Manuel José. *Vidas de españoles célebres.* Madrid: Imprenta Real, 1807.

Real Cédula de 21 de octubre de 1817, sobre aumentar la población blanca de la isla de Cuba. Havana: Imprenta del Gobierno y Capitanía General, por S. M., 1828.

Real Sociedad Económica de Amigos del País de La Habana. *Memorias de la Real Sociedad Económica de La Habana.* Havana: Oficina del Gobierno y de la Real Sociedad Patriótica, por S. M., 1793.

———. *Memorias de la Real Sociedad Económica de La Habana: Colección primera que comprende doce números, correspondientes a los doce meses del año de 1817.* Havana: Oficina del Gobierno y de la Real Sociedad Patriótica, 1817.

———. *Tareas de la Real Sociedad Patriótica de La Habana en el año de 1815 . . . con superior permiso.* Havana: Oficina de Arazoza y Soler, 1816.

Romay Chacón, Tomás. "Discurso sobre las sepulturas fuera de los pueblos." In *Obras completas*, compiled by José López Sánchez, 1:127–136. Havana: Academia de Ciencias de la República de Cuba, 1965.

———. "Memoria que envio a la Real Sociedad Económica informando del resultado de las oposiciones para proveer la plaza de director propietario de la Academia de Dibujo y Pintura de San Alejandro." In *Obras completas*, by Tomás Romay Chacón,

compiled by José López Sánchez, 2:260–264. Havana: Academia de Ciencias de la República de Cuba, 1965.

———. *Obras completas*. 2 vols. Compiled by José López Sánchez. Havana: Academia de Ciencias de la República de Cuba, 1965.

Rubalcava, Manuel Justo de. "El tabaco." In *Poesías de Manuel Justo de Rubalcava*, 372. Havana: Comisión Nacional Cubana de la UNESCO, 1964.

Saco, José Antonio. "The Arts Are in the Hands of the People of Color." In *Memoria sobre la vagancia en la isla de Cuba*, 58–59. Santiago de Cuba: Instituto Cubano del Libro, 1974. Originally published in Havana: Imprenta del Gobierno, Capitanía General y Real Hacienda, por S. M., 1831.

Sagra, Ramón de la. "Exámenes de dibujo de la academia establecida por la Real Sociedad Patriótica." In *Anales de ciencias, agricultura, comercio y artes*. Havana: Oficina del Gobierno y Capitanía General, por S. M., 1828. Biblioteca Nacional José Martí, Havana, Cuba.

Sigüenza y Góngora, Carlos de. *Teatro de virtudes políticas que constituyen a un príncipe, advertidas en los monarcas antiguos del mexicano imperio (1680)*. Mexico City: Coordinación de Humanidades, 1986.

Solís, Antonio de. *Historia de la conquista de México*. Mexico City: Editorial Porrúa, 1968.

Torquemada, Juan de. *Monarquía indiana*. Mexico City: Editorial Porrúa, 1969.

"Transcription of the Ordinances for the Discovery, the Population, and the Pacification of the Indies, enacted by King Philip II the 13th of July 1573, in the Forest of Segovia, according to the Original Manuscript Conserved in the Archivo General de Indias in Seville." In *Cruelty and Utopia: Cities and Landscapes of Latin America*, edited by Jean-François Lejeune, 18–23. New York: Princeton Architectural Press, 2003.

Urrutia y Montoya, Ignacio de. *Teatro histórico, jurídico y político militar de la isla Fernandina de Cuba y principalmente de su capital, La Habana*. Havana: Comisión Nacional Cubana de la Unesco, [1789] 1963.

Valdés, Antonio José. *Historia de la isla de Cuba, y en especial de La Habana*. Havana: Comisión Nacional Cubana de la UNESCO, 1964.

Varela y Morales, Félix. *Miscelánea filosófica*. Havana: Pueblo y Educación, [1819] 1992.

———. *Observaciones sobre la constitución política de la monarquía española: Seguidas de otros trabajos políticos*. Havana: Editorial de la Universidad, [1821] 1944.

Villanueva, Juan de. "Hoy, 21 de julio de 1796, á los 56 años de mi edad. Descripción del edificio del Rl. Museo, por su autor D. Juan de Villanueva." In *El Edificio del Museo del Prado*, edited by Juan de Villanueva and Fernando Chueca Goitia, 25–39. Madrid: Fundación Universitaria Española, [1796] 2003.

Villaverde, Cirilo. *Cecilia Valdés or El Angel Hill*. Translated by Helen Lane and edited by Sibylle Fischer. Oxford: Oxford University Press, [1839] 2005.

Vitruvius. *The Ten Books on Architecture*. Translated by Morris Hickey Morgan. New York: Dover Publications, 1960.

Wordsworth, William. "The Oak of Guernica." In *The Poetical Works of William Wordsworth*, 3:229. London: Edward Moxon, 1837.

Zequeira y Arango, Manuel de. "Oda a la piña" and "A la vida del campo." In *Cantos a la naturaleza cubana del siglo XIX: selección*, edited by Samuel Feijóo, 9–11. Santa Clara, Cuba: Editora del Consejo Nacional de Universidades, Universidad Central de Las Villas. Originally published in *Poesías*. Havana: Imprenta de Capitanía, [1852] 1964.

Zequeira y Arango, Manuel de, and Manuel Justo de Rubalcava. *Poesías*. Havana: Comisión Nacional Cubana de la UNESCO, 1964.

SECONDARY SOURCES

Acevedo, Esther. "Entre la tradición alegórica y la narrativa factual." In *Los pinceles de la historia: De la patria criolla a la nación mexicana, 1750–1860*, edited by Esther Acevedo, Jaime Cuadriello, and Fausto Ramírez, 115–131. Mexico City: Instituto Nacional de Bellas Artes, 2000.

Ackerman, James S. "The Tuscan/Rustic Order: A Study in the Metaphorical Language of Architecture." *Journal of the Society of Architectural Historians* 42, no. 1 (March 1983): 15–42.

Ades, Dawn. *Art in Latin America: The Modern Era, 1820–1980*. New Haven, CT: Yale University Press, 1989.

Alcalá, Luisa Elena. "The Image of the Devout Indian: The Codification of a Colonial Idea." In *Contested Visions in the Spanish Colonial World*, edited by Ilona Katzew and Luisa Elena Alcalá, 226–249. Los Angeles: Los Angeles County Museum of Art; New Haven, CT: Yale University Press, 2011.

Alcover, Antonio Miguel. "La Misa, la Ceiba y el Templete: Errores históricos." *Cuba y América*, Colección Facticia, no. 107 (1900): 249–256.

Alfonso López, Félix Julio. "La Ceiba y el Templete: Historia de una polémica." *Kosmopolita*, February 2006. http://www.euskonews.com/0335zbk/kosmo33501.html.

Anderson, Benedict. *Imagined Communities: Reflections on the Origin and Spread of Nationalism*. London: Verso, 1983.

Anderson, Kit. *Nature, Culture, and Big Old Trees: Live Oaks and Ceibas in the Landscapes of Louisiana and Guatemala*. Austin: University of Texas Press, 2003.

Araeen, Rasheed, Sean Cubitt, and Ziauddin Sardar, eds. *The Third Text Reader: On Art, Culture and Theory*. London: Continuum, 2002.

Arnold, Linda. *Bureaucracy and Bureaucrats in Mexico City, 1724–1835*. Albuquerque: University of New Mexico, 1977.

Ashworth, G. J., and Brian Graham, eds. *Senses of Place: Senses of Time*. Aldershot, UK: Ashgate Publishing, 2005.

Ashworth, G. J., Brian Graham, and J. E. Tunbridge. *Pluralising Pasts: Heritage, Identity, and Place in Multicultural Societies*. London and Ann Arbor, MI: Pluto Press, 2007.

Ashworth, G. J., and J. E. Tunbridge. *Dissonant Heritage: The Management of the Past as a Resource in Conflict*. Chichester, UK: Wiley, 1996.

Bailey, Gauvin Alexander. *Art of Colonial Latin America*. London: Phaidon Press, 2005.

Bakhtin, Mikhail. *The Dialogic Imagination: Four Essays*. Compiled by Michael Holquist. Austin: University of Texas Press, 1981.

Bargellini, Clara. "Originality and Invention in the Painting of New Spain." In *Painting a New World: Mexican Art and Life, 1521–1821*, edited by Donna Pierce, Rogelio Ruiz Gomar, and Clara Bargellini, 79–91. Denver: Frederick and Jan Mayer Center for Pre-Columbian and Spanish Colonial Art, Denver Art Museum, 2004.

Barnet, Miguel. *Afro-Cuban Religions*. Translated by Christine Renata Ayorinde. Princeton, NJ: Markus Wiener, 2001.

Barteet, C. Cody. "Colonial Contradictions in the Casa de Montejo in Mérida, Yucatán: Space, Society, and Self-Representation at the Edge of Viceregal Mexico." PhD diss., State University of New York at Binghampton, 2007.

Barthes, Roland. *Mythologies*. New York: Hill and Wang, 1972.

———. "Semiology and the Urban." In *Rethinking Architecture: A Reader on Cultural Theory*, edited by Neil Leach, 165–172. New York: Routledge, 1997.

Baxandall, Michael. *Painting and Experience in Fifteenth-Century Italy: A Primer in the Social History of Pictorial Style*. Oxford: Clarendon Press, 1972.

Bédat, Claude. *La Real Academia de Bellas Artes de San Fernando (1744–1808): Contribución al estudio de las influencias estilísticas y de la mentalidad artística en la España del siglo XVIII*. Madrid: Fundación Universitaria Española, Real Academia de Bellas Artes de San Fernando, 1989.

Benson, Elizabeth P., ed. *Retratos: 2,000 Years of Latin American Portraits*. San Antonio, TX: San Antonio Museum of Art, 2004.

Bermúdez Rodríguez, Jorge. "Vicente Escobar, nuestro pintor preliminario." *Revista de la Biblioteca Nacional José Martí* (January–March, 1984): 141–151.

Bhabha, Homi. *The Location of Culture*. London: Routledge, 1994.

———. "Of Mimicry and Man: The Ambivalence of Colonial Discourse." *October* 28 (Spring 1984): 125–133.

Bindman, David. *Ape to Apollo: Aesthetics and the Idea of Race in the 18th Century*. Ithaca, New York: Cornell University Press, 2002.

Birth, Kevin. "The Immanent Past: Culture and Psyche at the Juncture of Memory and History." *Ethos* 34, no. 2 (2006): 169–191.

Bleichmar, Daniela. *Visible Empire: Botanical Expeditions and Visual Culture in the Hispanic Enlightenment*. Chicago: University of Chicago Press, 2012.

Bleichmar, Daniela, Paula De Vos, Kristin Huffine, and Kevin Sheehan, eds. *Science in the Spanish and Portuguese Empires, 1500–1800*. Stanford, CA: Stanford University Press, 2009.

Bocchetti, Carla, ed. *La influencia clásica en América Latina.* Bogotá, Colombia: Universidad Nacional de Colombia, Facultad de Ciencias Humanas, Centro de Estudios Sociales: Grupo de Investigación sobre el Papel del Mito en el Pensamiento Geográfico Antiguo, 2010.

Boime, Albert. *Art in the Age of Bonapartism, 1800–1815.* Chicago: University of Chicago Press, 1990.

———. "The Cultural Politics of the Art Academy." *The Eighteenth Century* 35:3 (1994): 203–222.

Bourdieu, Pierre. *Distinction: A Social Critique of the Judgment of Taste.* Translated by Richard Nice. Cambridge, MA: Harvard University Press, 1984.

———. *Outline on a Theory of Practice.* Cambridge: Cambridge University Press, 1977.

Boyer, M. Christine. *The City of Collective Memory.* Cambridge, MA: MIT Press, 1994.

Brading, David. *The First America: The Spanish Monarchy, Creole Patriots, and the Liberal State, 1492–1867.* Cambridge and New York: Cambridge University Press, 1991.

———. *Miners and Merchants in Bourbon Mexico, 1663–1810.* Cambridge: Cambridge University Press, 1971.

———. "Patriotism and the Nation in the Spanish Empire." In *Constructing Collective Identities and Shaping Public Spheres,* edited by Luis Roniger and Mario Sznajder, 13–45. Brighton, UK: Sussex Academic Press, 1998.

Braham, Allan. *The Architecture of the French Enlightenment.* Berkeley and Los Angeles: University of California Press, 1980.

Brewer, John, and Ann Bermingham. *The Consumption of Culture, 1600–1800: Image, Object, Text.* London and New York: Routledge, 1995.

Brigham, Clarence S. *Paul Revere's Engravings.* New York: Atheneum, 1969.

Brito, Lilia Martín. *El desarrollo urbano de Cienfuegos en el siglo XIX.* Gijón, Spain: Mercantil Asturias, 2006.

Brown, David H. *The Light Inside: Abakuá Society Arts and Cuban Cultural History.* Washington, DC: Smithsonian Books, 2003.

———. *Santería Enthroned: Art, Ritual, and Innovation in an Afro-Cuban Religion.* Chicago: University of Chicago Press, 2003.

Brown, Thomas A. *La Academia de San Carlos de la Nueva España.* 2 vols. Mexico City: Secretaría de Educación Pública, 1976.

Burke, Marcus. "The Academy, Neoclassicism, and Independence." In *Mexico: Splendors of Thirty Centuries,* edited by Kathleen Howard, 487–496. New York: The Metropolitan Museum of Art, 1990.

———. "A Mexican Artistic Consciousness." In *Mexico: Splendors of Thirty Centuries,* edited by Kathleen Howard, 321–323. New York: The Metropolitan Museum of Art, 1990.

Burkholder, Mark A., and D. S. Chandler. *From Impotence to Authority: The Spanish Crown and the American Audiencias, 1687–1808.* Columbia: University of Missouri Press, 1977.

Burroughs, Charles. *The Italian Renaissance Palace Façade: Structures of Authority, Surfaces of Sense.* Cambridge: Cambridge University Press, 2002.

Cabrera, Lydia. *El monte: Igbo—Finda, Ewe Orisha—Vititi Nfinda: Notas sobre las religiones, la magia, las supersticiones y el folklore de los negros criollos y el pueblo de Cuba.* Colección del Chicherekú en el Exilio. Miami: Ediciones Universal, [1954] 1983.

————. *Yemayá y Ochún.* New York: C. R. Publishers, [1974] 1980.

Campanella, Thomas J. *Republic of Shade: New England and the American Elm.* New Haven, CT: Yale University Press, 2003.

Cañeque, Alejandro. *The King's Living Image: The Culture and Politics of Viceregal Power in Colonial Mexico.* New York: Routledge, 2004.

Cañizares-Esguerra, Jorge. "Entangled Histories: Borderland Historiographies in New Clothes?" *The American Historical Review* 122, no. 3 (2007): 787–799.

————. "How Derivative Was Humboldt? Microcosmic Nature Narratives in Early Modern Spanish America and the (Other) Origins of Humboldt's Ecological Sensibilities." In *Colonial Botany: Science, Commerce, and Politics in the Early Modern World,* edited by Londa Schiebinger and Claudia Swan, 148–165. Philadelphia: University of Pennsylvania Press, 2005.

————. *How to Write the History of the New World: Histories, Epistemologies, and Identities in the Eighteenth-Century Atlantic World.* Stanford, CA: Stanford University Press, 2001.

————. *Nature, Empire, and Nation: Explorations of the History of Science in the Iberian World.* Stanford, CA: Stanford University Press, 2006.

Cardoso Denis, Rafael, and Colin Trodd, eds. *Art and the Academy in the Nineteenth Century.* New Brunswick, NJ: Rutgers University Press, 2000.

Carley, Rachel, and Andrea Brizzi. *Cuba: 400 Years of Architectural Heritage.* New York: Whitney Library of Design, 1997.

Caro Baroja, Julio. *Ritos y mitos equívocos.* Madrid: Ediciones Istmo, 1974.

Carrera, Magali M. "Affections of the Heart: Female Imagery and the Notion of Nation in Mexico." In *Woman and Art in Early Modern Latin America,* edited by Kelly McIntyre and Richard Phillips, 47–72. London: Brill Press, 2007.

————. "From Royal Subject to Citizen: The Territory of the Body in Eighteenth-Century and Nineteenth-Century Visual Practices of Mexico." In *Images of Power: Iconography, Culture and the State in Latin America,* edited by Jens Andermann and William Rowe, 17–36. Oxford: University of London, 2005.

————. *Imagining Identity in New Spain: Race, Lineage, and the Colonial Body in Portraiture and Casta Paintings.* Austin: University of Texas Press, 2003.

————. *Traveling from New Spain to Mexico: Mapping Practices of Nineteenth-Century Mexico.* Durham, NC: Duke University Press, 2011.

Castañeda, Digna. "The Female Slave in Cuba during the First Half of the Nineteenth Century." In *Engendering History: Caribbean Women in Historical Perspective*, edited by Verene A. Shepherd, Bridget Brereton, and Barbara Bailey, 141–154. New York: St. Martin's Press, 1995.

Castro, Martha de. "Arte cubano colonial." In *Cuba: Arquitectura y urbanismo*, edited by Felipe J. Préstamo y Hernández, 283–335. Miami: Ediciones Universal, 1995.

———. *El arte en Cuba*. Miami: Ediciones Universal, 1970.

———. "Plazas y paseos de La Habana colonial." In *Cuba: Arquitectura y urbanismo*, edited by Felipe J. Préstamo y Hernández, 319–335. Miami: Ediciones Universal, 1995.

Certeau, Michel de. *The Practice of Everyday Life*. Translated by Steven Rendall. Berkeley: University of California Press, 1984.

Chapeaux, Pedro Deschamps. *Los batallones de pardos y morenos libres*. Havana: Instituto Cubano del Libro, 1976.

Charlot, Jean. *Mexican Art and the Academy of San Carlos, 1785–1915*. Austin: University of Texas Press, 1962.

Charno, Steven M. *Latin American Newspapers in United States Libraries*. Austin: University of Texas Press, 1968.

Chasteen, John Charles. *Americanos: Latin America's Struggle for Independence*. Oxford: Oxford University Press, 2008.

Chateloin, Felicia. *La Habana de Tacón*. Havana: Editorial Letras Cubanas, 1989.

Childs, Matt D. "The Defects of Being a Black Creole: The Degrees of African Identity in the Cuban *Cabildos de Nación*, 1790–1820." In *Slaves, Subjects, and Subversives: Blacks in Colonial Latin America*, edited by Jane G. Landers and Barry M. Robinson, 209–245. Albuquerque: University of New Mexico Press, 2006.

———. *The 1812 Aponte Rebellion in Cuba and the Struggle against Atlantic Slavery*. Chapel Hill: University of North Carolina Press, 2006.

Choay, Françoise. *The Invention of the Historic Monument*. Translated by Lauren M. O'Connell. Cambridge and New York: Cambridge University Press, 2001.

Christian, William A. *Local Religion in Sixteenth-Century Spain*. Princeton: Princeton University Press, 1981.

Collins, Peter. *Changing Ideals in Modern Architecture, 1750–1950*. London: Faber and Faber, 1965.

Connerton, Paul. *How Societies Remember*. Cambridge: Cambridge University Press, 1989.

Conquergood, Dwight. "Performance Studies: Interventions and Radical Research." *TDR* 46 (2002): 145–156.

Constantino, Roselyn. "Latin American Performance Studies: Random Acts or Critical Moves?" *Theatre Journal* 56 (2004): 459–461.

Cope, R. Douglas. *The Limits of Racial Domination: Plebeian Society in Colonial Mexico City, 1660–1720*. Madison: University of Wisconsin Press, 1994.

Corbett, David Peters. *The Modernity of English Art, 1914–1930*. Manchester, UK: Manchester University Press, 1997.

Cosgrove, Denis E. *Social Formation and Symbolic Language*. London: Croom Helm, 1984.

Cresswell, Donald H. *The American Revolution in Drawings and Prints: A Checklist of 1765–1790 Graphics in the Library of Congress*. Reprint, Mansfield Centre, CT, Martino Publishing, [1975] 2004.

Cresswell, Tim. *Place: A Short Introduction*. Malden, MA: Blackwell, 2004.

Cros Sandoval, Mercedes. *Worldview, the Orichas, and Santería: Africa to Cuba and Beyond*. Gainesville: University Press of Florida, 2006.

Crow, Thomas E. *Painters and Public Life in Eighteenth-Century Paris*. New Haven, CT: Yale University Press, 1985.

Cuadriello, Jaime. "Tierra de prodigios: La ventura como destino." In *Los pinceles de la historia: El origen del reino de la Nueva España, 1680–1750*, 180–227. Mexico City: Museo Nacional de Arte, 1999.

Cueto, Emilio. *Mialhe's Colonial Cuba: The Prints That Shaped the World's View of Cuba*. Miami: Historical Association of Southern Florida, 1994.

Cummins, Thomas B. F. "From Lies to Truth: Colonial Ekphrasis and the Act of Crosscultural Translation." In *Reframing the Renaissance: Visual Culture in Europe and Latin America, 1450–1650*, edited by Claire Farago, 152–174. New Haven, CT: Yale University Press, 1995.

———. *Toasts with the Inca: Andean Abstraction and Colonial Images on Quero Vessels*. Ann Arbor: University of Michigan Press, 2002.

Cummins, Thomas B. F., and Joanne Rappaport. *Beyond the Lettered City: Indigenous Literacies in the Andes*. Durham, NC: Duke University Press, 2012.

———. "The Reconfiguration of Civic and Sacred Spaces: Architecture, Image and Writing in the Colonial Northern Andes." *Latin American Literary Review* 26, no. 52 (1998): 174–200.

Cummins, Thomas B. F., and William B. Taylor. "The Mulatto Gentlemen of Esmeraldas, Ecuador." In *Colonial Spanish America: A Documentary History*, edited by Kenneth Mills and William B. Taylor, 147–149. Wilmington, DE: Scholarly Resources, 1998.

Curcio-Nagy, Linda A. *The Great Festivals of Colonial Mexico City: Performing Power and Identity*. Albuquerque: University of New Mexico Press, 2004.

Curl, James Steven. *The Art and Architecture of Freemasonry: An Introductory Study*. Woodstock, NY: Overlook Press, 1993.

Dean, Carolyn. *Inka Bodies and the Body of Christ: Corpus Christi in Colonial Cuzco, Peru*. Durham, NC: Duke University Press, 1999.

———. "Savage Breast/Salvaged Breast: Allegory, Colonization, and Wet-Nursing in Peru, 1532–1825." In *Woman and Art in Early Modern Latin America*, edited by Kellen Kee MacIntyre and Richard E. Phillips, 247–264. Leiden: Brill, 2007.

Dean, Carolyn, and Dana Leibsohn. "Hybridity and Its Discontents: Considering Visual Culture in Colonial Spanish America." *Colonial Latin American Review* 12, no. 1 (2003): 5–35.

Deans-Smith, Susan. *Bureaucrats, Planters, and Workers: The Making of the Tobacco Monopoly in Bourbon Mexico.* Austin: University of Texas Press, 1992.

———. "Creating the Colonial Subject: Casta Paintings, Curiosities and Collectors in Eighteenth-Century Mexico and Spain." *Colonial Latin American Review* 14, no. 2: 169–204.

———. "Dishonor in the Hands of Indians, Spaniards, and Blacks: The (Racial) Politics of Painting in Early Modern Mexico." In *Race and Classification: The Case of Mexican America*, edited by Ilona Katzew and Susan Deans-Smith, 43–72. Stanford, CA: Stanford University Press, 2009.

———. "Manuel Tolsá's Equestrian Statue of Charles IV and Buen Gusto in Late Colonial Mexico." In *Buen Gusto and Classicism in the Visual Cultures of Latin America, 1780–1910*, edited by Paul B. Niell and Stacie G. Widdifield, 3–24. Albuquerque: University of New Mexico Press, 2013.

———. "'A Natural and Voluntary Dependence': The Royal Academy of San Carlos and the Cultural Politics of Art Education in Mexico City, 1786–1797." *Bulletin of Latin American Research* 29, no. 3 (July 2010): 278–295.

Del Duca, Gemma Marie. "A Political Portrait: Félix Varela y Morales, 1788–1853." PhD diss., University of New Mexico, 1966.

Desmangles, Leslie G. *The Faces of the Gods: Vodou and Roman Catholicism in Haiti.* Chapel Hill: University of North Carolina Press, 1992.

Dickie, George. *The Century of Taste: The Philosophical Odyssey of Taste in the Eighteenth Century.* New York: Oxford University Press, 1996.

Domínguez, Jorge I. *Insurrection or Loyalty: The Breakdown of the Spanish American Empire.* Cambridge, MA: Harvard University Press, 1980.

Donahue-Wallace, Kelly. *Art and Architecture of Viceregal Latin America, 1521–1821.* Albuquerque: University of New Mexico Press, 2008.

Douglas, Eduardo de Jesús. "Our Fathers, Our Mothers: Painting an Indian Genealogy in New Spain." In *Contested Visions in the Spanish Colonial World*, edited by Ilona Katzew and Luisa Elena Alcalá, 116–131. Los Angeles: Los Angeles County Museum of Art; New Haven, CT: Yale University Press, 2011.

Dym, Jordana. "Conceiving Central America: A Bourbon Public in the *Gazeta de Guatemala* (1797–1807)." In *Enlightened Reform in Southern Europe and Its Atlantic Colonies, c. 1750–1830*, edited by Gabriel Paquette, 99–118. Burlington, VT: Ashgate Publishing, 2009.

Earle, Rebecca. "'Padres de la Patria' and the Ancestral Past: Commemorations of Independence in Nineteenth-Century Spanish America." *Journal of Latin American Studies* 34, pt. 4 (November 2002): 775–805.

————. *The Return of the Native: Indians and Myth-Making in Spanish America, 1810–1930*. Durham, NC: Duke University Press, 2007.

Eco, Umberto. "Function and Sign: The Semiotics of Architecture." In *Rethinking Architecture: A Reader in Cultural Theory*, edited by Neil Leach, 181–204. London: Routledge, 1997.

Edgerton, Samuel Y. *Theaters of Conversion: Religious Architecture and Indian Artisans in Colonial Mexico*. Albuquerque: University of New Mexico Press, 2001.

Eitner, Lorenz. *Neoclassicism and Romanticism, 1750–1850: Sources and Documents*. Englewood Cliffs, NJ: Prentice-Hall, 1970.

Engel, Emily. "Art and Viceregal Taste in Late Colonial Lima and Buenos Aires." In *Buen Gusto and Classicism in the Visual Cultures of Latin America, 1780–1910*, edited by Paul B. Niell and Stacie G. Widdifield, 206–231. Albuquerque: University of New Mexico Press, 2013.

————. "Facing Boundaries: Identity and Authority in South American Portraiture, 1750–1824." PhD diss., University of California, Santa Barbara, 2009.

Escobar, Jesús. *The Plaza Mayor and the Shaping of Baroque Madrid*. Cambridge: Cambridge University Press, 2004.

Esparza Liberal, María José. "La insurgencia de las imágenes y las imágenes de los insurgentes." In *Los pinceles de la historia: De la patria criolla a la nación mexicana 1750–1860*, edited by Esther Acevedo, Jaime Cuadriello, and Fausto Ramírez, 132–151. Mexico City: Instituto Nacional de Bellas Artes, 2000.

Etlin, Richard A. *The Architecture of Death: The Transformation of the Cemetery in Eighteenth-Century Paris*. Cambridge, MA: MIT Press, 1984.

Evernden, Neil. *The Social Creation of Nature*. Baltimore, MD: Johns Hopkins University Press, 1992.

Eze, Emmanuel Chukwudi. "The Color of Reason: The Idea of 'Race' in Kant's Anthropology." In *Postcolonial African Philosophy: A Critical Reader*, edited by Emmanuel Eze, 103–131. Cambridge, MA, and Oxford, UK: Blackwell Publishers, 1997.

Faivre d'Arcier, Sabine. *Vermay, mensajero de las luces*. Havana: Imagen Contemporánea, 2004.

Falola, Toyin, and Matt D. Childs, eds. *The Yoruba Diaspora in the Atlantic World*. Bloomington: Indiana University Press, 2004.

Fane, Diana, ed. *Converging Cultures: Art and Identity in Spanish America*. New York: The Brooklyn Museum in association with Harry N. Abrams, 1996.

Fanon, Frantz. *Black Skin, White Masks*. New York: Grove Press, 1967.

————. "On National Culture." In *Colonial Discourse and Post-Colonial Theory: A Reader*, edited by Patrick Williams and Laura Chrisman, 36–52. New York: Columbia University Press, 1994.

Fay, Elizabeth, and Leonard von Morze, eds. *Urban Identity and the Atlantic World*. New York: Palgrave Macmillan, 2013.

Fernández-Santalices, Manuel. *Las calles de La Habana intramuros: Arte, historia y tradiciones en las calles y plazas de La Habana Vieja.* Miami: Saeta Ediciones, 1985.

Fernández Villa-Urrutia, Rafael. "Las artes plásticas hasta el comienzo de la República." In *La Enciclopedia de Cuba: Artes, sociedad, filosofía,* edited by Vicente Báez, 115–160. San Juan y Madrid: Enciclopedia y Clásicos Cubanos, 1974.

Figueroa y Miranda, Miguel. *Religión y política en la Cuba del siglo XIX: El obispo Espada visto a la luz de los archivos romanos, 1802–1832.* Miami: Ediciones Universal, 1975.

Fischer, David Hackett. *Liberty and Freedom: A Visual History of America's Founding Ideals.* Oxford: Oxford University Press, 2005.

Fischer, Sibylle. "Bolívar in Haiti: Republicans in the Revolutionary Atlantic." In *Haiti and the Americas,* edited by Carla Calargé, Raphael Dalleo, Luis Duno-Gottberg, and Clevis Headley, 25–54. Jackson: University Press of Mississippi, 2013.

———. *Modernity Disavowed: Haiti and the Culture of Slavery in the Age of Revolution.* Durham, NC: Duke University Press, 2004.

Fisher, Lillian Estelle. *Viceregal Administration in the Spanish American Colonies.* Berkeley: University of California Press, 1926.

Forment, Carlos A. *Democracy in Latin America, 1760–1900.* Chicago: University of Chicago Press, 2003.

Forniés, Soledad Lorenzo, María Luisa Moro Pajuelo, and Esperanza Navarrete Martínez. *Renovación, crisis, continuismo: La Real Academia de San Fernando en 1792.* Madrid: Real Academia de Bellas Artes de San Fernando, 1992.

Foucault, Michel. *Discipline and Punish: The Birth of the Prison.* Translated by Alan Sheridan. New York: Vintage Books, 1995.

———. "Of Other Spaces: Utopias and Heterotopias (1985)." In *Rethinking Architecture: A Reader on Cultural Theory,* edited by Neil Leach, 348–367. New York: Routledge, 1997.

———. *The Order of Things: An Archaeology of the Human Sciences.* New York: Pantheon Books, 1971.

Franco, José Luciano. *La conspiración de Aponte, 1812.* Havana: Editorial de Ciencias Sociales, 2006.

———. *Las conspiraciones de 1810 y 1812.* Havana: Editorial de Ciencias Sociales, 1977.

Freiberg, Jack. "Bramante's Tempietto and the Spanish Crown." *Memoires of the American Academy in Rome* 50 (2005): 151–205.

Gaonkar, Dilip Parameshwar, ed. *Alternative Modernities.* Durham, NC: Duke University Press, 2001.

García Pons, César. *El obispo Espada y su influencia en la cultura cubana.* Havana: Publicaciones del Ministerio de Educación, 1951.

Garraway, Doris L., ed. *Tree of Liberty: Cultural Legacies of the Haitian Revolution in the Atlantic World*. Charlottesville: University of Virginia Press, 2008.

Garrigó, Roque E. *Historia documentada de la conspiración de los Soles y Rayos de Bolívar*. Havana: Academia de la Historia de Cuba, 1929.

Geggus, David Patrick. *The Impact of the Haitian Revolution in the Atlantic World*. Columbia: University of South Carolina Press, 2001.

Gil, Pablo Fornet. *La ciudad diminuta: Estudio urbanístico de Santa María del Rosario*. Havana: Editorial de Ciencias Sociales, 1996.

Gillis, John R., ed. *Commemorations: The Politics of National Identity*. Princeton, NJ: Princeton University Press, 1994.

Gilroy, Paul. *The Black Atlantic: Modernity and Double Consciousness*. Cambridge, MA: Harvard University Press, 1993.

González-Wippler, Migene. *Santería: The Religion: A Legacy of Faith, Rites, and Magic*. New York: Harmony Books, 1989.

Gott, Richard. *Cuba: A New History*. New Haven, CT: Yale University Press, 2004.

Gottlieb, Alma. *Under the Kapok Tree: Identity and Difference in Beng Thought*. Bloomington: Indiana University Press, 1992.

Graham, Brian, G. J. Ashworth, and J. E. Tunbridge. *A Geography of Heritage: Power, Culture, and Economy*. New York: Oxford University Press, 2004.

Graham, Brian, and Peter Howard. "Introduction: Heritage and Identity." In *The Ashgate Research Companion to Heritage and Identity*, edited by Brian Graham and Peter Howard, 1–15. Burlington, VT: Ashgate Publishing, 2008.

Grigsby, Darcy Grimaldo. "Revolutionary Sons, White Fathers, and Creole Difference: Guillaume Guillon-Lethière's 'Oath of the Ancestors' (1822)." *Yale French Studies* 101 (2001): 201–226.

Gruzinski, Serge. *The Mestizo Mind: The Intellectual Dynamics of Colonization and Globalization*. New York: Routledge, 2002.

Guitar, Lynne. "Boiling It Down: Slavery on the First Commercial Sugarcane Ingenios in the Americas (Hispaniola, 1530–1545)." In *Slaves, Subjects, and Subversives: Blacks in Colonial Latin America*, edited by Jane G. Landers and Barry M. Robinson, 39–82. Albuquerque: University of New Mexico Press, 2006.

Gutiérrez Haces, Juana. "The Eighteenth Century: A Changing Kingdom and Artistic Style." In *The Grandeur of Viceregal Mexico: Treasures from the Museo Franz Mayer*, edited by Héctor Rivero Borrell Miranda, 45–66. Austin: University of Texas Press, 2002.

Habermas, Jürgen. *The Structural Transformation of the Public Sphere: An Inquiry into a Category of Bourgeois Society*. Cambridge, MA: MIT Press, 1989.

Halbwachs, Maurice. *On Collective Memory*. Translated by Lewis A. Coser. Chicago: University of Chicago Press, 1992.

Hall, Stuart. "Introduction: Who Needs 'Identity'?" In *Questions of Cultural Identity*, edited by Stuart Hall and Paul du Gay, 1–17. Thousand Oaks, CA: Sage, 1996.

Hannaford, Ivan. *Race: The History of an Idea in the West*. Washington, DC: Woodrow Wilson Center Press; Baltimore, MD: Johns Hopkins University Press, 1996.

Harvey, David C. "The History of Heritage." In *The Ashgate Research Companion to Heritage and Identity*, edited by Brian Graham and Peter Howard, 19–36. Burlington, VT: Ashgate Publishing, 2008.

———. "'National' Identities and the Politics of Ancient Heritage: Continuity and Change at Ancient Monuments in Britain and Ireland, c. 1676–1850." *Transactions of the Institute of British Geographers* 28, no. 4 (2003): 473–487.

Hecht, Johanna. "Creole Identity and the Transmutation of European Forms." In *Mexico: Splendor of Thirty Centuries*, edited by Kathleen Howard, 315–321. New York: Metropolitan Museum of Art, 1900.

Hernández, Juan Antonio. "Hacia una historia de lo imposible: La revolución haitiana y el 'libro de pinturas' de José Antonio Aponte." PhD diss., University of Pittsburg, 2005.

Hernández-Durán, Ray. "Modern Museum Practice in Nineteenth-Century Mexico: The Academy of San Carlos and *la antigua escuela mexicana*." *Nineteenth-Century Art Worldwide: A Journal of Nineteenth-Century Visual Culture* 9, no. 1 (Spring 2010). http://www.19thc-artworldwide.org/spring10/modern-museum-practice-in-nineteenth-century-mexico.

———. "Reframing Viceregal Painting in Mexico: Politics, the Academy of San Carlos, and Colonial Art History." PhD diss., University of Chicago, 2005.

Herskovits, Melville. *The Myth of the Negro Past*. Boston: Beacon Press, 1958.

Hoberman, Louisa Schell, and Susan Migden Socolow. *The Countryside in Colonial Latin America*. Albuquerque: University of New Mexico Press, 1996.

Hobsbawm, Eric, and Terence Ranger, eds. *The Invention of Tradition*. Cambridge and New York: Cambridge University Press, 1983.

Hodgkin, Katharine, and Susannah Radstone, eds. *Contested Pasts: The Politics of Memory*. London: Routledge, 2003.

Honour, Hugh. *Neo-classicism*. London: Penguin Books, 1977.

Howard, Philip A. *Changing History: Afro-Cuban Cabildos and Societies of Color in the Nineteenth Century*. Baton Rouge: Louisiana State University Press, 1998.

Howe, Marshall Avery. "Some Photographs of the Silk-Cotton Tree (Ceiba pentandra), with Remarks on the Early Records of Its Occurrence in America." *Torrey Botanical* 6 (1906): 217–231.

Irwin, David. *Neoclassicism*. London: Phaidon Press Limited, 1997.

Jackson, John Brinckerhoff. *A Sense of Place, a Sense of Time*. New Haven, CT: Yale University Press, 1994.

Jay, Martin. "Scopic Regimes of Modernity." In *Vision and Visuality*, edited by Hal Foster, 3–28. Seattle, WA: Bay Press, 1988.

Jensen, Larry R. *Children of Colonial Despotism: Press, Politics, and Culture in Cuba, 1790–1840*. Tampa: University of South Florida Press, 1988.

Johnson, Sherry. *The Social Transformation of Eighteenth-Century Cuba.* Gainesville: University of Press of Florida, 2001.

Juan, Adelaida de. *Pintura cubana: Temas y variaciones.* Mexico City: Universidad Nacional Autónoma de México, 1980.

———. *Pintura y grabado coloniales cubanos.* Havana: Instituto Cubano del Libro, 1974.

Kagan, Richard L. *Urban Images of the Hispanic World, 1493–1793.* New Haven, CT: Yale University Press, 2000.

Kapcia, Antoni. *Havana: The Making of Cuban Culture.* Oxford: Berg, 2005.

Kasl, Ronda, and Suzanne L. Stratton. *Painting in Spain in the Age of Enlightenment: Goya and His Contemporaries.* New York: Indianapolis Museum of Art/Spanish Institute, 1997.

Katzew, Ilona. *Casta Painting: Images of Race in Eighteenth-Century Mexico.* New Haven, CT: Yale University Press, 2004.

———. "'Remedo de la ya muerta América': The Construction of Festive Rites in Colonial Mexico." In *Contested Visions in the Spanish Colonial World,* edited by Ilona Katzew and Luisa Elena Alcalá, 151–175. Los Angeles: Los Angeles County Museum of Art; New Haven, CT: Yale University Press, 2011.

———. "'That This Should Be Published and Again in the Age of the Enlightenment?': Eighteenth-Century Debates about the Indian Body in Colonial Mexico." In *Race and Classification: The Case of Mexican America,* edited by Ilona Katzew and Susan Deans-Smith, 73–118. Stanford, CA: Stanford University Press, 2009.

Katzew, Ilona, and Susan Deans-Smith, eds. *Race and Classification: The Case of Mexican America.* Stanford, CA: Stanford University Press, 2009.

Kaufmann, Thomas DaCosta. *Toward a Geography of Art.* Chicago: University of Chicago Press, 2004.

Kearl, Michael C. *Endings: A Sociology of Death and Dying.* New York: Oxford University Press, 1989.

King, Anthony D. *Colonial Urban Development: Culture, Social Power, and Environment.* London: Routledge and Kegan Paul, 1976.

Knight, Franklin W. "Origins of Wealth and the Sugar Revolution in Cuba, 1750–1850." *Hispanic American Historical Review* 57 (May 1977): 231–253.

———. *Slave Society in Cuba during the Nineteenth Century.* Madison: University of Wisconsin Press, 1970.

Koerner, Lisbet. *Linnaeus: Nature and Nation.* Cambridge, MA: Harvard University Press, 1999.

Kostof, Spiro. *The City Shaped: Urban Patterns and Meanings through History.* New York: Bulfinch Press, 1991.

Kubler, George, and Martin Soria. *Art and Architecture in Spain and Portugal and Their American Dominions: 1500 to 1800.* Middlesex, UK: Penguin Books, 1959.

Kuethe, Allan J. *Cuba, 1753–1815: Crown, Military, and Society.* Knoxville: University of Tennessee Press, 1986.

Lachatañeré, Rómulo. *Afro-Cuban Myths*. Translated by Christine Ayorinde. Princeton, NJ: Markus Wiener, 2005.

———. *El sistema religioso de los afrocubanos*. Havana: Editorial de Ciencias Sociales, [1942] 2004.

Lafuente, Antonio, and Nuria Valverde. "Linnaean Botany and Spanish Imperial Biopolitics." In *Colonial Botany: Science, Commerce, and Politics in the Early Modern World*, edited by Londa Schiebinger and Claudia Swan, 134–147. Philadelphia: University of Pennsylvania Press, 2005.

Landers, Jane G. *Atlantic Creoles in the Age of Revolution*. Cambridge, MA: Harvard University Press, 2010.

Landers, Jane G., and Barry M. Robinson, eds. *Slaves, Subjects, and Subversives: Blacks in Colonial Latin America*. Albuquerque: University of New Mexico Press, 2006.

Lang, Karen. "Monumental Unease: Monuments and the Making of National Identity in Germany." In *Imagining Modern German Culture: 1889–1910*, edited by François Forster-Hahn, 274–299. Washington, DC: National Gallery of Art; Hanover, NH: University Press of New England, 1996.

Lanning, John Tate. *The Eighteenth-Century Enlightenment in the University of San Carlos de Guatemala*. Ithaca, NY: Cornell University Press, 1956.

Lara, Jaime. *City, Temple, Stage: Eschatological Architecture and Liturgical Theatrics in New Spain*. Notre Dame, IN: University of Notre Dame Press, 2004.

Larkin, Brian. *The Very Nature of God: Baroque Catholicism and Religious Reform in Bourbon Mexico City*. Albuquerque: University of New Mexico Press, 2010.

Lavin, Sylvia. *Quatremère de Quincy and the Invention of a Modern Language of Architecture*. Cambridge, MA: MIT Press, 1992.

Lawrence, Henry W. *City Trees: A Historical Geography from the Renaissance through the Nineteenth Century*. Charlottesville: University of Virginia Press, 2006.

Leal, Luis. "Félix Varela and Liberal Thought." In *The Ibero-American Enlightenment*, edited by A. Owen Aldridge, 234–342. Urbana: University of Illinois Press, 1971.

Lefebvre, Henri. *The Production of Space*. Malden, MA: Blackwell Publishing, [1974] 1991.

Lejeune, Jean-François. *Cruelty and Utopia: Cities and Landscapes of Latin America*. New York: Princeton Architectural Press, 2005.

Lescano Abella, Mario. *El primer centenario del Templete: 1828–1928*. Havana: Sindicato de Artes Gráficas, 1928.

Libby, Gary R. *Cuba: A History in Art*. Daytona Beach, FL: The Museum of Arts and Sciences, 1997.

Linebaugh, Peter, and Marcus Rediker. *The Many-Headed Hydra: Sailors, Slaves, Commoners, and the Hidden History of the Revolutionary Atlantic*. Boston: Beacon Press, 2002.

Liss, Sheldon B. *Roots of Revolution: Radical Thought in Cuba*. Lincoln: University of Nebraska Press, 1987.

Littler, Jo, and Roshi Naidoo. *The Politics of Heritage: The Legacies of "Race."* London: Routledge, 2005.

Llanes, Llilian. *The Houses of Old Cuba.* New York: Thames and Hudson, 1999.

López Núñez, Olga. "Notas sobre la pintura colonial en Cuba." In *Pintura europea y cubana en las colecciones del Museo Nacional de La Habana*, 49–73. Madrid: Fundación Cultural Mapfre Vida, 1998.

Los pinceles de la historia: De la patria criolla a la nación mexicana, 1750–1860. Mexico City: Banamex; Patronato del Museo Nacional de Arte: Universidad Nacional Autónoma de México, Instituto de Investigaciones Estéticas; CONACULTA-INBA, 2000.

Los pinceles de la historia: El origen del reino de la Nueva España, 1680–1750. Mexico City: Patronato del Museo Nacional de Arte; Banamex; CONACULTA-INBA, 1999.

Low, Setha M. *On the Plaza: The Politics of Public Space and Culture.* Austin: University of Texas Press, 2000.

Lowenthal, David. *The Past Is a Foreign Country.* Cambridge: Cambridge University Press, 1985.

Luz de Léon, J. de la. *Jean-Baptiste Vermay, peintre français, fondateur de l'Académie de Saint-Alexandre de La Havane, 1786–1833.* Paris: Editions de la Revue de l'Amérique Latine, 1927.

Lynch, John. *Bourbon Spain, 1700–1808.* Oxford: Blackwell, 1989.

MacCormack, Sabine. "Poetics of Representation in Viceregal Peru: A Walk round the Cloister of San Agustín in Lima." In *The Arts of South America, 1492–1850*, edited by Donna Pierce, 89–118. Denver, CO: Denver Art Museum, 2010.

Maraval, José Antonio. *Culture of the Baroque.* Minneapolis: University of Minnesota Press, 1986.

Marrero, Levi. *Cuba: Economía y sociedad: Del monopolio hacia la libertad comercial (1701–1763).* Vol. 6. Madrid: Editorial Playor, 1985.

———. *Cuba: Economía y sociedad: Del monopolio hacia la libertad comercial (1701–1763).* Vol. 8. Río Piedras, PR: Editorial San Juan, 1980.

———. *Cuba: Economía y sociedad: Azúcar, ilustración y conciencia (1763–1868).* Vol. 13. Río Piedras, PR: Editorial San Juan, 1986.

———. *Cuba: Economía y sociedad: Azúcar, ilustración y conciencia (1763–1868).* Vol. 14. Madrid: Editorial Playor, 1988.

Martínez, María Elena. "The Black Blood of New Spain: Limpieza de Sangre, Racial Violence, and Gendered Power in Early Colonial Mexico." *William and Mary Quarterly*, 3rd ser., 61, no. 3 (July 2004): 479–520.

———. *Genealogical Fictions: Limpieza de Sangre, Religion, and Gender in Colonial Mexico.* Stanford, CA: Stanford University Press, 2008.

Martínez-Fernández, Luis. *Fighting Slavery in the Caribbean: The Life and Times of a British Family in Nineteenth-Century Havana.* Armonk, NY: M. Sharpe, 1998.

Marx, Bridget, and Isabel Morán Suárez. *Royal Splendor in the Enlightenment: Charles IV of Spain, Patron and Collector.* Dallas, TX: Southern Methodist University; Madrid: Patrimonio Nacional, 2010.

McClellan, Andrew. *Inventing the Louvre: Art, Politics, and the Origins of the Modern Museum in Eighteenth-Century Paris.* Cambridge: Cambridge University Press, 1994.

Meléndez, Mariselle. "Visualizing Difference: The Rhetoric of Clothing in Colonial Spanish America." In *The Latin American Fashion Reader*, edited by Regina A. Root, 17–30. Oxford: Berg, 2005.

Melero, J. E. García. "Juan de Villanueva y los nuevos planos de estudio." In *Renovación, crisis, continuismo: La Real Academia de San Fernando en 1792*, edited by Soledad Lorenzo Forniés, María Luisa Moro Pajuelo, and Esperanza Navarrete Martínez, 13–55. Madrid: Real Academia de Bellas Artes de San Fernando, 1992.

Mena, Luz. "Stretching the Limits of Gendered Spaces: Black and Mulatto Women in 1830s Havana." *Cuban Studies* 36 (2005): 87–104.

Méndez Rodenas, Adriana. *Gender and Nationalism in Colonial Cuba: The Travels of Santa Cruz y Montalvo, Condesa de Merlin.* Nashville, TN: Vanderbilt University Press, 1998.

Menocal, Narciso G. "Etienne-Sulpice Hallet and the Espada Cemetery: A Note." *Journal of Decorative and Propaganda Arts* 22 (1996): 56–61.

Mercer, Kobena. "Art History after Globalisation: Formations of the Colonial Modern." In *Colonial Modern: Aesthetics of the Past, Rebellions for the Future*, edited by Tom Avermaete, Serhat Karakayali, and Marion von Osten, 232–243. London: Black Dog Architecture, 2010.

———, ed. *Cosmopolitan Modernisms.* London: Institute of International Visual Arts; Cambridge, MA: MIT Press, 2005.

Merleau-Ponty, Maurice. *The Primacy of Perception: And Other Essays on Phenomenological Psychology, the Philosophy of Art, History and Politics.* Evanston, IL: Northwestern University Press, 1964.

Middleton, Robin. *The Beaux-Arts and Nineteenth-Century French Architecture.* Cambridge, MA: MIT Press, 1982.

Middleton, Robin, and David Watkin. *Neoclassical and 19th Century Architecture.* Vol. 1. New York: Harry N. Abrams, 1980.

Mignolo, Walter. *The Darker Side of the Renaissance: Literacy, Territoriality, and Colonization.* Ann Arbor: University of Michigan Press, 1995.

———. *Local Histories/Global Designs: Coloniality, Subaltern Knowledges, and Border Thinking.* Princeton, NJ: Princeton University Press, 2000.

Miller, David, and Peter Reill, eds. *Visions of Empire: Voyages, Botany, and Representations of Nature.* Cambridge: Cambridge University Press, 1996.

Miller, Ivor L. "Religious Symbolism in Cuban Political Performance." *The Drama Review* 44, no. 2 (Summer 2000): 30–55.

Mintz, Sidney W. *Sweetness and Power: The Place of Sugar in Modern History*. New York: Viking, 1985.

Mintz, Sidney W., and Richard Price. *The Birth of African-American Culture*. Boston: Beacon Press, [1976] 1992.

Mitchell, W. J. T. *Iconology: Image, Text, and Ideology*. Chicago: University of Chicago Press, 1986.

Moore, Niamh, and Yvonne Whelan, eds. *Heritage, Memory, and the Politics of Identity*. Aldershot, UK: Ashgate Publishing, 2007.

Navarro, Dolores González-Ripoll. *Cuba, la isla de los ensayos: Cultura y sociedad (1790–1815)*. Madrid: Consejo Superior de Investigaciones Científicas, 2000.

Navia, Juan M. *An Apostle for the Immigrants: The Exile Years of Father Félix Varela y Morales, 1823–1853*. Salisbury, MD: Factor Press, 2002.

Niell, Paul B. "'Bajo su sombra': The Narration and Reception of Colonial Urban Space in Early Nineteenth-Century Havana, Cuba." PhD diss., University of New Mexico, 2008.

———. "Classical Architecture and the Cultural Politics of Cemetery Reform in Early Nineteenth-Century Havana, Cuba." *The Latin Americanist* 55, no. 2 (June 2011): 57–90.

———. "El Templete and Cuban Neoclassicism: A Multivalent Signifier as Site of Memory." *Bulletin of Latin American Research* 30, no. 3 (2011): 344–365.

———. "El Templete: Classicism and the Dialectics of Colonial Urban Spaces in Early Nineteenth-Century Havana, Cuba." In *Buen Gusto and Classicism in the Visual Cultures of Latin America, 1780–1910*, edited by Paul B. Niell and Stacie G. Widdifield, 49–71. Albuquerque: University of New Mexico Press, 2013.

———. "The Emergence of the Ceiba Tree as Symbol in the Cuban Cultural Landscape." *Cultural Landscapes: A Journal of Cultural Studies* 1, no. 3 (2009): 89–109.

———. "Founding the Academy of San Alejandro and the Politics of Taste in Late Colonial Havana, Cuba." *Colonial Latin American Review* 21, no. 2 (August 2012): 293–318.

———. "From Colonial Subjectivity to 'Enlightened' Selfhood: The Spatial Rhetoric of the Plaza de Armas of Havana, Cuba, 1771–1828." In *Urban Identity and the Atlantic World*, edited by Elizabeth Fay and Leonard von Morze, 41–60. New York: Palgrave Macmillan, 2013.

———. "Rhetorics of Place and Empire in the Fountain Sculpture of 1830s Havana." *The Art Bulletin* 95, no. 3 (September 2013): 440–464.

Niell, Paul B., and Stacie G. Widdifield, eds. *Buen Gusto and Classicism in the Visual Cultures of Latin America, 1780–1910*. Albuquerque: University of New Mexico Press, 2013.

Nora, Pierre. "Between Memory and History: *Les Lieux de Mémoire*." In *The Nineteenth-Century Visual Culture Reader*, edited by Vanessa R. Schwartz and Jeannene M. Przyblyski, 235–237. New York: Routledge, 2004.

O'Gorman, Edmundo. *Meditaciones sobre el criollismo.* Mexico City: Centro de Estudios de Historia de México, 1970.

O'Keeffe, Tadhg. "Landscape and Memory: Historiography, Theory, Methodology." In *Heritage, Memory and the Politics of Identity: New Perspectives on the Cultural Landscape,* edited by Niamh Moore and Yvonne Whelan, 3–18. Aldershot, UK: Ashgate Publishing, 2007.

Oliveras Samitier, Jordi. *Nuevas poblaciones en la España de la Ilustración.* Barcelona: Fundación Caja de Arquitectos, 1998.

Omari-Tunkara, Mikelle Smith. *Manipulating the Sacred: Yorùbá Art, Ritual, and Resistance in Brazilian Candomblé.* Detroit, MI: Wayne State University Press, 2005.

Ong, Aihwa. *Flexible Citizenship: The Cultural Logics of Transnationality.* Durham, NC: Duke University Press, 1999.

Ortiz, Fernando. "The Afro-Cuban Festival 'Day of the Kings.'" In *Cuban Festivals: A Century of Afro-Cuban Culture,* edited by Judith Bettelheim, 1–39. Kingston, Jamaica: Ian Randle Publishers; Princeton, NJ: Markus Wiener Publishers, 2001.

———. *La hija cubana del iluminismo.* Havana: Molina y Compañía, 1943.

———. *Los cabildos y la fiesta afrocubanos del Día de Reyes.* Havana: Editorial de Ciencias Sociales, 1992.

———. *Los negros brujos: Apuntes para un estudio de etnología criminal.* Miami: Ediciones Universal, [1906] 1973.

———. *Los negros esclavos.* Havana: Editorial de Ciencias Sociales, [1916] 1987.

———. "The Social Phenomenon of 'Transculturation' and Its Importance." In *Cuban Counterpoint: Tobacco and Sugar,* translated by Harriet De Onís, 97–103. New York: A. A. Knopf, 1947.

Pagden, Anthony. *The Fall of Natural Man: The American Indian and the Origins of Comparative Ethnology.* Cambridge: Cambridge University Press, 1986.

———. "Identity Formation in Spanish America." In *Colonial Identity in the Atlantic World, 1500–1800,* edited by Nicholas Canny and Anthony Pagden, 51–95. Princeton, NJ: Princeton University Press, 1987.

———. *Lords of All the World: Ideologies of Empire in Spain, Britain and France c. 1500–c. 1800.* New Haven, CT: Yale University Press, 1995.

Palmié, Stephan. *Wizards and Scientists: Explorations in Afro-Cuban Modernity and Tradition.* Chapel Hill, NC: Duke University Press, 2002.

Paquette, Gabriel B., ed. *Enlightened Reform in Southern Europe and Its Atlantic Colonies, c. 1750–1830.* Surrey, UK: Ashgate Publishing, 2009.

———. *Enlightenment, Governance, and Reform in Spain and Its Empire, 1759–1808.* New York: Palgrave Macmillan, 2008.

Peraza Sarausa, Fermín. *Historia de la Biblioteca de la Sociedad Económica de Amigos del País.* Havana: Imprenta "Alfa," 1939.

Pérez, Louis A., Jr. *Cuba: Between Reform and Revolution*. 2nd ed. New York: Oxford University Press, [1988] 1995.

———, ed. *Slaves, Sugar, and Colonial Society: Travel Accounts of Cuba, 1801–1899*. Wilmington, DE: Scholarly Resources, 1992.

Pérez Beato, Manuel. *Habana antigua: Apuntes históricos*. Vol. 1, *Toponimia*. Havana: Seoane, Fernández, 1936.

Pérez Cisneros, Guy. *Características de la evolución de la pintura en Cuba*. Havana: Dirección General de Cultura, Ministerio de Educación, 1959.

———. *La pintura colonial en Cuba*. Havana: Corporación Nacional del Turismo, 1950.

Pérez Sánchez, Alfonso E., and Eleanor A. Sayre. *Goya and the Spirit of the Enlightenment*. Boston: Little, Brown, 1989.

Peterson, Jeanette Favrot. "The Virgin of Guadalupe: Symbol of Conquest or Liberation?" *Art Journal* 51, no. 4 (Winter 1992): 39–47.

Polonsky Celcer, Enrique, ed. *Monografía Antológica del Árbol*. Guatemala: Centro Editorial "Jose de Pineda Ibarra," 1962.

Porterfield, Todd, and Susan L. Siegfried. *Staging Empire: Napoleon, Ingres, and David*. University Park: Pennsylvania State University Press, 2006.

Préstamo y Hernández, Felipe J., ed. *Cuba: Arquitectura y urbanismo*. Miami: Ediciones Universal, 1995.

Puig-Samper, Miguel Ángel, and Mercedes Valero. *Historia del Jardín Botánico de La Habana*. Madrid: Doce Calles, 2000.

Rabasa, José. *Inventing America: Spanish Historiography and the Formation of Eurocentrism*. Norman: University of Oklahoma Press, 1993.

Rajagopalan, Mrinalini, and Madhuri Desai, eds. *Colonial Frames, Nationalist Histories: Imperial Legacies, Architecture, and Modernity*. Burlington, VT: Ashgate Publishing, 2012.

Rama, Angel. *The Lettered City*. Durham, NC: Duke University Press, 1996.

Reid, Michele. "The Yoruba in Cuba: Origins, Identities, and Transformations." In *The Yoruba Diaspora in the Atlantic World*, edited by Toyin Falola and Matt D. Childs, 111–129. Bloomington: Indiana University Press, 2004.

Richardson, Miles. "Being-in-the-Market versus Being-in-the-Plaza: Material Culture and the Construction of Social Reality in Spanish America." In *The Anthropology of Space and Place: Locating Culture*, edited by Setha M. Low and Denise Lawrence-Zúñiga, 74–92. Malden, MA: Blackwell, 2003.

———. "Culture and the Urban Stage: The Nexus of Setting, Behavior, and Image in Urban Places." In *Human Behavior and Environment*, edited by Irwin Altman, Amos Rapoport, and Joachim F. Wohlwill, 4:209–242. New York: Plenum, 1980.

Rigol, Jorge. *Apuntes sobre la pintura y el grabado en Cuba: De los orígenes a 1927*. Havana: Editorial Pueblo y Educación, 1971.

Ringrose, David. "A Setting for Royal Authority: The Reshaping of Madrid, Sixteenth to Eighteenth Centuries." In *Embodiments of Power: Building Baroque Cities in Europe*, edited by Gary B. Cohen and Franz A. J. Szabo, 230–248. New York: Berghahn Books, 2008.

Rishel, Joseph J., and Suzanne Stratton-Pruitt, eds. *The Arts in Latin America, 1492–1820*. New Haven, CT: Yale University Press, 2006.

Rodríguez O., Jaime E. *The Independence of Spanish America*. Cambridge: Cambridge University Press, 1998.

Roig de Leuchsenring, Emilio. *La Habana Antigua: La Plaza de Armas*. Cuadernos de Historia Habanera, no. 2. Havana: Municipio de La Habana, 1935.

———. *La Habana: Apuntes históricos*. Vol. 3, Chapters 1–3. Havana: Editora del Consejo Nacional de Cultura, 1963.

———. *Los monumentos nacionales de la República de Cuba*. Vol. 2, *La Plaza de la Catedral de La Habana*. Havana: Junta Nacional de Arqueología y Etnología, 1959.

Rojas, Elizabeth Fuentes. *La Academia de San Carlos y los constructores del Neoclásico: Primer catálogo de dibujo arquitectónico, 1779–1843*. Mexico City: Universidad Nacional Autónoma de México, 2002.

Rojas Mix, Miguel. *La plaza mayor: El urbanismo, instrumento del dominio colonial*. Barcelona: Muchnik Editores, 1978.

Rosenblum, Robert. *Transformations in Late Eighteenth Century Art*. Princeton, NJ: Princeton University Press, 1967.

Rouse, Irving. *The Tainos: Rise and Decline of the People Who Greeted Columbus*. New Haven, CT: Yale University Press, 1992.

Rykwert, Joseph. *The Idea of a Town: The Anthropology of Urban Form in Rome, Italy, and the Ancient World*. Princeton, NJ: Princeton University Press, 1976.

———. *On Adam's House in Paradise: The Idea of the Primitive Hut in Architectural History*. 2nd ed. Cambridge, MA, and London, 1981.

Said, Edward. *Orientalism*. New York: Columbia University Press, 1978.

Sánchez Agustí, María. *Edificios públicos de La Habana en el siglo XVIII*. Valladolid, Spain: University of Valladolid, 1984.

Schama, Simon. *Landscape and Memory*. New York: Vintage Books, 1995.

Schele, Linda, and David Freidel. *A Forest of Kings: The Untold Story of the Ancient Maya*. New York: Morrow, 1990.

Schiebinger, Londa, and Claudia Swan, eds. *Colonial Botany: Science, Commerce, and Politics in the Early Modern World*. Philadelphia: University of Pennsylvania Press, 2005.

Schlesinger, Arthur M. "Liberty Tree: A Genealogy." *New England Quarterly* 25, no. 4 (1952): 435–458.

Schreffler, Michael. *The Art of Allegiance: Visual Culture and Imperial Power in Baroque New Spain*. University Park: Pennsylvania State University Press, 2007.

Schwartz, Vanessa R., and Jeannene M. Przyblski, eds. *The Nineteenth-Century Visual Culture Reader*. New York: Routledge, 2004.

Scott, James C. *Domination and the Arts of Resistance: Hidden Transcripts*. New Haven, CT: Yale University Press, 1990.

———. *Seeing Like a State: How Certain Schemes to Improve the Human Condition Have Failed*. New Haven, CT: Yale University Press, 1998.

Scott, Julius, III. "The Common Wind: Currents of Afro-American Communication in the Era of the Haitian Revolution." PhD diss., Duke University, 1986.

Scott, Pamela. *Temple of Liberty: Building the Capitol for a New Nation*. New York: Oxford University Press, 1995.

Seed, Patricia. *To Love, Honor, and Obey in Colonial Mexico: Conflicts over Marriage Choice, 1574–1821*. Stanford, CA: Stanford University Press, 1988.

Segre, Roberto. *La Plaza de Armas de La Habana: Sinfonía urbana inconclusa*. Havana: Editorial Arte y Literatura, 1995.

Shafer, Robert J. *The Economic Societies in the Spanish World (1763–1821)*. Syracuse, NY: Syracuse University Press, 1958.

Shubert, Adrian. "'Charity Properly Understood': Changing Ideas about Poor Relief in Liberal Spain." *Comparative Studies in Society and History* 33, no. 1 (1991): 36–55.

Silverblatt, Irene. *Modern Inquisitions: Peru and the Colonial Origins of the Civilized World*. Durham, NC: Duke University Press, 2004.

Smith, Laurajane. *Uses of Heritage*. London: Routledge, 2006.

Smith, Robert C. "Colonial Towns of Spanish and Portuguese America." *Journal of the Society of Architectural Historians* 14, no. 4 (1955): 3–12.

Sommer, Doris. *Foundational Fictions: The National Romances of Latin America*. Berkeley: University of California Press, 1991.

Stanfield-Mazzi, Maya. "Cult, Countenance, and Community: Donor Portraits from the Colonial Andes." *Religion and the Arts* 15 (2011): 429–459.

Stoichita, Victor. *Visionary Experience in the Golden Age of Spanish Art*. London: Reaktion, 1995.

Stolcke, Verena. *Marriage, Class and Colour in Nineteenth-Century Cuba: A Study of Racial Attitudes and Sexual Values in a Slave Society*. Cambridge: Cambridge University Press, 1974.

Styles, John, and Amanda Vickery, eds. *Gender, Taste, and Material Culture in Britain and North America, 1700–1830*. New Haven, CT: Yale Center for British Art; London: Paul Mellon Centre for Studies in British Art, 2006.

Taussig, Michael. *Mimesis and Alterity: A Particular History of the Senses*. New York: Routledge, 1993.

Thomas, Hugh. *Cuba or the Pursuit of Freedom*. New York: Da Capo Press, 1998.

Thompson, Robert Farris. *Flash of the Spirit: African and Afro-American Art and Philosophy*. New York: Random House, 1983.

Tomich, Dale. "The Wealth of Empire: Francisco Arango y Parreño, Political Economy, and the Second Slavery in Cuba." In *Interpreting Spanish Colonialism: Empires, Nations, and Legends*, edited by Christopher Schmidt-Nowara

and John M. Nieto-Phillips, 54–85. Albuquerque: University of New Mexico Press, 2005.

Tomlinson, Janis. "Painters and Patrons at the Court of Madrid, 1701–1828." In *Painting in Spain in the Age of Enlightenment: Goya and His Contemporaries*, edited by Ronda Kasl and Suzanne L. Stratton, 13–25. Indianapolis: Indianapolis Museum of Art; New York: Spanish Institute, 1997.

Torres Cuevas, Eduardo. *Esclavitud y sociedad: Notas y documentos para la historia de la esclavitud negra en Cuba*. Havana: Editorial de Ciencias Sociales, 1986.

——. *Historia de la masonería cubana: Seis ensayos*. Havana: Imagen Contemporánea, 2004.

——. *Historia del pensamiento cubano*. Havana: Editorial de Ciencias Sociales, 2004.

——. *Obispo de Espada: Papeles*. Havana: Imagen Contemporánea, 1999.

——. *Obispo Espada: Ilustración, reforma y antiesclavismo*. Havana: Editorial de Ciencias Sociales, 1990.

Torres Cuevas, Eduardo, and Edelberto Leyva Lajara. *Historia de la Iglesia Católica en Cuba: La iglesia en las patrias de los criollos, 1516–1789*. Havana: Editorial Boloña de la Oficina del Historiador de la Ciudad, 2007.

Toussaint, Manuel. *Arte colonial en México*. Mexico City: Imprenta Universitaria, 1948.

Trouillot, Michel-Rolph. "The Anthropology of the State in the Age of Globalization: Close Encounters of the Deceptive Kind." *Current Anthropology* 42, no. 1 (February 2001): 125–138.

——. *Silencing the Past: Power and the Production of History*. Boston: Beacon Press, 1995.

Uribe-Uran, Victor M. "The Birth of a Public Sphere in Latin America during the Age of Revolution." *Comparative Studies in Society and History* 42, no. 2 (2000): 425–457.

Valderrama y Peña, Esteban, and Benigno Vázquez Rodríguez. *La pintura y la escultura en Cuba/Painting and Sculture in Cuba/La peinture et la sculpture à Cuba*. Havana: Editorial Lex, 1953.

Vargaslugo, Elisa. *Images of the Natives in the Art of New Spain: 16th to 18th Centuries*. Mexico City: Fomento Cultural Banamex, 2005.

Viarnes, Carrie. "All Roads Lead to Yemayá: Transformative Trajectories in the Procession of Regla." 2004. http://www.hemisphericinstitute.org/journal/5.1/por/p051_pf_viarnes.html.

Vidler, Anthony. *The Writing of the Walls: Architectural Theory in the Late Enlightenment*. Princeton, NJ: Princeton Architectural Press, 1987.

Voekel, Pamela. *Alone before God: The Religious Origins of Modernity in Mexico*. Durham, NC: Duke University Press, 2002.

Voeks, Robert A. *Sacred Leaves of Candomblé: African Magic, Medicine, and Religion in Brazil*. Austin: University of Texas Press, 1997.

Weiss, Joaquín E. *La arquitectura colonial cubana*. Havana: Instituto Cubano del Libro; Madrid: Agencia Española de Cooperación Internacional; Sevilla: Consejería de Obras Públicas y Transportes, Junta de Andalucía, [1972] 1996.

Whitaker, Arthur P. "Changing and Unchanging Interpretations of the Enlightenment in Spanish America." *Proceedings of the American Philosophical Society* 114, no. 4 (1970): 256–271.

Whitford, David M. *The Curse of Ham in the Early Modern Era: The Bible and the Justifications for Slavery*. Farnham, UK: Ashgate Publishing, 2009.

Widdifield, Stacie G. "El indio re-tratado." *Hacia otra historia del arte en México: De la estructuración colonial a la exigencia nacional (1780–1860)*, edited by Esther Acevedo, 1:241–256. Mexico City: Consejo Nacional para la Cultura y las Artes, 2001.

———. *The Embodiment of the National in Late Nineteenth-Century Mexican Painting*. Tucson: University of Arizona Press, 1996.

———. "Manuel Tolsá's Equestrian Portrait of Charles IV: Art History, Patrimony, and the City." *Journal X* 8, no. 1 (2003): 61–83.

Williams, Patrick, and Laura Chrisman, eds. *Colonial Discourse and Post-Colonial Theory: A Reader*. New York: Columbia University Press, 1994.

Williams, Roger. *Botanophilia in Eighteenth-Century France*. Dordrecht, Netherlands: Kluwer Academic Publishers, 2001.

Young, Alfred F. *Liberty Tree: Ordinary People and the American Revolution*. New York: New York University Press, 2006.

Young, Alfred F., and Terry J. Fife with Mary E. Janzen. *We the People: Voices and Images of the New Nation*. Philadelphia: Temple University Press, 1993.

INDEX

Note: Italic page numbers refer to figures.

and rationalization of society, 19; and
religious reform, 85; representation of,
148; and sociability, 69; and social mobil-
ity, 89; state mediating between wealthy
and poor, 64. *See also* elites; lower classes;
middle class
social hierarchy: and *cabildos de naciones*, 21,
53–54; and cemeteries, 81, 255n89; and
clothing, 149, 225, 274n48; and ideology
of white dominance, 208, 215; multivocal
images of, 149, 205; and Plaza de Armas,
48; and *sistema de castas*, 30, 221; and
socioracial hierarchy, 71, 213, 217, 225–226;
stability of, 148
social life, and urban spaces, 27–31, 33–34
social transformation, anxieties of, 4, 241n8
Sociedades Económicas de Amigos del País
(Economic Societies of Friends of the
Country), 17, 60, 61–62. *See also* Econom-
ic Society of Havana
Solá, Antonio, 82, *83*
Soles y Rayos de Bolívar (1823), 137, 168, 196
Solís, Antonio de, 194
Sommer, Doris, 271n88
Sons of Liberty, 190
Spain: academies founded in, 17–18, 21,
56–57; and cemeteries, 75–76, 254n58;
civil societies established in, 16–17; con-
solidation for Christendom, 36; con-
tributions to global modernity, 16–20;
economy of, 35–36, 56, 58, 59–60, 63, 166;
French invasion of, 49, 167; as homeland,
8; and *limpieza de sangre*, 30; Roman
legacy in, 18
Spanish Bourbon monarchy: academies
established by, 56–57; centralized imperial
practices of, 7, 57; and imperial classicism,
14; and mercantilism, 70–71, 168; and
Napoleon, 49; and palace architecture, 22,
140; and performance of order, 47–54;
and representation of King's presence, 150,
265n106; urban plans of, 26. *See also* Bour-
bon Reforms; *and specific kings and queens*

Spanish chroniclers, 102–103, 105, 194,
266n122
Spanish colonial houses: central doorway
of, 31, *32*, 33; internal divisions within, 33,
34, 44
Spanish Cortes, 49–50, 51, 53, 167, 168
Spanish Empire: architectural and urban
space of, 36; crisis of, 166–170; Cuba's his-
tory within, 8, 100, 121–122, 166; geopo-
litical vulnerabilities of, 25; and invoca-
tion of Columbus, 162; and paternalism
rhetoric, 170–171, 173, 175–176; political
tumult in, 48; threats to, 165
Spanish literature, 59
Spanish royal palace, Mexico City, 242n20
Spanish viceregal rule of Cuba (1511–1898):
and agency of architecture, 265n106;
collapse of, 164; influences of, 2, 3; insur-
rection in, 167, 175; representation of,
6–7, 148–149, 177, 264–265n101; role of
viceroy, 249n60
spatial order: Bourbon implementations of,
20, 47–54; fluctuation in, 166; rational
spatial order, 26, 65, 79
spatial reform, 26, 27, 56
Stanfield-Mazzi, Maya, 264n101
Stolcke, Verena, 222
subaltern responses, to heritage, 4, 20, 22, 23,
169, 227, 239–240
sugar industry: development of, 70, 96, 166,
181, 205, 212; labor demands of, 208, 238;
and racial politics, 204, 209; socioeco-
nomic changes of, 95, 167; and urban atti-
tudes toward African-descended people,
220; and work mandates, 252n39
surveillance, 26
syncretism, 3
Taíno: and ceiba tree, 102, 103, 105; popula-
tion of, 30, 103, 104; and Spanish Con-
quest, 195
taste. *See buen gusto* (good taste)
Temple of Portunus, Rome, 131
Temple of Solomon, Jerusalem, 134, *135*, 136, 137

187, 188, 193, 196, 199, 214–215, 220; and
Heredia, 195, 196; history paintings in El
Templete, 9–13, *12*, *13*, *14*, 22, 133, 140, 141,
142, 143, 145–147, *147*, 150, 151, 160, 169,
183, 187–188, 199, 200, 204, 207, 214–215,
219, 226, 227, 238, 239, 241n4, 265n116;
impact on representational conventions,
21; *The Inauguration of El Templete*, 12–13,
14, 133, 143, 146–151, *147*, 153, 155–158, 160,
177, 178, 179, 181, 215–216, 217, 219–222,
225, 226, 264–265n101; *The Inauguration
of El Templete*, details, *151*, *152*, *154*, *156*,
157, *215*, *218*; influence of French acad-
emy on, 142; *The Last Supper*, 84–85, *84*,
257n115; and local context, 183; *Portrait of
a Man*, 97, *98*; and racial mixing, 195, 196,
199, 208; and racial types, 198, 224–225;
self-portrait in *The Inauguration of El
Templete*, 152, 153, 155
Verrocchio, Andrea del, 40
viceregal portraiture, 18, 268n31
Vignola, M. Jacques Daroris de, 130
Villalobos, Juan de, *Miracle of Ocotlán*, 185,
186
Villanueva, Juan de, 39, 76, 127
Villaverde, Cirilo, 33–34, 157–158
Virgen of Remedios, 169, 185
Virgin and child statue, ceiba tree memorial,
1754, Plaza de Armas (Anonymous), 9, *10*,
113, 143, 186, 187; detail, *110*
Virgin Mary: Our Lady of the Pillar, Zara-
goza, Spain, 113, 119, 130, 186, 260n28;
Virgen of Remedios, 169, 185; Virgin and
child statue, ceiba tree memorial, 1754, 9,
10, *110*, 113, 143, 186, 187; Virgin of Gua-
dalupe, 144, 185; Virgin of Regla, 169,
234–235, *235*, 236, 239–240
visibility of subjects, 26
visual images: appropriation of Afro-Cuban
visual culture, 232; and collective mem-
ory, 101; and heritage, 23; and imperial
uniformity, 47; and local context, 183;
and maintenance of colonial ideolo-

gies, 242n19; of militia men, 47, *48*; and
paradigm of whiteness, 208, 213; of *posa*
chapels, 121; and propaganda, 141–142;
and religious reform, 82, 84–85; and
social hierarchy, 205; and social status, 30,
246n16; synthesis with architecture and
spatial reform, 56; and tree as genealogical
metaphor for blood purity, 224
Vitruvius, 36, 93–95, 125, 130, 132, 133, 139,
248n47, 254n65
Vives, Francisco Dionisio: and botani-
cal studies, 180–181, 200; on ceiba tree
monument of 1754, 114, 260n31; and
colonial ideologies, 178–179; and design
of El Templete, 113–115, 119, 120, 133; El
Templete as propaganda vehicle for, 166,
176; and Escobar, 90; Espada's ideologi-
cal conflict with, 15, 16, 100, 166; funding
of El Templete, 16, 100, 116, 117, 170; and
governorship of Cuba, 167, 170, 179; lin-
eage of, 274n46; in Vermay's *Inauguration
of El Templete*, *154*, 155, *156*, 178, 179, 181,
218, 219, 225
Voekel, Pamela, 73, 254n57

War of the Spanish Succession, 7
Washington, George, 192
Weiss, Joaquín, 132
Whitaker, Arthur P., 251n19
whites: identity of, 71, 96–97; and intermar-
riage, 222; militias of, 210; and paradigm
of whiteness, 208–209, 213, 214, 215–216,
220, 224–225; and presence of African-
descended people, 208, 210, 221, 225–226;
role in training of blacks, 217; royal *cédula*
for new towns for white immigrants,
211–212, 213, 273n18
women: as African slaves, 221–222; control
of white female sexuality, 224; in Ver-
may's *First Cabildo*, 146, 157, *197*, 220; in
Vermay's *Inauguration of El Templete*, 147,
151, *151*, *154*, 155, *156*, 157, 158, 215–216, *215*,
219–220, 221